WILD ISLES

Patrick Barkham and Alastair Fothergill

WILLIAM COLLINS

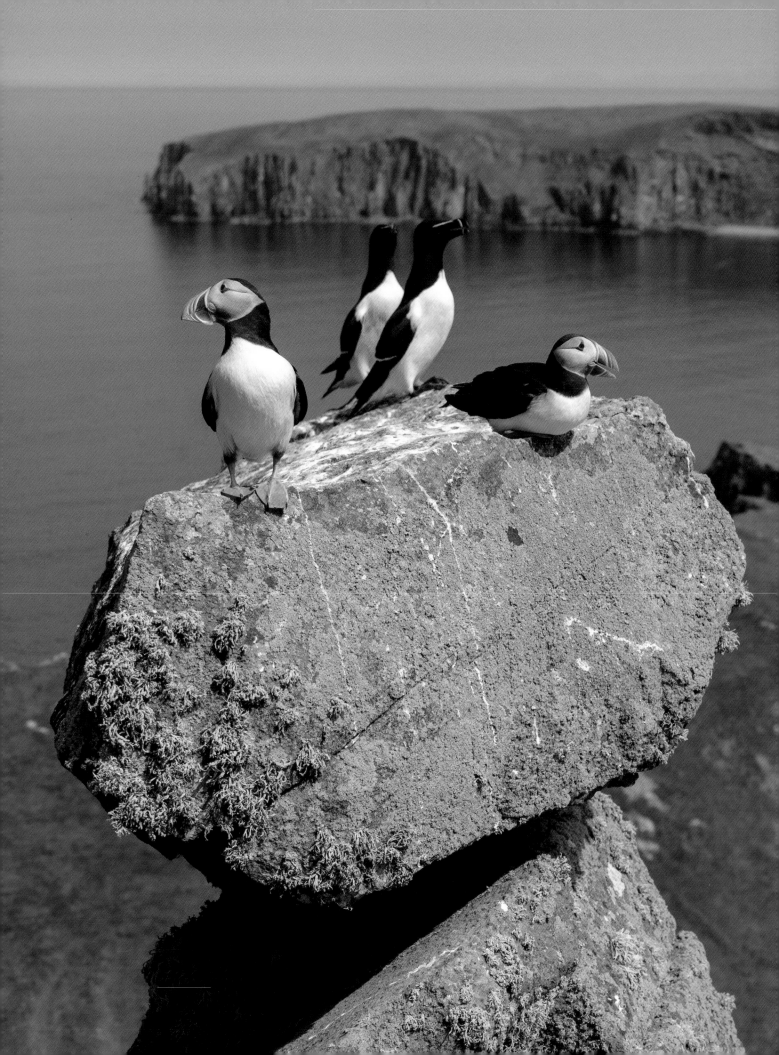

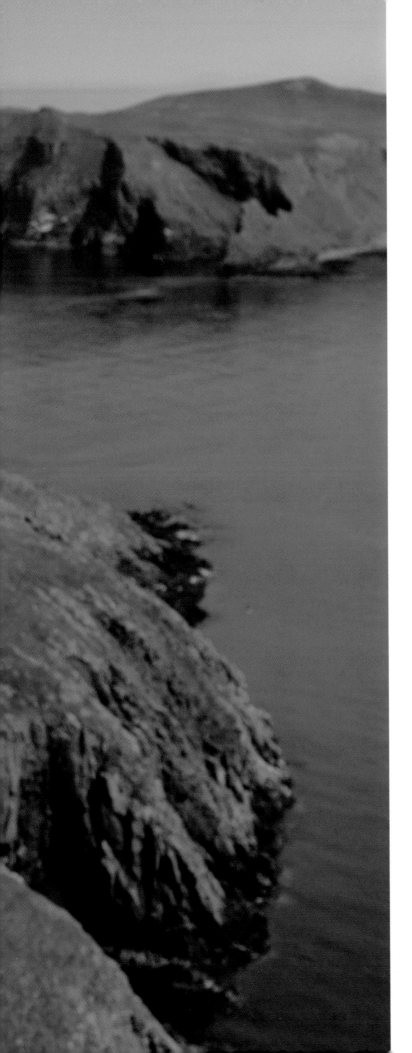

CONTENTS

INTRODUCTION:
A BOUNTY OF NATURE

Previous: Puffins and razorbills with Eilean Mhuire behind, Shiant Isles, Outer Hebrides, Scotland.

Opposite: Sir David Attenborough went on location across the British Isles in 2022 to film *Wild Isles*.

Wild Isles is a celebration of the wildlife found on a relatively modest collection of islands positioned at a latitude so northerly as to be unattractive to many animals and plants. Despite these unpromising foundations, the islands of Britain and Ireland, together with more than 6,000 lesser islets that make up our archipelago, contain some of the most diverse, beautiful and wildlife-rich landscapes and seas on our planet.

All life on Earth is interwoven and these islands hold crucial threads in the great global tapestry. They provide feeding and breeding places for visiting migrants and are a last repository for some of the world's rarest and most threatened habitats. As the world reaches a tipping point, challenged more than ever by an interconnected climate and an extinction crisis, we are faced with the practical challenge and moral imperative of not only conserving but expanding and strengthening our wild places and the species that inhabit them.

Over five chapters, each divided into several sections, we will explore the fascinating relationships within and between species who make their home on our beautiful isles. Each chapter focuses on a particular kind of wild space. Britain and Ireland are dominated by a wide variety of grasslands from lowland water meadows to upland moors, and we will see how these human-shaped, semi-natural landscapes thrum with insect, bird and mammal life. Life requires water to flourish, and we will discover how streams and rivers carry fresh water through our landscape, creating unique ecosystems and interrelations within and beside these waters. While Britain and Ireland's woodlands are now relatively thin on the ground compared with most of continental Europe, we will see that some of the forests and trees that remain are unusually ancient and are great repositories of life. Finally, of course, we are surrounded by sea, and our position on the continental shelf before it plunges into the depths of the Atlantic Ocean gives rise to an often overlooked abundance of marine life.

Why are we blessed with so much wildlife? As Sir David Attenborough says, 'Our position on the globe makes us a vital refuge for millions of visiting migrants. Our shores are washed by the Gulf Stream, which helps create some of the richest seas in Europe. And our geology is among the most varied found anywhere on the planet.'

Four characteristics give rise to our islands' bounty of biodiversity. The first is their prime geographical situation, based on one of the largest continental shelves in the world. We tend to only consider our seas from the surface, seeing a chilly expanse which is often rather grey or brown, and we don't always realise the riches beneath. We are surrounded by a large expanse of shallow seas, and shallow

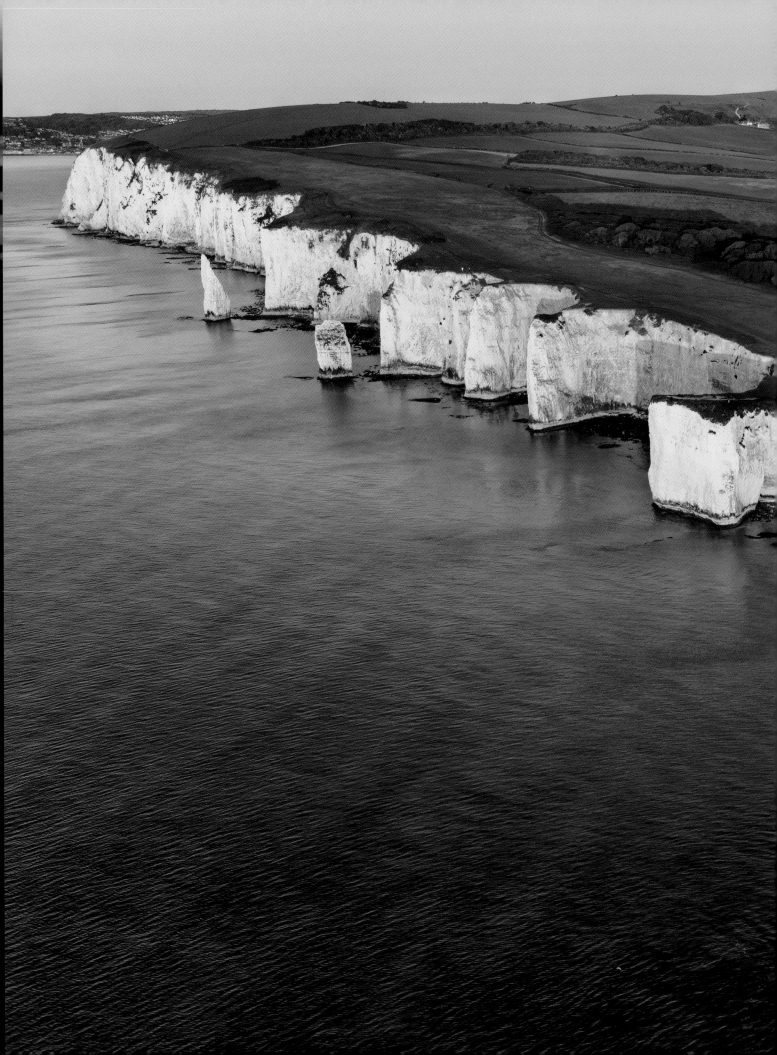

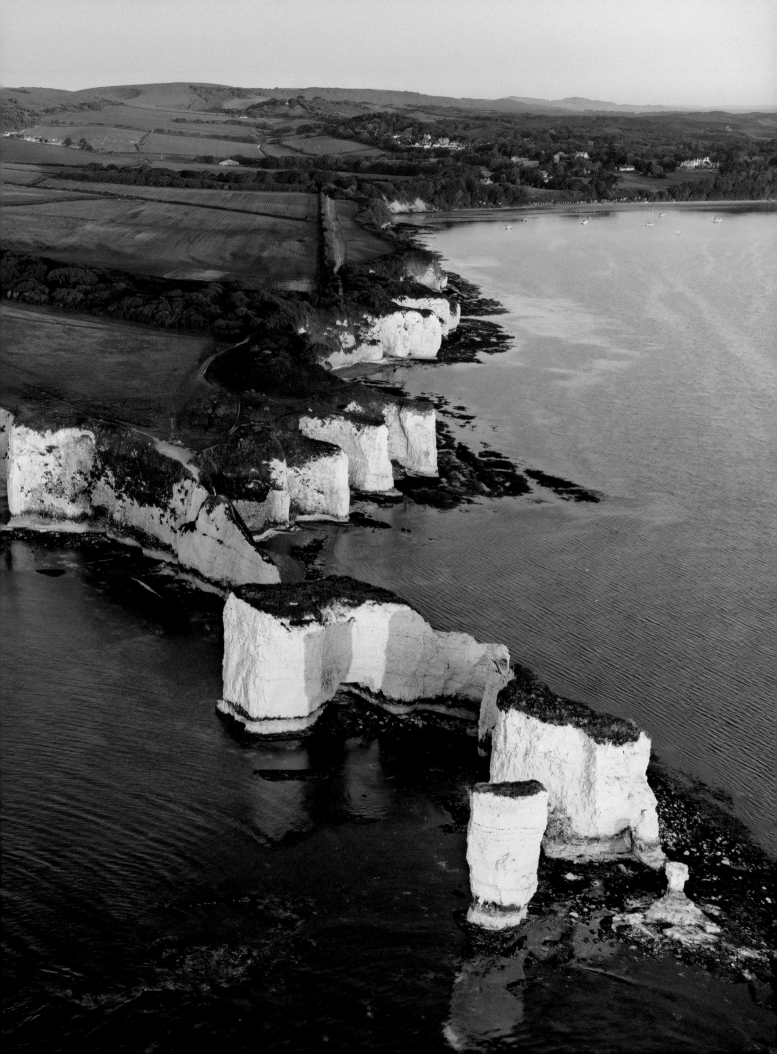

seas are filled with life. We also have weather systems that usher in violent winter storms, and some of the world's biggest tides, together with vicious tidal currents. In shallow seas, these storms, tides and currents stir nutrients from the nutrient-rich seabed and mix them into the water column. Warmed by spring sunshine, our nutrient-rich waters give rise to fabulous blooms of phytoplankton, microscopic plants which float in the water, and zooplankton, tiny animals and the offspring of much sealife, which feed upon these plants. These small organisms support a grand array of greater marine life, from scallops and cuttlefish to otters, basking sharks and, of course, millions of seabirds.

The second source of our wild riches is the size of our coastline. Wild species like edges. The boundary between wood and pasture, or land and sea, is always a dynamic place, offering opportunities to hunt, feast and shelter. And Britain and Ireland are more edge than middle. The coast of Britain alone is longer than India's, and its twists and turns total more than 10,000 miles. Bird lovers travel across the world to enjoy seabird spectacles on the Falklands or Galapagos islands, but the British Isles actually host eight million nesting seabirds each year – far more than either of those famed archipelagos. Scotland alone is home to 45 per cent of Europe's entire seabird population.

The third contributor to our wealth of nature is these islands' spectacularly varied geological foundations. From the chalk cliffs of Old Harry Rocks on the south coast to the Torridon sandstones of the Highlands, our isles have taken shape over millions of years – and from more than one continent. The northwest of Scotland and parts of Wales and Ireland are home to the gneisses, our oldest rocks at 2.7 billion years old. These rocks once formed part of an entirely separate continent, divided from the land that came to make Britain's southeast by 4,500 miles of ocean. Over millions of years, rocks were deposited as lands shifted, volcanoes erupted and seas came and went. Shales, siltstones and sandstones were created while the bounteous animal life in the warm tropical seas of ancient times was gradually laid down as chalk and carboniferous limestone. More recently, Ice Ages have come and gone, their glaciers and meltwaters carving out valleys, lakes and hills of shingle and sand. This varied geology has bequeathed a wide range of soils, habitats and plants. The chalk hillsides of England are not only rich in flowers and insect life but give rise to chalk streams featuring unique aquatic life: around 85 per cent of the planet's known chalk streams are found in England.

The fourth reason for our wealth of wildlife is a temperate Atlantic climate. Britain and Ireland are mild countries, with temperatures above the global average for their latitude. Cool winters are followed by warm summers with few of the extremes of temperature found on continental landmasses. The gentle warming that keeps our winters relatively mild is provided by the Gulf Stream, a swift current in the Atlantic Ocean which begins at the tip of Florida and heads up the east coast of the United States before crossing the Atlantic to western Europe. Mild weather, and rain, sweeps in from the west. These conditions have created a suite of Atlantic species and temperate rainforest. Nevertheless, there is also a gulf between the weather in the far north and that in the extreme south, and these contrasting near-Arctic and near-Mediterranean conditions give rise to a wide range of plants and animals that pursue very different lifestyles.

Previous: Old Harry Rocks are chalk pillars and stacks where the chalk rock of Dorset meets the sea at the tip of the Isle of Purbeck. Chalk creates a wealth of floral downland and precious streams across Britain.

We think of our islands as crowded and dominated by people, but there are formidable populations of wild animals too. England may be one of the most densely populated major countries in the world with an average of 432 people living in every square kilometre, but in the Highlands of Scotland there are only eight people per square kilometre. No wonder there are more golden eagles and red deer here than anywhere else in Europe. Britain has a higher density of badgers than any other country in the world too. These, and many other animals, have adapted to live very successfully in a landscape shaped by centuries of farming, industrialisation and urbanisation.

For all our isles' natural abundance, however, we know that species, habitats and our conventional weather systems are under threat from a changing climate and the increasing impact of humankind on our planet, which is causing a new epoch of mass extinctions. There is plenty of desire and action to protect and save wildlife, with Britain boasting a higher membership of conservation charities than any other large nation in the world. British charities prioritising the protection of our precious landscape and species have seven million members. But there is certainly plenty of work for us all to do: according to a recent study, Britain is the twelfth worst of 240 nations for the amount of wildlife and habitats lost to human activity, hanging on to around half of its plants and animals, compared with 67 per cent for Germany and 89 per cent for Canada. In the past century, England and Wales have lost 98 per cent of their wildflower meadows and three-quarters of heathland. More than half our ancient woodland has been destroyed. Intensifying our farming systems has led to a great thinning of abundance in the natural world. And today our seas remain remarkably unprotected from the devastating fishing and other industrial activities that have stripped them of much life over the last century, and continue to degrade and pollute marine life.

This book and the television series it accompanies showcase the life that makes its home on the British Isles today. It will reveal what makes rare wildlife tick and tell stories of globally important species and how their unique homes and habitats survive and can flourish. Prepare to encounter wildlife behaving in ways you have never witnessed before. For the wildlife of these isles has one great and constantly recurring quality: its capacity to not only delight but surprise us.

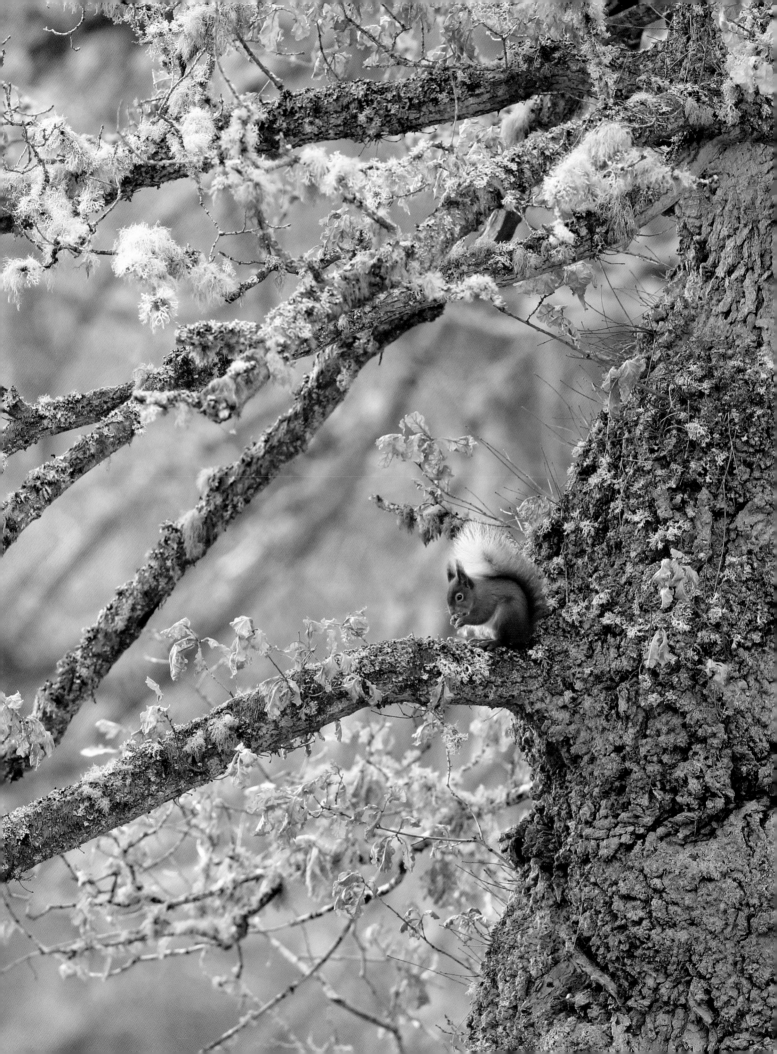

1. Our Precious Isles

OUR SURPRISING ISLES – ORCA HUNTING SEALS

Opposite top: A young harbour seal is a vulnerable target for the orcas who visit the Shetland Isles in summer and autumn.

Opposite below: The orcas work together to isolate and attack the harbour seal. These orcas are a pod known as the 27s.

The waters off our most northerly archipelago can dazzle an unexpectedly brilliant blue on a fine day. The coast of Shetland is gloriously wild, constantly swept by the wind and pounded by the surf. Holidaymakers may appreciate its beauty but another visitor makes it a truly hazardous place for a young seal. Every summer and autumn, one of the world's most ruthlessly efficient apex predators makes a pilgrimage to our shores. Groups of orcas (*Orcinus orca*), popularly known as killer whales, travel together in matrilineal family groups, or pods, from the northern Atlantic to the northern and northwestern islands of Britain and Ireland to search for food. These magnificent killing machines know that these months are the best time to seize an immature seal.

The orcas are unmistakable when spotted from the safety of the land. Their black, triangular dorsal fins rise almost preposterously high from the water, up to 1.8 metres for a male, the tallest of any cetacean. Crowds of people often gather on Shetland to watch whenever the orcas cruise past a harbour or headland. These mammals swim at speed – up to 56 kilometres per hour – and there's a spray of water and the hint of a superbly muscular black body as they power along. Each individual has a name and is identifiable to both conservation scientists and ordinary enthusiasts who follow their lives from their unique fin shape, their size and patterns and scars.

This enthusiasm for these majestic animals is providing new insights into their complex behaviour. The pod of orcas seen around the northern isles of Shetland and Orkney has three matrilineal groups, the 27s, the 64s and the 65s. Each one is named after the identifying number of the matriarch who leads the group.

A female with a distinctive dorsal fin came to be called Mousa because she was first spotted near the island of Mousa on the Shetland archipelago. It was then discovered that she was also regularly seen 1,000 kilometres away – in Iceland. Orca watchers eventually pieced together her lifestyle: every April, she brings her family on the long swim south to Shetland, switching from feeding on herring in Iceland to hunting seals in Scotland. When she first arrives in Britain, she tends to swim south as far as John O'Groats before heading back north to Orkney, arriving in Shetland in July and August. After a summer holiday in Scotland, she and her family head north back to Iceland for the winter.

Since Mousa was identified in both Iceland and Scotland's registry of orcas, around 30 animals have been found to live a similar migratory lifestyle, switching between locations and prey as the seasons turn. It is almost certain that Mousa's children will learn from her, and follow her way of life too. This is animal 'culture'

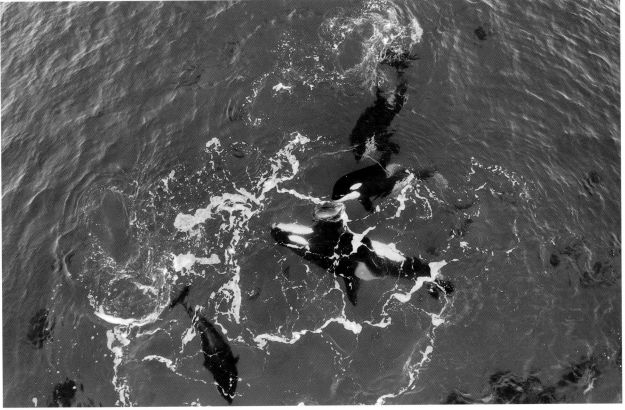

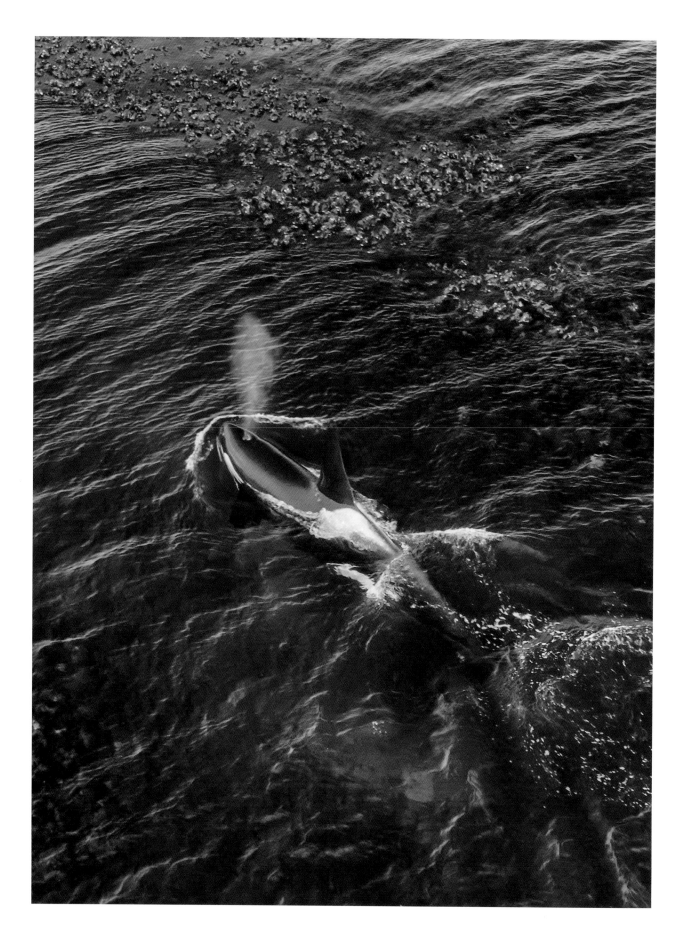

Opposite: The kelp beds off the Scottish coast are a rich source of marine life – and hunting grounds for orca. This bull orca is systematically searching the shallow channels in the hope of surprising a seal.

in action, and the study of culture in whales and dolphins is a fascinating emerging area of science.

But the common seal pup, also known as a harbour seal, birthed on the rocky Shetland coast knows nothing of the orca pods, their intelligence or the danger that they pose. It has only just been born. Soon the tide will rise and wash the seal into the bay, where it can play – and learn to fish – in kelp-rich shallows.

The orca is a versatile, adaptable predator. Different pods acquire different skill-sets depending on where they live; scientists call these 'ecotypes'. Some pods specialise in taking porpoises and dolphins; others focus more on seals. The orca's popular name, 'killer whale', is derived from sailors watching them attack whales such as minke, which can be larger than the orcas. Apart from humans, orcas are the only known predators of great white sharks. They may work together to surround and devour shoals of fish or beach themselves to attack sea lions or penguins. They'll eat squid and even a deer or moose foolish enough to swim across ocean channels.

Orcas are supremely communicative mammals, exchanging information with their families using a sophisticated language of clicks, whistles and, sometimes, bodily signs such as slapping their flippers or tail on the water. When they begin to patrol shallower waters in search of prey, they stop calling to each other and switch to silent mode. The seals are playing in the kelp and do not hear any approach. By the time they see the predator, it is too late to return to the safety of the rocks. The orcas separate one young seal from its group. It swims for its life. For a moment, twisting and turning, it looks like it might out-manoeuvre the heavier animal. But the orcas make an efficient team. They force the seal into deeper water. Soon it can race no longer.

For anyone who witnesses such a hunt from the land, it ends with a thrashing of white water. A circle is traced on the surface of the ocean. A body leaps from the green-blue depths, flashing white, and slams down again. The sky above turns white as gulls glide in, seeking any scraps of leftover seal. The water turns silver with oil from the slaughtered animal. A pungent, fishy smell – dead seal – drifts across the waves towards the land. On the rocks are two sets of mammal families: humans, binoculars in hand, open-mouthed with wonder, and seals, glancing around nervously, apparently aware of the predator they've just evaded.

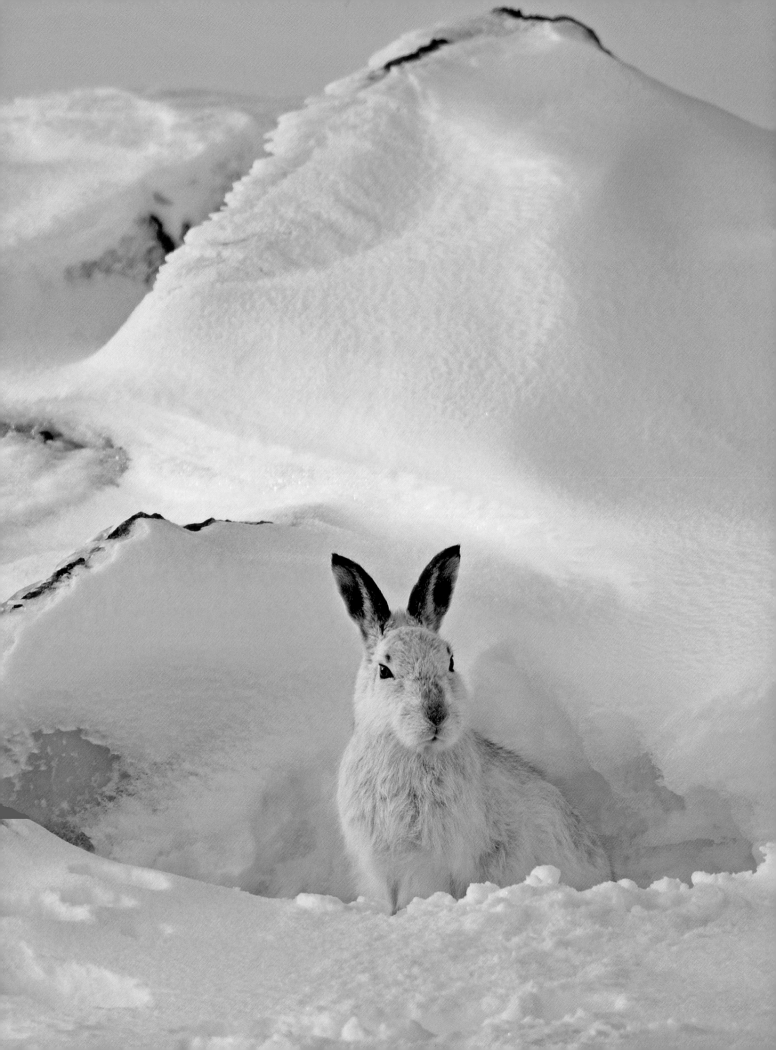

ARCTIC EXTREMES – SNOW HARES, SNOW BUNTING AND A GOLDEN EAGLE SCAVENGING TO SURVIVE

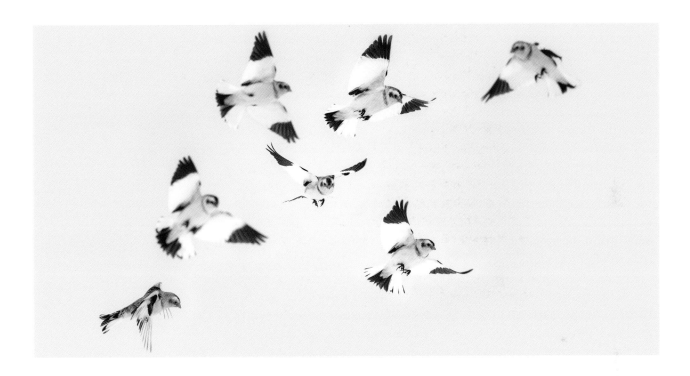

Above: The snow bunting is an Arctic specialist – a rare breeding bird in Britain but a more frequent winter visitor.

Opposite: A mountain hare's coat turns white to camouflage it in wintry conditions in the Highlands of Scotland, but one study has found an increasing mismatch between the white hares and more frequently snow-free terrain.

The coasts of the British Isles are fantastically rich in wildlife but another great driver of diversity is the climate. In the far north of Britain, in midwinter, talk of 'Arctic blasts' is not an exaggeration. Travel south from one portion of the Arctic Circle – as the wind often does – and the first land you'll reach is Britain. Shetland lies at 60 degrees north of the equator – as far north as the tip of Greenland, south-central Alaska, Russia, Finland and Canada. Much further south, even Newcastle lies on the same latitude as Novosibirsk, the capital of Siberia.

The Cairngorms in northeastern Scotland are cloaked in white for many days of winter. Here reside Arctic animals equipped with Arctic fur and feathers: snow hares and snow buntings. The latter is the most northerly passerine in the world, a member of the same large order of songbirds as house sparrows and blue tits. Snow buntings (*Plectrophenax nivalis*) breed inside the Arctic Circle, except for a tiny resident population of 60 breeding pairs in the high Cairngorms. In winter, Arctic-dwelling birds retreat to the relative comfort of the British coast, and the high mountains.

Here, despite layers of snow, flocks of the birds must find plants and seeds to eat, foraging in the snow to collect microscopic grass seeds. By spring, miraculously, the birds have increased their body weight by a third to power their nocturnal migration back to their breeding grounds in the high Arctic, where they will nest in crevices on the tundra as the snow melts away.

For the mountain hare (*Lepus timidus*), finding food is also a challenge, but so is not becoming food. When the snow begins to fall, mountain hares blend into the landscape by shedding their dark summer fur to become a brilliant – but camouflaged – white. These hares, and other Arctic and high-altitude species, will be challenged in the near future by global heating. In recent decades, climate change has brought noticeably fewer white days to the Highlands each winter and a scientific study suggests that mountain hares are failing to adapt quickly enough, by not changing their moult times. Highland hares lack appropriate camouflage on an extra 35 days each year on average compared with 65 years ago. They still plan for snow but the snow does not fall. It means that for more than a month extra each winter, the winter-whitened hares reveal themselves as an alluring white blob on a dark, snowless hillside – rather more conspicuous to the keen eye of a passing eagle.

Even a predator as impressive as a golden eagle (*Aquila chrysaetos*) may struggle to find food when the midwinter snows come in. This mighty eagle is the most widely distributed eagle species in the world, but over many decades illegal persecution has reduced its breeding range in our islands to northwest Ireland and Scotland, where 440 pairs breed each year. In winter, live prey is scarce and so the birds rely on carrion. They need an average of 250 grams of food each day to keep flying, although one good meal can last several days. The carcass of a red deer provides an apparently easy ready meal but even this bird, which has long been Scotland's top predator, has to fight for a feast. When one eagle feeds, hooded crows peck at its tail and dodge around it to steal some flesh. Ravens, foxes and other hungry scavengers are quick to seek a share of the spoils too.

Opposite: For a golden eagle in the Highlands, a red deer carcass is a valuable winter feast.

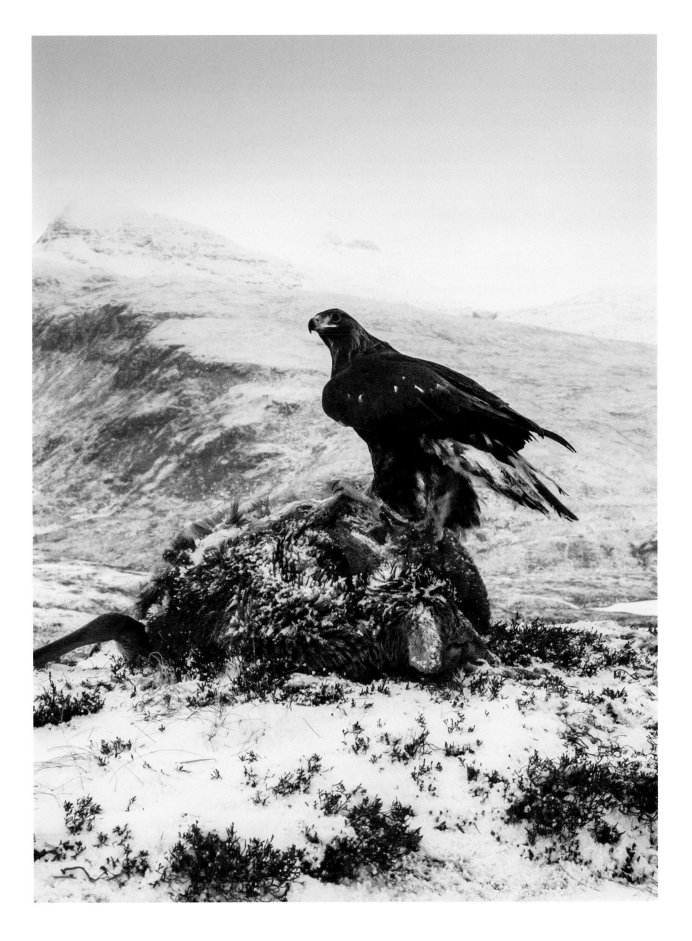

OUR VALUABLE FORESTS – THE MIGHTY OAKS OF BRITAIN

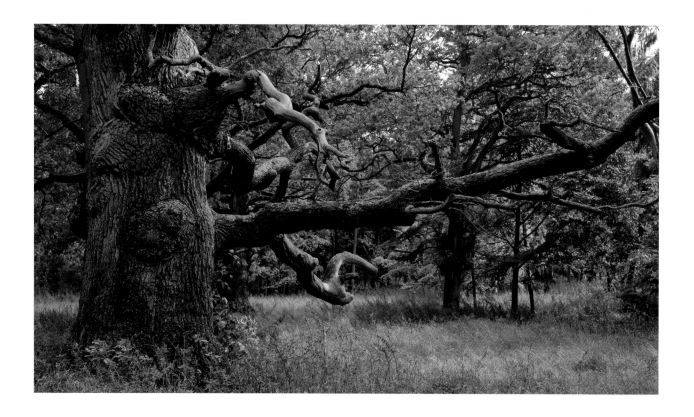

Above: An ancient oak in Blenheim Park, Oxfordshire, home to more ancient trees (more than 400 years old) than any other place in Europe.

If a golden eagle were to fly south over Britain, its keen eye would see a noticeably less wooded land than on the continent. But trees are returning. In the early decades of the twentieth century, Britain's forest cover had shrunk to barely 6 per cent. Today it is 13 per cent, and rising, although our landscape is still noticeably less wooded than France (31 per cent) or Finland (73 per cent). Some of our most impressive and important forests are found in Scotland. In the Cairngorms, Abernethy is the largest remnant of ancient Caledonian forest, home to elderly 'granny' Scots pines (*Pinus sylvestris*) and a rich combination of native vegetation including juniper, blaeberry, heather and downy birch. The RSPB made what was then the largest ever land purchase by a conservation charity in Europe when it bought 8,000 hectares of Abernethy for £1.8 million in 1988. Cairngorms Connect, a partnership of landowners and charities including the RSPB, has a 200-year vision to restore the ancient forested landscape of the Cairngorms across 60,000 hectares, an area equivalent to half of the entire county of Bedfordshire. Abernethy contains a wealth of around 5,000 species, including rare capercaillie, black grouse and osprey, but there are many other, very different but still internationally important woodlands across these isles.

Heading into England and Wales, although woods do not dominate the landscape, these nations retain a unique treasure trove of ancient trees. Ecologists

Overleaf: It is often said that oaks are 300 years growing, 300 years living and 300 years dying. Even ancient oaks with rotten trunks provide invaluable habitat for hundreds of invertebrates for hundreds of years.

and enthusiasts have identified 3,400 ancient oak trees in England – estimated to be more than are found across the rest of continental Europe put together. Historically, the oak has been highly prized for its high-quality, super-strong timber, but as well as being useful to humans, the oak's value to other species is superlative. This giant of biodiversity helps support more than 2,000 species of birds, plants, fungi and smaller creatures – more than any other British tree. Our isles' two native species, the pedunculate oak (*Quercus robur*) and the sessile oak (*Quercus petraea*), have been found to support 423 species of invertebrates compared to just 37 species in a non-native spruce. And ancient oaks are particularly beneficial. As the woodland ecologist Oliver Rackham put it: 'A single 400-year-old oak, especially a pollard with its labyrinthine compartment boundaries, can generate a whole ecosystem of such creatures, for which ten thousand 200-year-old oaks are no use at all.'

An ancient oak is a wondrous thing. They are huge, stout trees filled with crevices and hollows, throwing massive limbs in all directions. These limbs stretch far beyond their trunks. Oak is such strong wood that even dead branches, which resemble a stag's antlers, can remain sticking from a tree for decades. Like people, oaks stoop and lower in old age, losing outer branches and the upper crown but continuing to grow in girth. It is often said that oaks grow for 300 years, mature for 300 and then slowly decay for 300 years. The greatest collection of these ancient trees that are slowly reaching senescence, but still gloriously full of life, are found in the grounds of Blenheim Palace, Oxfordshire. There are more ancient trees (more than 400 years old) in the woods here than in any other place in Europe. Here grow at least 291 oaks possessed of a girth of five metres or more, with 220 of these oaks in High Park, a Site of Special Scientific Interest. Like the orcas, these charismatic individuals often have names and identities. The oldest was long thought to be the King Oak. More recently, however, ancient tree experts estimated that another oak in the wood predates the Norman Conquest, and is 1,046 years old.

Ancient trees continue to be discovered and although there is a lack of universal legal protection for these giants of history – unlike churches and other ancient monuments – society is increasingly aware of their value. The survival of so many old trees in a country that has lost most of its woodland is, at first glance, puzzling but it reflects Britain's stable patterns of land ownership since Medieval times. At Blenheim, the ancient oaks are the remnants of a Medieval royal hunting forest called Wychwood. Henry I used it for hunting deer, and royal forests were closely regulated, with local people barred from harvesting wood. These Medieval deer parks are a major reason for the presence of so many ancient oaks in Britain, helped by the fact that many have been owned by the same families for centuries. The absence of political revolutions that have seriously disrupted patterns of land ownership has also helped these ancient specimens survive, although every ancient tree has had many lucky escapes over time. Blenheim's oaks were incorporated into the first Duke of Marlborough's estate more than 300 years ago. Whereas other ancient trees were removed when estates were redesigned by Capability Brown, the legendary landscape gardener, in Blenheim's case Brown recognised the importance of the venerable oaks in 1763 and left them alone.

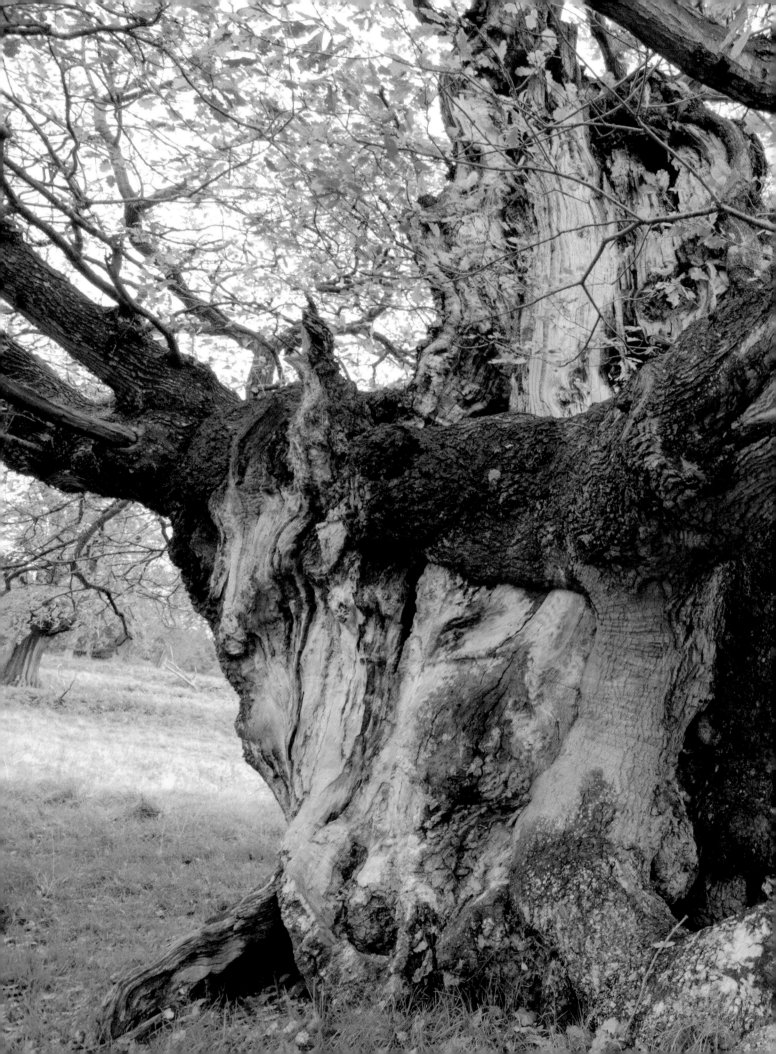

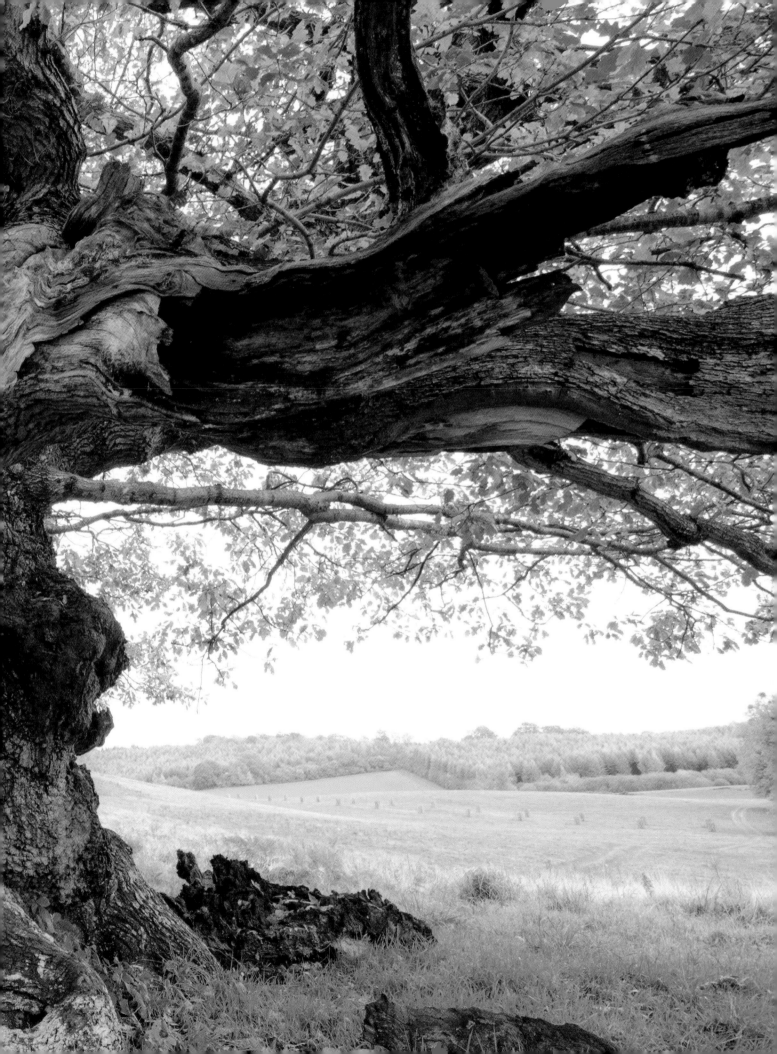

OAK NIGHT LIFE – HAZEL DORMOUSE AND SWARMS OF BATS

One of many creatures that finds sanctuary among ancient oaks and in mixed native woodlands is the only British small mammal (a grouping covering mice, shrews and voles) that has a furry tail. With its big blackcurrant eyes and diminutive size, the hazel dormouse (*Muscardinus avellanarius*) is one of the cutest small beasts to scamper across these isles, and also one of the most elusive.

Hazel dormice are nocturnal and arboreal, and spend much of the time safely above ground, in trees. The oak is their larder, and their home. Their nests – in tree cavities, former squirrel dreys, or nestboxes provided by conservationists – can be as high as ten metres above ground. Although treetops are their home, they spend more than half the year among tree roots – in hibernation. To tackle the winter, dormice build a dense and expertly woven sphere of shredded leaves and grasses beneath the ground. It will keep them snug through the colder months.

As the spring sunshine warms the woodland floor, the hazel dormice emerge from their deep sleep. They must fatten up quickly, so they begin by eating the unfurling flowers of oak, hawthorn and willow. Later in the summer, when the honeysuckle that winds its way up the oak's trunk comes into flower, its scent soon attracts the hazel doormice. The dormice deftly clamber into the canopy. To reach the nectar, they snip off the petals of the flowers, which fall to the ground like confetti.

By midsummer, when a typical litter of four baby dormice are just three weeks old, they venture out of their treetop nest for the first time to forage with their parents under the cover of darkness. They learn to balance and climb among the branches of the oak, and gain valuable nutrition from protein-rich invertebrates they find among the leaves: juicy caterpillars, sweet aphids and wasp galls. Each dormouse must reach a weight of between 15 and 18 grams to survive a long winter underground, and late summer fruits and nuts, from blackberries to hazelnuts, are another crucial source of food.

The hazel dormouse is in long-term decline, its estimated population falling by 52 per cent between 1995 and 2015 according to a national survey. The decline is thought primarily to have been driven by a fragmentation of habitat and the loss of the diverse range of plants and scrubby woodland understoreys that the dormouse requires. Protecting this special animal is a conservation priority, and conservation work to reconnect suitable woodlands and also reintroduce the animal is having a positive impact. As long as Britain's ancient woodlands are cherished, the hazel dormouse will continue to enjoy its life among the oaks.

There's another creature enjoying the night-life of the woodlands of northern England but the key to its remarkable swarms are the rocks beneath the trees.

Opposite: A hazel dormouse in a coppiced hazel. This protected species was photographed under licence.

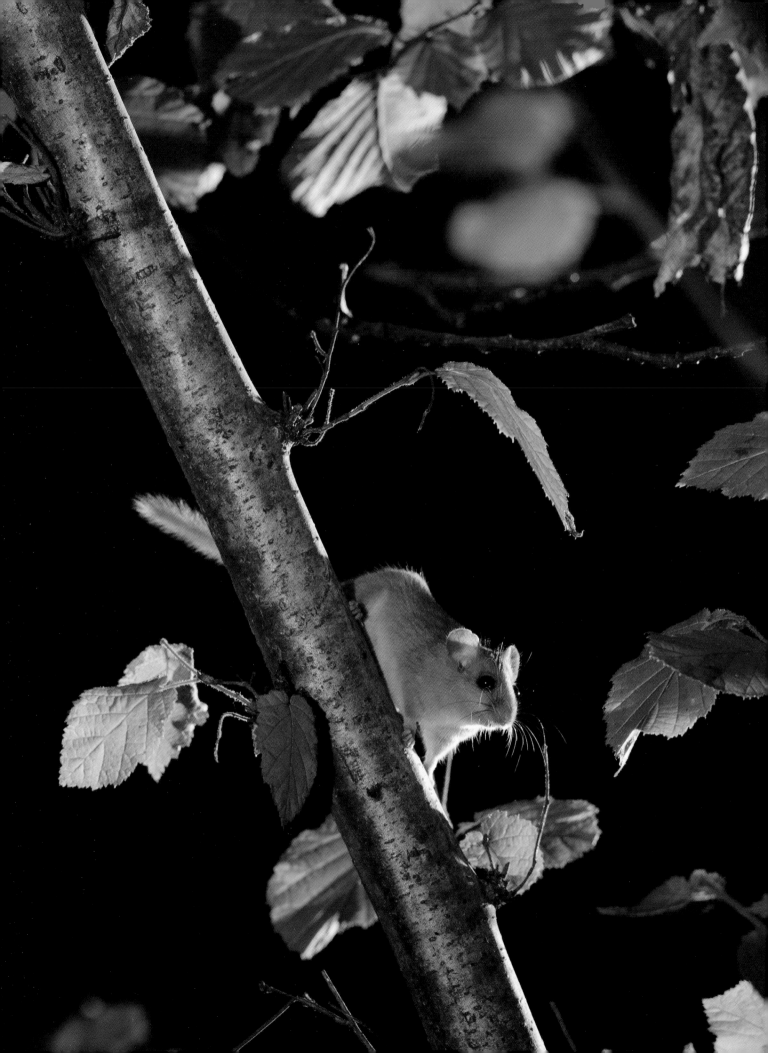

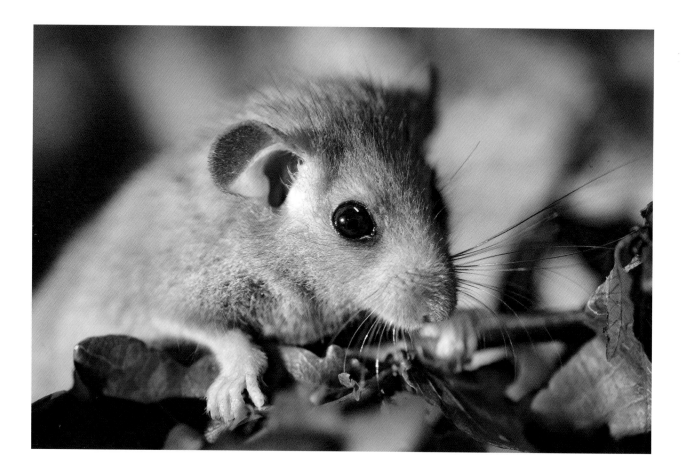

Millions of years ago, tiny marine organisms built their skeletons and shells out of calcium carbonate, metabolising the mineral content of the water in which they lived. When they died, their compressed bodies came to form the limestones that make up many of the hills of North Yorkshire. Limestone is soluble and so, in time, the rain that falls on limestone starts to etch and erode it. Trickles of water push into subterranean streams that force their way through it, inside and beneath it. Limestone landscapes 'have the unexpected volumes of a lung's interior', writes Robert Macfarlane. They are riddled with caves made up of shafts and chambers, with all the complexity of mountain streams and rivers – underground. Like any other natural feature, this is a habitat, and it has been colonised by the most elusive and mysterious group of mammals in the land: bats.

The Windy Pits in the North York Moors National Park are so called for the warm, steamy air that rushes out of these caves on cold winter days. Here is just one of the places where there gathers remarkable nocturnal swarms. This was only discovered relatively recently. In the mid-1990s, ecologist John Altringham saw swarms of *Myotis* bat species on a visit to Canada. Inspired, he set out to search for similar behaviours in Britain. When he visited the first site on his list, Slip Gill Windy Pit in the woods above Rievaulx Abbey, he was amazed to discover a steady stream of bats arriving and flying in and around the entrance. That night, he caught 99 Natterer's bats (*Myotis nattereri*) and also Daubenton's, Brandt's, whiskered and brown long-eared bats.

Above: Hazel dormice are nocturnal and arboreal, and spend much of the time safely above ground.

Like all good scientists, Altringham knew that his discovery only raised more tantalising questions. How many bats in total visited these caves? Where did they come from? And why were they here?

In the years since, Altringham and his team have captured, marked and recaptured thousands of bats to build up a picture of this remarkable nocturnal behaviour around the limestone caves of the Dales. They've discovered that around 5,000 Natterer's bats visit three different caves of the Windy Pit system, alongside several hundred individuals each of the other species. These bats travel from summer roosts across Yorkshire and beyond.

The bats arrive and swarm on still, dry evenings in autumn. They gather in the air, like a cloud of dust, and spiral around each other, darting and whirling. It is impossible to count them by sight because their movement is so haphazard – they do not all stream into or out of the entrance to the cave. Bit by bit, they disperse again, into the cave or the dark trees all around.

The swarming behaviour is not to catch insects such as moths or midges. The bats do not emit the echolocation feeding 'buzzes' of bats closing in on prey. The aerial flights are an intense chase. Altringham and other experts believe the prime purpose of these gatherings is to mate. The swarms are a lek, a gathering where males display and compete for females.

Late summer and autumn is the prime mating season. Because young bats are typically raised in maternal roosts, this may be the first time since the spring that the sexes have been together. Leks are dominated by males, who make up between 70 per cent and 95 per cent of the bats, but females pop in and out of the area to observe and choose a mate. The number of females rises at the peak of the swarming season, when there are more males to choose from and evidence suggests that females visit fairly fleetingly: after all, they only need one suitable male. Genetic analysis confirms that swarming enables bat populations to mingle, ensuring that they remain genetically diverse and healthy.

John Altringham and his colleagues made a fascinating discovery when they studied the swarms. They discovered that groups of males arrived together over several autumn seasons. Picture a group of men going to a nightclub. Are the same groups of bats turning up together by chance? Or are they working together to attract females? 'The interesting and rather controversial possibility is maybe it's a coalition just like lions have coalitions', says Altringham. 'Maybe the males work together to attract mates.'

The chasers may be males demonstrating their 'quality' as potential fathers, competing for female attention. Until the *Wild Isles* filmmakers put their super-fast cameras on the action, scientists had been unsure of whether the chasing bats actually made contact, but the film showed for the first time that bats did occasionally spiral around each other and lock their claws, rather like birds of prey when exchanging food in midair. Whether these were warring males or reluctant mates remains to be discovered. Intriguingly, Altringham and his researchers found that although it was clearly a great social gathering, the swarming bats were not making many social calls. Perhaps it is futile to try and communicate by sound when there is such a whirling mass of bats.

The swarming bats are not mating in flight but mating has been observed within the caves. Scientists are unsure how commonplace this is because it has only

been observed in Britain on a few occasions. It may be more widespread in the trees around the swarming area.

An additional reason for swarming may be so that bats can explore locations for hibernation. Adult bats may need to confirm that their favourite hibernaculum is still there, and in a suitable condition. Young bats must learn where to hibernate, having been born in far-distant summer roosts. More bats enter the caves in late autumn than are seen to leave but only a handful of individual bats have been found hibernating within the caves. These subterranean systems are huge and complicated and it may be that researchers simply cannot see or access the crevices where most bats gather.

Such swarms are a good way to assess the health of a bat population and, over time, its changing numbers. Our modern, human-dominated world appears to be uniquely inhospitable to bats. Insect declines driven by intensive agriculture remove bats' source of food. New roads and railways block traditional foraging pathways through the countryside. Energy-efficient houses seal up roof spaces where bats once roosted. Wind farms can be dangerous to bats: researchers using sniffer dogs to find and retrieve bat carcasses calculated in 2016 that 29 onshore wind farms killed 194 bats per month – a kill-rate that would dispatch 80,000 bats a year across Britain. Even apparently less intrusive LED lighting is bad for moths, and bad for bats too. Lighting up the night sky attracts insects away from the dark areas which slower-flying bats prefer. And climate change may be posing new challenges for hibernating bats. Bats require steady, cool temperatures, with particular species seeking out particular temperature ranges. Milder winters and more extreme rainfall may make some caves too hot or too humid – or too flooded – for the bats. Species may have to travel further north to seek suitable hibernacula.

Bats also get a bad press, feared or inaccurately blamed for the spread of viruses. There are so many mysteries in the lives of bats that we have still to unravel. If we can do so, perhaps we will learn to cherish and protect these remarkable creatures.

BLUEBELLS AND BADGER CUBS

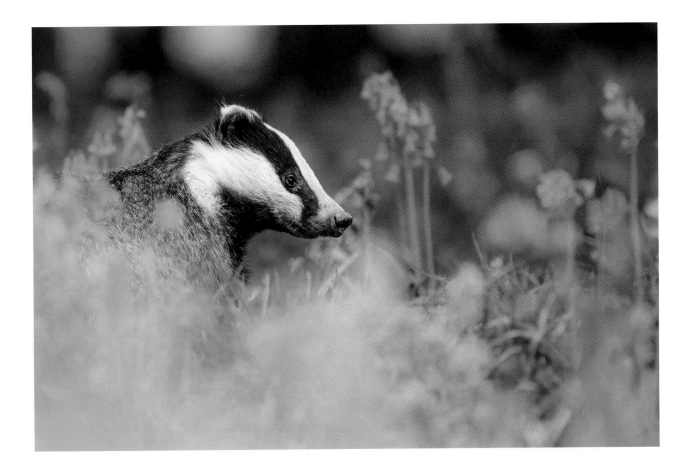

Above: Britain is one of the badger capitals of the world, with its temperate climate, damp woodlands and mixed farming systems providing plentiful earthworms and other food for this adaptable mustelid.

From the middle of April to the first half of May, woodland floors turn a rich and vivid haze of purple as native bluebells (*Hyacinthoides non-scripta*) come into flower. Almost half of the world's supply of this species is found in Britain and Ireland. They spend most of their time underground, as bulbs, growing rapidly in spring before the woodland canopy comes into leaf and casts the woodland floor into deep shade. Its scientific name, 'non-script', signifies that the petals are unlettered, unlike the mythical hyacinth that grew from the blood of a dying prince, Hyacinthus, and had petals inscribed 'alas' by Apollo to express his grief. The bluebell is also adorned with numerous folk names, from 'wood bell' and 'cuckoo's boots' to the evocative 'cra'tae', or 'crow's toes', a sign of its long appreciation by the people of these lands. Sometimes that appreciation can damage the bluebells, with trampling inhibiting future flowering as admirers seek the perfect purple-surrounded selfie. The flowers are used to being trampled by the smaller residents of British woodlands, however, such as young badgers, who gambol across the forest floor in the first warm days of spring.

The badger (*Meles meles*) is Britain's largest surviving land carnivore; while its favourite food is undoubtedly earthworms, which it will suck from the soil like spaghetti, it enjoys a wide range of beetles, shoots and leaves in spring, and is fond

of wild fruits in the autumn. The badger is found across Asia and Europe and today it is thriving in Britain, where it lives at high density in much of the countryside. Cubs are raised in large, clannish family groups, often residing in ancestral setts that were first excavated hundreds of years ago and have housed generations of badgers.

Badger bones dating from the Pleistocene, between 750,000 and 500,000 years ago, have been found alongside the bones of human ancestors at Boxgrove, West Sussex. Ice Ages caused the badger to retreat but it returned, alongside bears, wolves and lynx – and humans – when the ice thawed again, around 10,000 years ago. While more formidable animals have been driven to extinction, the badger, a mustelid related to otters and weasels, has endured, perhaps because of its tenacity, adaptability and super-powered senses of hearing and smell, which helped it evade humans.

The cubs enjoying spring frolics are usually born between January and March after a short gestation period of only around eight weeks. But another of the (female) badger's superpowers is delayed implantation, whereby she may mate at any point in the year but can then delay giving birth by up to 11 months. The egg is fertilised soon after mating and develops into a very early form of foetus called a blastocyst, which floats in the womb until a hormonal change causes it to be implanted in the wall of the womb and resume its normal growth. In recent years, biologists have also established that to help maximise its number of young, the badger is one of only a handful of mammals capable of 'superfetation'. A female who has already mated can mate again and top up her supply of blastocysts in the womb, so that even though a female usually only releases one egg per cycle, she can collect fertilised eggs from several cycles and produce a litter of three or more cubs.

The badger is one species that is clearly benefitting from climate change. More females are surviving milder winters in good condition, and giving birth to more cubs. Although a controversial cull of badgers because of the wild animal's (small) contribution to bovine TB in cattle has reduced populations in western England, the population is rising over the long term as historic persecution dwindles and the animal heads further north in a warming world. Ironically, given the clash between some cattle farmers and badgers, it is mixed farms with earthworm-rich pastures and crops of maize that are providing excellent food for badgers and enabling them to thrive beyond their traditional domain of the forest floor.

Another resident of our woodlands is that great mammalian survivor: the red fox. Often, foxes will take over a disused badger sett and make it their den. Sheltered in one woodland, a female fox has been bringing food to her hungry cubs. The cubs have enjoyed prey such as pigeons and rabbits but as the season moves into summer, it is time for cubs to become more independent and learn to hunt for themselves. At the edge of the woodland is a freshly cut hay meadow: a perfect arena for hunting practice on a summer evening. The young foxes dance, jump, dart and dodge, developing moves that will serve them well, particularly when there are voles to find amongst the cut grass.

Opposite: While other, apparently more formidable mammals have been driven to extinction, the badger has endured, assisted by its highly sensitive senses of hearing and smell, which have helped it evade humans.

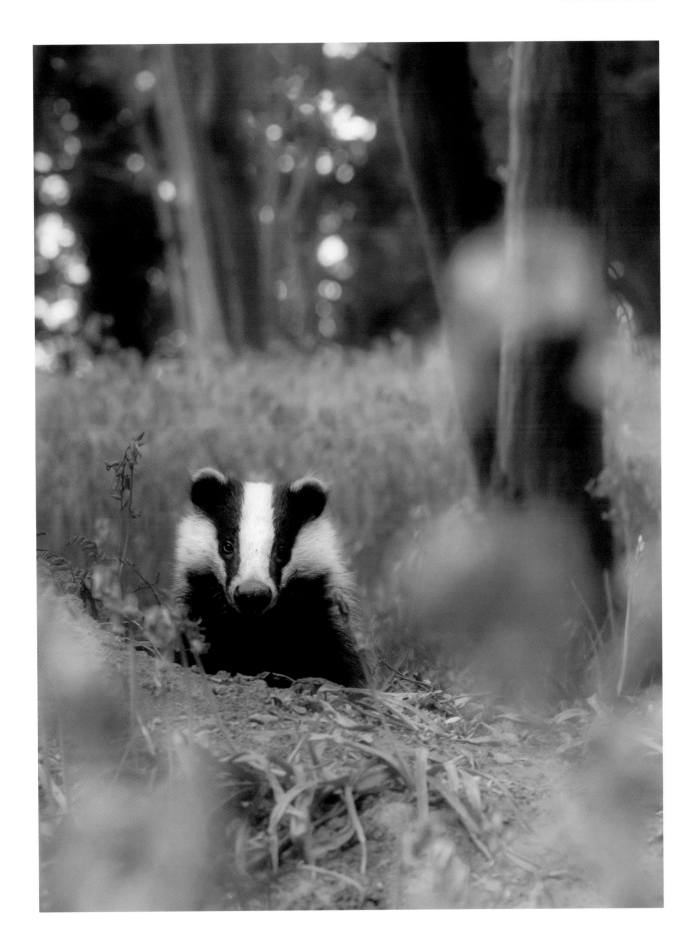

A Goose Hunt – By White-tailed Eagles

Silhouetted against pink-lined clouds, the skeins of geese straggle far across the wide skies of the Outer and Inner Hebrides. As they near the north coast of the Scottish island of Islay, their soft, slightly hoarse, dog-like calls combine to become a cacophony. The drifting lines of individual geese break apart and each goose 'whiffles' – zigzagging in the air – to rapidly lose height, before touching down on the salt marsh around the broad, shallow-edged sea loch.

These vast flocks of geese have come to Britain for one reason: to feed on grass. In autumn, as their Arctic breeding grounds freeze over, they head south for the relatively mild climes of our most remote grassland. These herbivore migrations of epic proportions are the nearest in northern Europe to the famed migration of the wildebeest and others, and these mass movements of creatures bring new life, new ecological relationships and new drama as winter begins to bite over northwest Scotland.

These barnacle geese (*Branta leucopsis*), emissaries of the frozen north, are weary. They have flown from their summer breeding grounds in Greenland, inside the Arctic Circle, and paused in Iceland, waiting for favourable winds to hurry them to the northwest coast. They have journeyed mostly at night, not to avoid predators for there are few on the open seas, but probably because it is easier to navigate. These geese also have to flap constantly, which generates great heat, and it is also easier to keep cool during the hours of darkness. Early every October, usually in groups of between 50 and 200, the geese arrive at dawn. Beside Loch Gruinart, the northerly sea loch that divides the very different geology of east and west Islay, they quickly build in number. One day there are a mere thousand; the next morning, there may be 20 times that.

The senior site manager of the RSPB reserve at Gruinart, James How, likens this vast, usually tranquil loch, salt marsh and surrounding grassland to a Heathrow for these birds – a bustling arrival and departure zone after their long-haul flight. It provides safety and sustenance: salt marshes where they like to roost at night, and ample meadows immediately next door where they feed during the day. Many birds begin their winter holiday at Gruinart before dispersing to other parts of the Hebrides, sometimes even flying to Scottish islands further north once again.

Geese have been overwintering on Islay for as long as people remember, and their massed gatherings and their evocative cries are a grand consolation for bird-lovers during the long dark months. At its peak, Islay has hosted more than 40,000 barnacle geese, a sociable, medium-sized and strikingly beautiful goose. 'A barnacle goose's lustrous black neck embraces its pure white face, like a gloved hand holding a ball', writes the naturalist Nick Acheson. 'Its black eyes and neat black bill are

Opposite: A young white-tailed eagle hunts an adult barnacle goose at RSPB Loch Gruinart on the island of Islay, Scotland.

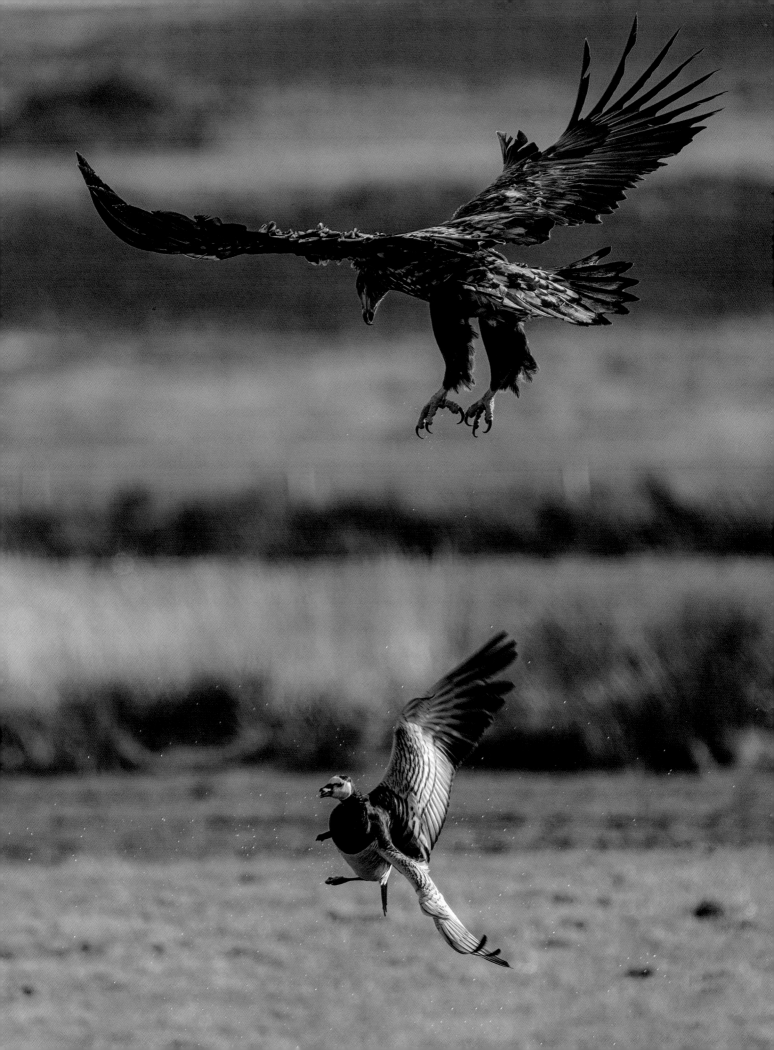

joined by a short black line, giving it a look of mild reproach.' Its body is pale grey, with darker blue-grey barring on its back. 'It is hard to look at a barnacle goose and not feel happy', concludes Acheson.

Islay is also the winter residence for thousands of Greenland white-fronted geese (*Anser albifrons*), a rarer species, which is actually a mostly grey goose possessed of a face featuring a distinctive white front with a black border. Both species thrive here in western Scotland because the winters are relatively mild – certainly compared with the Arctic – and there is ample grass to nibble and graze. They have also prospered because for many years Islay has been free of potential predators. There are no foxes or badgers on the island, and otters are not known to trouble the geese.

In recent years, however, a cloud has appeared on Islay's wide horizons for a travel-weary barnacle goose. Britain's largest airborne carnivore has wings like scaffold planks and a meat-cleaver for a beak. The white-tailed eagle (*Haliaeetus albicilla*) is an awesome creature. It is known in Gaelic as 'the eagle with the sunlit eye'; its Anglo-Saxon name, 'erne', means 'soarer'. It is the apex predator along these coastlines, but for decades the barnacle geese had a peaceful time on Islay because the last white-tailed eagle in these islands was shot in Shetland in 1918. Now, thanks to the perseverance of conservationists who began a reintroduction programme releasing young eagles from Norway onto the Hebridean island of Rum in 1975, the white-tailed eagle has re-established itself as a breeding bird across the isles north and west of Scotland. There are now more than 150 breeding pairs in Britain, with birds also successfully reintroduced – although not yet breeding – on the Isle of Wight.

The white-tailed eagle is so huge it has been mistaken for light aircraft in flight. This unmissable bird, with a conspicuous pale head and neck and a tuft of white feathers at the tail, can look rather lumbering in flight. Despite its size and obvious power, it is mostly seen scavenging, and is often spotted devouring whatever the tide has washed in – a dead guillemot or the carcass of a common seal.

The eagle bred successfully again first on the Isle of Mull to the north of Islay in 1985. Although Mull can be seen in the distance from Loch Gruinart, for years only the occasional white-tailed eagle pitched up on Islay. Eventually the birds began roosting on nearby Jura. Finally, in 2016, the eagles realised that Gruinart in the autumn offered an irresistible banquet of birds.

The hunt begins when the massed ranks of exhausted geese have touched down to refuel. At its winter peak, there can be more than 40,000 geese on Islay, including 4,000 Greenland white-fronted geese (a species which is suffering a significant fall in its global population). At any one time, 25,000 tired geese may be feeding at Gruinart. This is when a group of eagles arrive to take a look. The eagles seem to lounge around a lot of the time, like vultures. Then one climbs up into the air and flies over the grounded geese. The barnacle geese may be mostly heads down, plucking hungrily at the grass, but they are no fools. Some quickly spot the huge, dark silhouette above. Instantaneously, it seems, every bird in the flock knows of the danger overhead. Together, the massed ranks of geese rise in alarm; together, the formidable noise and mass of these large birds appears to offer strong protection.

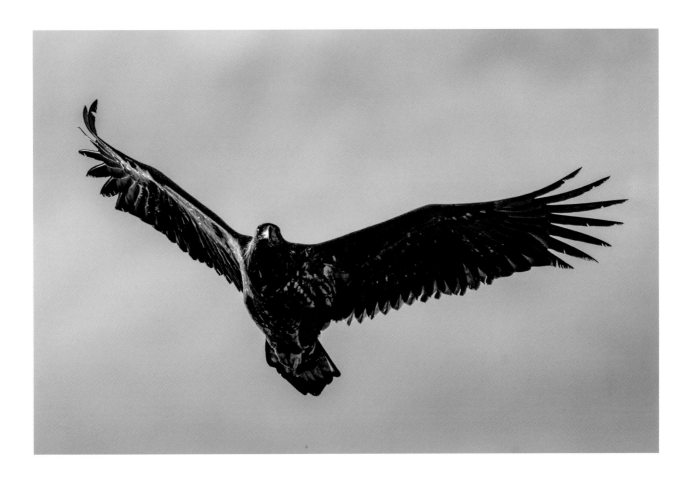

Above: White-tailed eagles are expanding their range across Scotland since their successful reintroduction. On Islay, they have learned to prey upon large flocks of overwintering geese.

The eagle is unconcerned. This is a reconnaissance flight only. For hours, the eagles may loiter and fly high overhead. In so doing, they appear to be observing not the impressive spectacle of the geese taking flight in unison, but assessing the health of each individual bird. As the geese fly up in alarm, that keen 'sunlit' eye is making a cold calculation: which goose among thousands is particularly jaded after its long migration?

Finally, the hunt begins. The eagle may be unmissable overhead, but its wide brown wingspan is less visible against the land. The bird will fly low, hugging the terrain, and using whatever contours it can find to its advantage. If it can surprise its prey, it will. Occasionally, the eagle may even approach from the sun, hiding in its glare in the way that enemy pilots once did during the First World War.

Despite these manoeuvres, the geese still spot the approaching predator, and rise up noisily in alarm. The yapping geese sow confusion but now the eagle has a clear target in mind. Remarkably, according to close observers such as RSPB senior site manager James How, the hunter appears to have chosen its target – a visibly weaker bird – and, cutting through a swirling mass of thousands of birds, rarely changes its mind.

Now the apparently 'lumbering' eagle picks up the pace. The goose identified as a vulnerable bird twists and turns to escape. Suddenly, it is separated from the safety of the flock. It flies fast and hard, to outpace its foe. The eagle dwarfs the goose but its wing-beats are slower. Then, imperceptibly, taking great scoops of air with every flap, the eagle closes the gap between it and its prey. As it closes in

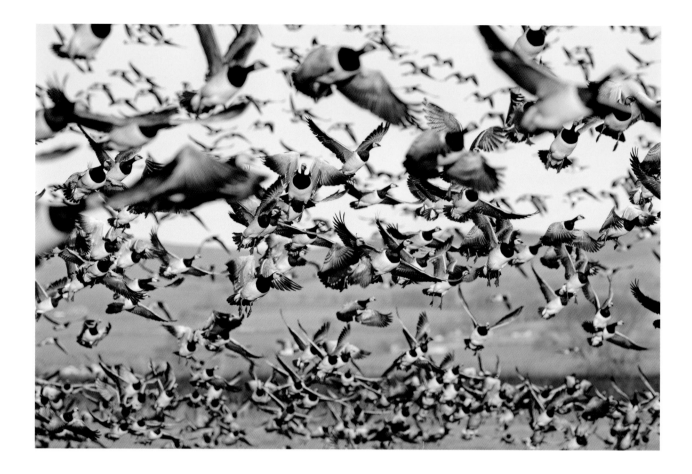

on the goose from behind, it approaches from beneath. With a swoosh, it tips the goose off balance, so the bird falls forwards, through the air. The eagle grabs its prey with its bright yellow talons. These are like grappling hooks: the more the goose struggles, the more the talons grip.

Now the eagle will try to fly with its heavy burden to a quiet, safe spot for a feast. Successful hunters will get to feed first but will often end up sharing their goose with other eagles. One white-tailed eagle was spotted catching two geese in one day. This made such a fine feast that the eagle then sat in a field for two days, digesting.

But its meal is not in the bag quite yet. No eagle strikes with a 100 per cent success rate. Sometimes, just as the eagle is pinning the goose to the ground, another eagle drops in. Momentarily distracted, the predator allows its prey to wriggle free. Once airborne, the goose can accelerate away to safety. On another occasion, the goose is seized on the water. Here, if the goose wriggles free, it can dive underwater to escape. Plenty of barnacle geese do possess enough strength, cunning or luck to live to graze another day. But those who escape an eagle's clutches are rarely uninjured. Then they will be singled out by the eagles another day. In this way, in the natural way of animal populations the world over, the weakest of a large herd of prey animals are targeted by expert predators.

The goose guardians of the RSPB, which made Loch Gruinart a nature reserve because of its winter populations of geese, are not opposed to such natural predation. James How worked on the reserve for 15 years, managing it for the

Above: Thousands of barnacle geese fly from the frozen Arctic to spend winter on the unfrozen grasslands and estuaries of the west coast of Scotland.

benefit of geese, before he saw the eagles return. Juvenile eagles were the first to drop in for a goose hunt during October, when the migrants from the Arctic first return to Islay. 'I see the eagles as completing the circle, especially now I've witnessed what they do', says How. 'Watching the way they catch the goose, you can't help feeling that is what they used to do and we've rebalanced it a little bit.'

How considers the white-tailed eagle to be 'more of a vulture than a golden eagle'. The smaller golden eagle is a faster-flying predator, a supreme aerial acrobat. In comparison, the white-tailed eagle can look clumsy and is opportunistic and unfussy about its food. They will take rabbits or rats from the ground, fulmars and razorbills from their cliff-edge nesting sites, and ducks and fish from the water. They are thieves too, and will often snatch food caught by other, less mighty predators. During winter, they'll feed on carrion.

As the nearest predator in Britain to the wolf, the presence of white-tailed eagles still aggravates some people, particularly farmers and crofters who blame it for taking lambs. The eagles' defenders argue that these are almost always already dead. When the most numerous carcasses on the remote grasslands of northwestern Scotland are lambs, some remains invariably end up in an eagle's nest. Surveys of nests on Islay suggest that, so far, none of the island's breeding eagles are habitually feeding on lambs. Some pairs of white-tailed eagles may learn this behaviour and develop a habit of finding easy prey this way. Fortunately on Islay, there is plenty of other food.

By feeding on geese, some farmers feel the eagles are doing them a favour. Such vibrant populations of barnacle geese on Islay may bring the sights and sounds of the Arctic to Britain, but the hungry geese also consume a lot of grass.

The reserve of Gruinart is a big farm for nature, but it is a real farm too, with 200 cows and 200 sheep to help the RSPB manage its grasslands not only for the geese but for other notable birds that find sanctuary here, including 200 breeding pairs of lapwing, 100 redshank, 60 drumming snipe, 15 to 20 pairs of curlew and then another summer migrant, the corncrake. These birds have differing requirements and so it is not simple to manage the land in a way to suit them all.

The geese do move across Islay and feed on other grasslands, and so they are counted each month, field by field. Grass is a precious resource for farmers and so they are awarded compensation by NatureScot, Scotland's government agency for nature, based on an assessment of the amount of grass the geese consumed. But the voraciousness of the geese is still controversial. In recent years, there has also been a government-sanctioned cull of up to 3,000 barnacle geese each winter, which is opposed by the RSPB. At Gruinart, James How hopes that the eagles' relatively new goose hunt could solve this problem. 'Maybe the eagles arriving is the natural answer to this whole situation', he says. 'They are taking lots of geese and they are doing it in the right way, picking out the ones that aren't fit, to create a healthier population of geese.'

RARE MEADOWS AND BESPOKE POLLINATORS

Opposite: Hogchester nature reserve in Dorset – a mixed hay meadow in full flower in June.

There are many different types of grassland across these isles, and the wildflower meadows of southern Britain are a particularly precious, and dwindling, feature. These are grasslands that for centuries were gently managed by people. The last hundred years have not been so gentle. 'When I was a boy growing up in Leicester in the 1930s, I spent days on my bicycle exploring the local countryside', says Sir David Attenborough. 'Back then, it was easy to find hay meadows rich with wildflowers and swarming with butterflies and insects of all kinds. But since then, we have lost more than 97 per cent of these wonderful habitats in England and Wales.' All is not lost, however, for these isles have clung on to some exceptionally beautiful lowland meadows and there is now a burgeoning movement to restore and recreate many more.

Wildflower meadows developed over centuries of traditional farming. Pastures were kept for grazing livestock and meadows were cut for hay every July. This cycle proved perfect for a myriad of plants, from orchids to oxeye daisies. When these burst into flower, they provided a rich nectar source for flying insects, from hoverflies to butterflies. The plants prospered because they could set seed and spread before the hay was cut. But farming practices have become more intensive in the twentieth century, particularly with the need to grow more food during the Second World War. After the war, technological advances and government subsidies for farmers encouraged further agricultural 'improvement'. Larger tractors replaced horses and enabled hedgerows to be removed and fields made much bigger. Boggy meadows were drained to produce more reliable land for growing crops. Grassy fields were ploughed up to grow arable crops or resown with vigorous, non-native grasses. Instead of a single crop of hay, meadows were cut four times each year for multiple crops for silage – too often for flowers to seed or ground-nesting birds to rear chicks. Artificial fertilisers were added to meadows which stimulated grass growth at the expense of other, more delicate flowering plants. Pesticides and other chemicals enhanced the production of one crop at the expense of all other life on the land. Huge road and house building programmes, alongside the expansion of industrial estates and factories, saw meadows disappear under concrete. Many flower-rich meadows also disappeared when post-war conifer plantations took root as Britain sought to produce more of its own timber.

Some of the most important and wondrous relationships between plants and insect pollinators were placed under strain, and with them many more links in the food chain. Since systematic scientific recording began in the 1970s, populations of insects such as butterflies and moths have been shown to be in long-term decline. The larger animals that feed on flying insects, most notably 'farmland' birds, have

declined over the last 50 years too. During this last half-century, conservation scientists have acquired new and important knowledge about the intricate workings of some of the extraordinarily specialised relationships between different plants and insects, and a movement to restore the meadows that enable these relationships is growing. Since 2013, 5,000 hectares of wildflower-rich meadows have been created, including 90 Coronation Meadows to mark the sixtieth anniversary of Queen Elizabeth's coronation. Grassroots meadow groups are springing up all over the country, recreating meadowland not only in the countryside but in towns and cities too. The importance of meadows is recognised by the government and financial support for agriculture now rewards farmers for producing meadows for pollinators.

Many flowers have a straightforward relationship with their insect pollinators. Flying insects are incentivised to visit a flower by the promise of energy-rich nectar. In return, each visitor is dusted with pollen, which they carry to other flowers. Bumblebees and solitary bees are most commonly acclaimed for their tireless pollination work but the pollinating power of moths is less celebrated, partly because most of Britain's 2,500 moth species carry out their labours under the cover of darkness. One particularly charismatic bespoke pollinator from the world of moths is a day-flying migratory moth that at times can be mistaken for a tiny hummingbird. The hummingbird hawkmoth (*Macroglossum stellatarum*) usually reaches British gardens in late summer to hover before a flower, its blurred wings beating 85 times every second – so fast that they produce an audible hum. This is effortful work, and needs plentiful nectar. Many flowers don't supply enough, and lots of little sips would be exhausting but the hummingbird hawkmoth has evolved with an extra-long proboscis to reach the larger quantities of nectar stored deep within some flowers. Even though the moth appears able to drink at a distance, the structure of the flowers it feeds from has evolved so that the hovering moth will still collect and deposit the pollen each flower requires to continue its lifecycle.

Many relationships between particular species of flower and pollinator are fantastically precise. Like the hummingbird hawkmoth, bumblebee species require a lot of energy for flight and visit many different flowers to obtain their fuel. Some flowers, such as purple bittersweet, don't offer the anticipated reward of nectar but provide something even more precious: a huge supply of pollen that is high in the protein they require to build strong muscles and wings. This is an expensive resource, and it is locked away from most pollinators. Even honeybees can't access it. But bumblebees have a special mechanism to make these flowers release their pollen.

First the bee has to find a flower where the pollen is ripe to collect. The perfect flower can be hard to find. When the bees identify a suitable flower, like a safe-cracker deploying precisely the right amount of gelignite, the bee's expert buzzing causes the flower to explode. The bees contract their flight muscles to produce strong vibrations. Using their legs and mouth parts, they direct this 'enhanced' buzz onto the anther (the part of the stamen that contains the pollen). This causes it to open and shake out pollen like a pepper pot. The bee combs the pollen into the collecting baskets on its legs but stray grains slip away and pollinate other flowers.

If the bumblebees appear to have the mastery of these relationships, other flowers exert rather more control over their insect pollinators. Like the bluebell,

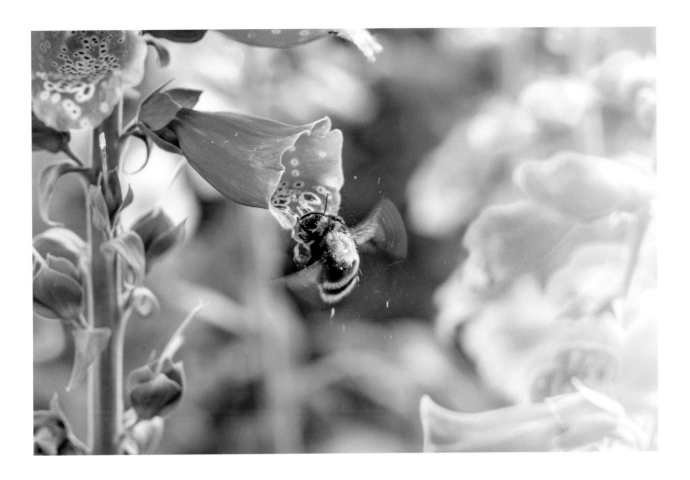

Above: More than 97 per cent of wildflower meadows in England and Wales have been destroyed since the 1930s. But there are moves to restore traditional flower-rich meadows and a growing awareness of the importance of pollinators for all our futures.

wild arum (*Arum maculatum*) has a great wealth of folk names from cuckoo pint to lords-and-ladies, which point to it being noticed and studied by people throughout the ages. And no wonder, because it is a strikingly odd-looking flower. A single, cupped petal encases a maroon, poker-like appendage called a spadix that rises above a complex flower. The spadix produces heat and a putrid smell that is alluring to flies. They are drawn into the flower at its base and enter to feed. Once inside, a slippery circle of downward-facing hairs trap the insects, preventing them from leaving for several days. Wild arum has both male and female parts, and the female parts at its base produce a sticky nectar reward for the flies. But the plant will not let them leave until the male parts above are ripe with pollen. Only then does it relax and open its hairs to allow the flies to escape. The flies are coated in pollen from the male part of the flower as they leave and move on to feed once more, inadvertently delivering pollen to another flower in the process.

GLOBALLY IMPORTANT RIVERS – CHALK STREAMS, KINGFISHERS AND THE COURTSHIP OF THE DEMOISELLE

Many of Britain's enduring meadowlands are found beside one of our most wildlife-rich and globally important natural features: its rivers. Picture a chalk stream, where gin-clear waters ripple over beds of gravel, and emerald-green waterweeds wave as mayflies dance above the mysterious flashes of silvery fish and the distinctive plop of a water vole disappearing below the surface. If this seems like a quintessential English scene, as celebrated by the painter John Constable, the poet Sir John Betjeman and, of course, in Kenneth Grahame's *The Wind in the Willows*, that's because it is.

Chalk streams are sometimes called 'Britain's rainforest'. This may sound like hyperbole but their waters are uniquely diverse. They may be our isles' most distinctive and significant contribution to the ecology of the planet.

The water in chalk streams collects in underground aquifers and is filtered through layers of chalk, meaning that this water is not only extremely pure but has an unusually stable (alkaline) chemistry and temperature. After springs bring this water to the surface, streams ripple over broad gravel beds which were deposited when the rivers were much more vigorous, when they were powered by the melting of ice sheets at the end of the last Ice Age. These broad, shallow streams of crystal-clear water are therefore able to support a lush range of plant life, which in turn provides food and shelter for a wide range of invertebrates, fish, birds and mammals.

A high-pitched whistle pierces the somnolent summer scene over a chalk stream. A flash of blue and rusty orange is the best view we get of one of our most iridescent species, *Alcedo atthis*, the kingfisher. Darting downstream, this starling-sized bird is intently focused on its task: patrolling its territory. Intruders are not tolerated; these fishing rights are not shared. Once the kingfisher has hustled other fishers off its patch, it turns its gaze to the water, looking for the movement of minnows against the gravelly bottom.

Diving and extracting the small fish from the water, the victim is dealt a swift blow to subdue it. Before swallowing its meal, it spies another flash of blue. An intruder? It flies over but soon discovers this is its mate. Offering her his catch, she in turn allows him to mate. Together the pair will defend their territory with such aggression that rivals are not only chased but fought in midair, locking bills and even pushing the interloper into the water, seeking to drown it.

In midsummer, a gentler but equally territorial creature takes to the air above the water of our streams and rivers. Banded demoiselles (*Calopteryx splendens*) are one of only two species of British damselfly to have coloured wings. They can be mistaken for a butterfly because their slow, bouncing flight is quite unlike the vigorous darting of other damsel and dragonflies.

Opposite: The flash of a kingfisher in full fishing mode is a sight much prized by wildlife photographers.

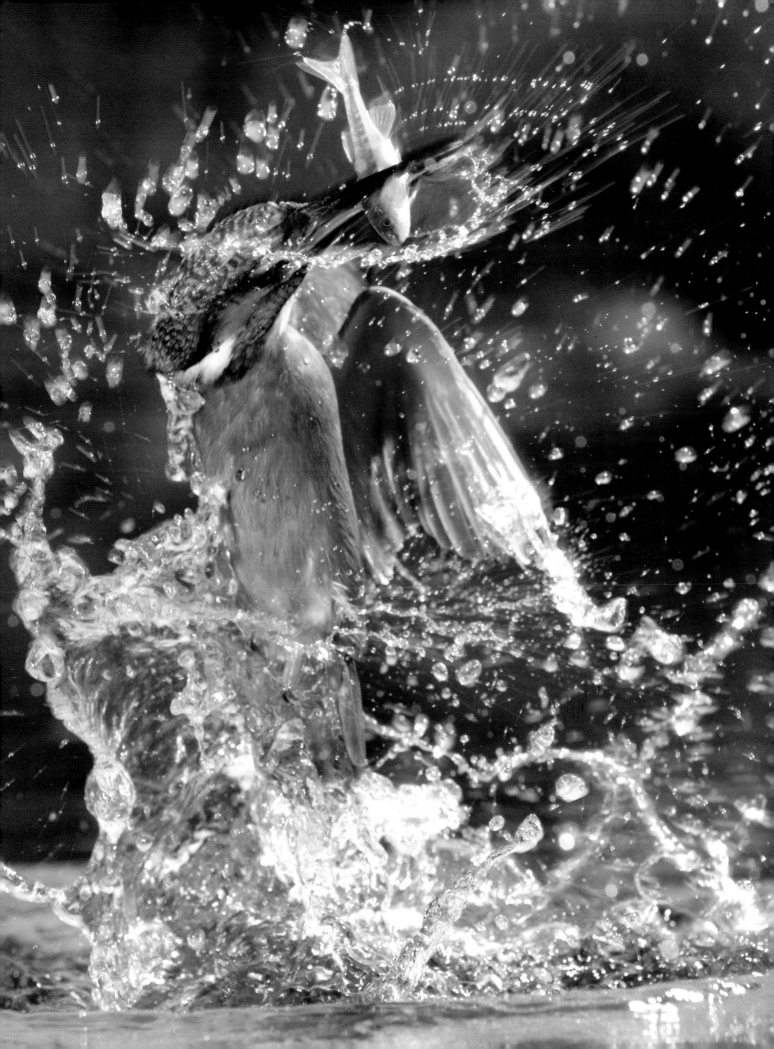

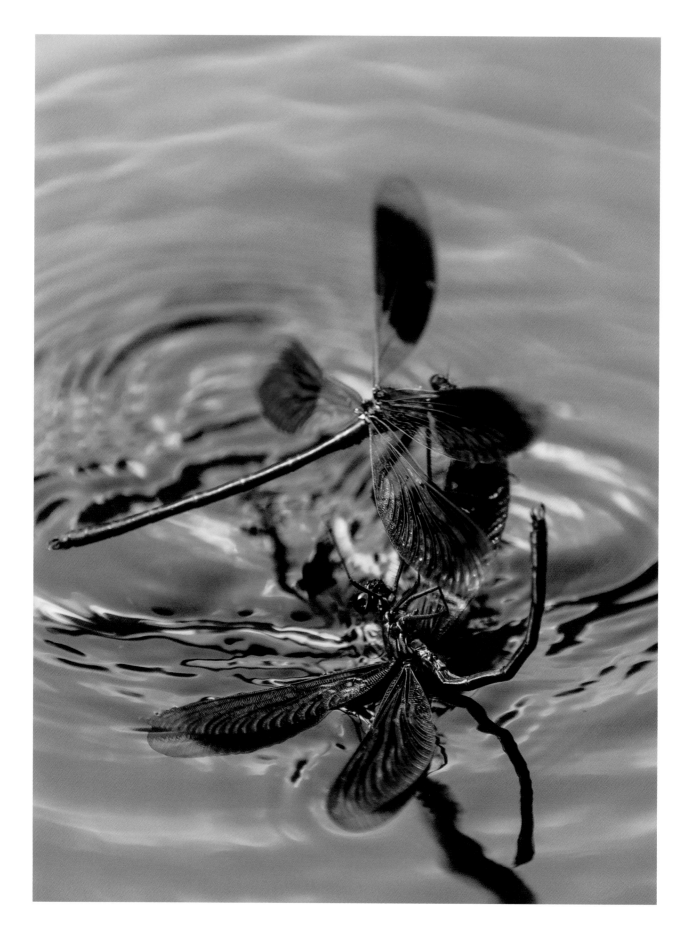

Opposite: Two male
banded demoiselles
fighting. This damselfly can
look like a butterfly in flight
with its slow flapping above
lakes and lowland rivers
during summer months.

The banded demoiselles' genteel flapping over the water may form part of a bucolic scene in our eyes, but for the metallic blue males these flights are another keenly fought territorial battle. The males clash to determine the ownership of the most desirable territory to attract metallic green females – a specific patch of aquatic plants that looks a tempting place to lay eggs. A determined male may defend a territory for as long as ten days. To do so requires an aptitude for aerial dogfights that include pushing and even biting.

When a female approaches, there is flight of a different kind: the male will display the finery of his wings and entice her with showy flypasts and a pulsing of wings. He will even drop into the water to demonstrate the flow of the river, and show it is well oxygenated and a good place to lay eggs. Eventually, the female is grasped by the neck for mating, and the male scrapes out any sperm that she may already be carrying and gives her his own sperm package. There is still no guarantee of successful pairing however, for other males try to dislodge the mating male and steal his mate. Some even carry the mating pair into the air to prise them apart. No wonder a successful male will guard his female as she locates his floating raft of water weed and crawls under the surface of the water to lay her eggs. Peace descends when she is completely submerged and she deftly slices into underwater stems to safely deposit each egg.

Chalk streams are beautiful, tranquil places and enthusiasts travel from all over the world to try their hand at fly-fishing for trout on the River Itchen in Hampshire, where the sport was invented. Despite their beauty, ecological importance and cultural significance, only 12 out of Britain's 224 chalk streams have protected status and three-quarters of all our chalk streams fail to meet the required health standards. Only 14 per cent of Britain's rivers are in good ecological health.

In the increasingly dry and increasingly populated southeast, demand for domestic water as well as farming practices is causing the abstraction of too much water. Some chalk rivers are being starved of water and run dry. Too many farm fertilisers are running into some rivers, and too many nitrates and phosphates can cause harmful blooms of algae and diminish the purity on which more delicate aquatic plants depend. Sewage has also been released into some rivers, while native species are also threatened by invasive non-native arrivals, such as the North American signal crayfish.

Today there is at least greater recognition that chalk streams are precious and in peril. There is a public hunger for cleaner rivers and streams, and where they are protected and flow freely there is bountiful life, of the kind that should be found on all our waterways.

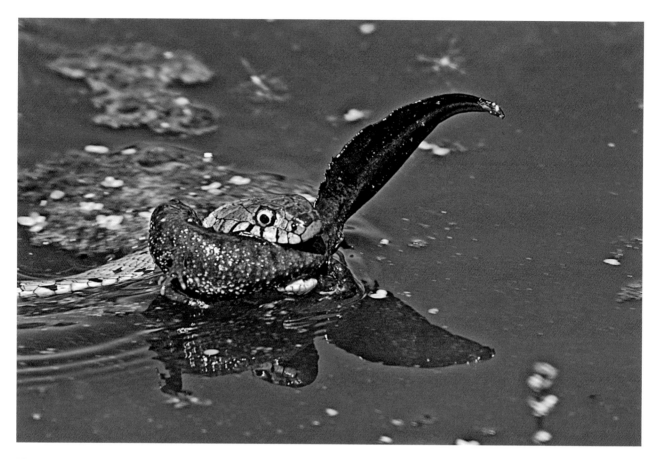

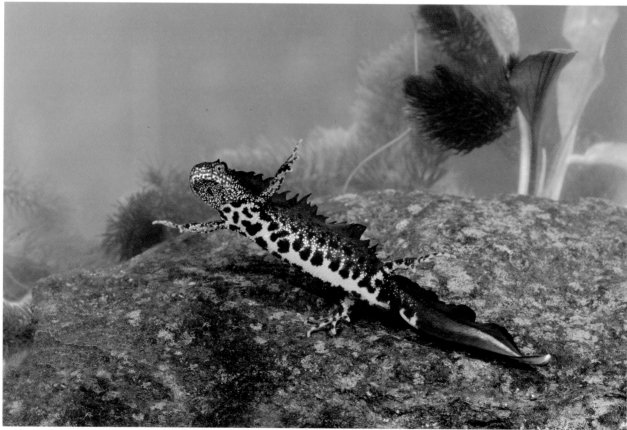

Pondlife – A Great Crested Newt Meets a Grass Snake

In spring, one of the most spectacular denizens of our ponds stirs in large, well-vegetated waterholes across lowland Britain.

The great crested newt (*Triturus cristatus*) is the largest of our three native species of newt and resembles a miniature dragon. Unlike the much smaller smooth and palmate newts, it can grow up to 15 centimetres in length. It has a spectacular bright orange belly but its visible upper body is usually black in colour and covered in small warty lumps. During the spring breeding season, the male develops an impressive jagged crest along its back and a pale white stripe on its tail, which flashes in the light to woo a female.

The male also releases tantalising pheromones into the water and wafts his tail to attract the female. But this male has competition. Another male approaches and the first suitor squares up to the intruder, raising his jagged crest as a threat. A short but violent scuffle ensues, and the intruder backs off. Now the newt can focus on his female.

Unfortunately she has disappeared and another, rather more menacing creature has entered the pond. The grass snake (*Natrix helvetica*) is a surprisingly good swimmer. Our largest and only egg-laying snake slips through the water with no ripple or commotion, raising its head above the surface as it moves forwards. As the newt rises to the surface for a breath of air, the snake grabs the newt in its mouth. There is a mighty struggle. Water sprays as the snake writhes to keep hold of its prey. The newt is large and the grass snake is slender, but the strength of the snake wins out. It swallows the newt whole.

These vivid dramas of life and death are played out every day on ponds across Britain, but there are far fewer arenas for this theatre. The government estimates that more than a million ponds have been lost over the last century. This century, however, the number of ponds is growing once again. More than 50,000 extra ponds were created in Britain between 1998 and 2007. In recent years, thousands more ponds have been dug or restored to health. The Norfolk Ponds Project has recreated hundreds of historic farm ponds that had been lost over the years. With climate change, we will need ponds in our landscape more than ever.

Bass Rock – Gannets and the Arrival of the Bonxie

Despite the popularity of seaside resorts, our long coastline still serves up a wealth of remote sand dunes and inaccessible shingle spits, islands and towering cliffs of chalk, granite and sandstone that provide ideal places for eight million seabirds to return to breed every year. Our isles are home to 90 per cent of the world's Manx shearwaters, 60 per cent of the global population of great skuas and 65 per cent of the northern gannets. Each year, they breed and thrive on our coastline in awe-inspiring numbers.

One of the most spectacular natural seabird sanctuaries is the Bass Rock. It stands 107 metres high in the Firth of Forth, a vertiginous volcanic outcrop that is a geological and biological wonder.

The Bass, as it is sometimes known, has been home to a hermitage, a castle and a prison but today hosts the world's largest breeding colony of northern gannets, the biggest seabird in the North Atlantic whose scientific name, *Morus bassanus*, derives from its association with this rock. In summer, 150,000 nesting birds can gather here. When viewed from the mainland, this great rock can look white, such is the quantity of seabirds at home there (and such is the quantity of the guano they deposit each year: the equivalent of that produced by 10 million broiler chickens).

The gannet, known in Scotland as the 'solan goose', is a magnificent bird with its striking blue eye, yellow, white and black colouration and its considerable wingspan. 'Gannet' has become a byword for a person with a voracious appetite, and the gannet's single chick stays in the nest for ten weeks, demanding a constant supply of nourishment as it grows to four kilograms, becoming bigger than its parents. So the parent gannet stretches its slender two-metre wingspan and flies low over the water on epic quests for food. When they find it, their hunting style is awesome, rising up before plunging in a streamlined shape, hitting the water at 50 miles an hour. This helps the bird propel itself down to depths of 20 metres to catch its fish.

In the Shetland Islands, the gannets must deal with raids by a merciless pirate. The great skua (*Stercorarius skua)* is widely known as a 'bonxie', a name probably taken from an old Norse word for 'dumpy'. The bonxie has a bad press: it is widely seen as a bully, a robber and a tyrant. It is a large, intelligent, brown gull-like bird known for its fearless dive-bombing of people who stray near its nests on the ground of islands and open moorland. The supposedly aggressive bonxie, of course, is simply being a protective parent. But it dive-bombs gannets too, after quietly waiting on the water close to a gannetry for the far-flying birds to return from fishing forays to feed their chicks. After a long fishing expedition, the gannet carries its catch of fish in a bag in its throat. The bonxies seem to be able to recognise a bird

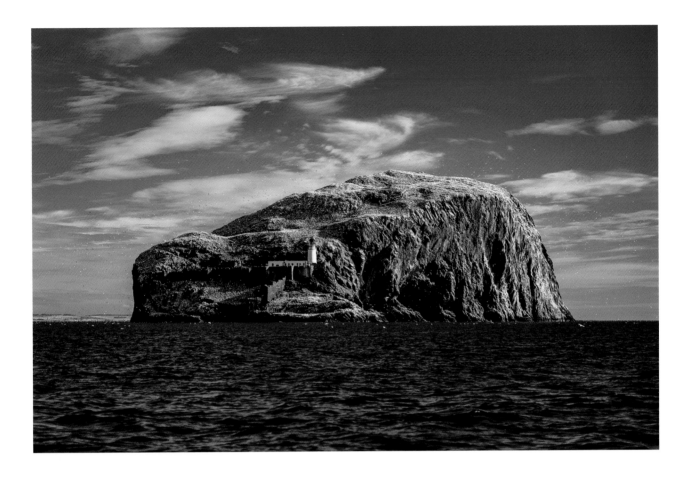

Above: The Bass Rock has been a hermitage, a castle and a prison but today hosts the world's largest breeding colony of northern gannets.

Overleaf: Northern gannets are the largest seabird in the North Atlantic. Their scientific name, *Morus bassanus*, derives from its association with this rock.

carrying a full load. For the gannets, there is safety in numbers but the bonxies will target a lone bird, chasing and harassing it in midair, pulling at the gannet's tail and wing feathers and trying to tip it into the sea.

Eventually it gets too much for the bigger gannet and the intimidated bird throws up its fish. As soon as the catch lands on the sea, the bonxies pile in, and sometimes even other gannets take advantage of the free meal.

While we may not enjoy the bonxie's thieving, it is just another bird seeking to feed its chicks. And while there are more than 600,000 gannets thriving in Britain, the great skua has a global population of just 16,000, with 60 per cent of the birds found in Scotland. The pirate life is paying off, however – at least, it is in an era of climate change and with gannet numbers expanding too. Bonxies have moved south into the isles of western Scotland and Ireland in recent decades, finding rich pickings on our westerly seabird islands.

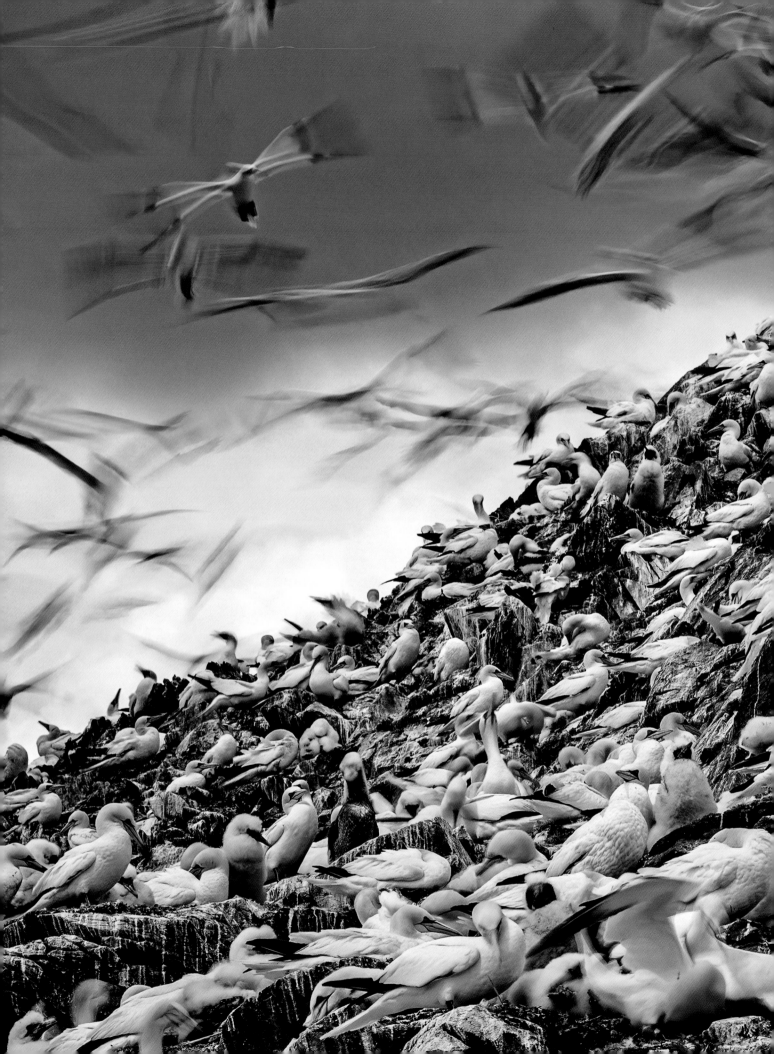

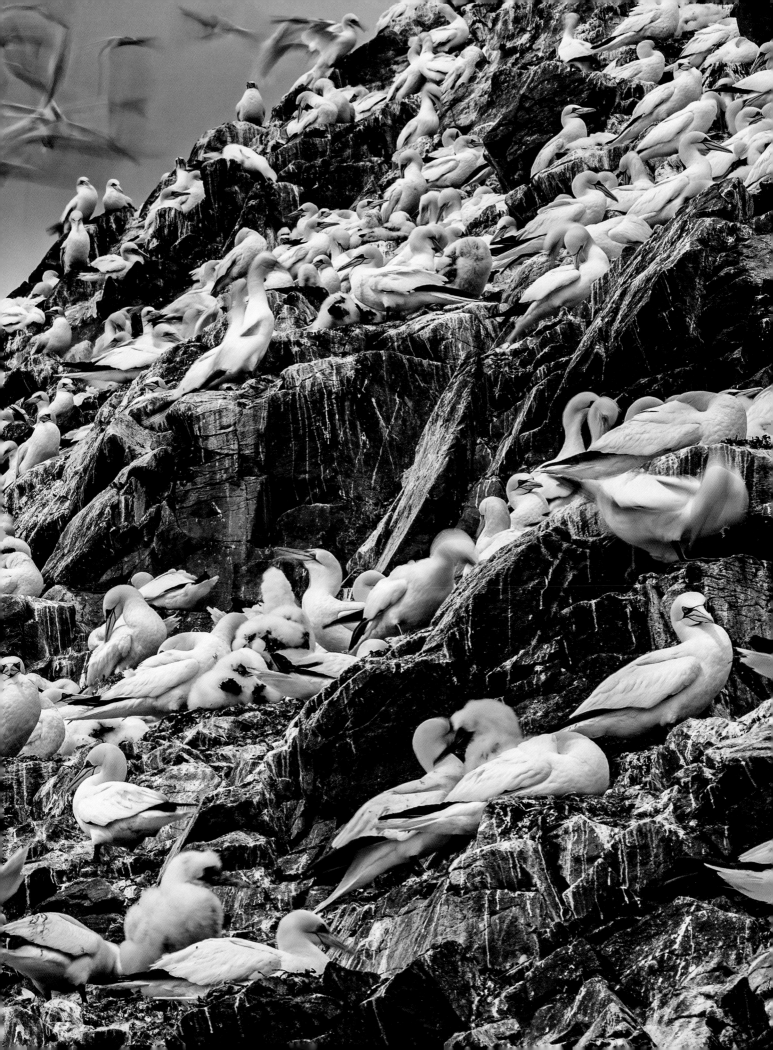

Puffins and the Pirate Gulls

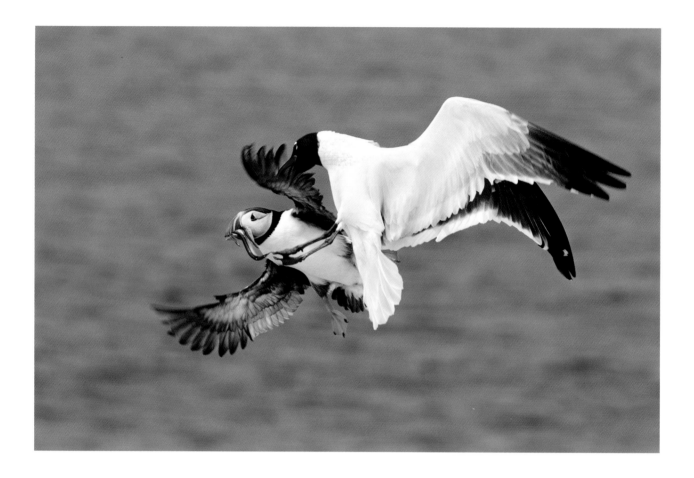

Birds laden with fish are an easy target and the diminutive puffin, which can also be grabbed and killed by a bonxie, falls victim to piratical raids from other birds.

As spring unfolds, 450,000 Atlantic puffins (*Fratercula arctica*) are busy fishing for their young. They live in colonies mostly in northern parts of Britain but also found in small numbers as far south as Lundy, Land's End, the Isles of Scilly and the Channel Islands. The birds' buzzing flight takes them out to sea where they swim after sand eels that must be the right size for the single chick, the puffling, that lives safely in their burrow on a remote island.

Returning with their catch is not a straightforward task because the glint of silver is obvious in their large bills, and it catches the eye of plenty of larger species, particularly smart, opportunistic black-headed gulls. To avoid these raiders, puffins will circle in the sky, forming a huge doughnut shape that makes it hard to pick off a single bird. But the puffins who reach land with their catch are still not out of danger.

Mammal-free small islands such as the Farnes in Northumberland may be safe from predators such as rats and foxes but there are plenty of large gulls that will attack the puffins on the ground. Parents returning with a meal must dodge in and out of other nesting burrows. Often they find themselves being evicted by outraged

Above: A small seabird laden with fish is vulnerable to piratical behaviour, and this puffin risks having its beak-full snatched by an opportunistic black-headed gull.

Opposite: A puffin at sunset on the island of Skomer, South Wales.

neighbours. Their plight can look comical but there's a happy ending for many fishing forays: sand eels safely slipped down the gullet of a fluffy and extremely grateful youngster.

The puffin's unique looks and charm make it a hugely popular animal. Although many of its colonies still look epic in scale, the species is enduring serious declines as rising sea temperatures cause the sand eels to shift further north. Studies have shown that as their crucial food disappears from proximity to the puffins' traditional breeding grounds, the birds have to travel further and bring back less food for their chicks, and so their fledging success rates fall.

This is not a problem confined to our isles but extends to the entire breeding population of Atlantic puffins. A colony on the Røst archipelago in Norway that numbered more than one million pairs of puffins has declined by more than 80 per cent since the 1970s. Such declines remind us that our archipelago and its inhabitants are intimately connected to the rest of the world. As we all face unprecedented climatic changes, we will have to work both locally and globally to save the wondrous and surprising wildlife of home.

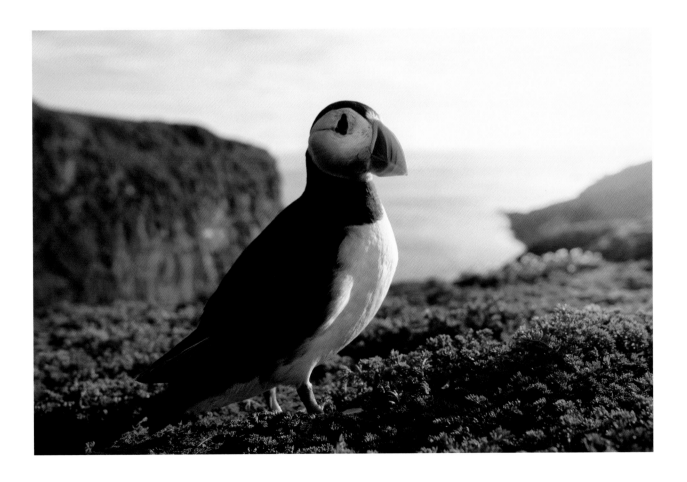

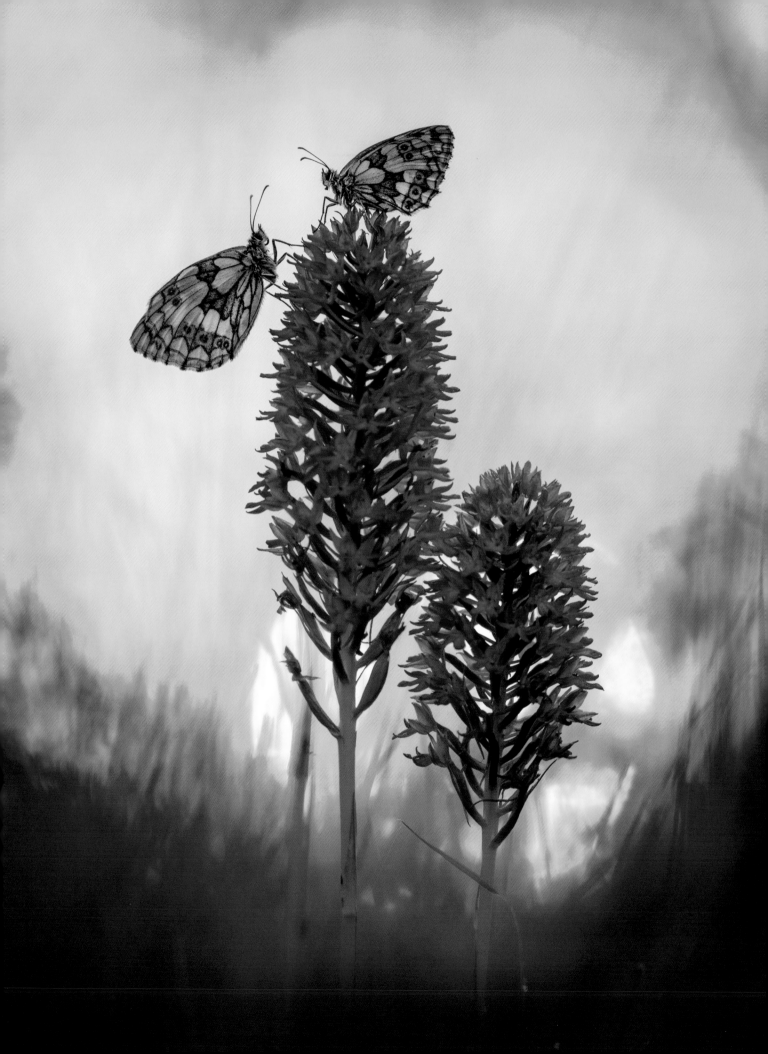

2. Our Grasslands

BOXING HARES AND THE GOLDEN EAGLE

Opposite top: A young golden eagle surveys the island of Islay, Scotland, for potential prey.

Opposite below: These 'boxing' hares are a female, a jill, fending off the unwelcome attentions of a jack, an amorous male.

The grasslands that cover 40 per cent of our land area may be a landscape modified and cultivated by people but they are still an arena for dynamic encounters between wild and charismatic species. The brown hare (*Lepus europaeus*) resides in a mosaic of woods and meadows but is more often seen in open fields than the rabbit. The hare was brought over the seas to Britain by people, most likely during the Iron Age, and in the centuries since has become deeply enmeshed in folklore. The expression 'as mad as a March hare' comes from its courtship behaviour in spring, when this usually timid animal is seen brazenly darting around fellow hares out in the open before rearing up as high as possible on its powerful hind legs and 'boxing' with its front feet.

It was long presumed that mad March hares were jousting males but it is often a female, a jill, fending off the unwelcome attentions of a jack, who will travel miles looking for receptive mating partners. Boxing does not mark a breeding season, for hares mate at any time from February to September, and fights can occur throughout the season, but it is less visible in summer, when grasslands and crops have grown tall.

If males clash, a female looking for a mate may wait for more males to arrive before leading them on a chase to see which is fittest. Scores gather in some spring fields, and the interactions between competitive males and then females and males are complex and varied – not just boxing but swiping and biting, jumping and chasing. When the hares choose to fight, it can leave this usually cautious animal oblivious to the moment they really should choose flight.

For a young golden eagle developing its skills, boxing hares are easy to spot in the open grassland. Pouncing on a hare in such open terrain appears to be a simple task but the young eagle may underestimate a hare's running prowess. Hares and rabbits are often regarded as similar animals but the hare is not only larger but has a much larger heart – up to 2 per cent of its body weight, compared with 0.3 per cent in a rabbit – which means it can reach 45 miles per hour in a sprint for its life.

Since a sixteenth-century poem called the hare 'braynles', the hare's spring antics have become a byword for 'hare-brained' schemes. But there is nothing idiotic about a hare in full flight. When the chase is on, the hares run seemingly at random, relying on the aerial eagles to lose the height and power they require to mount a successful attack. By twisting and turning, an inexperienced eagle can be outfoxed by the supposedly foolish hare, and the fast-moving mammal lives to fight another day.

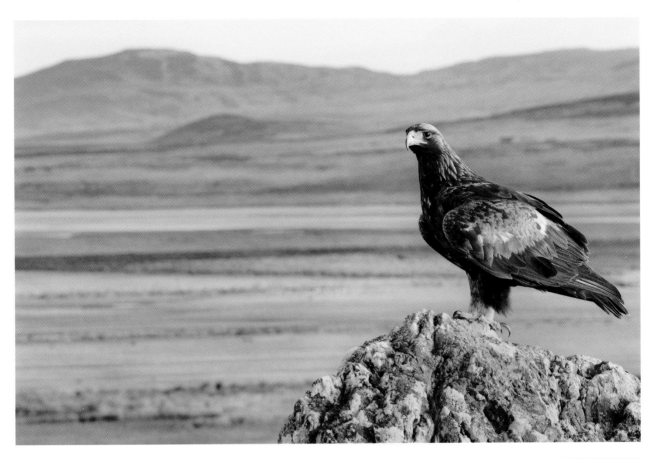

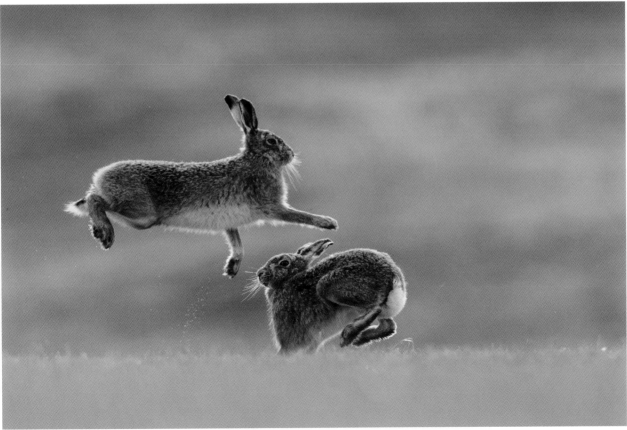

WHAT IS GRASSLAND?
THE MACHAIR AND THE WADERS

Opposite: A newly hatched ringed plover chick is well camouflaged against the sandy soil of the machair, the floral, species-rich coastal grasslands found in western Scotland.

A small piece of dried seaweed is blown along a vast sandy beach. It tumbles over the sands that have been ribbed by the previous day's tide. As it rolls, it picks up other minute pieces of wind-blown root, stem and seed. A gust sweeps it up the beach to rest against a couple of fronds of grass. These spiky tufts are the first growth of marram, which grows around our coastline and can make a living where few other plants can – on the dry, salty, windswept expanse of the beach.

The spindrift wedges against the marram, and sand is blown against both, slowly collecting into hummocks, hills and eventually sand dunes. The tough matts of the marram roots help stabilise this constantly shifting young form of grassland. And sheltered behind the marram, along the broad and storm-tossed coastal strip of the Outer Hebrides, there forms a unique grassy habitat.

This chapter tells the story of the grasslands of the British Isles. Forty per cent of Britain's land surface is covered by one group of plants: grasses. They convert light into life and are part of the food chain for almost every British animal. They are the foundation for all our open lands from dry heaths to damp bogs, meadows, moors and dunes. Our grasslands are incredibly varied. Chalk downland in southern England filled with butterflies in summer. Further north, heather-carpeted upland turns purple in August, while ancient peat bogs fill with multi-coloured sphagnum mosses.

These open habitats were once maintained by huge herds of wild herbivores. When these were hunted to extinction by our ancestors, many of these open habitats became forests and, later, farmland. Today, most open grasslands are a product of human activity. Flower-rich meadows are so floral because they are cut for hay each year. Moorland is open and heathery because it is managed, either by herds of deer or for organised shooting of grouse. Heathland is kept open by conservation management to preserve its rare flowers, invertebrates and reptiles. In the south, the biggest area of grassland is Salisbury Plain, which rather than being conventionally farmed has been owned by the Ministry of Defence and is increasingly managed with its wild inhabitants in mind.

Unfortunately, while much of Britain's grasslands look superficially the same as ever, they have been drastically impoverished. Over the past 90 years, 98 per cent of wildflower meadows in England and Wales have been destroyed and three-quarters of heaths have vanished. Grassy pastures still look pretty when framed by the patchwork of hedges and hedge-banks that remain in western Britain but since the Second World War farmers have been paid to 'improve' meadows. Hay meadows managed in a traditional way with an annual hay cut are full of flowers but 'improved' pasture has been ploughed and re-sown with a single species of

vigorously growing grass. It is fertilised and enriched with nutrients, which help the grass grow for farmers, but vigorous grasses then crowd out more delicate species of wildflower. Grasslands and hay meadows today are often cut numerous times each year for silage, preventing wildflowers from flowering, pollinators from feeding and other grass-dwelling species from breeding and thriving, from voles to ground-nesting birds.

Where older grasslands remain, they are great engines of biodiversity, and today great efforts are being made to restore and even recreate more traditional, species-rich grasslands. From a distance, a traditional meadow may look like a monoculture but it is rampaging with different grasses, herbs and flowers. Linked to these plants are beetles, butterflies, hoverflies and other invertebrates who base their lifestyles on particular species. Then there are the larger vertebrates, from grass snakes to field voles to skylarks, who make their homes here. Although many of the big wild grazers have gone, other grazing animals have taken their place, from Arctic geese to rabbits introduced by the Normans. And drawn to the presence of the grazers come their predators too. Each finds a niche and makes their living in the surprising, often secretive and subterranean world of our open grasslands.

Below: This machair grassland in South Uist thrives because it is part of a traditional farming system, with gentle cattle grazing enabling many wildflowers, invertebrates and birds to flourish.

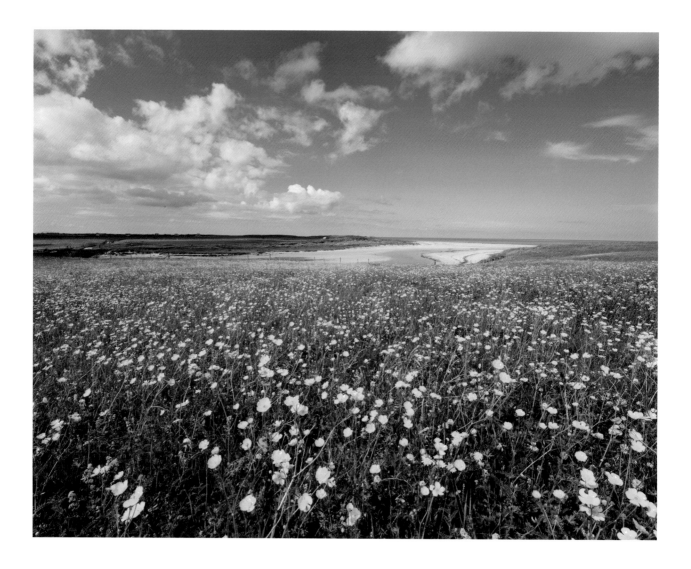

On the western coast of Scotland, the machair (pronounced 'macker') is a beachside grassland. It is not a single habitat but a mosaic of dry grassland, wet grassland, lightly cultivated fields, salt marsh and freshwater bogs found within a mile of the sea. There are wind-scoured plains, lochs, wetland and, most spectacularly in late spring and summer, carpets of wildflowers.

South Uist in the Outer Hebrides has the largest cultivated area of machair in Scotland, extending the entire length of the island's west coast. A total of 5,019 hectares is protected, and this varied habitat is the best place in Britain for the rare slender naiad (*Najas flexilis*), which grows in 11 lochs in the area. Dotted through the grasslands are also oligotrophic freshwater lochs, which have unusually low levels of nutrients that enable rare plants to thrive, such as water lobelia and quillworts. More recognisable wildflowers include meadowsweet and yellow flag irises on wetter grassland, alongside marsh, early marsh and northern marsh orchids. Rare pollinators also thrive on the machair, which is home to the moss carder bee (*Bombus muscorum*) and the great yellow bumblebee (*Bombus distinguendus*), one of our rarest bumblebees which is only now found in north and western Scotland.

People are a crucial part of the natural abundance of the machair too. These varied grasslands are a farmed system, and the crofting here is a traditional, low-impact form of cultivation that allows and enables many wildflowers, invertebrates and animals and birds to flourish. A gentle pattern of grazing and crop-growing rotations is crucial. Crofters graze cattle on the machair but traditionally withdraw the animals after 15 May to allow areas of corn to be grown. The removal of grazing enables wildflowers to come into flower. The corn is grown to feed the cattle so it doesn't need to be 'pure' and usually includes an understorey of wild flowers. Importantly, most crofters do not use herbicides or pesticides and some still use seaweed as fertiliser. Expensive 'inputs' are used sparingly in this small-scale farming. Most crofters also receive conservation payments from the government which support wildlife-friendly, chemical-free farming.

The machair is a sandy, fragile habitat and endures because it is farmed lightly. Crofters cultivate a rectangle of land for two years and then leave it fallow for two years so the soil can recover. The first- and second-year fallow areas fill with different wildflowers. In the first year, the sandy, exposed field is filled with annuals and species such as seaside pansies. By the second year, clovers and vetches take over. In later summer, crofters also take big bales of silage from the meadows, which does not look pretty but removes nutrients and ensures that delicate wildflowers can continue to thrive.

In early summer, the machair is a nursery for wading birds. The sounds of the machair are the calls of dunlin, ringed plover, redshank, lapwing and oystercatchers. There is an abundance of small birds not found in most parts of Britain. Other migrants which have vanished from much of the rest of the country continue to flourish here too, including the cuckoo and the corncrake, which fills the spring air with its strange, noisy, scratchy, mechanical-sounding call.

Ground-nesting birds thrive on South Uist and other islands in the great Hebridean chain because there are so few mammalian predators. On the machair, dunlin can nest at high densities that would be wiped out on the mainland by the visit of a single fox, but here there are no foxes so they are much safer.

Ringed plover often nest on a beach just above the high tide-line where they are vulnerable to disturbance by walkers and their dogs. But the machair gives them and other ground-nesting species such as lapwing more shelter and seclusion.

They need it, because even without many mammalian predators they are constantly under threat – from the air.

A newly hatched lapwing is tiny, wobbly and barely pokes its head above a daisy. Predators are invariably drawn in. Black-headed gulls and common gulls, and the occasional herring gull, are opportunists, constantly seeking to snatch an unguarded chick. Their parents know it, and a coalition of waders forms to repel such attacks. Smaller birds such as dunlin find it useful to nest near oystercatchers because the larger waders give them more protection.

When the first predators swoop into view, a multi-species airforce takes to the wing. Dunlin and ringed plover flock below the gulls to distract them. Then redshank zoom up from their nests to follow and harry the gulls from behind. They are joined by the lapwing, who will flounce and dive-bomb the gulls repeatedly. The toughest parent is the bulky oystercatcher with its formidable red bill who dares to fly beak-first at a gull. All these defensive manoeuvres are accompanied by a cacophony of shrieks and calls. The waders take it in turns, a tag-team of distraught parents, to distract, baffle, bully, mob and ultimately hassle the gulls so much that they drift away on the breeze to find an easier source of food on the shoreline.

Opposite: In early summer, the machair is a nursery for wading birds, including this young lapwing, with watchful parent nearby.

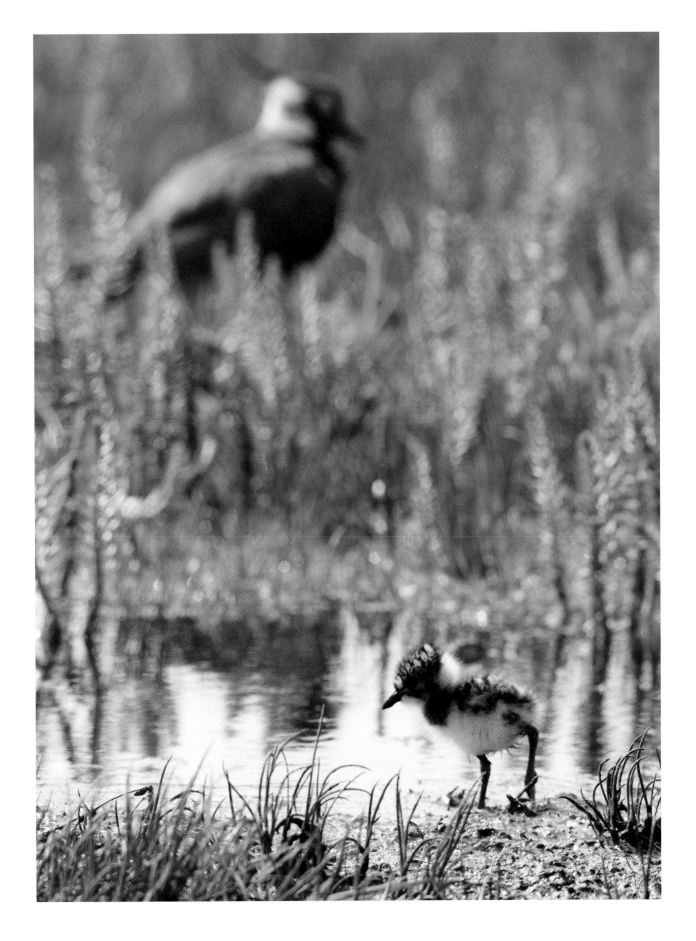

WILD PONIES CLASH ON BRITAIN'S NEW GRASSLANDS

Two stallions face each other and rear up on their hind legs, manes swirling. Two mighty animals threaten to collide in a fearsome heavyweight contest. One slams its body into the other. Its hooves come crashing down on its rival's shoulders and both ponies twist and turn their necks, seeking to bite or intimidate their opponent into surrender.

There is a lunge and one takes hold of the skin of the other's neck, and then they are both rearing up again. Another one turns and gives a dismissive back-kick. Suddenly, they retreat, prancing off through the long grass, the ferocious clash and apparently bitter feud over as quickly as it began.

In ancient times, wild horses were among a suite of large herbivores who roamed across the landscapes of western Europe, their grazing shaping the character of open plains and grasslands. The history of wild horses is shrouded in mystery. The wild horse that became extinct in Eurasia in the 1800s is known as the tarpan, but the status of this species is uncertain. Fossil evidence suggests that *Equus ferus*, the wild horse, evolved in North America more than a million years ago and crossed the Bering Land Bridge to Europe, Asia and North Africa, as well as migrating to South America. The wild horse evolved on river plains and in an open steppe landscape, and in these landscapes in central Asia a wild species, Przewalski's horse, has been reintroduced to roam once again. It is still debated whether Przewalski's horse is a distinct species in its own right or is a subspecies of the wild horse, or even a population derived from the domestic horse.

There were wild horses in Europe after the last Ice Age but they were probably absent from Britain for at least 5,000 years until domesticated horses were returned to the landscape. For many hundreds of years, however, many of Britain's grasslands have been shaped by horses that were the cornerstone of farming, industry and transportation. Until 200 years ago, the horse was our prime means of transport. Until 80 years ago, farming was almost exclusively powered by horse. The engines of vehicles, of course, are still measured in horsepower. For centuries, almost every farm was set up to provide fuel – hay, fodder and fresh grass – for these living machines. Each farm's working horses also shaped the landscape via trampling, grazing, the fertilising power of their dung, and their inadvertent seed-spreading. The replacement of the horse by tractors had a profound impact on farmland flora, invertebrate life and everything else beyond.

The people of Britain have long developed their own semi-wild breeds. A series of horse laws passed by Henry VIII sought to stop small domestic horses. The king wanted every horse on common land to be above a certain height: he desired warhorses, not workhorses. But small, sturdy horses proved impossible to subdue

Opposite: Konik ponies have been widely introduced onto wetland nature reserves in recent decades because of their resilience in the wild. Their grazing prevents marshlands rapidly turning into woodlands.

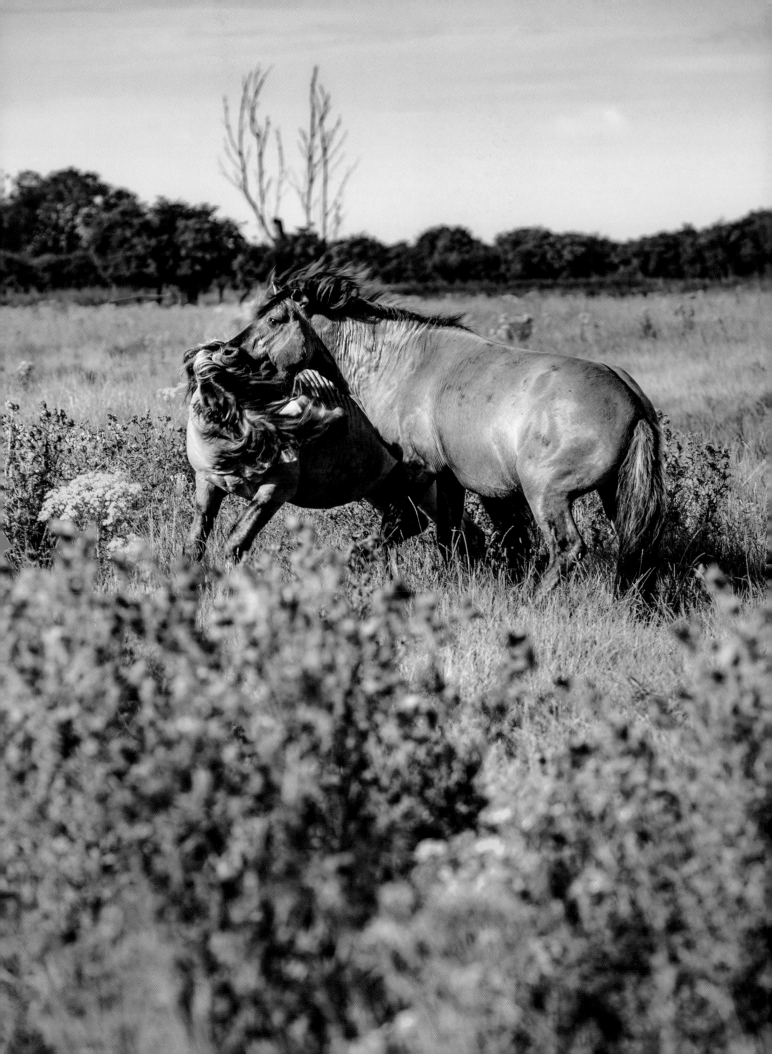

and horses were mixed and moved around the country via horse fairs. Pit ponies and pack ponies have contributed to the Exmoor, Dartmoor, Welsh Mountain and New Forest ponies that are well suited to their distinctive habitats today.

But the magnificent silver and blue-grey beasts with gunmetal-grey manes found fighting on grasslands such as Wicken Fen, Cambridgeshire, are more recent arrivals. They are the Konik pony, and they are increasingly popular as a proxy for the wild horses of prehistory, especially on the most diverse wetlands of large nature reserves.

This Polish horse breed is often hailed as a descendant of the wild tarpan that once roamed Eastern Europe. This is incorrect because the Konik's DNA is virtually identical to many other domesticated horse breeds. During the First World War, sturdy small horses called *panje* from the Bilgoraj region of Poland were used to transport equipment for Russian and German troops. After the war, Tadeusz Vetulani, a Polish agriculturalist, named them *konik,* Polish for 'small horse'. (Koniks are generally referred to today as ponies, as their average height is under 14.2 hands/4 foot 10 inches, so in English we are essentially calling them 'small horse ponies'.) In 1936, Vetulani created a reserve for wild Koniks in the Bialowieza Forest, arguing that exposing them to 'natural' conditions would bring back their original characteristics.

The pony's reputation for being the nearest thing to an extinct tarpan as well as its resilience in the wild and ability to live well on boggy wetlands without ill-effects led to it being introduced to large nature reserves in the Netherlands during the late twentieth century. The largest population of free-ranging Koniks lives on the Oostvaardersplassen, a famous and sometimes controversial rewilding reserve which shows how wild herbivores may have influenced the development of grasslands and woodlands in the ancient past.

In Britain, free-living herds of Koniks were first introduced onto Redgrave and Lopham Fen (home of the fen raft spider discussed in the Freshwater chapter) and some nature reserves on the Norfolk Broads in the 1990s. They were brought to Wicken Fen in Cambridgeshire by the National Trust at the start of this century. A small breeding group was established in 2003 and today there is a group of 74 breeding ponies across a 154-hectare section of the reserve, with 31 non-breeding animals in another similar-sized area.

The Konik ponies live wild. Unlike conventional, domesticated horses, wild horses and ponies don't have to be microchipped or have an animal passport unless they require veterinary attention. This means the young can grow up completely undisturbed by people. If they encounter people, the Koniks of Wicken are not like a wild deer. They will stand and watch a passing person, curious about them. But if a pony does require medical attention and rangers try to put a halter on it they soon discover how wild it is – not kicking wild but incredibly stubborn. 'If you're wanting to work with them you have to think of them as more like wild animals than domestic animals', says Carol Laidlaw, the National Trust's Livestock Ranger at Wicken Fen.

The breeding herd on Wicken Fen is arranged into seven or eight self-formed family groups, or harems, typically containing one adult male and between one and ten mare 'followers'. The number of mares depends upon the fitness and forcefulness of the stallion. Mares can conceive after just over a year and a stallion

Overleaf: A group of 74 koniks live wild across a 154-hectare section of Wicken Fen nature reserve in Cambridgeshire.

can mate after a similar time but they usually live in bachelor groups for several years. It can take three or four years for a stallion to reach sexual maturity. Only now has he the stature to form a band of his own. Successful stallions can maintain their bands for a long time: the oldest breeding stallion on Wicken Fen is 22 years old.

Each stallion does not defend a territory but his access to a group of mares. In spring and early summer, females come into heat. As the young foals follow the herd, learning about their new world in creches, spectacular fights occasionally erupt between the stallions as they compete to retain their mares. Challengers from bachelor stallion groups are aggressively fought off, using teeth, hooves, body weight and sometimes sheer force of personality.

Foals will constantly try to imitate the actions of their older relatives by play-fighting or chasing. But when the big fights break out, they must stay well away. Conflict can rumble on all year but even the most reactive of stallions spends the vast majority of his time eating and sleeping.

Each wild pony on Wicken Fen has a name because that's the easiest way for Carol and her colleagues to identify individual animals if one requires medical attention. *Wild Isles* filmmakers documented the fighting between three stallions: Boxer, Spod and Ellis. This proved to be a fascinating love triangle with a plotline belonging to the best soap opera.

Ellis was a lead male. Unusually, one of his harem was a stallion, Spod, who attached himself to Ellis as a subordinate. Spod was Ellis's sidekick, and would help the lead stallion defend his mares from other rivals in return for a chance to reproduce with one or two mares. Having two males leading a harem can be beneficial for the mares, meaning they receive less hassle from other horses who are reluctant to challenge a pair of stallions. A potential disadvantage for the mares however is that if the two stallions are not being challenged from the outside so much, they have more opportunity to hassle their own mares.

The battle between Boxer, Spod and Ellis began when Boxer, a young stallion within the family group, approached sexual maturity. As he grew in size, strength and sexual desire, Boxer started to challenge the lead males in his group, believing that he should have a chance to mate with some of the mares.

The three males lived in an unusual truce for a while in their family group before fighting erupted. Ellis successfully defended his position during filming. In the months after the film crew departed, however, Boxer steadily grew in strength and authority. Eventually, the revolution was complete, and Ellis was ousted from within, by Boxer. Pragmatically resigned, perhaps, to being the beta male, Spod switched allegiances and began serving Boxer, the new leader of the harem. Ellis was kicked out, quite literally.

There was one consolation for Ellis. Although he lost his parade of mares, he managed to persuade one of the mares to join him, and headed into the fen with a new harem of one. 'They can show a lot of loyalty', Carol says of the wild ponies. 'And it's not just the males imposing their will on the females. They do get a choice and they can reject a stallion. If they don't want to stay with him they will leave.'

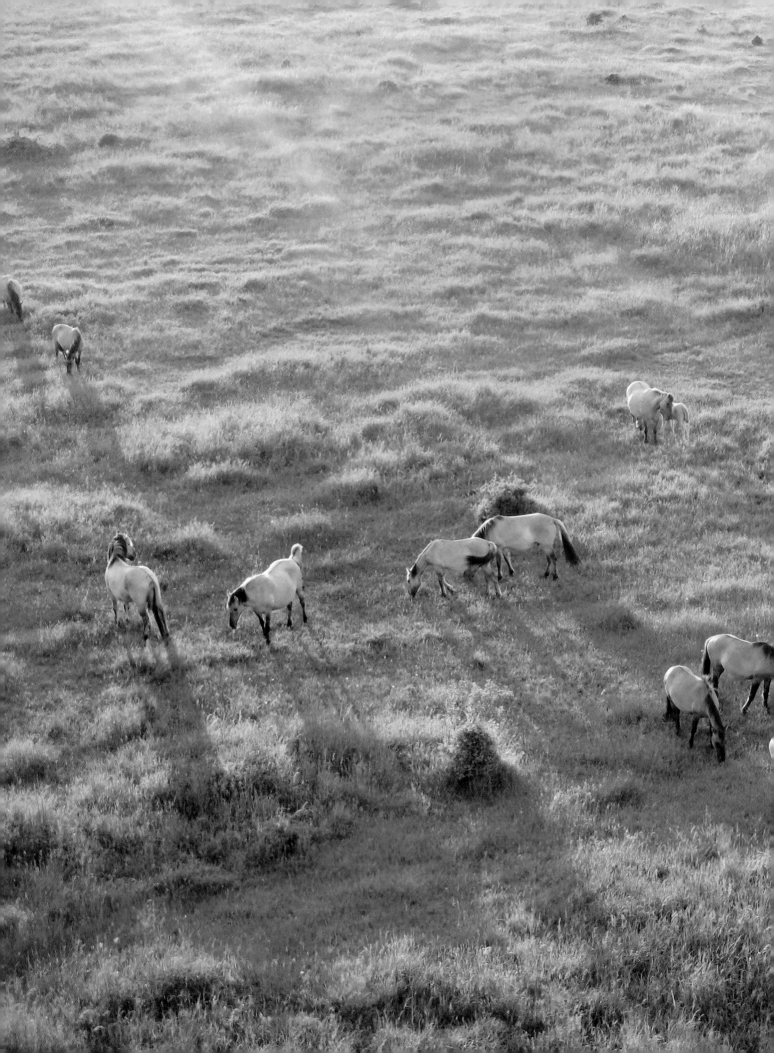

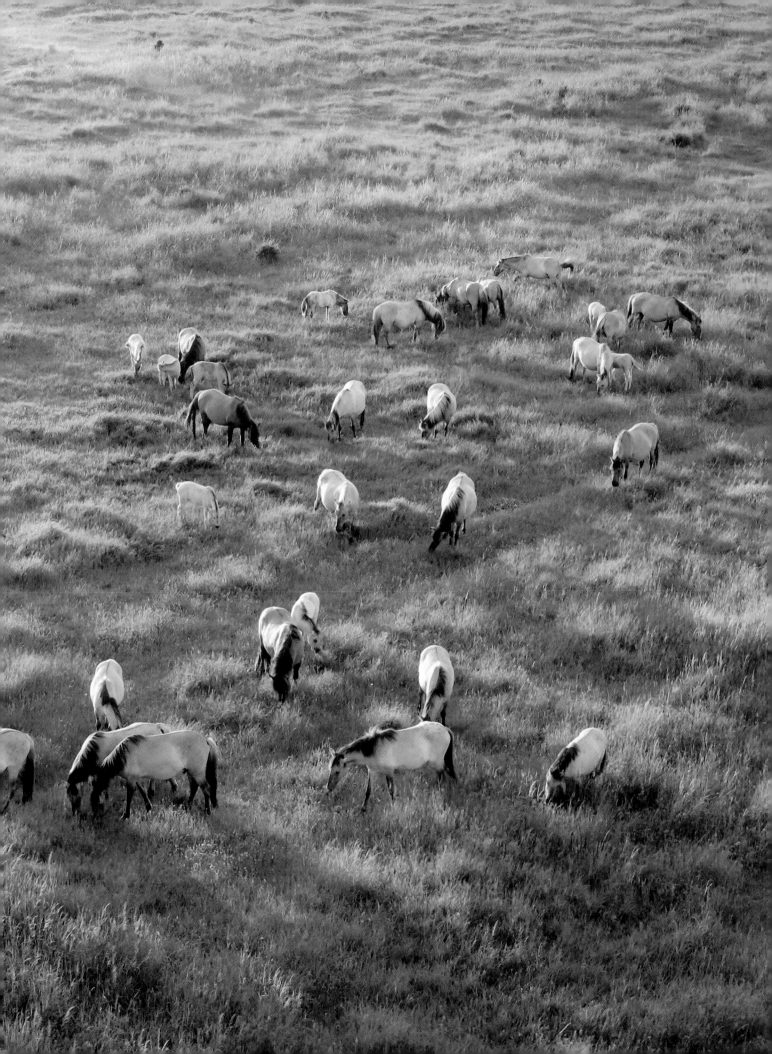

CONSERVATION HERO:
CAROL LAIDLAW, LIVESTOCK RANGER, WICKEN FEN

Wicken Fen is one of the first and most famous nature reserves in the country. Its importance as a surviving fragment of the kind of undrained wetland that once existed across eastern England's Fen region was recognised by the naturalist Charles Rothschild, who bought part of it in 1899 and donated it to the National Trust in 1901. It became the fledgling charity's first nature reserve. To save species by preserving a special type of habitat was at the time a radical concept that steadily gained in popularity as the twentieth century progressed. The Trust slowly acquired more sections of Wicken in the 1910s.

Today, it is one of Europe's most important and best studied wetlands, with more than 9,000 species recorded on it, from rare plants to charismatic species such as bitterns and cuckoos.

But Wicken has been increasingly exposed as a tiny fragment of biodiversity within a sea of intensively farmed, fertile lands that make up the Fens – itself once a vast inland sea and wetland before it was drained by Dutch engineers over the centuries. In 1999, the National Trust began the Wicken Fen Vision project, a 100-year programme to extend Wicken and create more habitat around it, so that rare species are not precariously enisled on such a small portion of land.

Is it rewilding or restoration? Carol Laidlaw, who has worked for 20 years as the Trust's Ranger in charge of the Koniks and the Highland cattle used to carefully graze Wicken's grasslands, prefers to call it a 'creation' project.

'We're creating something new, something is evolving', she says. 'We don't quite know what it's going to turn out like. It's not going to be exactly like the old fen which is the core of the reserve. It's creating something new but also something old.' Because much of the wilded land has been intensively farmed for so long, the seedbank has changed, and classic wetland species may not emerge as expected. Climate change is also changing what thrives, and when, and also changing the hydrology – the way the water moves through the wetland system.

Research has found that the areas of the expanded reserve that have been grazed by the Koniks and Highland cattle possess more habitat diversity and a higher turnover of species than the ungrazed areas. Grazing animals add dynamism to an ecosystem.

For Carol, it is important to have herds that live naturally and contain breeding animals and animals of all ages. 'We believe that allowing them their full freedom of expression, allowing them to live in the family group causes different interactions and micro-changes in the habitats.' Conventional livestock simply don't shape the landscape in the same way. For instance, a beef cattle herd is usually of the same sex and age. Each animal in the herd therefore has the same nutritional requirements, and a need for the same kind of shade, shelter and water. So they will browse the same grasses and seek out the same kinds of shelter. But a mixed sex, mixed age group is completely different, and individual animals are likely to seek out a wider range of plants, shrubs and trees to browse, and open up turf

and spread seeds in more varied ways. 'It gives you a more nuanced impact on the landscape', says Carol. Is it more natural? 'Natural is a very difficult word', she says.

Some conservationists and land managers would prefer to see native British breeds used for wildlife management. Carol does not argue that Koniks are a superior breed but she says that the British natives tend to be highly adapted to where they have evolved, so the Exmoor ponies are uniquely well suited to grazing on Exmoor for instance. When it comes to seeking a horse to graze the East Anglian Fens, no 'native' fenland breed endures today. A surviving local variety, the Suffolk Punch, is too big and heavy for the Fens' peaty soils. Other horse breeds are likely to put on too much weight on the area's incredibly rich wet pasture.

'Given there was no archetype for the Fens, we looked at the success of the Koniks at other grazing places in Europe and Britain and for our aim of having free-living, expressive breeding herds, the Koniks were going to suit our needs best. Twenty years of experience hasn't really changed our minds.'

Carol has seen how the Koniks are happy to go into wet areas, and will be quite content grazing belly-deep in water. They will also dig for roots and rhizomes. Common ailments for horses in boggy landscapes include thrush and mud fever, but none of these conditions have been noticed in the Wicken Koniks. 'There's a lot of anecdotal evidence but no objective scientific evidence to prove they are better or more suited to this landscape than a British native horse', says Carol.

The Koniks are allowed as much self-determination as possible at Wicken but at some point the National Trust will need to regulate their numbers. They have been able to allow the population to expand so far, but when it meets the carrying capacity of the land it will need to be managed by humans, given that the wild ponies have no natural predators. The Trust is considering contraceptives for mares, and vasectomies for stallions to prevent numbers increasing to a level where the grasslands are grazed too heavily for some rare species. The traditional 'gelding' – castration – will probably be avoided because this reduces a horse's 'natural' behaviours, and the non-breeding animals tend to suffer from health issues: left to their own devices, they get fat.

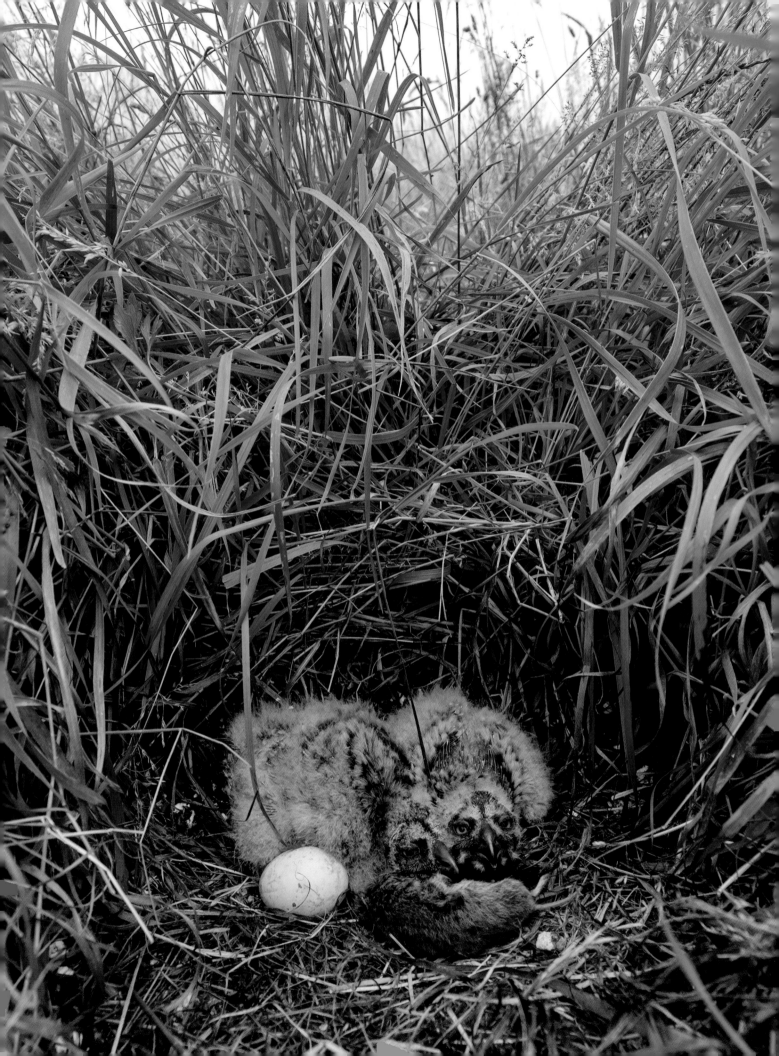

CHILDCARE IN THE GRASSLAND JUNGLE – FIELD VOLES *VS* SHORT-EARED OWLS

Opposite: Two short-eared owl chicks have been brought a dead vole for a meal.

Overleaf: The short-eared owl is known as 'little cattie face' in some Scottish dialects. Their cat-like faces can be seen hunting over grasslands, where field voles make up the bulk of their prey.

Beneath the feet of mighty animals such as the semi-wild ponies lives one of Britain's most abundant mammals. Despite its ubiquity, many people have never seen the furtive, fast-moving field vole (*Microtus agrestis*), also known as the short-tailed vole. The field vole makes its living among the roots of grassland, creating a network of tunnels that twist and turn through the base of the stems. The busy voles make tunnels wherever they need to go to the best feeding grounds – and whenever they need to hide. The tunnels lead to their nest too, which is securely made deep in the tangle of roots at the bottom of a thick tussock of grass.

Even so, a female vole feeding her babies must break for cover at times in her quest for the best grass roots and shoots. She moves carefully, with bursts of speed followed by a sudden stop and pause. She's afraid of a vole specialist, the short-eared owl (*Asio flammeus*), known in some Scottish dialects as 'little cattie face', for its features can look as appealing as a domestic moggy. This name has a Norse influence too, for its common name in Sweden translates as 'the cat-faced owl'. The birds shuttle between Britain and Scandinavia as well, sometimes even within one breeding season. The British Trust for Ornithology fitted satellite tags on some birds, which revealed that one pair nested in Dumfries one spring before heading off to make another nest in Norway later that summer.

The owl nests early in the year, sometimes producing chicks in April. They are usually nocturnal but when they are feeding young they can be seen out hunting in the morning and as early as 4 p.m. during the long evenings of midsummer. They specialise in hunting in the grass, sensing movement and listening carefully before they pounce. Field voles make up 80 per cent of their diet.

The 'shorties' seem to know where populations of voles proliferate each year and fly to wherever their prey is most abundant. Variable weather creates bad and good vole years. In a good summer, a vole may produce as many as seven litters of up to eight babies each. In some seasons, then, the grasslands are literally jumping with voles.

The short-eared owl will perch on a fence above grassland to look and listen. Its keen hearing can detect the tiniest rustle. If the vole senses that she has been spotted, she must freeze. This, the silence of stillness, and the natural camouflage of her grey-brown body, is her best – and only – hope. The owl swoops and snatches a vole – an essential fresh meal for its babies. But four out of five short-eared owl 'pounces' are unsuccessful, and this particular mother vole runs free, back to her nest, safe for another day.

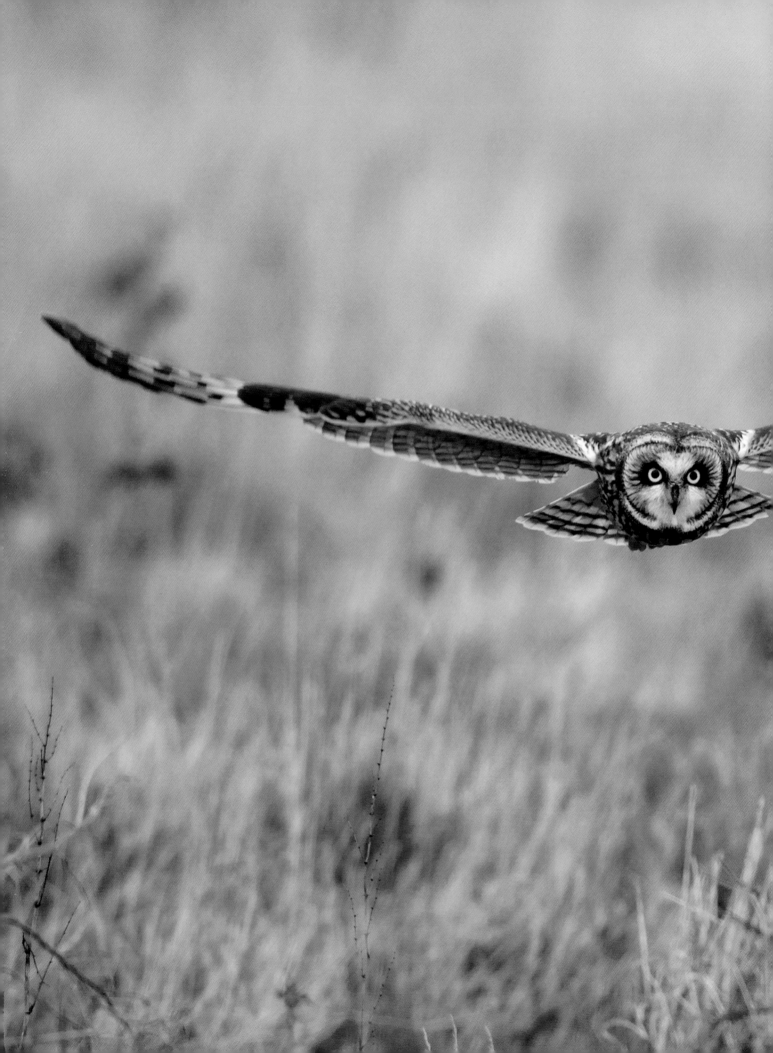

THE SNAIL AND THE BEE

The flower-rich chalk grasslands of southern England are famed for their conspicuous pollinators: the dazzling, electric-blue Adonis blues and ghost-pale Chalkhill blues that bounce between knapweed and bird's foot trefoil in summer. But there's another, less heralded pollinator with a unique and fascinating lifestyle.

On the sunny meadows below the huge chalk figure of the Cerne Abbas giant in Dorset, it appears that the banded snails are having a party. These small, pretty snails twist and turn and roll in the grass. In fact, the dancing is the work of the female of another species: *Osmia bicolor*, a small, solitary, bi-coloured bee. The snail shells are empty, and the devoted mother bee is looking for the ideal home in which to rear her family.

Finding the perfect shell is a bit of a mission. The shells of garden snails are mostly too large. The shell of a garlic snail is too small. And *Osmia bicolor*, which is just 12 millimetres in length with a black head and thorax and an abdomen brightened by ginger hair, wants one in very good condition too. Snails that have been killed by thrushes are no good, because their shells are splintered and smashed. Even one crack is no good for the little bee. Fortunately, the grasslands of Cerne Abbas contain healthy populations of glow worms. The glow worm larvae are not quick but they are fast enough to catch a garden banded snail (*Cepaea hortensis*) or a lemon snail (*Cepaea nemoralis*), and after the hungry larvae have eaten their fill they leave the shell intact and in tip-top condition.

There are many stories of maternal devotion in the natural world and the female *Osmia bicolor* bee's labours of love are particularly impressive. Once she has selected a suitable disused shell, the mother bee bustles around cleaning it up. Using chewed-up leaves – leaf mastic – she builds a cell inside, in which she deposits a provision of pollen collected from the surrounding meadow for her larva to feed on. Into this nursery-and-larder, she lays an egg, before sealing up the cell with more mastic. Sometimes she will lay another egg, in a separate cell. After this, she back-fills the snail-shell with rubble – dry soil, chalk and tiny snail shells – before sealing up the entrance with more leaf mastic. Now she is sure that she has built an impregnable barrier to predators, particularly parasitic wasps, which seek to burrow into the shell and parasitise the young bee.

But this protective mother is not done yet. She carefully turns the shell so its meticulously sealed entrance is facing downwards, into the earth. Sometimes she will even dig the shell into the ground. Even now, she takes further measures, covering the shell in little bits of leaf mastic, possibly to camouflage it. For her final trick, she turns into a witch, flying across the meadow collecting fragments of last year's dead grasses, which she carries through the air as if she is riding a broomstick.

Above: *Osmia bicolor*, a small, solitary bee, goes to great lengths to hide its eggs, carrying twigs through the air to disguise the empty snail-shell in which they are laid.

She meticulously arranges these twigs into a wigwam over the shell, to better hide it from view. Finally, her work is complete.

These labours are quite an investment for just one or two eggs inside a snail shell. It is not known precisely how many eggs *Osmia bicolor* lays but naturalist John Walters, who has studied the bee, believes it is up to around 20, similar to other insects that make a huge investment in the security of their young, such as potter wasps. Whereas many insects that lay hundreds of eggs expect only a few to make it through to adulthood, *Osmia bicolor* has a much higher success rate, with Walters estimating that half its eggs successfully develop into an adult bee.

Unusually, the bee develops into an adult within the shell by the autumn after the egg was laid, and overwinters in this state, ready to fly as soon as the world warms up. The male *Osmia bicolor* bee, a smaller, greyer creature, is one of the first bee species to emerge in early spring, and can be seen on a warm day in February. If the weather turns cold or wet again, the males will find an empty snail shell and shelter within it. Perhaps it reminds them of home. When it is warm, they devote their energies to cruising around other snail shells scattered across the meadow, waiting for females to force their way through the leaf mastic and rubble to emerge into the sunshine. Then the bees will mate. The males are short-lived, unlike the females who fly on through the spring, building safe-houses for their offspring and riding their broomsticks all over the meadow.

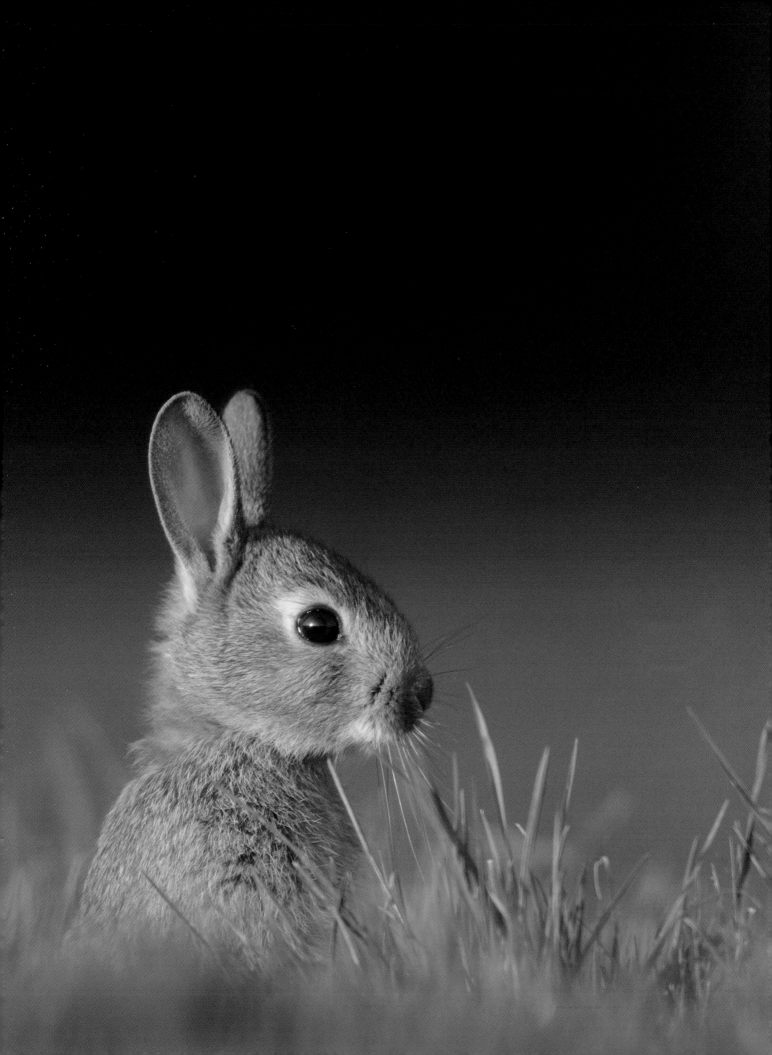

GRASSLAND MAKERS – AND THEIR TAKERS

Opposite: Rabbits may be dismissed as pets or pests but they are also crucial ecosystem engineers, their grazing sustaining vital grasslands such as the Brecks in Norfolk which are home to numerous rare plants.

The grass is short and yellow, the ground desert-dry, and the grey soil detonates into dust when it is scuffed. The flat terrain of the Brecks is hot by day, cold at night, and looks pretty similar whatever the season. This arid, sandy grassland is more redolent of the steppe in Kazakhstan or Russia than lowland England.

Seeming desolation at first glance is deceiving. Look more closely, and the tightly grazed sward is full of life. The Breckland of Norfolk, Suffolk and Cambridgeshire is a hotspot for rare plants, particularly those that require warm, bare ground to survive, such as spring and fingered speedwell and the fabulously named prostrate perennial knawel. Alongside these rarities are warmth-loving invertebrates, such as the wormwood moonshiner beetle and the dingy skipper butterfly. And these grasslands are a haven for bigger, more noticeable creatures too: adder, common lizard, skylark, woodlark, nightjar.

All these plants and animals are here because of one keystone species, an ecosystem engineer like no other. This charismatic creature is arguably more important than any other mammal in its ceaseless work to preserve a range of precious landscapes, from the South Downs to the Cotswold grasslands. It's the rabbit.

Rabbits were possibly first brought to the post-glacial British Isles by the Romans but seem to have disappeared again until being reintroduced following the Norman conquest. In medieval times, rabbits were kept in warrens and farmed for their meat and fur. By the early eighteenth century, rabbit farming had become industrial in scale with large warrens placed everywhere – often on common land – from the Mendips and the Yorkshire and Lincolnshire wolds to Dartmoor, Sussex and Sherwood Forest. Rabbit warrening was a perfect use for the sandy, poor soils of the Brecks. During one year in the nineteenth century, the region produced more than 500,000 rabbits. The farming was so intense that exposed sand became mobile dunes. In 1688, sand engulfed the village of Santon Downham in Suffolk; the rabbits spread everywhere as well.

Ironically, the rise of the gamekeeper helped wild rabbits spread as populations of predators – from stoats to buzzards – were decimated. So did farming, with the enclosures of common land in the nineteenth century in particular bringing hedges for cover and winter crops for food. As they gained in popularity as pets, and fell out of favour as a source of meat, so warrens were abandoned. The growth of uncultivated land during the agricultural depression of the early twentieth century further encouraged the wild population, which grew to an estimated 100 million. Farmers, gardeners and all kinds of growers understandably railed against this 'pest'. On the eve of the Second World War, a new law made it an offence to fail to

control rabbit populations. Although the rabbit had some champions – notably Winston Churchill – many people were relieved when a devastating new disease, myxomatosis, arrived in Britain in 1953. Within a few years, more than 99 per cent of the rabbit population had vanished.

Over time, rabbits developed some immunity to myxomatosis and populations recovered. But wild rabbit populations have crashed again in recent years after the arrival of a new virus, rabbit haemorrhagic disease virus type 2 (RHDV2), which first emerged in commercial rabbit farms in northern France in 2010. Rabbit numbers have slumped by 88 per cent in the East Midlands and 83 per cent in Scotland between 1996 and 2018, falling by 43 per cent across the whole of the UK over the decade to 2018. More recent surveys suggest there is no slowing of these declines.

Fortunately, ecologists now recognise the value of a much-derided species. With the decline of livestock grazing on 'marginal' or unprofitable grasslands, rabbits have played a key role in keeping meadows, heaths and duneland grass systems open. Their activities create space for many other species. They are selective grazers, and keep vigorous grasses in check, thereby assisting more delicate wildflowers. Rabbits' earth-scratching and burrowing helps seeds germinate and creates what ecologists call 'mini mosaic habitat' – patches of warm, bare earth which are havens for rare flowers and invertebrates, as well as the common lizards and adders that bask there. The caterpillars of the declining lunar yellow underwing moth are found close to rabbit burrows, and even endangered birds are helped: rabbits unearth lots of flints from the sandy soil which provide perfect camouflage for the stone curlew, which lays its flint-coloured eggs on the ground.

Rabbits are also food. It is fortunate they breed like rabbits on the Breck when there are so many creatures that will take their babies, from foxes and badgers to stoats, weasels, polecats, crows, barn and tawny owls and Britain's most thriving bird of prey: the buzzard.

The wild rabbit found in Britain, *Oryctolagus cuniculus*, evolved on the Iberian Peninsula, where they had to flee eagles as well as other large birds of prey. Few other rabbit species actually live underground but our rabbit found that a network of subterranean burrows was the best way to stay safe. The burrows are mostly dug by the females, the does, who bring up their babies in large, fairly matriarchal communal colonies.

When it comes to breeding, the male, the buck, has an unusual seduction technique. Out on their grasslands, he will sniff the ground to check if a female is in season. If she is, he will chase her, running in circles around her. To really impress her, while moving at high speed, he wiggles his bum and flicks his urine at his potential mate. He hopes this pheromone-filled liquid will convince the female that he is the fittest buck for her. Before giving birth after a 30-day gestation, the female plucks fur from her belly to make a deliciously soft nest for her babies, safe underground.

Within a colony of rabbits, there is usually a dominant pair who have more offspring than most. The rabbits tend to live in groups of around six females, with grandmas and great-grandmas as well as aunts, sisters and daughters staying with their maternal group. The male rabbits grow up and disperse. A dominant female can live up to nine years and will often stop subordinate females from breeding.

Opposite top: A buck rabbit will flick his urine at a doe in an effort to persuade her to mate with him.

Opposite below: A buck will also rub pheromones from under his chin onto the head of a doe.

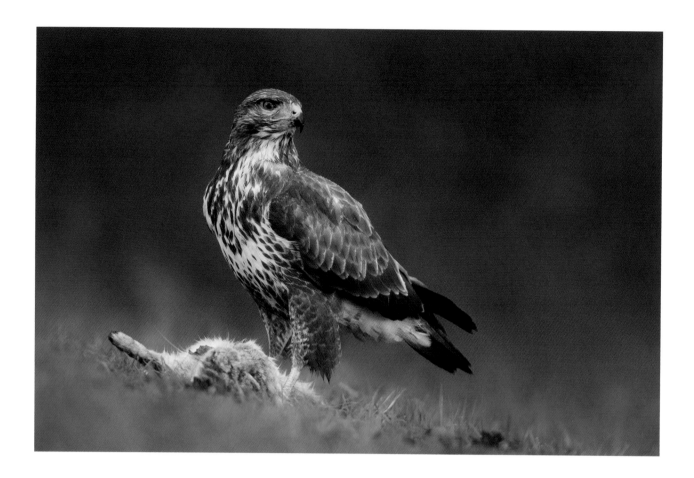

She may chase great-nieces or younger rabbits from the warren, preventing them from nesting within it, or even drag a rival's babies above-ground to die. She knows that if the warren produces too many babies at once, this will attract predators.

Even so, up to 15 babies may come from multiple female litters inside the same warren. The rabbits are weaned at 21 days and emerge onto the grassland for the first time: small, extremely cute, and fatally naïve. As the popularity of the pet name 'Thumper' suggests, rabbits communicate impending danger by foot-thumping on the ground. Alert rabbits feel the warning vibrations and race for the security of the nearest hole. But not every young rabbit is alert. The young does are more cautious and stay close to the burrow. The young bucks know they must disperse and take more risks, darting around, exploring and drawing attention to themselves.

Sitting silently in the trees overlooking the warren, one particular predator is paying close attention. Despite falling rabbit numbers, populations of one of their main predators, the buzzard (*Buteo buteo*), have risen like a phoenix over recent decades. Following legal protection and the lessening of centuries of persecution, the buzzard is today seen everywhere across Britain, flying off from a favourite perch if startled, a hulking brown bird that is sometimes mistaken for an eagle when it soars, broad-winged, on a thermal.

The buzzard is successful because it is such a versatile carnivore. It is not fast like a peregrine, or silent like an owl, but it is adaptable, and can turn its talons to most living things. It will root through fields to find unglamorous fare such as earthworms and beetles, and will also take frogs or snakes. Small mammals such

Above: Buzzards are versatile hunters who can fly in low at surprising speeds to ambush and catch an unwary rabbit.

as voles are favoured fair game, and so are baby birds, grey squirrels and pheasants. Even barn owls have been found in buzzard nests. Carrion or roadkill is the easiest meal but when a buzzard has chicks to feed it really wants some fresh and nourishing meat.

To catch this, a buzzard will sit and wait patiently, perched in a tree overlooking a rabbit warren for up to six hours. Then it springs into life. It hasn't got a great burst of speed but it is strategic, flying low to the ground, following contours and thereby concealing itself from view.

The young rabbits nibble grass close to the security of patches of nettles and brambles, which give them cover. These are also cover for the approaching buzzard. By the time it powers up into view from behind the brambles, it is too late for the baby who hasn't heeded his colony's thumped warnings. The buzzard lands on the rabbit and grabs it with its talons. The bird has an extremely strong grip and can easily hold the little kit.

The parent has not given up on its baby. The female rabbit emerges from hiding and charges at the grounded buzzard, swerving away at the last minute. It is a brave and defiant act of maternal dedication but it doesn't dislodge the baby rabbit from the talons. It is too late. The buzzard kills the baby with a convulsive grip across the head or thorax, squeezing the life out of the small rabbit. Then it airlifts its prize back to its own ravenous babies who are waiting away in the woods, in its discreet nest high in a tree.

CONSERVATION HERO:
DIANA BELL, PROFESSOR OF CONSERVATION BIOLOGY, UNIVERSITY OF EAST ANGLIA

'The rabbit is unique', says Professor Diana Bell, a conservation biologist who has devoted much of her career to studying rabbits. 'It's a nursery pin-up. It's a pet. We use it in laboratory research. It's eaten as meat but its role as a conservation ecosystem manager is neglected. There aren't any other species that play that range of roles in our lives.'

Diana has spent years studying the colonies that bounce around the campus outside her office at the University of East Anglia. Rabbits are still being killed by myxomatosis but the recent slump has been caused by RHDV2. 'This virus has decimated rabbit populations across the country – they've just crashed everywhere, and the virus keeps coming back', she says. 'It's become endemic like myxomatosis. Even now we still don't see baby rabbits by the side of the road as we used to.'

The virus can kill rabbits at a young age, and a typical sight is of baby rabbits sat motionless at the entrance to a hole. The earlier variant, RHD1, caused bleeding from the nose but this virus often has no visible signs. When dead animals are subject to post mortem, their livers and organs are found to have been subject to major haemorrhaging. Myxomatosis still kills rabbits as well.

'If you take out the rabbit in some locations, the ecosystems collapse', says Bell. 'It's a major food source in many places. On our chalk grasslands, the South Downs, the Wiltshire Downs, the rabbit is absolutely key to maintaining the short sward required by butterflies and certain rarer plants and other invertebrates.'

So, after centuries of being treated as a pest, today the unthinkable is happening: conservation efforts are being made to revive rabbit populations.

Shifting Sands, a four-year National Heritage Lottery-funded project to restore rare species in the East Anglian Brecks, has seen landowners encouraged to create 'rabbit hotels' to help revive its numbers. The 'rabbit enhancement plots' are made from piles of branches carefully arranged near existing rabbit warrens to provide safety from predators such as buzzards, and stepping stones through the landscape. Crucially, the brash piles also provide extra places for the subordinate female rabbits to burrow and safely give birth to their kits without aggravating the dominant female. In this way, each warren can produce more offspring.

The hotels have been successfully trialled in five locations. Monthly monitoring has found that 41 per cent of the brash piles contained rabbit burrows – which usually leads to breeding – and 91 per cent contained scrapes – evidence of use by rabbits. The project also trialled digging artificial banks for rabbits to burrow and breed, which Diana says also showed they could help boost rabbit populations.

Conservationists hope more landowners will take up this new rabbit-support 'toolkit'. Attitudes are changing. Rabbit populations are now so low in many areas that they simply aren't the pest to vegetable growers that they once were.

And rabbits can save landowners money. The owners of lowland heaths and grassland

Above: Rabbit populations decimated by disease are now the focus of conservation projects to create good habitat for warrens and encourage rabbits to breed, well, like rabbits...

that are designated Sites of Special Scientific Interest are often required to maintain 'open, disturbed conditions' on the site. While they will have to pay for diggers to disturb the ground, or livestock to graze it, the rabbit will do these jobs for nothing.

Scientists are notoriously reluctant to get sentimental about the subjects of their study but Diana is happy to admit to admiring more than the scientific and ecological qualities of this underestimated animal. She had a house rabbit for years. 'He'd come and meet me at the door when I got home, and courtship dance around my feet when I was brushing my teeth. He'd sit on the arm of my chair when I watched TV in the evening', she remembers. 'Rabbits are very intelligent, amazing animals.'

RED ANTS AND LARGE BLUES

Opposite top: The large blue begins its lifecycle conventionally enough, with adults pairing up and females laying eggs on thyme and marjoram in meadows.

Opposite below: When tiny, the large blue caterpillar throws itself onto the ground and encourages red ants to take it into their underground nest. Here it spends the winter, devouring ant larvae and pupating underground before emerging in June as an adult butterfly.

Grasslands depend on grazing, and so do many of their inhabitants. The large blue butterfly became extinct in Britain because of a catastrophic loss of grazing – by livestock but also by rabbits – that occurred in many grasslands during the second half of the twentieth century. This loss of grazing caused another crucial meadow-maker to decline as well: ants.

Healthy grasslands do not merely dance with wildflowers; they hum, buzz and bustle with grand cities of invertebrate life. And ants are not only the prime movers in this invertebrate ecosystem but, ultimately, help engineer the entire grassland ecosystem that we all enjoy.

The tunnelling of ants aerates the soil and spreads seeds, ensuring a wealth of floral diversity. Ants are also voracious predators, collecting all kinds of insect and plant food, which they roll, heave and bundle into their bustling subterranean communities. A plump, juicy and apparently defenceless caterpillar is an ideal feast for a nest of ant grubs, but some of these tasty victims have adapted, with extraordinary cunning, to turn the ants' dominance to their advantage.

The large blue, which has been successfully reintroduced to our grasslands, has a lifecycle even more extraordinary than most butterflies. For the early days of its life, its minuscule caterpillar munches nothing but wild herbs. It hatches from an egg laid on the flowers of wild thyme and marjoram, and here it feeds, camouflaged and apparently safe, high in the 'canopy' of its grassland home. Then it makes what seems to be a foolish decision: in late afternoon, precisely when the ants are at their busiest foraging in the meadow below, this tasty treat walks to the edge of its dinner-plate, and jumps.

It falls to the ground, tucks itself in a little recess on the surface of the soil and waits to be found. Usually, a curious ant is quickly upon it and a great deception begins.

The caterpillar has evolved to survive in a world ruled by ants by mimicking the smell of a lost ant grub. More ants gather round, tasting the caterpillar's sweet scent glands. They decide they must adopt it so they carefully carry it into their nest, and into a brood chamber. If a caterpillar isn't spotted when it falls to the ground, it will move a couple of centimetres to a more obvious spot and wait for its adoption. In captivity, the caterpillars have even been observed walking to the entrance of an ants' nest to ensure they are picked up.

Entering the nest is like seeking sanctuary within an enemy's castle: here, the caterpillar is far safer from predation by every other creature that would snaffle it above ground, from earwigs to shrews to birds. But the danger is not over. If the

caterpillar fails to convince the ants that it is part of their family, it will be swiftly slaughtered.

So the caterpillar's deception deepens. Not only do its chemical secretions convince the ants it is one of their grubs but the caterpillar softly 'sings' to them, emitting sounds that cement its status not just as any old grub. The large blue's song successfully mimics a queen ant, ensuring it is given royal treatment in the nest.

The caterpillar is taken into the nest in summer and will spend ten months safely underground. But it still needs to eat and there are no fresh leaves here. So this defenceless, herbivorous Jekyll turns into a predatory carnivorous Hyde. It finds a quiet spot, an empty cell of an ant grub usually about 10 centimetres away from the ordinary ant larvae. Here it rests and, every week, glides forth through the nest to binge-feed on ant grubs before returning to its rest to digest its feast. It gains 98 per cent of its body weight in the ants' nest, becoming many times larger than an ordinary ant grub.

The British large blue, *Maculinea arion*, is also found in continental Europe, where there are four similar large blue species. Some of these have different relationships with their nests of ants and are 'cuckoos' – cosseted and fed directly by the ants, who give them regurgitated food. In some cases, the servant-ants are tricked into killing their own grubs and feeding them to the caterpillar. But *arion* is purely predatory. It grows to a monstrous size on its diet of grubs before pupating in the ants' nest. Here it rests all winter, warm, dry and protected by the presence of the ants from predators.

On a warm June day, the next generation large blue crawls through the ants' nest and up to the surface. Its wings are folded, soft and crumpled to enable its passage through the soil. Once in the meadow, it climbs a stem of grass and slowly unfurls its blue-and-black patterned wings, stretching them so they stiffen and dry in the morning sunshine.

Despite its great cunning, the large blue's story in Britain has been one of a struggle for survival. In Victorian and Edwardian times, its rarity made it a great prize for butterfly collectors. But it was also prized above all other butterfly species because no-one could produce specimens for collectors' cabinets by breeding it in captivity. Without the meadowland ecosystem of *Myrmica* ants, caterpillars couldn't grow and pupate. Collectors swarmed on some meadows where large blues were known to fly and picked up so many they caused the species to die out.

But the large blue's fate was also intertwined with other grassland inhabitants, particularly the rabbit. When myxomatosis struck in the 1950s, rabbit populations crashed, and tightly grazed meadows grew up tall. The loss of rabbits coincided with a reduction in the traditional grazing of ancient meadows by cattle and sheep, and the 'improvement' of other grasslands, removing the abundance of wildflowers and herbs such as thyme and marjoram. Crucially, longer grass made meadows too shaded and cool for *Myrmica sabuleti*, the ant species that usually adopted the large blue caterpillars. As these ant colonies disappeared, so did the large blue.

By the 1970s, the large blue was teetering on the edge of extinction. Its parasitic lifestyle had begun to be understood two decades earlier but the full complexity of its dependency on the ants was not yet known. Despite the creation of special reserves for the butterfly and the fencing off of its grassland home, it was

vanishing nonetheless. Without better knowledge of how it lived in the wild, it couldn't be saved.

A young conservation scientist, Jeremy Thomas, was dispatched to uncover its secrets. He worked long hours, for several summers, tracking large blue caterpillars and the movement of ants. By laying trails of different coloured crumbs from Battenburg cakes, he could see how ants foraged across the meadow and follow the trails to their nests. Eventually, he discovered that the large blue could perfectly impersonate only one species of red ant, *Myrmica sabuleti*, and this ant required particularly hot, well-grazed meadows to survive.

Unfortunately, Thomas was too late. After the dry summer of 1976, the last large blue populations entered a death spiral, becoming smaller and smaller until the butterfly became extinct in Britain in 1979.

Undeterred, Thomas and his colleague, David Simcox, set about its restoration. They knew now what this species required to survive: grasslands with thyme and marjoram where the grass was grazed short enough to be warm enough for the colonies of *Myrmica sabuleti* to survive. Simcox drove his VW campervan to the island of Oland in Sweden where he collected, with permission, eggs from the large blues that fly there. Together they released the caterpillars onto carefully managed secret locations: first, 'Site X' in Devon and later sites in Somerset.

It took a while for the reintroduction project to gain momentum. Thomas and Simcox needed to very precisely identify the species' needs. They realised they could only establish the butterfly by placing the young caterpillars in new sites at the exact moment they dropped off the thyme in search of ants. This had to be in the late afternoon, when the ants began foraging. And if they didn't release the ant-ready caterpillars within about 24 hours, they would die. With grasslands carefully grazed to enable the warmth-loving ants to thrive, the large blue began to prosper again, particularly on the Polden Hills in Somerset. In 2010, the butterfly was successfully returned to the Cotswolds.

CONSERVATION HEROES:
JEREMY THOMAS, DAVID SIMCOX AND SARAH MEREDITH, THE LARGE BLUE PROJECT

Jeremy Thomas is now retired from his post as professor of ecology at the University of Oxford but he and his old colleague David Simcox continue to work with their colleague Sarah Meredith on the Large Blue Project, a coalition of a dozen wildlife charities and landowners, from the Royal Entomological Society to Gloucestershire Wildlife Trust.

Their painstaking work to save the large blue butterfly – which still involves counting thousands of microscopic eggs each summer (Sarah is an expert) – isn't simply about playing god with one species. Its reintroduction has revived a suite of other grassland species including beetles, birds and rare flowers. The restoration also continues to reveal fascinating insights into biology, evolution and how conservation can meet the challenges posed by dramatic climate change.

Studying the large blue so closely for so long has revealed evolution in action – and it can be unexpectedly rapid. Some butterflies will fly across continents to find food but the large blue is more sedentary by nature. It can take ten years for the species to move 500 metres across a meadow. When Jeremy and David brought the caterpillars from Sweden and put them on Green Down in Somerset, they calculated there was a 50 per cent chance it would take 42 years for them to reach another suitable site, Collard Hill, which was barely seven kilometres away. Unsurprisingly, they decided to give the species a helping hand, reintroducing it to other sites across the Poldens and moving caterpillars to the Cotswolds as well.

But nine in ten of the Somerset meadows where large blues fly today are a result of the butterfly arriving under its own steam, and the scientists have detected a very strong selection for increased dispersal abilities. Since they began reintroducing large blues 40 years ago, dispersal rates among the butterflies have nearly doubled today compared with the butterflies that were first brought over from Sweden. Evolution is happening before our very eyes.

The reason for this is because female large blues, which are more likely to fly far and disperse to a new meadow, will reach a neighbouring site and find virgin habitat. Lots of ants' nests and no other large blues mean that the female's eggs have a very high success rate in the beginning. Later on, once a site fills up with large blues, overcrowding becomes a limiting factor – there are only so many ants' nests, or food plants, to go around. So the female who is bold and flies off is rewarded with her genes being reproduced in a larger number of new individuals. This creates a strong selection for a more adventurous race of butterflies. 'You're watching evolution, which is amazing', says Jeremy. 'We were always brought up to believe that evolution takes place over millions of years but actually it happens all the time, and sometimes over really short spans.'

Two distinct 'races' of large blue have also emerged in Britain: those whose caterpillars feed on thyme at the start of their lives and those who eat marjoram. The latter flowers later in the summer, and so marjoram-adapted large blues emerge a little later in the summer. Unlike thyme, marjoram can also grow in longer grass and while *Myrmica sabuleti* likes it hot, it doesn't like it too hot, and so warmer,

south-facing slopes with longer grass sometimes suit it better.

The fact that the large blue is laying on two different plants gives the species more resilience. At Daneway Banks in the Cotswolds, half the large blues lay on thyme and half on marjoram. But this changes as droughts and dry periods vary during different summers. In 2020, three-quarters of the eggs laid at Daneway were on thyme; in 2021, that switched to three-quarters on marjoram. If a drought comes in later summer and shrivels up the marjoram plants, the thyme-eaters thrive; in other years, it's the marjoram feeders who do best. 'Having the two plants is creating a lot more plasticity in the system and helping give them a bit more resilience', says David.

Climate change should allow the ant – and its butterfly – to thrive further north but climate change is 'a double-edged sword', says Jeremy. During droughts, if food becomes scarce, ants will seal themselves into their nests and eat their own ant grubs – including the large blue caterpillars. If it becomes too hot, their colonies can suddenly collapse. If temperatures rise by more than 2 °C, then the ants, and the butterflies, will need much cooler grasslands in which to survive.

As the climate warms, the optimum height of the turf for *Myrmica sabuleti* has risen from 1.4 to about 2.5 centimetres – that's still short, but it makes it easier to manage grassland for the species. Another discovery has helped, too: the ants actually only need the heat that comes from short turf at certain times of the year – in spring and again in the autumn when they are rearing their broods.

One problem with managing meadows for the large blue was that it was previously thought that short turf was essential all through the summer. This put the butterfly's conservationists on a collision course with lovers of orchids and other rare plants that flower in midsummer and must not be cut or grazed before then. Now, however, conservationists of all hues realise that large blue meadows can be allowed to grow up into a flower-rich sward from May to August, and do not have to be heavily grazed all the time. In this way, says Jeremy, 'the flora and insects have spectacularly increased on pretty much every site under so-called large blue management'. Rare species that are benefitting from grassland conservation work for the large blue include the rugged oil beetle, pearl-bordered fritillaries, fly orchids, frog orchids, and musk orchids, as well as more common wild flowers such as cowslips.

Saving the butterfly has been a lifelong effort for Jeremy and Dave and it has been wildly successful. Today, large blues fly in greater numbers in England than anywhere else in the world. Their restoration is almost certainly the most successful insect conservation effort anywhere on the globe, and it reveals that saving one apparently insignificant species can provide a key to unlocking our understanding of an entire ecosystem, and learning how to help it thrive in all its diverse glory.

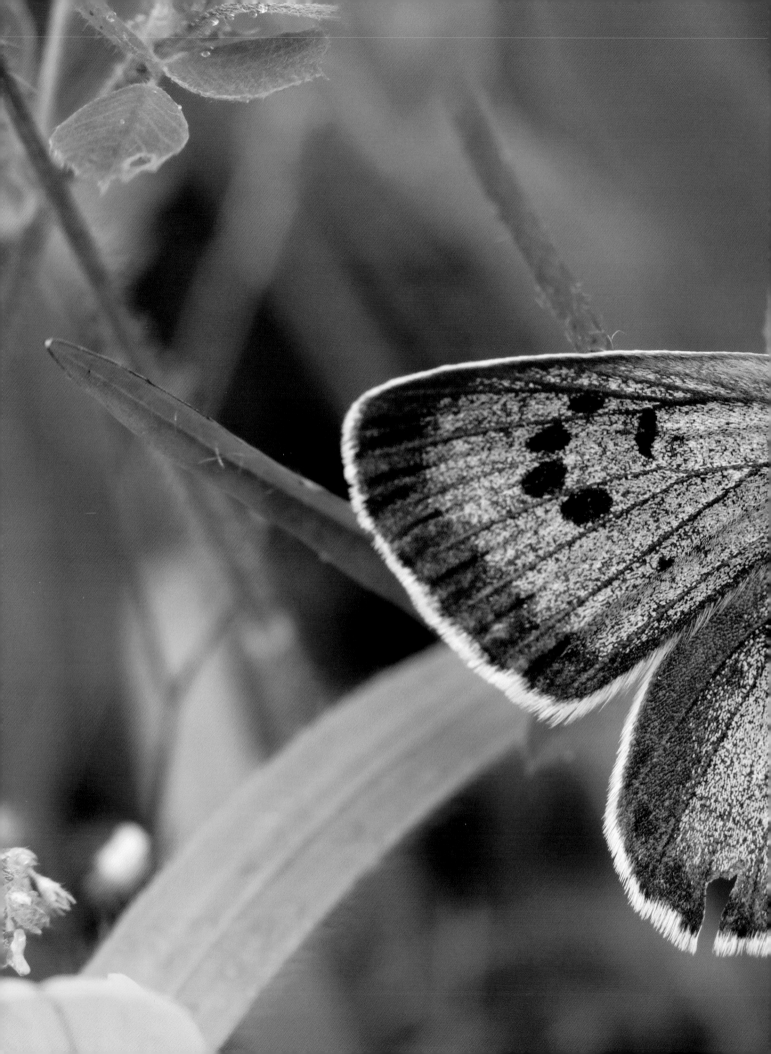

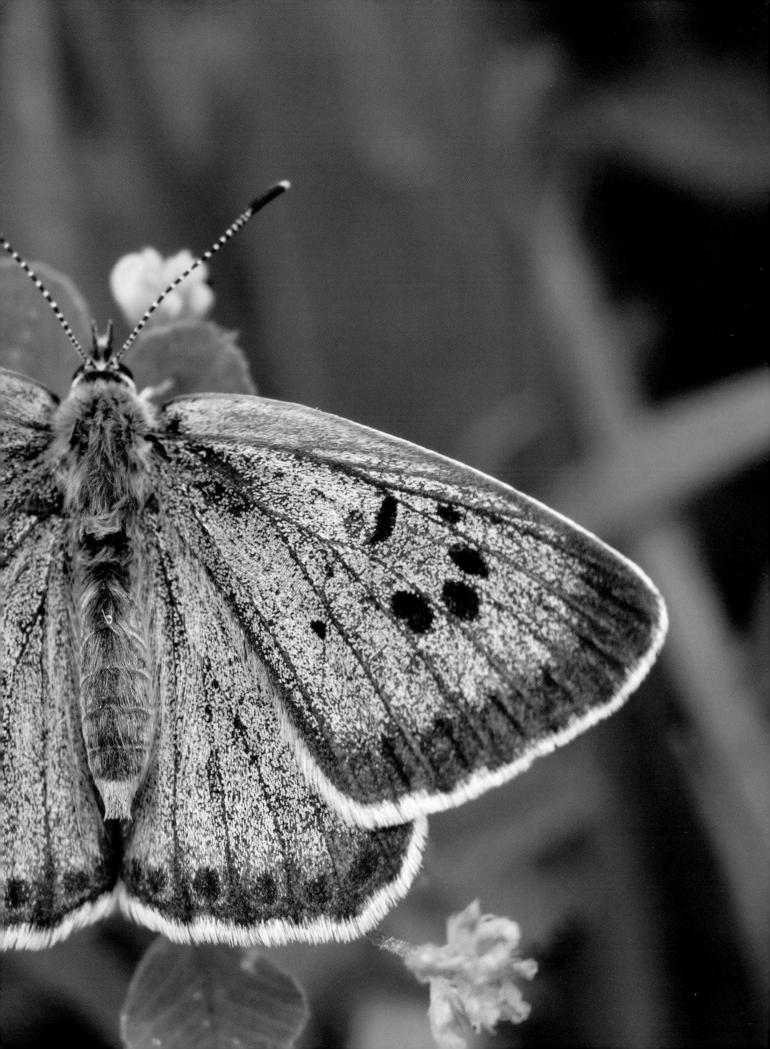

COCK OF THE MOOR

On a vast open moor, the first buds of spring belong to the dwarf willow, a hardy low-slung shrub that grows in conditions and altitudes where grander trees cannot flourish. These buds are eagerly sought by one of Britain's most spectacular birds, whose flouncy appearance is belied by aggressive encounters as it prepares for breeding.

The male black grouse (*Tetrao tetrix*) fuels up on whatever protein and sugar-rich pollen he can find on Britain's uplands before congregating at a traditional site for the spring lek. All his energies are devoted to this competition. Here, on the most exposed moorlands, these 'blackcocks' must preen and prance, sing and dance and fight male rivals to prove themselves worthy of one of the visiting females, or greyhens.

The blackcock is a magnificent, almost preposterous-looking bird, its exotic appearance incongruous given its lifestyle in the coldest, wettest and most exposed parts of Scotland and northern England. The birds are feathered in a sheeny, iridescent black, which can glow and flash in shades of midnight blue. Their tail is shaped like a lyre and fans out behind them. When they begin their lekking contest, their tail is fanned and raised to reveal white under-tail feathers. Above their eyes are bold, red, Denis Healey-style 'eyebrows', or wattles, that protrude and give each bird a faintly comic appearance. During display, the wattle becomes enlarged with blood. Its size is linked to testosterone levels, and it may be a sign by which females assess the strength and suitability of a male.

'Lek' comes from the Old Norse for 'play'. The sites where males gather all year round – but with the most intense competition in spring – are chosen for their good acoustics and visibility. These males want their contests to be seen by the females. Blackcocks fly into their traditional arenas before dawn, and take up positions according to a kind of pecking order. The cocks' displays look rather comical but this, of course, is deadly serious. These battles will determine which cock gets the prime territory and the pick of the hens this year.

The males face each other. One rival will lower his head like a charging bull and strut briskly towards his foe. Both birds duck down and make a low-pitched bubbling noise, produced with the help of air sacs in their necks. Then one will stretch his neck to the heavens and emit a dry, rasping hiss. On a calm, clear morning, their competitive calls can be heard up to four kilometres away. They hop at each other, circle each other and flutter their wings, looking like a remote-controlled toy gone haywire.

Females drawn in to the lek peck amongst the heather nearby, playing it cool. The males' rivalry can at first look rather sedate. Then the hopping battles become

Previous: The large blue became extinct in Britain in 1979 but has been reintroduced using specimens from Sweden. The butterfly is flourishing on grasslands in Somerset and Gloucestershire.

Overleaf: Male black grouse perform spectacular ritualistic sparring in spring, choosing arenas with good acoustics and visibility so they will be heard and seen by females.

more confrontational. Displays descend into a serious scrap. Two birds leap and peck at each other. Beaks grab hold of claws and feathers and even the majestic tail. Wings flap and feathers fly, drifting away on the moorland breeze.

The black grouse and the larger capercaillie (*T. urogallus*) are the only two polygamous British birds that routinely perform at a lek each year. In upland landscapes where healthy populations of black grouse remain, there may be up to 40 males attending a lek. After 150 years of population decline in Britain, however, most British leks now contain fewer than ten males. Sometimes there is just a single lekking male, shadow-boxing with himself.

Black grouse were once a relatively common countryside bird but they have disappeared from much of Britain over the last century. They were once not restricted to remote upland grasslands but were common in southern and central England from Lincolnshire to Cornwall. By the late 1960s they were gone from the south. Now they are disappearing from the north, quite rapidly in recent years. Since 1989, the Game and Wildlife Conservation Trust has recorded a halving of the number of black grouse males on leks. Today there are fewer than 5,000 lekking males left.

The reasons for its rapid decline are numerous and long-standing but mostly related to more intensive modern farming and forestry. The post-war agricultural revolution, in which farmers were paid to drain rough grazing land, plough up heathland and graze uplands more heavily with sheep, has reduced the amount of tall vegetation the grouse require for shelter. A landscape mosaic of lightly farmed scrubby grassland, wetlands and woodland that the species needs to thrive has vanished. Conifer plantations have grown up and crowded out the dwarf scrub the birds require for survival. The draining of wet fields has reduced the number of invertebrates, which are crucial for the survival of black grouse chicks in the first weeks of their life. Today climate change may be hastening their demise, often bringing wetter Junes to Scotland that further inhibit chick survival. Other factors include birds colliding with livestock fences, accidental shootings and increased predation on their nests.

The black grouse is declining across Europe but in Britain conservationists are seeking to improve their last strongholds on the fringes of moorland by reducing the intensity of livestock grazing. Restoring a mosaic of rough moorland, rewetting of wetlands and the rewilding of Scottish uplands is helping too. Black grouse are thriving in places such as Glen Feshie, where drastic reductions in the number of red deer is allowing dwarf willow and blaeberry to regenerate, providing food and shelter for the birds.

There is hope for the black grouse even while it is something of an underdog in modern Britain. And there is also hope for the underdogs at the lek too. One blackcock at the lek is known by observers as Half Tail, for he only has one sorry feather remaining in one half of his magnificent tail. He looks scruffy as he struts around the lek. But it turns out that the quietly observant greyhens are not looking for the showiest male. The bird who manages to 'hold' the central-most position at the lek is usually the male who gets to mate with the most hens. And Half Tail may be scruffy but that shows he's the most tenacious fighter. So there are hens to mate with for him this spring. As his hens go on to raise their chicks single-handedly, and the blackcocks continue to strut their stuff, onlookers will hope there's a happy ending for the black grouse in Britain as well.

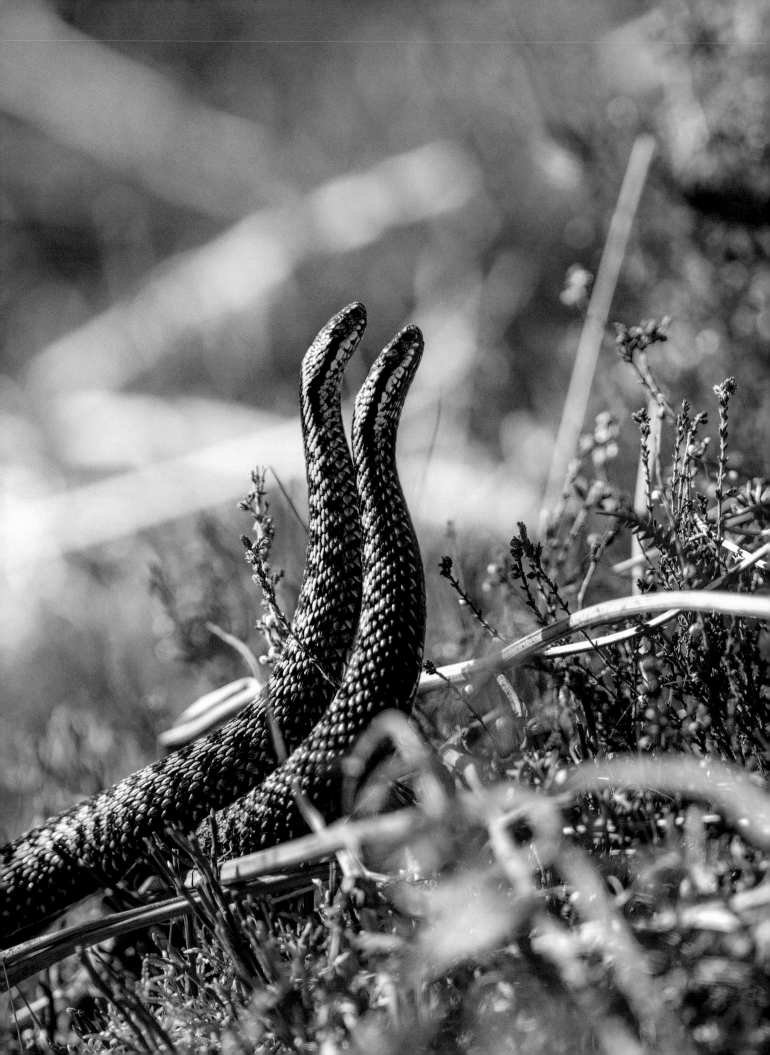

COURTING ADDERS

Opposite: Evenly matched male adders will wrestle, writhe and rear up in an attempt to see off their competitors and secure a female for themselves.

As the spring sun warms the heather on the moors of northern England, one of our most beautiful, threatened and least-loved animals makes its first appearance of the year. The adder (*Vipera berus*) is shy, secretive and the smallest species of snake in Britain. But on an island shorn of almost every creature perceived to be a threat, its name has been blackened by its menacing reputation.

The male snakes are the first to emerge from hibernation, as early as late January when watery rays of sunshine slant through the grasslands. Though it is rarely longer than 60 centimetres, the adder is a hardy snake, and the species can even survive in the Arctic Circle. They will bask on snow, drink snow melt and may emerge in any winter month from their secluded, often subterranean hibernacula in old rodent burrows or at the base of tree stumps, roots and heather.

As the sun begins to warm the earth in February, the males find the most sheltered and sunny spot and begin to bask. They have not fed since the previous autumn but are prepared to go hungry. Their priority is to ripen their sperm, and they require long hours of sunshine to get into tip-top physical shape for the breeding season. To do so, males will cluster together, and even gather with other species such as grass snakes and slow worms. The adders will practise 'blade basking' or 'pancaking', flexing and flattening their bodies to absorb the heat of the sun at all angles. The blacker the snake's colouration, of course, the more heat it can absorb. Even when they are basking, they remain alert, and always choose a spot from which they can make a swift getaway if disturbed.

Females usually begin to emerge at the end of February but before they can mate, the male snake requires a new suit. The spring slough in April is the cue for the mating game to heat up. Their basking fires up their metabolism so the males can shed their skin. Now, with his immaculate black and silver zig-zag patterning glinting in the spring sunshine, one male is ready to find a female.

He is not the only one. Females who are ready to breed don't move far, but emit pheromones. This love potion can be so strong that human noses can detect it too: the scent is a little mouldy, rather like washing that has stayed in the washing machine too long.

The males roam more widely, seeking those pheromones. Once a dominant male has found a receptive female, he will 'guard' her by coiling himself around her. Occasionally only the female's head and one eye is visible in a coiled mass of male snake. The dominant male will also woo his female by moving in a staccato fashion over her back, tongue flicking over her and staying very close, guarding her.

As one male follows the trail of female pheromones, his path converges with other males, and battles begin. The male snakes size each other up. If an opponent

is too large, they will draw back rather than challenge. More evenly matched males wrestle, writhing and coiling, but very rarely 'mouth' or attempt to bite their opponent. Their bite is for immobilising prey that may bite back, such as mice, and occasionally for defence against predation.

Fighting males rear up against each other, dancing and ducking in the air, each one attempting to push the other's head to the ground. Most wrestling matches are fleeting, but sometimes they will continue for 15 minutes and possibly longer. When one snake finally rolls and pushes its rival to the ground, its opponent seems to know when he's defeated. He slides away. Occasionally the winner will chase the vanquished from the scene. Where there is a small population of adders, the males seem to know each other and their own place in the hierarchy, and don't challenge it. Like most species, they are pragmatists, and opportunists: if two males become engrossed in their battle, a third may dare to sneak past them to mate with the female.

Even when a male is mating, securely locked on to the female with his barbed hemipenis, the adder's version of the human penis, other males will approach. The mating male is vulnerable because he is locked on to the female and cannot engage against his rivals. Other males coil in and start rubbing the female on her back, or caressing her head. A mating ball of snakes develops, with as many as a dozen adders coiled around a mating pair. Others wait more meekly at the sidelines of the wrestling match, hoping to get the opportunity to mate. The males of some snake species use a sperm plug to stop others mating, but not so the adder. Instead the female will mate multiple times to maximise the genetic diversity of her offspring and ensure that small populations stay viable.

For the male adder, mating is sometimes a costly and undignified process. If the mating female gets fed up with all the hassle from rival males she will slide away to escape the unwanted attention. Unfortunately, her mate of choice is still hooked into her. So the male finds himself in the unhappy position of being dragged backwards through a gorse bush – by his hemipenis.

In Britain today, adder populations are diminishing in size. The snakes need to be undisturbed within a connected countryside, but face increasing disturbance and a fragmentation of the kind of rough grassland in which they thrive. The species has all but disappeared from entire counties including Warwickshire, Nottinghamshire and Oxfordshire. There were 260 adders in the Wyre Forest in the Midlands in 1990; today the population is 30 adders at most. The hot, sunny lowland heaths of southern England remain a stronghold for all British reptiles but while most heaths have protected status, this is a landscape under pressure from increased housing and habitat fragmentation caused by regular wildfires, new roads and the Ministry of Defence selling off some of its previously undisturbed land.

Adders are more vulnerable if they have to cross roads or even forest tracks to reach habitat. When they are exposed on an open track, they are easily attacked by birds, including the burgeoning population of buzzards and, more controversially, by some of the 60 million non-native pheasants released for game-shooting each year. When baby adders emerge in the autumn, they are the size of a pencil and, if spotted, can be easily killed by smaller birds. There are cases where tiny adders have even been found to have been killed by beetles. Climate change may also be a challenge: if it is too dry when the baby snakes are born in September there

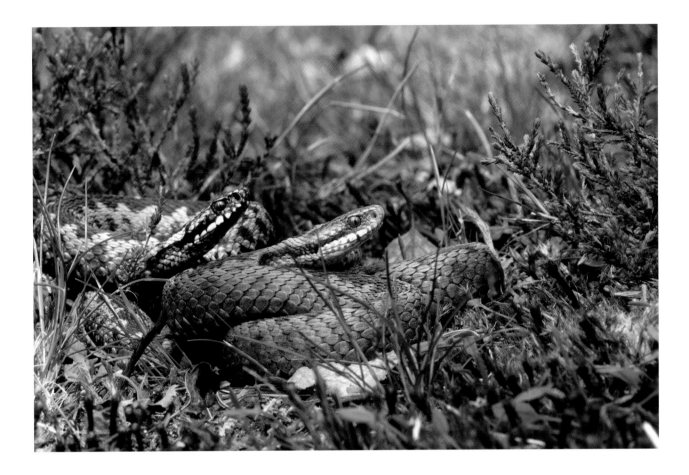

Above: A silvery male adder with the larger, brown-patterned female.

Overleaf: Adder populations are disappearing particularly from southern and central England because of habitat fragmentation from roads and the loss of their favoured rough grassland.

may be a shortage of their key prey species – frogs and common lizards – when they are small.

Public attitudes don't help adders either. Many people are fearful of these small snakes, or worried that their dogs or children will get bitten by them. Simon King, who filmed the adder sequences for the *Wild Isles* series, says he hopes his footage will provide some positive public relations for this majestic animal. King says the snakes do their utmost to keep out of the way of humans but during the two-week shoot, he got incredibly close to them by remaining still and quiet. 'I was sitting on the ground and there were adders using my body heat to warm up in the morning', he says. 'The only time I had to move was when one decided it might be nice to go up my trouser leg. They are so lovely.'

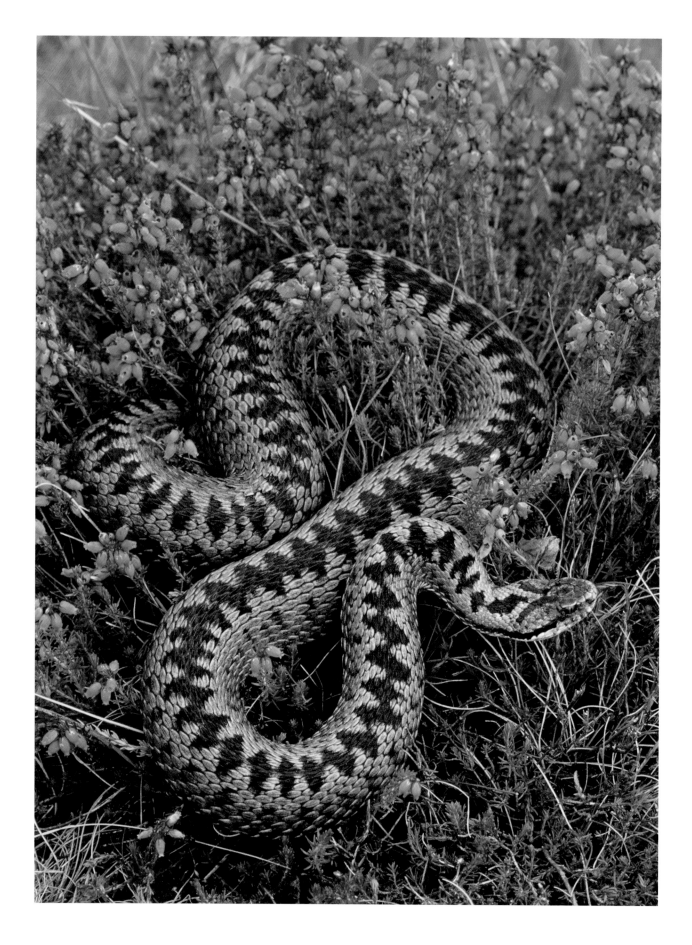

CONSERVATION HERO:
NIGEL HAND, ADDER TRACKER AND CONSULTANT

'It's a bit of a Marmite species', says Nigel Hand, 'but it's a beautiful snake and ... has suffered more than any British wildlife.'

Nigel, who works to monitor and boost snake populations across Britain, can literally sniff out an adder. He has learned the scent of the pheromones spread by the female and can use his nose to find adders in the landscape. He has been passionately working to save adders ever since he found them on a patch of rough woodland at the back of his secondary school in the Midlands at the end of the 1970s. His teacher didn't believe that they were there until he showed him.

He has entered the secret world of the adder by attaching tiny 1.1-gram radio tags with a 12-centimetre antennae to snakes, allowing him to track their movements for the 70 days or so until the snake next sloughs its skin. It has revealed how males will roam up to 1.3 kilometres later in the year, but also how all adders are helped when their landscape is not fragmented. Radio-tagged adders on the maritime heaths of Pembrokeshire were revealed to follow the wiggling lines of dense Welsh hedge-banks to safely disperse through the landscape. 'To some people we've got a green and pleasant land but it's not an easy habitat to cross', says Nigel. 'Some species can fly. The poor old adder is very restricted to a certain area.'

What's needed is simple: a countryside that is not too tidy and has plenty of well-connected rough corners, acid grassland and woodland edge.

Projects to revive the adder don't often garner much public support, thinks Nigel, because while the public will cheer lowland heath restoration for bringing back nightjar or silver-studded blue butterflies, if conservation work is framed as helping the adder, people worry about their dogs getting bitten. 'It's hard to get the general public on the side of an animal that most people are fearful about', he says. At the other extreme, well-meaning adder admirers who seek to photograph the males during their sensitive spring basking season may risk trampling their hibernation areas or disturbing the snakes and worsening their condition for the breeding season.

Adders are not easy to find and a British-wide census and genetic studies are needed to map their decline. Nigel fears they will disappear from much of our increasingly built-up southern and central England and come to be associated with coastal heaths and more remote, wilder places.

Nevertheless, he was heartened by the *Wild Isles* filming effort, during which he helped the crew find more than 50 individual adders during an intensive two-week shoot. 'The number of snakes astounded me', he said. One male earned the nickname Adderconda because it was so large and impressive that all the other males fled when it slid along, and it swiftly pushed off other male suitors before mating with a number of different females on the high slopes and again in the lower valleys.

HEN HARRIERS – A DANCE IN THE SKIES

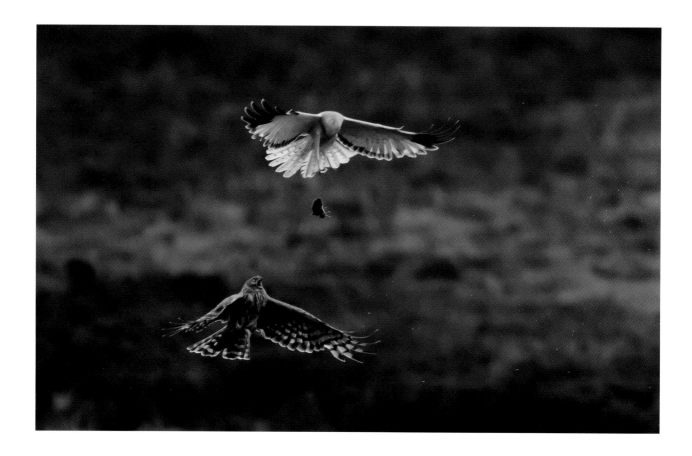

Large swaths of grassland in Britain are heather moors, a special upland landscape mostly created by humans, who first cleared ancient forests and today manage this land by grazing, cutting or (controversially) periodically burning to keep the heather the right age and the moors treeless, Above this rolling, apparently empty countryside of rough grass, mossy bog and heather moor, there is a speck of a bird high in the sky doing a rather strange thing.

The silver-grey bird with black-tipped wings is flying vertically up-up-up in the blue heavens of early spring. Then it deftly rolls its wings and plunges downwards. Towards the ground it plummets like a stone before applying the air brakes and pulling away seemingly at the last, death-defying moment when it would surely shatter itself on the earth.

It is a male hen harrier, and it is sky-dancing, displaying its aerial prowess, strength and daring, in an attempt to capture the attention of a female with whom to breed. By flying so high and so distinctively, indefatigably repeating its loop-the-loops like a stunt pilot with a death-wish, it can be seen by a gimlet-eyed female from miles around.

Above: A pair of hen harriers perform a food pass – the silver-grey male dropping a parcel which the larger, brown female catches in midair and returns to feed her chicks in the nest.

The harrier is not just a magnificent flying machine. It is a stealth predator. A disc of feathers around its face gives it the piercing gaze and acute hearing of an owl. It can snatch a creature as small as a beetle or as bulky as a duck, although the majority of its diet is made up of small mammals, birds and reptiles, such as the field voles, meadow pipits and common lizards that live in such numbers on our upland moors and grasslands. These aerial acrobats are masters of the moorland and its edges, using terrain and wind to their advantage, sometimes even flying backwards in pursuit of prey.

In the spring, males will sky-dance over the moors at every opportunity to demonstrate their stamina and fitness to mate, pirouetting and plunging. Female hen harriers will join in too. They advertise themselves to potential mates in the same spectacular style.

To an untrained eye, the speckled brown females, known as ringtails due to the clear white bands on their rumps, look like a different species altogether. Early ornithologists thought they were. Sexual dimorphism – males and females of the same species looking quite different – is common among birds, but the hen harrier, like many raptors, exhibits reversed sexual size dimorphism: the females are much larger than the males.

Once a male and female have attracted each other's attention, there is further courtship. They will sky-dance over the spot where they have decided to nest, which is on the ground, amidst the heather and bracken. The female is larger, potentially because she is entrusted with guarding their chicks on these vulnerable nests. She depends on the smaller male to bring her and her chicks all their food during their early development, and if anything happens to the male, the female and chicks will be at risk. Sometimes males can be polygynous, ending up with two or more nests to provision.

So the food pass is an important test of a male's ability to provide for his female. The male has found a prey item such as a vole and flies with it held tight in his yellow talons, calling to his female. She rises from the heather, crying out for him to release his gift. They manoeuvre together in midair but miss the first opportunity to pass the parcel. The male tries again, flipping himself upside down while holding the vole in just one talon, before flicking his prize up into the air. The female, following closely, deftly catches the meal and takes it away.

The hen harrier is an unusual raptor because it is not as territorial as other raptors about nesting but may form loose colonies, with new pairs nesting close to other harriers. There may be safety in numbers, because the community of birds can work together to alert each other to potential predators – the foxes or stoats and weasels that pick their way through the grasslands in search of a meal. Several hen harriers will rise up to mob a buzzard if it passes across their landscape. A stoat running through will also be dive-bombed by hen harriers who yicker at them to alert the others.

But the biggest threat to the hen harrier in Britain in recent decades has been human beings. There is a bitter irony here: the moors are managed in a way that creates ideal conditions for hen harriers to thrive but some people see the birds as a threat to their livelihoods. Harriers are opportunists and will feed on whatever prey is most abundant: where vole numbers are high, they will take a lot of voles. On moors managed intensively for driven grouse shooting, the high numbers of red

grouse mean that this bird can form a large part of the harrier's diet. This has caused conflict with this lucrative industry.

The heather-rich moorlands are kept open, relatively free of mammalian predators such as foxes and incredibly well-stocked with one of the hen harriers' favourite foods – red grouse – for the lucrative sport of driven grouse shooting. People pay big money for a day on the moors firing guns at large numbers of fast-flying wild red grouse. Unfortunately, the traditional management of driven grouse moors has included the illegal killing of hen harriers, along with other birds of prey such as peregrines, because they are perceived to take too many red grouse and reduce the numbers of birds that can be shot by the enthusiasts who pay thousands of pounds for the privilege of doing so.

Like other birds of prey, the harrier has been protected by law since 1954, but illegal killing of hen harriers continues. In 2013, no hen harriers bred successfully in England at all for the first time in half a century. While their numbers have increased since, their numbers and distribution remain far below their potential. Ecologists have calculated that the uplands of England should naturally support more than 300 breeding pairs of hen harrier.

The hen harrier does well in upland landscapes where there is no grouse shooting, such as Orkney, where there is also a good population of voles and meadow pipits. In recent years, there have been campaigns by conservationists to ban driven grouse shooting and appeals to catch the criminals who have been killing the birds. But successful prosecutions are vanishingly rare because, in the largely unpeopled uplands where much of the land is privately owned, it is easy to shoot, trap or poison a hen harrier without anyone witnessing it. Such crimes are now more frequently often suspected because many of the birdsharriers are fitted with satellite tags as chicks, and sometimes these tags have mysteriously and abruptly stopped transmitting just when the bird is flying over a moor managed for grouse shooting.

One pragmatic potential solution to this problem has been introduced by the government against the wishes of many conservationists. Grouse moor managers argue that their problem with the hen harrier is its habit of preying on young grouse and nesting colonially. If they tolerate one hen harrier nest (as they should, by law) then others could rapidly appear alongside it, and soon their moor filled with red grouse would be inundated by their rapacious predator.

So the government is trialling 'brood management' in England, whereby moor managers are allowed to apply to have the chicks removed from a nest within an agreed distance of a second nest, and taken into into captivity, reared and released elsewhere. In return for this safety-valve against concentrations of harriers developing on grouse moors, it is hoped that the grouse shooting industry and all its employees and supporters obey the law and stop persecuting hen harriers. Many prominent conservation groups including the RSPB oppose this policy on ethical and scientific grounds, and see it as rewarding law-breakers rather than tackling the illegal killing of hen harriers head on, preventing it from happening and prosecuting the perpetrators. Hen harriers also continue to disappear on or close to land managed for driven grouse shooting.

So far, judged on its own terms, brood management has gone well. Captive-reared birds have proven to be as wild and as successful at breeding as wild-born

Overleaf: This female hen harrier is making her nest on heather moorland in Sutherland, Scotland.

birds. Of eight captive-bred birds reared and released in 2021, six were still on the wing at the end of the year – a decent survival-rate for young hen harriers. Its English population is in recovery although it still has a long way to go before it reaches its 'natural' level: in 2021, there were 24 successful nests in England, fledging 84 chicks, the highest number of fledglings since monitoring began in 2002.

It is not possible to say whether this improvement is because of reduced persecution caused by the brood management policy. Conservationists working with hen harriers say there were signs that some grouse moor managers and gamekeepers were learning to live with the bird before the brood management trial began.

But the latest data does show an interesting paradox: hen harriers thrive on grouse moors if they are not persecuted. This is because if they are not persecuted many species of ground-nesting bird do well when gamekeepers are killing predators such as stoats, weasels, crows and foxes. Lapwing, curlew and golden plover are three increasingly rare species that benefit from the protection gamekeepers give to the red grouse in their area. The hen harrier is no different.

Stephen Murphy, an ornithologist for Natural England who has studied hen harriers for years, has fitted scores of birds with miniature satellite tags to learn more about their lifestyles. His tag data has revealed that many birds that nest in Lancashire think nothing of flying to Scotland or North Wales for a few days, and may flit off to Spain when they are not breeding. Sadly, the tag data has also revealed that far too many birds disappear – their tags abruptly stopping – when they pass over grouse moors to be coincidental.

Most conservationists believe that far too much illegal persecution continues on England's uplands. But Murphy detects hopeful changes in attitudes among some grouse moor managers. Recent successes with hen harrier fledging in England have been helped by factors including mild springs and a series of boom years for field voles, a staple for these birds, which must consume prey equalling a fifth of their body weight each day to stay alive. However, Murphy also argues that persecution may be lessening over some moorlands: he cites the presence of older tagged birds that have survived several years or more on grouse moors. In 2021, he continued to monitor three tagged birds that had lived for five years, one of which had bred successfully every year on a grouse moor. 'There is change afoot', says Murphy. 'We haven't solved it yet but this is an indomitable species that has long compensated for their losses by producing lots of chicks.'

Hen harriers may be indomitable, but they need a complete change in how our uplands are managed and an end to illegal persecution.

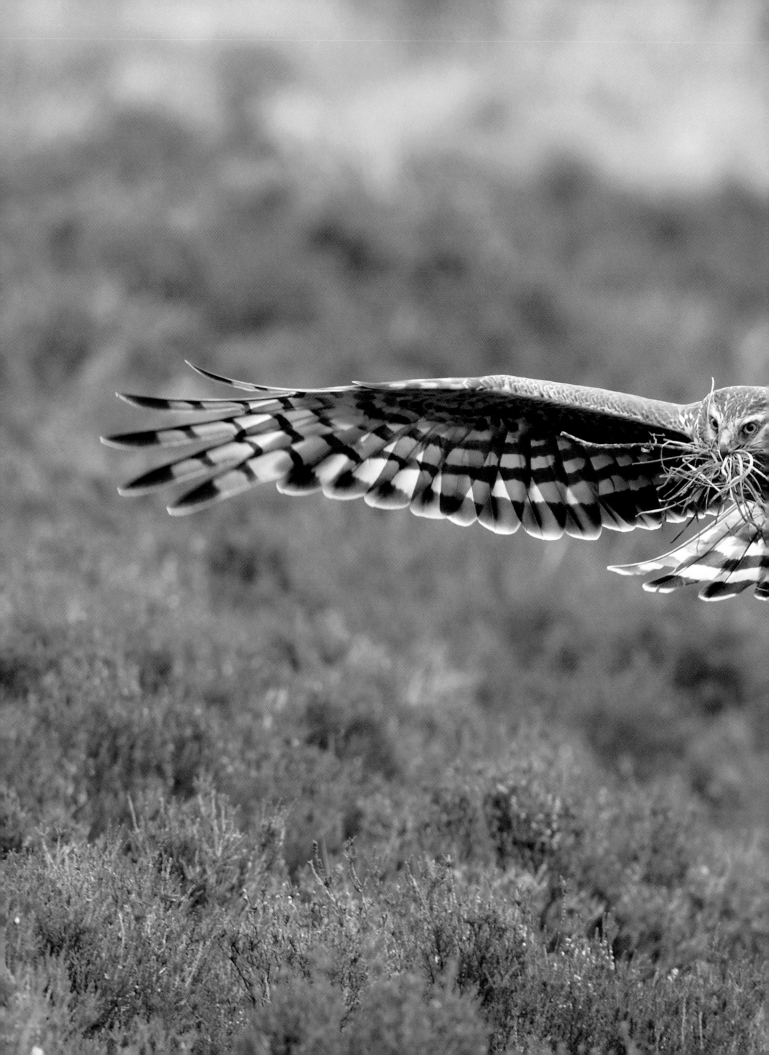

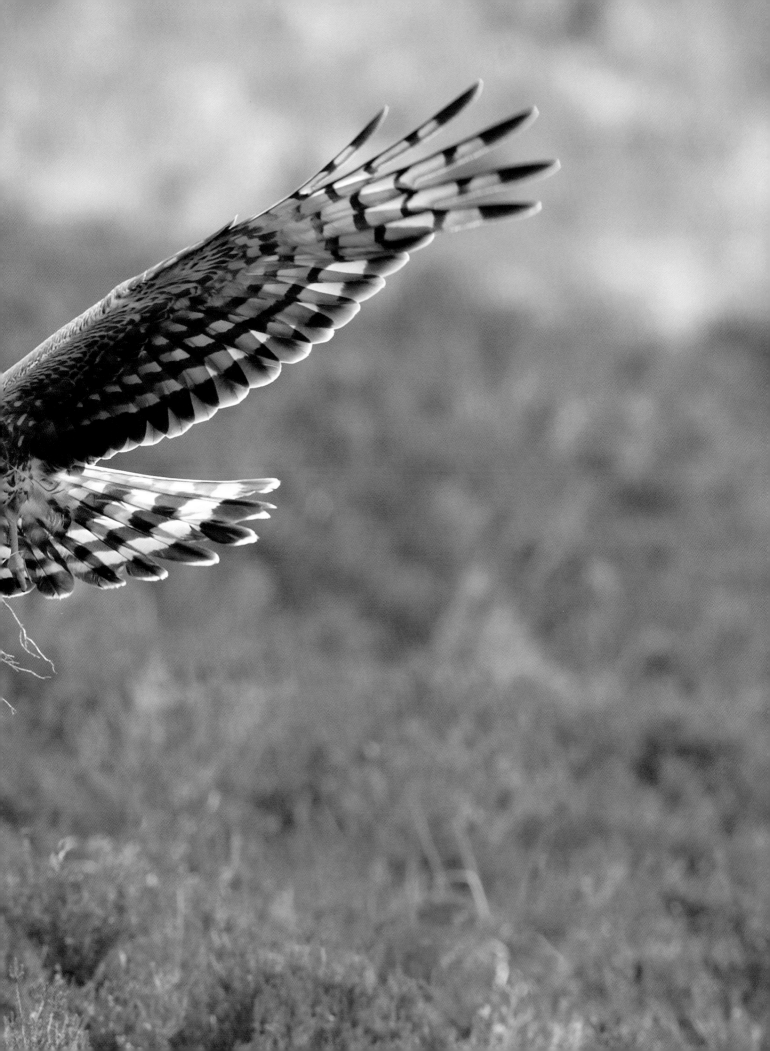

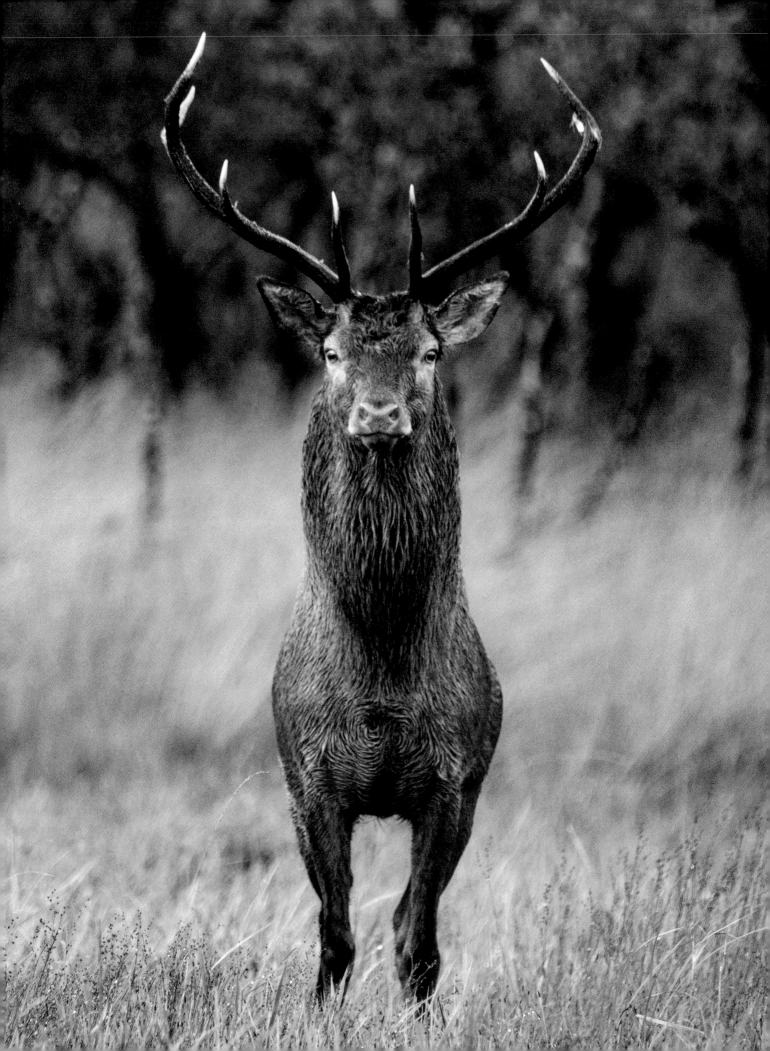

THE RUT OF THE RED DEER

Opposite: Britain has a larger population of red deer than any other country in Europe. The stags may be majestic native animals but too much deer grazing prevents natural tree regeneration and can damage rare plants.

Through the shallows of a glassy lake beside a backdrop of wooded mountains strides the largest land mammal found in Britain and Ireland. One stately red deer stag, at the pinnacle of his fitness, is joined by another. Their coats contain barely a hint of red but match the autumn browns in the trees and grasses. Heads proudly aloft, with antlers of 12 points or more, they look like calm animals as they walk side-by-side. But they are not.

As autumn falls, turning the oak woods of Killarney National Park in southwest Ireland yellow, ginger and brown, the trees and the lakes resound to the guttural roars of rutting red deer. It is the start of an annual competition to establish a favourable rutting territory and mate with as large a group of hinds as one stag can muster. Walking in parallel is one of the first stages of an unforgivingly brutal competition in which each stag assesses the merits of his rivals and seeks to dispatch them so he can claim his mating rights.

The stags have spent the year preparing for this moment. They have piled on the pounds, eating all the grasses and shoots they can find, and grown a magnificent pair of antlers. Less obvious physiological changes include increased levels of testosterone and a thickening of the neck. In some settings, stags will thrash their antlers in bracken and other undergrowth to gather a crown to make themselves look more forbidding.

The red deer of Killarney and the rest of Ireland were brought over by people 5,000 years ago. Depicted in European cave paintings dating from 40,000 years ago, red deer crossed the land bridge into Britain after the last Ice Age around 11,000 years ago. Their meat, skins and antlers were an important part of life for hunter-gatherers and the first Neolithic farmers. They were hunted to extinction in many parts of Britain but populations of this instinctively forest and woodland-edge animal endured on the open grasslands of the Scottish Highlands and southwest England. By Norman times, deer hunting was a prestigious pastime and animals were protected in royal parks and forests. During the Victorian era, many new populations were established by reintroductions and escapees from deer farms. The lucrative pastime of deer stalking in the Highlands saw red deer numbers grow.

Today Britain has a far larger population of red deer (*Cervus elaphus*) than any other European country, greater even than heavily wooded nations such as Germany. On some stalking estates in Scotland there are 20 red deer per square kilometre, the highest concentrations in Europe.

Red deer are majestic and much-loved animals but many conservationists are increasingly highlighting the damage that so many grazing animals can do, particularly without any apex predators, such as wolves, to move herds around

and lighten the grazing pressure. In the Scottish Highlands, high densities of red deer are preventing the natural regeneration of ancient Caledonian forest, and the scrubby, montane landscape of dwarf willow and birch intermingled with grassland that supports many other rare species, such as black grouse.

Similarly in Ireland, conservation ranger Padraig O'Sullivan must carefully monitor red deer numbers in Killarney National Park. Each year, a certain proportion of the deer are culled to enable rare plants to flourish and the ancient oak woods to regenerate. The red deer's impact is further complicated by the introduction of sika deer in 1861, who breed rapidly and devour most plants although, unhelpfully, not the non-native rhododendron which is also a challenge to the biodiversity of the national park.

At least the rutting stags are not another pressure on the plants and trees of Killarney. They are so preoccupied by establishing their dominance that they can forget to eat. Individuals will even wander across a road at this time of year, oblivious to the traffic, so obsessed are they with the rut.

Although stags can be sexually mature at two years old, most do not acquire enough stature to seriously challenge rivals for hinds until they are five. The first way a stag seeks to assert its dominance is by roaring. A stag's larynx becomes more prominent and its tongue changes shape in preparation for the rut: the deeper and louder the roar, the more formidable the animal. Rivals can judge from a distance whether to challenge a stag; females are listening too.

If neither rival backs down over an exchange of grunts and roars, they will walk alongside each other to assess the condition of their opponent. Until recently, it was not realised that a key role is played by the stag's ventral patch, an area of their coat which is coloured dark brown and varies in size but can stretch from the neck to the lower stomach.

Red deer stags have long been observed urinating on their ventral patches, which they do to retain chemical compounds and create an alluring scent that signifies 'dominant male' to other deer of both sexes. Researchers studying red deer in Spain found that the larger the ventral patch, the more likely the male was to engage in rutting behaviours and more likely to subsequently win over a larger harem of hinds. While the number of antler tines has long been thought to signify the most alpha male stag, scientists have found the size of the ventral patch is a better predictor of male dominance.

On the shores of the lakes around Killarney, the rivalry of two evenly matched stags becomes more intense. At first, the animals' bowing seems rather human, like the respect of two martial arts masters facing each other. But their lowering of heads is not out of respect: it is to engage. Suddenly, their antlers clash with a great rattle. Water spurts from the boggy grassland beside the lake. Their fight moves into the shallows of the lake. They disappear behind a curtain of spray and then emerge again, dripping wet, as if a shower has been turned off abruptly.

The hinds watch from the bank, a group of them, apparently curious as the battle continues. It is an unashamed test of strength and weight. The stags lean in, taking the strain with their rear legs, seeking to push the other animal backwards, dominate, subdue. One beast appears to be winning and the other is rammed further into the lake but still returns for more. Mostly they are head down, locking

Overleaf: In autumn, the roaring of rutting stags fills the air on the shore of Lough Leane in Killarney National Park, Ireland. Evenly matched animals will clash antlers in exhausting and occasionally fatal battles.

antlers in combat with a dry rattle, but they rear up too. When one turns and runs, it is in danger of being gored by the other. They pant and roar, mouths open.

It is an exhausting battle and it is dangerous too. Sometimes stags will gore each other to death. Padraig O'Sullivan had to put down one stag injured in a rut fight. A postmortem revealed it had a collapsed lung and 19 puncture wounds from its rival's antlers.

Finally, the winning stag, dripping with lake water, shakes himself like a dog, his breath coming in great puffs on the chilly autumnal air. In some areas heavily populated by red deer, one stag may hold a group of 40 hinds, but in Killarney, where around 700 deer roam across an expansive terrain of lakes, woodland and moorland, a stag usually holds up to 12.

Now a stag has won a group, his labours have just begun, and he must continually check when each hind comes into season, and continue to fight off rivals. Towards the end of the rut, the dominant stags are drained. They have eaten little or nothing, relying on the body fat stores they have accumulated over the summer. Now they are weary, and may slump in the grass, almost nodding off. This is the moment for younger stags on the periphery of the group, who will opportunistically sneak in and mate with a hind if a dominant male's back is turned.

After the rut finishes, the exhausted stags form bachelor groups, and retreat to a sheltered spot in the woodland where they can feed and recuperate over the winter. Fortunately, in western Ireland, mild Atlantic weather ensures there is grass growing all year round. For both victors and vanquished, it is the grasslands that provide the succour and food to refuel, repair and prepare for next year's contest.

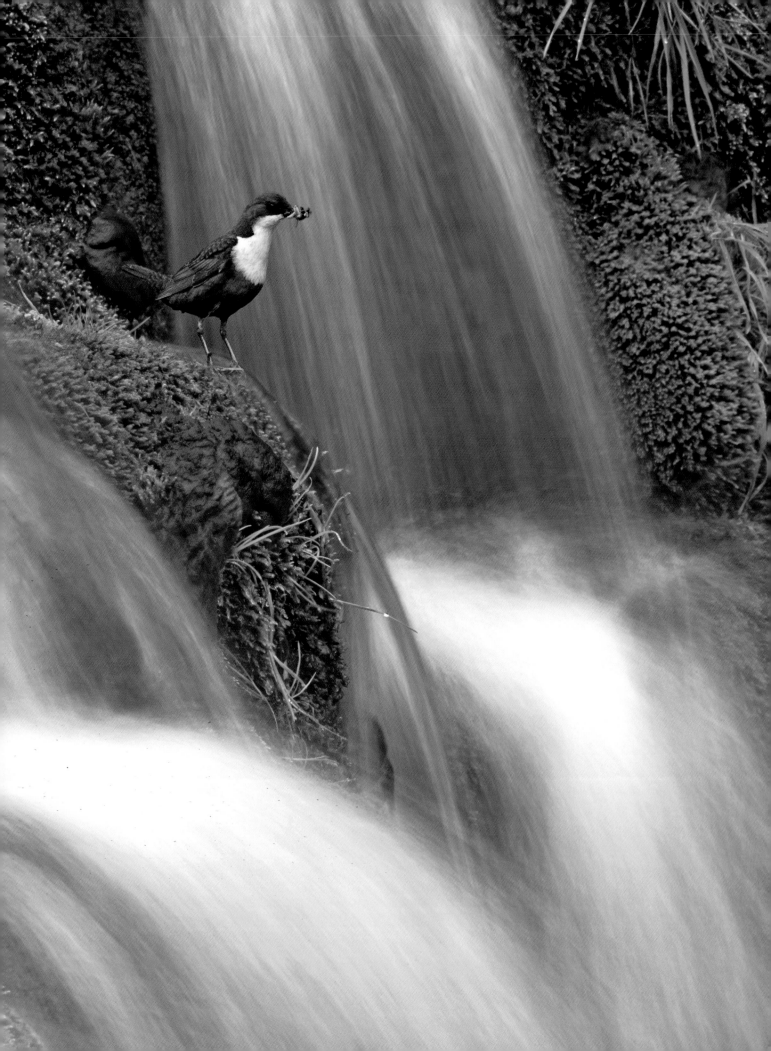

3. Our Freshwater

HOBBIES *VS* DRAGONFLIES –
A HIGH-SPEED HUNT

A vast expanse of tawny-coloured reeds glows in the early morning summer sun. The rays gradually warm the insects waiting by the water. Four-spotted chasers perched high on the reed stems have just emerged from the pool. Their veined wings shine in the sun like a stained glass window. For two years, these dragonflies have skulked in the freshwater and mud as wingless nymphs, preying upon smaller subaquatic species, and slowly growing and developing.

Once they are ready, and when the temperature and day length are suitable, they crawl onto a water lily or waterside plant and painstakingly push their head, legs, thorax, wings and abdomen out of their larval skin. After three hours or so, during which the dragonfly's legs, wings and abdomen harden, it is ready to make its maiden flight. The translucent exuvia remains behind, a ghostly silhouette stuck to a leaf or stem.

Now the dragonflies warm up and zoom off over the water and reedbeds to feed, find territory and mate. These insects are superbly adapted predators and great survivors. They have perfected the business of being a dragonfly for more than 300 million years. Recognisable ancestors are found in the fossil record in the Late Carboniferous Epoch – this remarkable family of animals is older than the dinosaurs.

Dragonflies are born and raised in freshwater, and for a short time live in the air column above it. Aquatic invertebrates mostly live at the lower end of a grand chain of invertebrates and vertebrates, finding a niche in the water or nearby, participating in a transfer of energy from small to large. And it all begins with the freshwater.

Every drop of water that enters a river is on a journey. As it travels from the uplands to the sea, it shapes a swath of riparian landscape. Britain and Ireland are Atlantic islands. Our weather, climate and land itself is shaped by our proximity to the ocean. Our prevailing winds are from the west and it is from the Atlantic that most of our infamously unpredictable British weather – and rain – arrives.

A hurricane lashes the west coast of Ireland. The rain moves across, gathering and falling around our westernmost peaks. Falling raindrops animate rivulets, which race and bounce off the uplands, gathering more water into regular streams as they go. Water collects in lakes, both natural and made by us, and the fast-moving upland torrent cuts through the mountains. As the valleys open out, and the contours diminish, so the water coalesces in the inexorable glide of a lowland river. Great quantities of water are carried along, and in times of storms they can flood 'water meadows' and marshes that take in the water and spring into new life.

Opposite top: A four-spotted chaser warms up in the early morning sun at the RSPB's Ham Wall nature reserve on the Somerset Levels.

Opposite below: Four-spotted chasers can roost in large numbers, as they do here, at RSPB Ham Wall. When the dragonflies are airborne, they become a target for another masterful flier – the hobby.

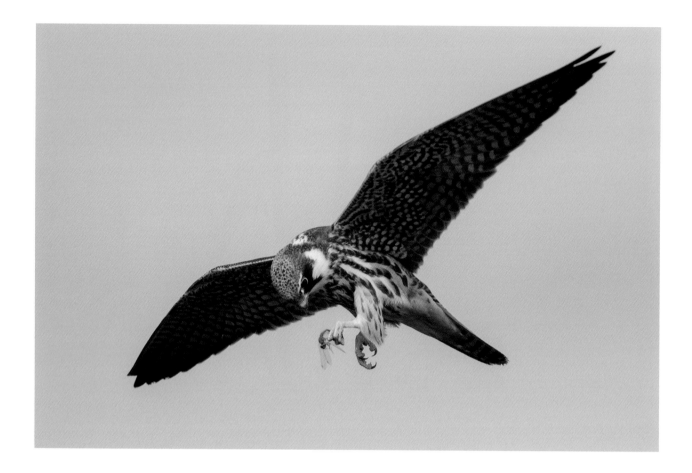

All the while, within the water, on the water, by its side and just above it, all forms of life take advantage, as they must, of the food and shelter that freshwater can provide. Wild creatures and plants have undergone extraordinary adaptations to live around water, and their health vividly illustrates the wider health of Britain's rivers, streams, lakes and wetland ecosystems.

There are around 1,500 discrete river systems in Britain. They are a source of great life but they are also increasingly tarnished by human activities. A plethora of challenges face our waterways: climate change, chemicals, intensive farming, sewage, plastics pollution, invasive species, and too much abstraction for use in agriculture, industry and households like our own. Astonishingly, in 2020, the Environment Agency found that none of the hundreds of English rivers, lakes and streams it monitors could be classified as in good health. Every single freshwater body failed stricter new chemical standards (16 per cent were judged 'good' four years earlier). Scotland's waterbodies are in better health, with 66 per cent judged to be 'good', alongside 46 per cent in Wales and 31 per cent in Northern Ireland.

But there are rivers of hope too. Plenty of waterways have been cleaned up, restored or protected by small communities and big charities. There is a surge of freshwater habitat creation in Britain at the moment too – some by humans, and some by other denizens of the wetlands (of which more later). Lakes and ponds are easily created, often as the accidental byproduct of another human activity. As the dragonflies of Shapwick Heath in Somerset demonstrate, a dazzling array of life – and drama – is quickly drawn to any new, wild freshwater.

Above: Hobbies migrate from Africa to breed in Britain. In places such as Ham Wall, dragonflies form an important part of the hobbies' diet when they first return in spring, and again later in the summer.

Dragonflies have been enjoying the wilderness of lake and reedbed known as Shapwick Heath for less than a fraction of a wingbeat in evolutionary time. This national nature reserve is part of the Avalon Marshes on the Somerset Levels. It looks like a vast, primeval wetland but it is actually a post-industrial wilderness. These precious reserves only came into being after peat was extracted from the marshes in the 1960s to sell to gardeners. This destructive practice will belatedly be outlawed in England because it releases huge quantities of carbon into the atmosphere but in this case, shallow lakes formed where the peat was removed, and all kinds of nature rapidly moved in.

The dragonflies are the helicopter gunships of the airspace above these lakes, ponds and waterways. Zigging and zagging in rapid straight lines with abrupt changes of direction, their wings flick far faster than the human eye as they patrol in search of airborne prey. A dragonfly's own large compound eye is a superlative thing, containing up to 30,000 miniature lenses and able to detect light both above and below them. We have tri-chromatic vision, seeing colours as combinations of red, blue and green thanks to three different types of light-sensitive proteins in our eyes. Dragonfly species have been found to have between 11 and 30 of these light-sensitive proteins. As well as possessing panoramic vision and 'binocular' vision, their colour vision is far superior to our own.

This eyesight is ideal for intercepting midges, mosquitoes and other fast-moving flying insects. Speed helps too. The largest British species, the emperor (*Anax imperator*), can burst through the air at velocities that would get it a speeding ticket in a 30 mph zone – up to 15 metres per second (33 mph). Their average cruising speed is a more stately 10 mph but even at that pace a nimble, manoeuvrable large dragonfly can comfortably seize butterflies and moths in midair. An emperor can catch and eat the largest British butterfly, the swallowtail, which it finds in the marshlands where both species live.

But there is one predator that has evolved to move even faster than the dragonfly: the hobby.

To describe the hobby (*Falco subbuteo*) as a small bird of prey with a grey-brown head, a white-and-brown streaked breast and distinctive rust-coloured 'trousers' doesn't really capture the experience of a hobby at all. This bird is a dashing, dynamic raptor with extravagantly sculpted wings like a sickle. It slashes through the skyline, its silhouette that of a large, menacing swift, and is famed for being one of the few birds that can pluck from the firmament an ultra-rapid swift as well as other fast-flying birds, such as swallows and house martins. Like these species, it is migratory, spending winters in Africa before returning to southern Britain each spring to feed and breed. It is one species that is extending its range into Scotland and Northern Ireland, assisted by global warming.

Hobbies generally feed on dragonflies and other insects such as flying ants, moths and beetles when they first arrive in the country. But their insect consumption may lessen between June and August, when they choose to feed their chicks on more meaty birds rather than insects. Within a week of a chick taking its first flight, however, it is adept enough to try to catch a dragonfly with its talons in midair, and late-summer and autumn dragonflies and other insects again become a key part of a hobby's diet as it gets into shape for its long flight south.

There are two moments in a dragonfly's life when it is more vulnerable than usual. The first is during its early days as a dragonfly, when it is called a teneral. It is pale in colour and sometimes rather insipid in flight, weakly fluttering a few metres on its maiden voyage. At this point, it is easily snatched by predatory birds.

The second comes when it finds a mate, and dragonflies or damselflies are clasped together. The male first moves sperm from near the bottom of his abdomen to his genitalia near the top. He grasps a female by the back of the head and the female curls the tip of her abdomen around to meet the male's genitalia, forming an arch. While many larger dragonflies are attached to each other for only a few seconds, smaller species including blue-tailed damselflies may remain attached for many minutes and even hours. Two dragonflies flying in tandem are not nearly as quick as one.

For a hobby, copulating damselflies are an easy meal, even if they are a relatively modest one. But the challenge of catching individuals is trickier.

A hobby picks out its tiny target – the sparkle of a small, winged insect – from a remarkable distance, sometimes more than 250 metres away. Its pursuit flight begins. A hobby can calculate a dragonfly's flight-line and intercept it. The raptor flicks its wings in midair to adjust its position at high speed. As it reaches out its talons to grab the dragonfly, like a cricketer catching a ball, the insect responds, dropping like a stone out of the sky to avoid the predator's reach.

A young hobby's dragonfly failures are more numerous than its successes, but the aerial combat continues. There is a wealth of dragonflies on which to practise. And that wealth is growing. More than 40 per cent of resident dragonflies and damselflies have increased in number across Britain and Ireland since 1970, according to a study of 1.4 million records. Six new species of dragonfly have colonised Britain this century, including the southern migrant hawker, which was first observed laying eggs here in 2010. Our biggest dragonfly, the emperor, also has the fastest growing population distribution and has moved into Scotland and Ireland this century.

Every predator follows food availability, and the hobby is moving north too. Scotland recorded its first breeding pair in 2001. Habitat changes may also be helping, as many more former quarries have been flooded and designated as new wetland nature reserves or habitats for wildlife. Wetland restoration in previously intensively farmed parts of the Fens and the Somerset Levels, and the new wetlands being engineered by reintroduced beavers have also added dragonfly-rich habitat where their predators can prosper. Around 2,800 pairs of hobbies now breed in Britain each summer.

Opposite: More than 40 per cent of resident dragonfly and damselfly species have increased in number across Britain since 1970, mostly because of global heating. Predators follow food availability, and the hobby is moving north as well – Scotland recorded its first breeding pair in 2001.

CONSERVATION HERO:
SIMON KING, NATURALIST AND WILDLIFE FILMMAKER

Simon King has watched hobbies taking dragonflies for 40 years on the wetlands of the Somerset Levels. He filmed the first of these aerial combats when he was just 18, and has never tired of watching hobbies at work – or filming them. 'I've always marvelled at their capacity to glean insects on the wing', he says.

Simon is struck by the hobby's ability to perceive such a small target, even a small red dragonfly such as a common darter. 'They are clearly seeing a fine target at a great distance', he says. He is sure they are able to distinguish a single dragonfly from a tandem pair. He finds it extraordinary that within a week of a hobby's first wing-beat, it is plucking a dragonfly from midair with its feet.

This hunt and chase can be followed more easily now there are digital cameras capable of capturing 400 frames per second without cumbersome reels of film, but the technical challenges are still formidable. This high-speed spectacle 'always lifts my spirits', says Simon, who filmed the sequences for *Wild Isles* over several seasons on the Somerset Levels. 'The hobby is a truly mercurial species.'

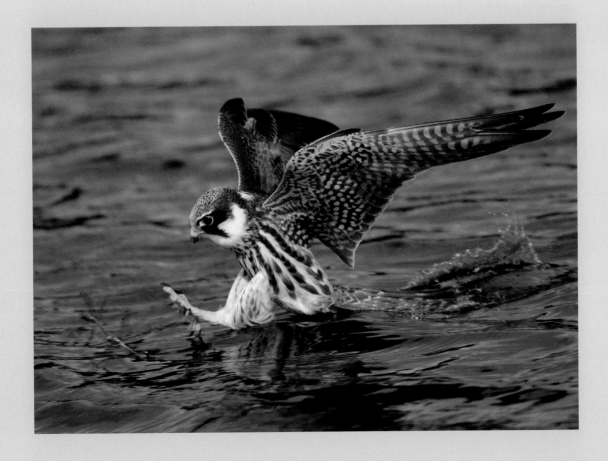

SALMON – MIGRANTS ON A MISSION

Opposite top: Bottlenose dolphins have come to know that the deep channel around Chanonry Point on the Black Isle is a good spot to hunt migrating salmon.

Opposite below: Atlantic salmon look completely at home in the sea but they lead a miraculous double life – adapting their physiology to move from the salty ocean to freshwater rivers to breed and lay eggs.

Freshwater surges, dances and flows off the uplands into rivers that build in power and volume and end in the sea. Far out in North Atlantic waters, Atlantic salmon (*Salmo salar*) can detect chemical traces from their natal river, and start to make their way towards it.

These majestic creatures look completely at home in the sea but they lead a miraculous double life. They are slim, powerful seafish, silver-blue-grey in colour, and they gather in impressive shoals near the mouths of rivers to prepare for their mission. They lose their feeding teeth and stop eating altogether in preparation for a special pilgrimage. The cock fish also change their appearance, growing a distinct hooked jaw, known as a kype, which can signify their readiness to breed.

When the time – and temperature, currents and river conditions – is right, they are ready with an adapted physiology to move from the salty ocean to freshwater, swimming against the current, jumping waterfalls, navigating weirs, branching off into tributaries to head upstream to the gravelly shallows of their birth, where they will mate, lay eggs and bequeath a next generation of life to the river.

It is a journey fraught with difficulty and danger. For the salmon gathering off Chanonry Point on the Black Isle, off the northeast coast of Scotland, their first challenge is to dodge the dolphins. Beyond this narrow peninsula is the Moray Firth, and the freshwaters of the Ness and the Beauly, rivers historically famed among anglers for their clear waters, fast-flowing shallows and bountiful salmon.

Bottlenose dolphins (*Tursiops truncatus*) have come to know that the deep channel around the point is a bottleneck for the fish. The dolphins hang in the menacing-looking rip of white water where the rivers rush out and the tide rushes in. When the low tide turns, and begins to rise, the salmon – with smaller, spotty sea trout among them – make their move, seeking the sanctuary of inland waters. But the dolphins are on the move too.

The water shines green and silver and the smooth skins of the dolphins glisten as they dip above the surface, accelerating through the water. At times, there are up to 30 dolphins here, swimming almost in unison, their fins rising and falling above the waves in metronomic fashion, dashing with ease after their fast-moving prey. When a dolphin catches a salmon, it seems confident of keeping its prey. The dolphin will pick them up and spit them out, tossing them in the air. One older dolphin has a habit of doing this, either to rearrange the salmon in its mouth or perhaps just for fun. People gather at the end of the point to watch the dolphins here, savouring the apparent joyfulness of their spectacular leaping out of the water.

No-one really knows why dolphins leap or throw their fish, but to us it looks like the playfulness of a fellow mammal.

Opposite: This salmon is attempting to leap a 3-metre-high waterfall in the Flow Country in Scotland to continue its journey upriver.

The salmon that make it through will head upriver when conditions allow. Individual salmon possess specific knowledge of their own river but don't always get it right: salmon have been found miles up one river before being found again in the same season on a completely different river system, suggesting they have taken a wrong turn before heading back downstream to find the correct one. A small proportion of salmon seek out new rivers as well, because without those wanderers the species would never be able to colonise new places if old rivers become unsuitable.

Entering freshwater has its advantages: parasitic sea lice, for instance, acquired in the ocean, will drop off in freshwater. However, the salmon do not dive upstream straightaway. There must be enough water in the upper streams, and enough flowing over a waterfall for them to leap up it – but not so much that it is an unnavigable torrent.

When the fish find a suitable river pool, they will wait, sometimes for months, not eating but just holding themselves against the current. Treading water takes on a new meaning if you see the handsome fish with black specks on its topside of silver hanging in the current. It looks effortless but, of course, it draws on their reserves of energy from months of good feeding at sea.

When rainfall comes, and a waterfall is laden, the salmon can make their move. Salmon leap occasionally at sea and during their freshwater migration, seemingly practising for this moment. Now they must deploy huge strength, agility and persistence to leap their way up. Fish can leap more than three metres to propel themselves over the most formidable of obstacles. Unfortunately, the weirs and dams that have been placed on many rivers over the past century are insurmountable for even the fittest Atlantic salmon, just one of a myriad of challenges facing this species. Even on a natural waterfall, a salmon may hurl itself up and fall back many times, crashing into rocks or failing to clear the fall. They pause and rest in calmer waters, before trying, and trying again.

Once the waterfall has been navigated, the salmon move further upstream. Sometimes they will travel for hundreds of miles to reach the precise point where they were born to breed again. When the female releases her eggs, the male cock must be ready to fertilise them with his sperm. The male will patrol along the river, seeking pheromones that reveal when a hen is ready. Cocks will fight off others for hours and even days in an attempt to secure a hen for themselves. The cocks are often scarred by bite-marks between their dorsal and tail fins, where they have been grabbed by their rivals.

The size of a male is his biggest competitive advantage but less bulk doesn't exclude cocks from the mating game. Juvenile salmon that have lived in the river for at least one summer but have not yet headed downstream to the sea are called parr. They may live in the river for up to seven years, particularly in the harshest environments, but most stay in freshwater for around three years. Male parr, only about 15 centimetres long, can nip in and fertilise the eggs as well, and in some rivers may account for more than 50 per cent of all offspring. If the mature male notices 'the precocious parr' – as he is often known – the juvenile fish can

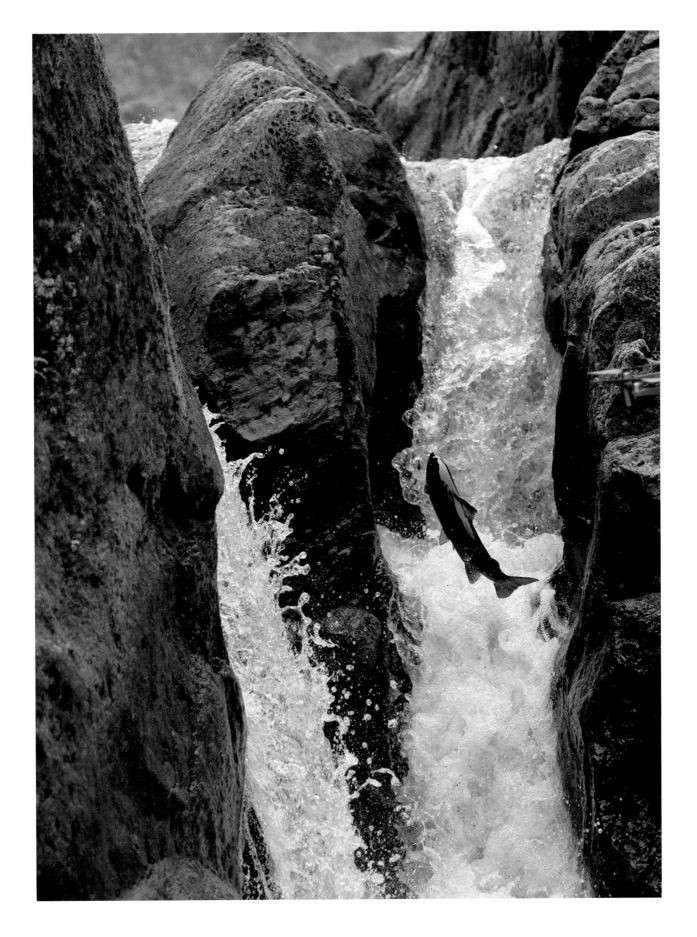

be snapped at and killed. But the ability of juveniles to fertilise the eggs is a wise insurance policy for the salmon: if no mature males make it back to a stretch of river, a lone hen can still breed, thanks to the young fish.

The hens lay their eggs on the gravelly bottoms of unpolluted rivers. They must have running water to be able to dig a hole in the gravel. They seek spots where oxygenated water will run over the gravel where their eggs are laid in 'nests' – shallow depressions in the gravel known as redds. The hen salmon has a wide tail and when she is sexually mature will turn on her side and practise digging with it, even in the sea. They flap their tail to create turbulence so that rock and silt lift into the stream and are washed away. The hen will test the flow around her tail to check there is enough oxygenated water and measure the depth of her redd by dipping her anal fin into it. The digging also releases small quantities of ovarian fluids – the pheromones that tell a male she is ready. A female won't accept any old male, however, and will lunge at and push away a male who doesn't look big enough to meet her requirements. When she is ready, the hen lowers down her vent and lays her eggs, which are fertilised by the cock's sperm before the female covers them again with gravel. She will then move up or downstream and repeat the process, creating up to 20 nests.

The number of eggs laid by a salmon depends on the condition of the individual female but also the river system. More fertile rivers may enable more eggs to be laid, so a hen whose home is a nutrient-poor Hebridean river may lay 1,400 eggs, but a hen who returns to a river on the east coast of Scotland may lay up to 5,000 eggs. If hens return from their ocean feeding grounds smaller, they are less capable of laying so many eggs.

This is the end of the journey of life for many exhausted adults. The males are often covered in scars from fights which attract pale-coloured fungal markings. They die in the streams where they were born. If they have lost more than 40 per cent of their body weight in their arduous journey upriver, they won't make it back to the ocean but, unlike Pacific salmon, whose life is just one return trip to their spawning grounds, some Atlantic salmon – mainly hens – will make it downriver and out to sea again, and return to the river for a second and occasionally further egg-laying missions.

Many of the hen's eggs are washed away, particularly in floods and storms. Other eggs are eaten by parr, trout and birds from dippers to goosanders. When the eggs are ready to hatch, the baby salmon, known as alevins, break out of the egg's soft shell but retain the yolk as a nutrient-rich 'lunch bag' to feed on. The tiny alevins are fairly safe hidden in the gravel but once they have eaten the yolk, they have to emerge into the stream and hunt for themselves. As fry, barely 20 millimetres long, they are food for almost every bigger lifeform in the river. After a season or so, they are known as parr. They have vertical markings that serve as camouflage and they feed on aquatic insects. At first they shoal, and swim together, and later they form territories, living among stones, and can become quite competitive over food.

How long they remain as river-dwelling parr depends again on the river. The eggs usually hatch in the spring and the fish may be ready to go to sea by the following spring on rich chalk streams. On less fertile rivers the parr grow more slowly, and typically take three or four years to reach ocean-readiness. By now, they

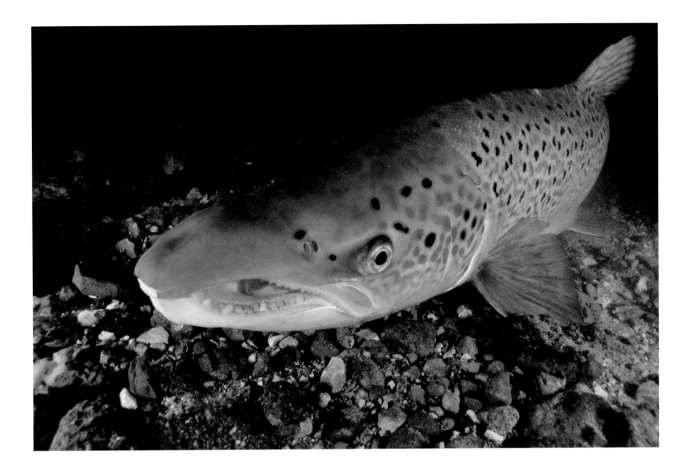

Above: A male salmon showing its breeding colours, photographed on the River Itchen in Hampshire.

are imprinted with the knowledge and scent of their home river but a new instinct is pulling them downstream – towards the sea.

The transition from river-going to sea-going fish is called the smolt. The smolt are around 12 centimetres long and develop silver scales. Their organs change to allow them to process salt water. They have an instinct to drop down towards the sea. They lie up during the day to avoid predators, moving mostly in the evening and at night, gathering in number as they go. Sometimes they will travel backwards, tail first, letting the current carry them into a world they have never seen.

The lifecycle of the salmon is miraculous and the fish is treasured in human culture, particularly via the sport of fly-fishing, in which the migrating fish are tempted to snatch at a fly cast on the end of a line, despite the fact that they are not feeding. But the Atlantic salmon is also a crucial player in the ecosystem and health of the rivers of northern Europe.

Uniquely, the salmon carry and transfer nutrients from the ocean to tiny streams. They have done most of their feeding and growing at sea, building up huge reserves of energy for their epic migrations. Upstream, when they die, their ocean-acquired nutrients go into the river, while their eggs and offspring feed a great raft of freshwater life. During their journey, they feed everything else, including many mammals, from dolphins to otters and seals. Traditionally they have fed communities of humans too.

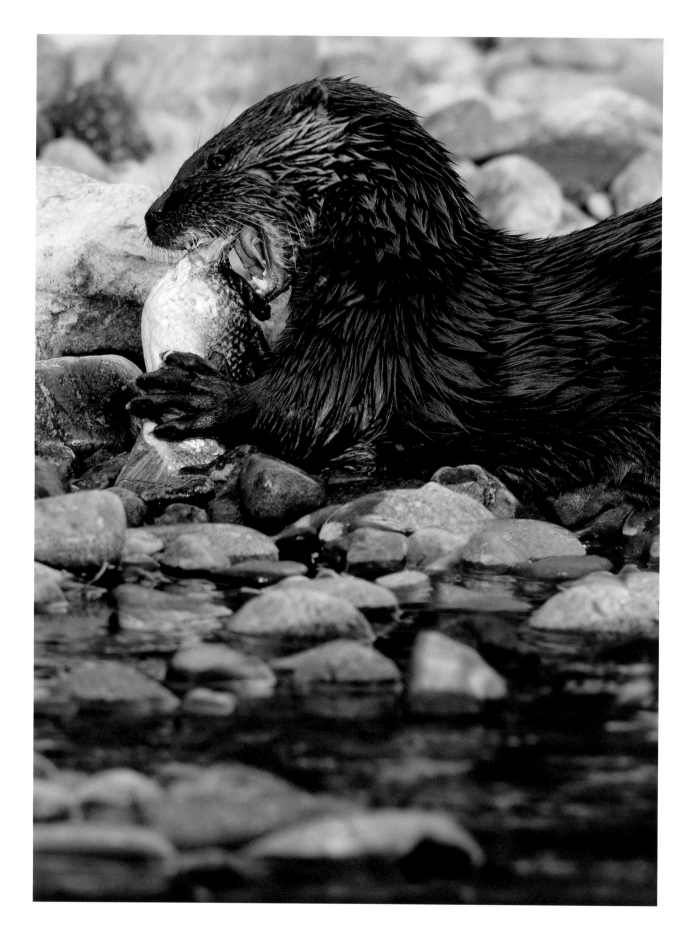

Opposite: The migrating salmon represent a flow of nutrients upriver – delivering protein to predators such as this Scottish otter.

Unfortunately, the great gatherings of Atlantic salmon and the spectacle of masses on migration is a vanishing sight. The species is one of the most studied fish in the world and yet the complex causes of its demise are not fully understood. There may still be several million adult salmon in the sea but the population is spread across hundreds of rivers in Europe and the east coast of North America. Every angler knows that salmon numbers are drastically down on a few decades ago. And to put it in context, the 'run' of Pacific species of sockeye salmon at Bristol Bay, Alaska, totalled 62.3 million fish in 2018. Are Atlantic salmon under very real threat of extinction?

Despite reducing the impact of the salmon's top mammalian predator – the human being – numbers have continued to fall. In the past, too many salmon have been fished but even on rivers where traditional fishing via nets has been stopped and anglers return every caught fish to the water, populations are still shrinking. The River Dee was the first major river in Scotland to enforce a catch-and-release rule for anglers in 1994. But the salmon haven't returned.

The challenges on each river are many, and varied. 'Each river system has its own issues, nearly all created by the economic activities of humans, from aquaculture, abstraction and agriculture to pollution, barriers to migration and longer term climate change', says Richard Davies, a filmmaker and angler who works to conserve the fish in Scotland. 'If we want to save the wild Atlantic salmon we must help nature maximise the outward migrating smolts. Even then, bigger climatic changes are happening at sea and we may have to get used to greatly reduced adult numbers.'

In western Scotland, the spotlight has fallen on salmon farms for spreading parasites and diseases among wild salmon as they swim past the caged, intensively farmed fish. Like most diseases, those that kill salmon are endemic and tend to strike individual salmon when they are weak underfed, or when under great stress, something that is happening more and more with increased temperatures and low oxygen levels in some rivers.

While fish-farming may be a problem for salmon returning to rivers in northwest Scotland, conventional land-based farming is a challenge for fish returning to southerly rivers. Salmon have drastically declined in recent years on the River Wye in Wales and conservationists fear that the proliferation of giant chicken farms in the catchment is a prime factor, causing the Wye's waters to become too rich in nutrients, starving other life of the oxygenated water they need to survive. Salmon, in particular, require high concentrations of dissolved oxygen in all the water they live in. They are symbols of aquatic purity and, sadly, too many British rivers are not pure enough. Intensive arable farming using lots of fertilisers and livestock farming too close to waterways is causing too many nitrates and phosphates to wash into streams and rivers.

Rivers in more populated areas also possess more physical barriers, including dams, hydro-schemes and weirs. Countries such as Sweden have embraced environmentally-friendly renewable energy via widespread hydro power on rivers which block salmon from reaching their spawning grounds. In some cases, building salmon passes is a solution but it can be more expensive to do this than to demolish a dam.

The climate crisis is perhaps the biggest challenge for Atlantic salmon on British and Irish rivers. Summer droughts triggered by climate change can leave river water levels too low in the Highlands of Scotland for the salmon to swim up river. Warmer river water is also a threat to the species. High temperatures can trigger eggs to hatch too soon; higher temperatures also trigger more algae and less oxygen in the water. Low oxygen levels and high temperatures put salmon under stress, and many river populations suffer outbreaks of disease. In Scotland, the River Dee has become, on average, two degrees warmer over the past 20 years. Southerly rivers, particularly the Severn, Wye and Thames may simply become too warm in the summer for salmon to enter. On average, summer temperatures in the upper tidal Thames have been increasing by 0.19°C a year since the turn of the century.

The Thames is a good example of just how challenging it is to restore lost populations of salmon. The river may never have been a major salmon river in the distant past but before the industrial revolution, 3,000 salmon were being caught on the lower Thames each year and sold at London's Billingsgate fish market. Pouring sewage into the Thames, chemical pollution from heavy industry, and the building of locks and weirs preventing the salmon's movement upstream saw the species disappear. George IV sought a Thames salmon for his coronation feast in 1821 but none could be found. The last Thames salmon was believed to have been caught in the summer of 1833.

After the furore that followed the Thames being declared ecologically dead – and virtually fishless – in 1957, moves were made to treat the sewage still discharged into the river. Pollution from heavy industry was more closely regulated. In the 1960s and 70s, much heavy industry disappeared or moved away from the edge of the Thames. In 1974 a miracle occurred: a hen salmon, four years old and weighing 3.97 kilograms, was found once again in the Thames.

The river through Europe's largest city continued to be cleaned up. For three decades, great efforts were made to restore salmon to the river. Juvenile smolts released into the tidal Thames were found to be able to return – 338 in the peak year, 1993. A decade earlier, the first salmon to be caught by a rod on the Thames for hundreds of years was found in the pool beside Chertsey Weir. But when fish were restocked at suitable spawning grounds on the Kennet, a chalk stream that was a tributary of the Thames, few returned. In fact, just one fish was ever found to have swum to the sea and returned to breed in its home stream, despite salmon passes being built around every weir, mill and other obstacle on the rivers. The last restocking of salmon on the Thames took place in 2011 but despite these Herculean efforts, the species hasn't come back.

The Thames is still troubled by sewage discharges (which should finally be solved by a super-sewer scheduled to open in 2025), but also the abstraction of too much river water by water companies which leaves the Thames in summer with insufficient flow to tempt the salmon upstream. Rising temperatures from climate change make the return of the salmon even less likely.

But even when conditions on rivers are ideal – as they still are on some well-managed rivers in the Highlands of Scotland – Atlantic salmon are disappearing. The biggest driver of their decline today is changing conditions at sea.

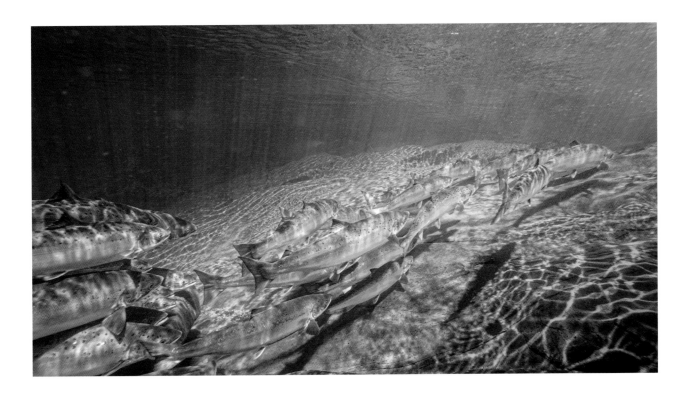

Above: There are many obstacles to a salmon's migration but the biggest one today is climate change – higher river and ocean temperatures are imperilling the salmon's future.

Overleaf: A bottlenose dolphin photographed in the Moray Firth, Scotland.

Fewer salmon are returning to British rivers and laying fewer eggs. The survival rates of smolts – the young salmon at sea – appear to be falling fast. In Ireland, before 2000, 15 per cent of the smolts who went to sea returned to rivers to spawn. By 2015, that had fallen to 5 per cent.

Smolt survival rates are higher when sea surface temperatures are cold, and so warmer seas threaten the fish. Depending on their home river, salmon follow ancestral routes far into the Atlantic or north to the waters around Greenland. If they find a lack of food at sea, they have to travel further, and use more energy to find it. The climate crisis is causing the adult salmon's food to move further north, and it may never come back. The salmon that return to the rivers of our isles are doing so smaller, possessing less energy; fewer will survive the arduous migration and if they do they will be in poorer condition, and will lay fewer eggs.

One of the leading theories for the salmon's decline is a reduced supply of capelin, a small fish which is also a key food source for cod. Reductions in small baitfish have historically been driven by changes in the North Atlantic Multidecadal Oscillation, and this system has been at a high level in the early part of this century. But biologists have another theory: climate change is causing the salinity of the ocean to decline as the ice caps melt, also causing a decline in zooplankton and a resultant loss of the abundance of species that feed on it, such as capelin.

For any globe-trotting species, the answers to any problems lie in multiple environments around the globe. Sadly, even if the rivers of Britain and Ireland are restored to pristine health, the fate of the Atlantic salmon lies in the health – and temperature – of the wider ocean. Restoring lost riches of salmon will demand decisive human action to limit climate change and a restoration of ways of living more lightly on the planet.

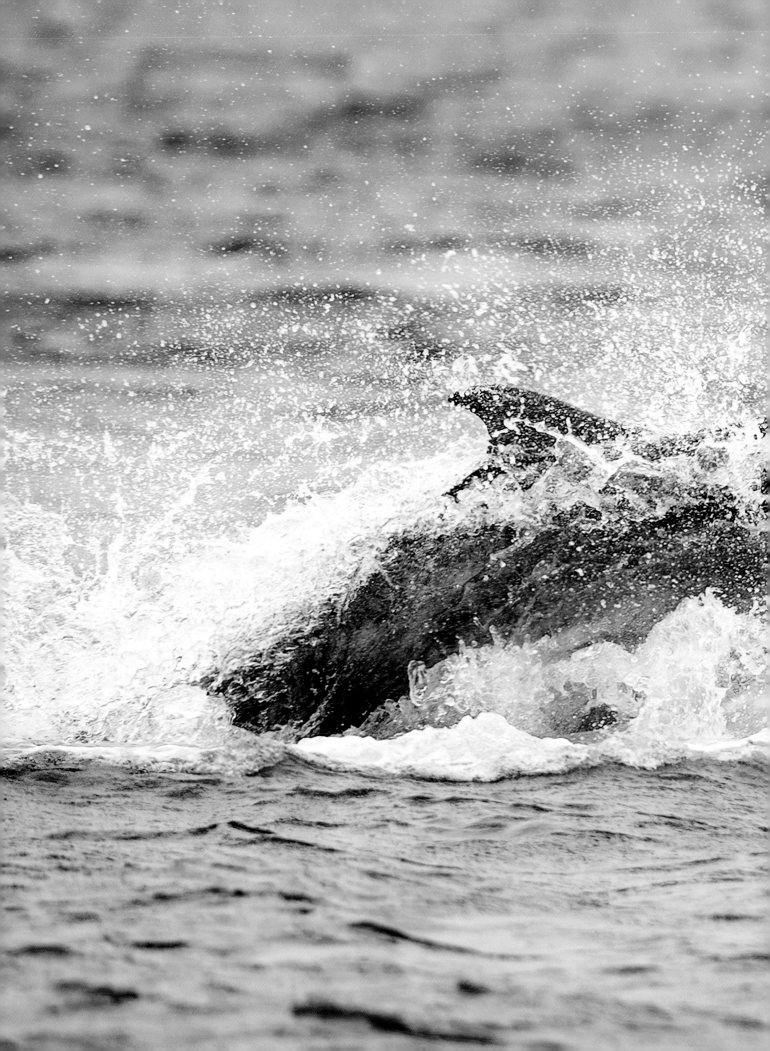

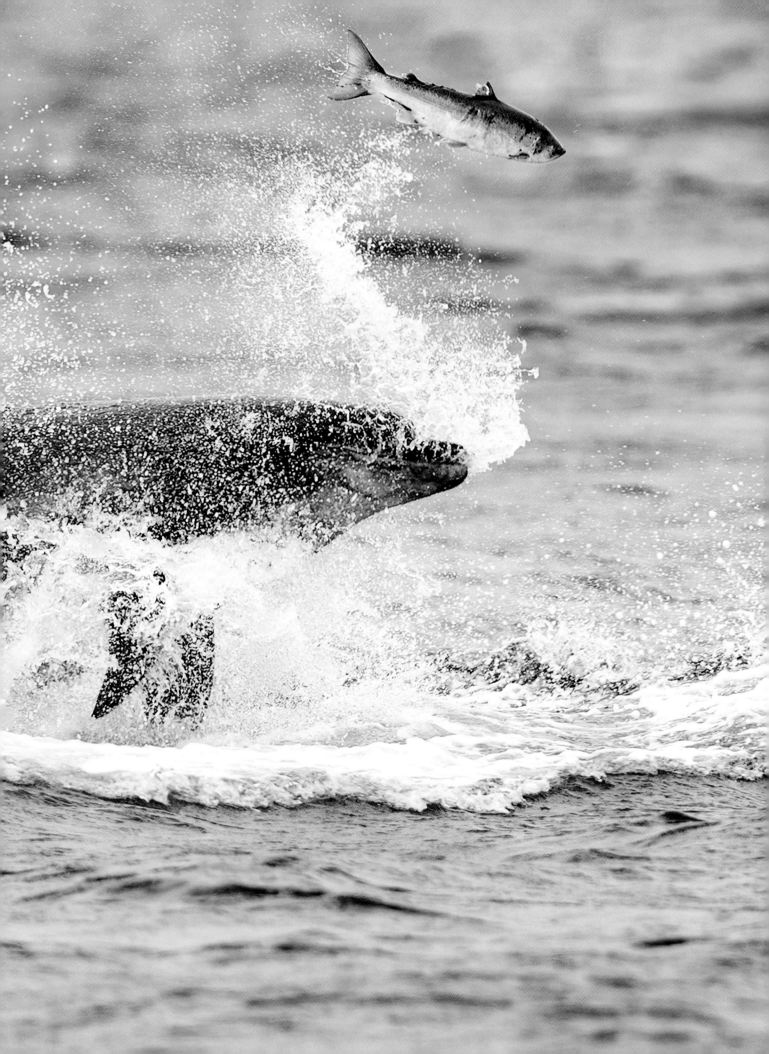

BEAVERS – CREATORS-IN-CHIEF

In Britain, the activities of a returning native are transforming rivers and valleys. This modest, aquatic creature is not easy to spot. But its handiwork is dramatically visible. On a misty, still autumn morning, the waters of a silent loch turn to glass. There is no shimmer of movement in this mirror that displays the ginger bracken and the purple-hued hills of heather beyond. On the banks below the moorland, however, there are signs of frenetic activity: silver birch trees have fallen – or have been felled – and great accumulations of sticks and mud block streams. Something has been beavering away.

A bubble of air appears on the loch followed by another and another. There's a ripple and a dramatic plop as a tail the colour of mud slaps against the water. Sometime later, a large furry head emerges with dainty ears, a blunt nose and big black nostrils. Swimming steadily across the water, skilfully adjusting its flat tail like a rudder, is a beaver. At peace, in its natural home, the beaver is a very different animal to the more familiar otter. The latter is a sinuous carnivore and must live frenetically, hunting fast-moving fish. The beaver is a broader, slower herbivore, and its languid movements belie its extraordinary industry.

Beavers look placid and rather dishevelled but they are relentless workers who wreak profound change upon their environment. The phrase 'busy as a beaver' reflects their active lifestyles: they fell riverside trees with their bright orange teeth to eat the leaves and strip tender bark but also to use the branches to dam ditches, streams and small rivers. They do this to create deeper water, and new ponds and channels, in which they can hide underwater and feel secure. By coppicing trees, they open up this landscape to more sunshine, bringing in flowers, insects, amphibians and birds. The ponds and dams they create spread and store water across valleys, slowing the flow during floods and slowly releasing water during droughts. Their dams can prevent flooding downstream. They also filter out pollution, making streams and rivers clearer and healthier and far better for fish. These humble rodents are ecosystem engineers.

For centuries, they were also too valuable to leave alone. The beaver was already rare in Britain by medieval times, when bestiaries depicted the hapless creature on the run, pursued by a horn-blowing hunter and his dogs. Its thick fur was desirably warm, the animal was quite meaty, and most of all it was sought out for its castoreum.

The medieval bestiaries depict an improbable myth: the crafty male beaver knew why it was hunted and would bite off its testicles so the hunter would have nothing to take and would leave it alone. This legend possesses a grain of truth because hunters killed the beaver for its castoreum, a pleasant-smelling substance

Opposite: The Eurasian beaver has been successfully returned to Britain and is now fully recognised in law as a native species once again. This female is part of a thriving colony in the catchment of the River Otter in Devon.

in its castor sacs which the beaver secretes to mark its territory. This is still used today in some perfume and flavourings; in earlier times, it was considered to have medicinal value, and treated everything from headaches to hysteria. After being wiped out in Britain nearly 500 years ago, the Eurasian beaver (*Castor fiber*) was hunted to the verge of extinction across Europe, with just 1,200 individuals left by the beginning of the twentieth century.

Now the beavers are back. On the continent, reintroductions and legal protection have seen populations increase by more than 14,000 per cent since the 1960s. Today, the beaver thrives everywhere from Norway to Germany to Romania. Britain was one of the last countries to welcome back this popular animal but in 2009 an official trial reintroduction of the beaver began at Knapdale, Argyll. Earlier this century, beavers also mysteriously reappeared on far-distant river systems in Scotland, including the Tay and the Beauly. Later, beavers also reappeared on the River Otter in Devon. Within Scotland and England, the beaver has now been officially recognised as a returning native, with a right to live and thrive here.

On the edge of the loch is the beaver's lodge: a huge pile of sticks which the beaver accesses through an underwater front door. All around are pools and waterways where the beavers can forage on leaves and grasses. They gather up bracken and bring it down to eat by the water's edge, where they feel more secure, and able to escape their predators with a flick of the tail and a rapid dive.

Their dams need constant upkeep and the adults keep themselves busy at dawn, dusk and through the night, adding sticks and mud into their structures to

Below: Beavers' lodges can be impressively large, but even more notable is their indefatigable dam-building. This creates wetlands that benefit hundreds of other species, from marsh plants to toads, dragonflies and herons.

hold back the water. They will hold huge mouthfuls of mud, swimming to their dams to pack it into their structure. As they busily move along the dam they look like an engineer inspecting their work. There's a popular belief that a beaver cannot stand the sound of running water but it is mistaken, for beavers live with the constant trickle of water that moves through their structures.

This pair of beavers has enjoyed a successful season, for soon a pair of kits emerge from their home, which resemble miniature aquatic guinea pigs as they scoot through the water. They are naturally buoyant, their backs still up high, unlike their parents who keep a lower profile as they swim through the water.

Beavers are perfectly at home in this, their native land, but it sometimes takes us humans longer to become comfortable with their activities. To those who farm close to rivers, particularly if they grow crops on fertile riverside soils, the beavers can be a pest because their ponds can spill onto farmland or they may burrow into banks. The beavers strip bark from many riverside trees, and the dead and fallen trunks can look derelict or scruffy to those of us unused to sharing a space with these animals. But beneath the skeletons of dead trees is a new beaver-created wetland and it is roiling with life.

From kingfishers to herons, grass snakes and rare barbastelle bats, all kinds of species prosper in beaver wetlands, which begin by turbo-charging plant and invertebrate diversity. A Scottish study of four beavers living in an enclosed area for over a decade on a small stream in Tayside found they created 200 metres of dams, 500 metres of canals and an acre of ponds across a 30-acre area, increasing the number of species by 148 per cent, with plants that thrive in wetlands and require sunshine increasing significantly. Five years after beavers were released into an experimental enclosure around a small stream in west Devon, the ten clumps of frogspawn had multiplied to 681, and eight species of water beetle became 26 species. Studies have also shown beavers to help populations of water voles, which have suffered a 90 per cent decline since the 1970s. 'Bringing that type of biodiversity back is something that you couldn't engineer', says Professor Richard Brazier of the University of Exeter, who has studied their impact in Devon and elsewhere.

Beavers are still viewed with suspicion by some anglers, for which we might blame C. S. Lewis, who put fish-eating beavers in Narnia. Anglers also fear beaver dams will disrupt the flow of fish along river systems, but a five-year study of the beavers released onto the River Otter in Devon found that in pools created by beaver dams there were 37 per cent more fish than in comparable stretches of the river where there were no dams. Trout were also recorded leaping over beaver dams and swimming through braided streams around the side of dams during high river flows.

Fish thrive in beaver wetlands because of the beavers' free water filtration and pollution removal services. Phosphates and excessive fertilisers washed into waterways can create toxic algal blooms, which kill fish and other creatures. Beaver dams trap and filter out such sediments. It is difficult to imagine an animal more useful to humans than the beaver, with their wetlands also storing great quantities of carbon.

For farmers tending riverine fields, the beaver dams can cause flooding on their land. There are solutions, which have been successfully trialled in Devon,

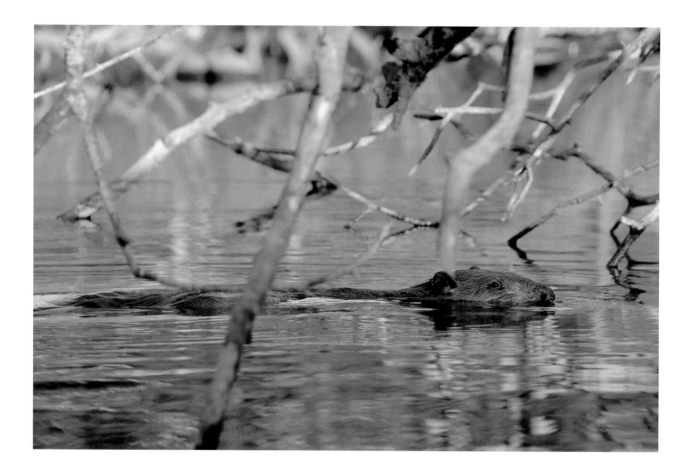

including the 'beaver deceiver', a pipe which is surreptitiously placed through a beaver dam allowing water to flow through rather than build up and flood a field. In many cases, however, it is more desirable for water to be stored on fields next to rivers than to flood villages and towns, and, in future, farmers may be rewarded for alleviating flooding by hosting beavers living on their land. Beaver dams may look haphazard but they can drastically slow and reduce the flow of floodwater during storms, which can protect villages and towns downstream from flooding. Beavers have been deliberately introduced to a stream in the Forest of Dean to reduce flooding in the village of Lydgate. In Devon, the beavers have built six dams upstream of the flood-prone village of East Budleigh, reducing peak flood flows through the village. Beaver dams will get washed away by dramatic storms but of course these busy flood engineers are on duty 24/7 to repair them. Nor are humans the only species to benefit directly from the beavers' engineering. For an osprey in need of a feed, a loch fed by water filtered by beavers is more likely to provide the kind of clarity required to spot a fish. This magnificent, fish-feeding predator dives and grabs a tasty trout. As the beaver is returned to more river systems across our isles, such spectacular sights will become more commonplace.

Above: Beaver wetlands slow the flow of rivers during high rainfall, reducing the risk of flooding downstream. The wetlands act as a sponge, which is beneficial during droughts too, helping rivers to continue to flow.

The Raft Spider – Tension at the Surface

In the kind of lush wetland that could be created by a beaver there lurks an extraordinary animal. Most predators are masters of either land or water. But this creature hunts in three dimensions. As well as running after prey, and diving for it, the raft spider lives for much of the time on the meniscus, the tensioned surface of the water.

We think of spiders as being vulnerable to water but here is a water-repellent spider, a master of the meniscus, a walker-on-water who will devour anything that dares cross its path, from pond skaters to tadpoles to adult hawker dragonflies that are larger than itself. It can even hunt and kill fish. An ambush predator, the raft spider uses the surface tension to detect prey, and expertly skates, rows and even sails across it to find its meal.

Of Britain's 680 or so species of spider, raft spiders are one of the biggest and most spectacular. Their colours vary but they are at their most striking when black with pure white 'go-faster' stripes along the sides of their bodies; at other times they may be more mahogany in colour, with bold creamy-yellow stripes. A female can grow to 2.3 centimetres in body length; her legs can span the palm of a hand. There are two very similar-looking species: the raft spider (*Dolomedes fimbriatus*), which is rare, and the even scarcer fen raft spider (*Dolomedes plantarius*). The raft spider is found in acidic bogs in Dorset, the Surrey Heaths and further north in wetlands in Wales and Scotland. Until recently, the fen raft spider was only found on three sites – in South Wales, and on the Pevensey Levels in East Sussex and Redgrave and Lopham Fen in Suffolk.

On the Arne peninsula in Dorset, a female raft spider is hungry. She will sit, camouflaged and quiet, on the surface of the water. The meniscus is her favoured mode of transport but it is also a plane of communication. She uses long, fine hairs on her legs to detect the direction and distance of movements in the air and water caused by predators and prey.

The raft spider has mastered the entire range of aquatic transportation. Water repellent or hydrophobic hairs on her body and legs enable her to be a skater, dancing along the surface of the water, causing the meniscus to dimple but not break under her feet. She is a rower, casually oaring across the water using her second and third pairs of legs. She is a sailor, and can raise all eight legs into the air to catch the wind and move across the water, or can stand on tiptoe on the water to raise her body so the wind pushes her along. She is also a speedboat, accelerating to a speed of 0.75 metres per second in a high-stepping gallop across the water. She brakes rapidly by using her tarsal claw to catch her silk dragline, rather like fighter jets produce a parachute to land on an aircraft carrier. And the spider is also a jump-

jet, launching herself vertically into the air from the surface of the water to evade attacks by predators.

If none of these feats can find prey, the female raft spider can always try another technique – and another dimension. A layer of dense, velvety hair on her body can trap bubbles of air, which the spider uses as a lung to dive beneath the surface of the water. She can use this to survive underwater for at least half an hour, diving to escape larger predators and continue her own hunt. A raft spider was once seen attacking a winged ant, which defended itself by squirting formic acid. This so startled the spider that she dived underwater and hid for a long time. Because the trapped air makes her buoyant, she cannot swim freely but moves along underwater by grasping submerged stems. In this domain, she soon finds her next essential meal.

It is spring and the female must eat well to get into good shape for the breeding season. The slightly smaller males only stop for a light snack here and there, for they have something else on their minds. Wooing a female is, potentially, a dangerous game. If the vibration of his approach is mistaken for prey, he could be attacked. To minimise this risk, the male has developed an elaborate and protracted courtship. When he has followed pheromone trails to where a female is hiding, he signals to her by tapping his feet on the water. He dances with his front feet, tracing arcs on the surface of the water that set off ripples. Then he bobs his body up and down and sways his abdomen from side to side. The female bobs her body up and down too, and kicks her front legs to show if she is receptive to mating. The male moves in, flips the female upside down, and mates before quickly departing to recharge and

Below: The raft spider is one of the biggest of Britain's spider species, a rare creature found in acidic bogs in Dorset, the Surrey Heaths and on wetlands in Wales and Scotland.

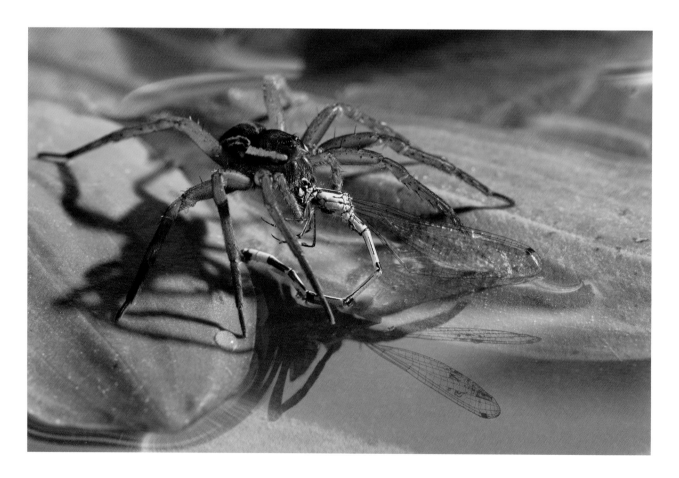

seek out more mating partners. Very occasionally, a male who misreads the signals will be eaten by a female, but raft spider expert Helen Smith has observed this happen just once in captivity out of 150 courtship routines. And it's really nothing personal: females will sometimes eat other females too.

Around 15 per cent of females mate more than once and females can produce two or occasionally even three sacs of eggs, a thick silk ball the size of a large marble. The males are so obsessed with pursuing females that they don't feed properly and become progressively thinner and weaker, usually dying of exhaustion by late July. The females, however, still have important work to do.

The female raft spider carries her cumbersome egg sac beneath her body for three weeks. They often forego feeding to look after their burden, which they must submerge under water every few hours during hot weather to prevent their young from drying out. Eventually, the smooth grey sac becomes brown and saggy-looking as the spiderlings hatch inside and undergo their first moult. When up to 700 spiderlings are ready to emerge, the female builds a nursery, a web up to 30 centimetres across anchored to stiff-leaved vegetation – water soldier is particularly important for the fen raft spider – in a sunny location. Nurseries are sometimes built to connect to those of neighbouring spiders and they are almost impenetrable: a dragonfly flying full-tilt at one will bounce off it. For around five days, the spiderlings remain in the safety of the nursery, guarded by their mother, before they disperse to begin their own independent lives, at just two millimetres in length. Some will seek out new terrain by 'ballooning', using silk 'parachutes' to travel on air currents, but only a few will grow up to become the apex predator of small things in the bog the following spring and summer.

These tiny, vulnerable spiderlings are devoured by almost everything, including many of the animals the survivors will come to predate. And so the web of life continues and flourishes: 700 baby spiders per female is a vital injection of food into ponds, ditches and wetlands.

Conservation hero:
Dr Helen Smith, independent conservation scientist

Helen Smith has done more than anyone in Britain to save the fen raft spider from extinction. But she only stumbled upon it by chance, when she moved in the early 1990s to the edge of Redgrave and Lopham Fen, the largest remaining river valley fen in England, which crosses the boundary of Norfolk and Suffolk.

It was here in 1956 that the fen raft spider was first discovered and described in Britain. While the raft spider is better known, only two further populations of fen raft spider have been discovered in Britain, on the Pevensey Levels in East Sussex in 1989 and around Crymlyn Bog in South Wales in 2003.

In her spare time, Helen began monitoring the spider at Redgrave and Lopham Fen. She was soon hooked. 'They are very small, beautiful and fascinating animals', she says. 'You can stand and watch them out on the water and even an arachnophobe doesn't have to worry that they are going to run up your leg. Most people who are arachnophobic and see them think they are beautiful.' As a scientist too, the raft spiders were appealing. 'The more you look, the more complicated the biology and conservation of the raft spiders becomes. Finding we've been ignorant is such a positive in science because it shows we are moving forward and turning another page in the book.'

The spider was in danger of extinction at Redgrave and Lopham Fen because the wetland was drying out after a borehole to supply public water was sunk into the underlying chalk aquifer in the 1950s. The borehole was finally relocated in 1999, saving this internationally important wetland, and allowing it to be recharged with water through natural springs and seepages from the aquifer. But this scare demonstrated the vulnerability of the species.

So, in 2010, Helen oversaw a translocation programme for Natural England whereby the fen raft spider was reintroduced at four new sites – two on the lower Waveney valley in Suffolk and two on the Broads in Norfolk. The spiders were first collected as females carrying egg sacs. When the spiderlings emerged, they were moved to individual test tubes and reared on by Helen (later with some help from ten British zoos). Eventually, more than 30,000 spiderlings were released across the sites. Wild populations have been established at all four areas, with spiders moving in the landscape well beyond their original release locations. 'Many organisations and individuals have made a difference', says Helen, who is keen to stress that conservation and restoration is always a team effort. 'Natural England supported the initial years of the translocation and other organisations such as the Broads Authority, Suffolk Wildlife Trust and the British and Irish Association of Zoos and Aquariums (BIAZA) made kind contributions alongside many other volunteers.' More translocations of fen raft spiders and raft spiders too will be required in the future, says Helen, because of the climate crisis.

'The lowland populations of both species face a threat from climate change, and that goes for all fen raft spider populations', she says. Climate modelling suggests that the south coast and East Anglian sites for the fen raft spiders won't be suitable within the next 50 years. Southern heathland sites are likely

Below: This female raft spider is a deadly ambush predator – she can dance along the surface of the water, catch the wind to sail across it, and even capture bubbles of air to dive below the water in pursuit of prey.

to become too dry for the raft spider as well. The great loss of British wetlands over previous centuries, and the fragmentation of those that remain, mean that it is not easy to find other suitable large-scale wetlands that could hold a viable population. And it is extremely unlikely for the spider alone to find such places.

The standard conservation rule governing the reintroduction of species is to only place them into their known historical range, but so little is known for certain about the fen raft spider's former range that this is not

practicable. And the old historical range may not be suitable as the globe heats up. So Helen hopes that future translocations into new areas will secure the future of the species, moving the fen raft spider into restored fenland areas further inland but also into valley wetlands further north.

In the meantime, she continues to work to persuade the wider public of how 'harmless, interesting and wonderful' spiders really are.

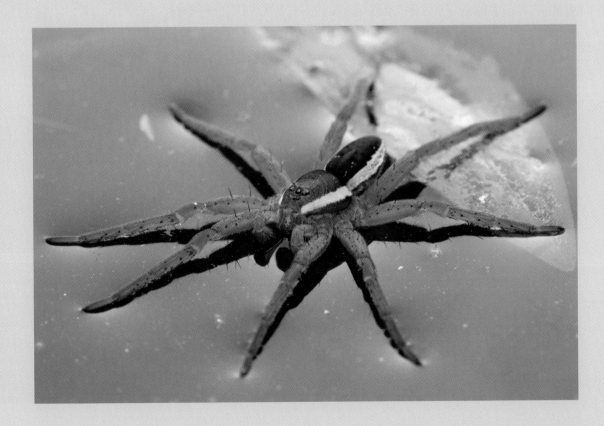

Daubenton's – The Water Bat

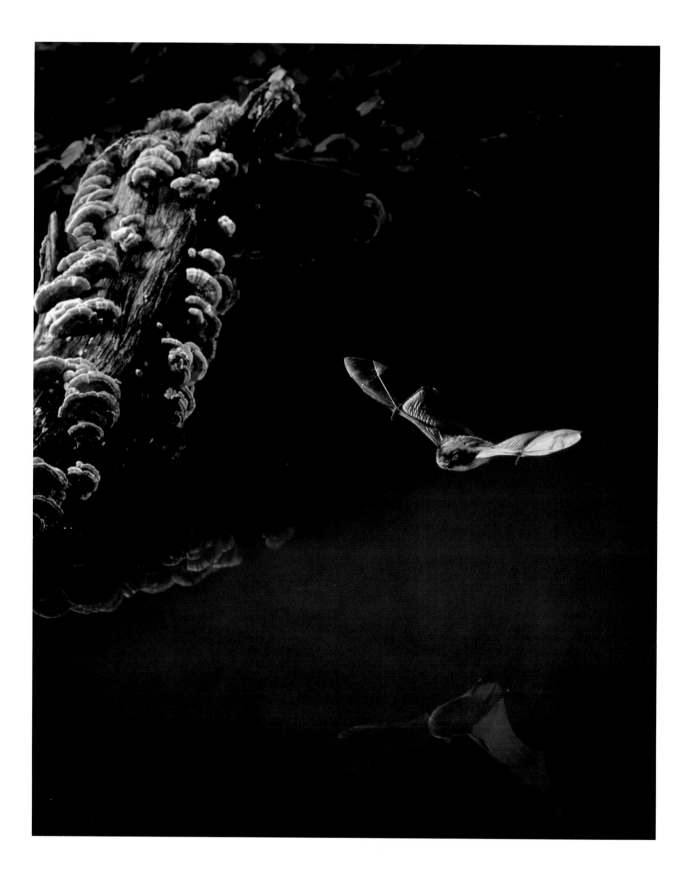

Opposite: Known as the water bat, Daubenton's bat specialises in flying low over rivers and lakes, foraging just above the water surface for insects.

Our freshwater rivers and lakes are a source of food for a surprising number of mammals as well, and some only visit at night. As dusk falls, the first of many darting shapes appears over dark water: a bat.

Many bats will feed over water and even duck down upon it to take a flying sip. But the only creature that moves steadily and low over the surface of the water is one species: Daubenton's bat (*Myotis daubentonii*). Fondly known as the water bat, Daubenton's in the lowlands gather in large female-dominated roosts. These females feed almost exclusively over rivers and other waterbodies. Individual bats occupy small 'beats', foraging up and down short stretches of river, often all night. Bats may defend these beats, although they are more likely simply to avoid direct competition with each other.

Studies of Daubenton's bats in the Yorkshire Dales National Park by ecologist John Altringham and his colleagues have revealed some surprising complexities in the way male Daubenton's fit into these arrangements. Males mostly roost apart from females for reasons that are not yet fully understood. Perhaps females exclude males from the roost and the river in order to reduce competition for prey at a time (during pregnancy and lactation) when they need a lot of food. Alternatively, males may stay away in order to avoid competition for food or to escape the ectoparasites that are often abundant in nursery colonies.

Altringham studied colonies of Daubenton's bats in Upper Wharfedale, lower down the dale and in the lowlands outside the national park. While lowland summer roosts were exclusively female, in the lower dale between the lowlands and the highlands, Daubenton's live in mixed colonies, with males present. Moving to the uplands, here the Daubenton's were all-male colonies. Because there is less plentiful food in the uplands, these poor males have to feed longer each night than downstream residents and travel further to find their food. Altringham even discovered that these males are skinnier – being lighter for their size, which is calculated by measuring the length of their forearms.

It appears that the males living in the mixed colonies have a massive advantage, being close to more plentiful food, and potential mates as well. Are the males in the uplands low-status individuals pushed into marginal habitat?

Perhaps, or perhaps not. As Altringham likes to say, there is more than one way to be a successful bat. The slender upland Daubenton's may regulate their weight to reduce the energy costs of their flights, using torpor to save energy on nights when foraging is poor. And upstream they are away from the intense competition in mixed sex colonies. Paternity studies have demonstrated that these upland males are fit enough to visit swarming sites, which are relatively close to their summer roosts. Here, they have a high probability of fathering the offspring of visiting females. These underdogs of the bat world are not as pitiful as they first appear.

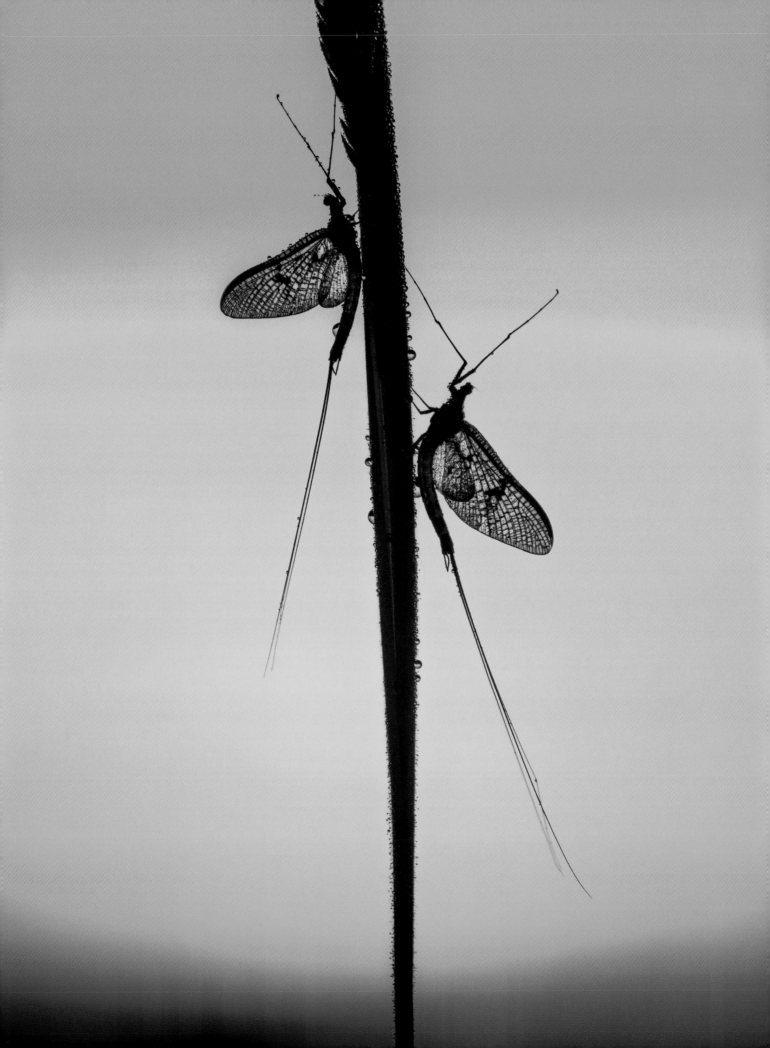

Mayfly – The Dazzling Dance of Light

Opposite: The green drake mayfly is Britain's biggest mayfly, and its emergence animates a great dance of life on our rivers.

An English river in late May twisting in peace well away from roads and houses is a special kind of miracle. The water curves between willows and watermint and the sun turns ripples, eddies and dimples into golden glitter. Pigeons clap their wings and sail up out of the oaks on the river cliff. A blackcap sings, hidden in the shallows, and then there's the rat-tat-tat of a woodpecker working the trunks of alders for beetles.

This isn't a dancing upland stream but a lowland river, and the water moves smoothly but relentlessly after recent rain. The river merges with the bank, and bright yellow buttercups and kingcups are in flower with meadowsweet yet to burst forth. Last year's bullrushes look like feather dusters now, scattering their seeds to the summer breeze. Fragments of torn leaf and twig sail along in the current, backlit by the morning sun.

The river is clear, and delicate filiments of ranunculus water weed flow like long hair in the current. And beneath the surface of the water, at the bottom of the river, something starts to stir.

This is a chalk stream, one of fewer than 300 known on the planet, of which around 85 per cent rise from the chalk hills of England. (The remainder are found on the chalk terrain of northern France.) Chalk is the fossilised remnants of billions of minuscule creatures which filled the warm, shallow seas of millions of years ago. When they died, they settled on the ocean floor and became compressed into chalk. Over the years, the seas retreated, and erosion sculpted the chalk hills, which run from southern England – from west Dorset to east Kent – into East Anglia and as far north as the Yorkshire wolds. Rain falling on this chalky terrain slips through fissures and gathers in aquifers beneath the chalk. Eventually, it is released again via springs, having been filtered many times, and our precious chalk streams take shape.

These streams are a unique and precious ecosystem. Their purity and alkaline character support a range of special plants, which in turn give rise to a diverse set of invertebrates, fish, birds and mammals. This particular stream, in Wiltshire, is in excellent condition, and well protected, but the chalk streams of England face some unique and pressing challenges.

For the insect at the bottom of the stream, the pressing challenge is to pop out of its aquatic world.

The creature has a pinkish carapace like a shrimp, with miniature claws at the front like a crab. Its strong front limbs are for heaving gravel out of the way, which constitute immense boulders for this tiny thing. Its back legs are like miniature frog's limbs. It possesses feathery gills for breathing underwater and three tails,

rather like a slender garden rake. At the rear of its thorax are black buds, which are the key to its miraculous transformation.

This is *Ephemera danica*, Britain's biggest mayfly, and its emergence is about to animate a great dance of life on this chalk stream.

The drastic move from strange crab to angelic winged insect is long in the making. This nymph has spent two years in the bottom of the stream, burrowing in the gravels, slowly growing and preparing for this moment. The water temperature has to reach about 14°C before the nymphs are ready. They wait for sunlight, or a sudden bright spell, and then they're off, fanning up through the water with their tail.

They reach the surface and now the current is whisking them downriver. There is no pupal stage like a butterfly, and no elaborate, hour-long unzipping of their skin as most dragonflies do. The black buds open into wings that show up like a tiny shark's fin on the sun-drenched surface of the water. The mayfly flail around, looking helpless, struggling to break the surface tension of the water. They must turn themselves from swimmer to flyer in seconds. They struggle like moths in treacle, extricating their wings from the water and seeking to become airborne. Nearly every maiden flight ends in the gentle crash-landing back onto the water. That's okay, they can try again. One mayfly makes four attempts before it takes off successfully. And every second spent on the surface of the water is another second in peril.

A mayfly struggles into an upright position, ready to fly. Plop. A small fish, a grayling, leaps acrobatically from the water, its silver belly glinting in the sunshine, and gobbles the mayfly. The mayfly synchronise their emergence, flooding the river with so much food that some will evade predation and survive to mate. Every second, it seems, a newly emerged nymph is swept along the surface of the river, and more predators arrive.

Ducks busy around, hoovering them up. Wagtails and sparrows pick them off one by one. Swallows and swifts will grab them in midair. But they are easy pickings for almost any bird, from pied flycatchers to great tits, blue tits, sedge warblers, even common gulls will be tempted in by a mass emergence. In this way, the mayflies are a crucial link in the food chain. Because they emerge in such numbers, they constitute a large proportion of the invertebrate biomass on a river, and when they emerge this energy is transferred to the fish and the birds.

The mayfly are an irresistible protein buffet for brown trout, a handsome river fish with grey uppers and a golden brown middle that shimmers silver and copper at the same time, with lead-grey spots along its body. And so the emergence of the mayfly is hugely significant for a long tradition of anglers as well, who have their own names, from sprawlers to burrowers, for the flies. Some anglers call the hawthorn 'the mayfly bush'. When it is fully in bloom, it is said, the mayfly will emerge, and the sub-adult flies often fly into the may blossom.

By late afternoon, the surface of the water is covered in the shucks, the shed skin from the nymphal stage. Unusually, the nymphs first hatch into a sub-imago, which is known by anglers as 'the dun'. This winged form enables it to fly up and into the trees and shrubs beside the river. These mayflies have no mouth-parts, so eating is no longer part of their life but, contrary to popular myth, they do not

Above: In late afternoon, male adult mayflies begin to dance in the tops of the trees to attract a mate. Their mass emergence provides a protein buffet for countless other river dwellers – both birds and leaping fish.

always merely live for 24 hours. They can tuck themselves in a willow for days, waiting until the temperature is warm enough for their final emergence to mate and lay eggs. At this point, they moult once again, into the imago, which anglers know as 'the spinner'. The female also needs to change again to develop stronger wings, so she undergoes another moult.

The ethereal adult mayfly is about 2.5 centimetres long with a pale yellow body and brown dots on its abdomen, which lends it a tigerish appearance. They have translucent wings, which are darkly veined and a stretched oval in shape.

In late afternoon, the males begin to dance in the tops of the trees to attract a mate, spinning through the firmament and sparkling in the lowering sunlight. When the females emerge, they are grabbed and mobbed by the males. After their mating is done, the males fall from the trees and die, often carried off along the river where they were raised. The trout come to the surface once again, and gobble up the spent mayfly, also making themselves uniquely accessible to the angler.

The stronger females fly upstream for one last task. They will return to the water to lay their eggs. On a fine evening, there may be thousands of females on the river. To enter the water, they have to hit it with quite a smack to break the surface tension. Then they spread their eggs around, dropping them one by one into the clear water to start this grand cycle once more.

On most English chalk streams, the emergence of mayfly is not as numerous as it once was. A riverfly census by Salmon and Trout Conservation UK found that mayfly numbers are down by between 37 and 58 per cent compared to 1998. In chalk streams, the average loss of mayfly abundance is 44 per cent.

The unique qualities of the streams are celebrated in literature, sport and wider culture, but these habitats are under pressure like never before. For the streams in the southeast, and close to London, the biggest challenge is the sheer quantity of people living in their catchments. The biggest threats are the discharge of sewage and the steady increase in demand for water in areas where new houses continue to be built, the population is growing and climate change is causing long periods of dry spells and drought.

Water companies continue to discharge sewage into rivers. The companies themselves admitted discharging untreated sewage into English water bodies on 400,000 occasions in 2020 alone. During wet weather, wastewater is released from storm overflows into rivers to prevent sewage and rain overloading sewers and backing up into homes and businesses. Put simply, ageing sewage systems often dating from Victorian times have not kept pace with more extreme rains caused by climate change and new housing, and developers and water companies have not been required to upgrade these systems to prevent discharges. In 2021, the government's new Environment Act enshrined in law a duty for water companies to progressively reduce the adverse impacts of these discharges. Water quality campaigners – including anglers who enjoy trout and salmon fishing on chalk streams – argue that this duty does not go far enough, and sewage will continue to pollute our rivers for years to come.

In less populated lowland areas, intensive farming is the major threat to chalk streams, with agricultural fertilisers washing into rivers causing levels of nitrates and phosphates to increase. The arrival of invasive non-native species, such as the North American signal crayfish, further complicates the picture, threatening more delicate native species.

Surprisingly, only 12 out of Britain's 224 chalk streams have protected status and three-quarters of all our chalk streams fail to meet the required health standards. Only 14 per cent of Britain's rivers are in good ecological health. But action is being taken. Rivers are being protected, restored, rewiggled – having their natural meanders reinstated – and championed by numerous ordinary people, grassroots groups and global charities. The three-year WaterLIFE project implemented by WWF-UK alongside The Rivers Trust and the Westcountry Rivers Trust is working with farmers and land managers to enhance soil quality and reduce the damage caused by sediment and fertilisers running into rivers. Smarter farming in the vicinity of chalk streams will help these precious places stay vibrant and healthy.

The fate of chalk streams is held very directly in the hands of the government who ultimately must regulate how water companies manage increasingly precious water supplies. But everyone living in southern England can take steps to reduce their water usage – collecting rainwater in water-butts for use on the garden and shortening showers and turning taps off. Only by treating water like the scarce and precious resource that it is will the great dance of life continue on the chalk streams of England.

Opposite: Britain has most of the world's chalk streams and their unique qualities are celebrated in literature, sport and wider culture. Now these waters and their wildlife are under pressure like never before – but we can all do our bit to help save them.

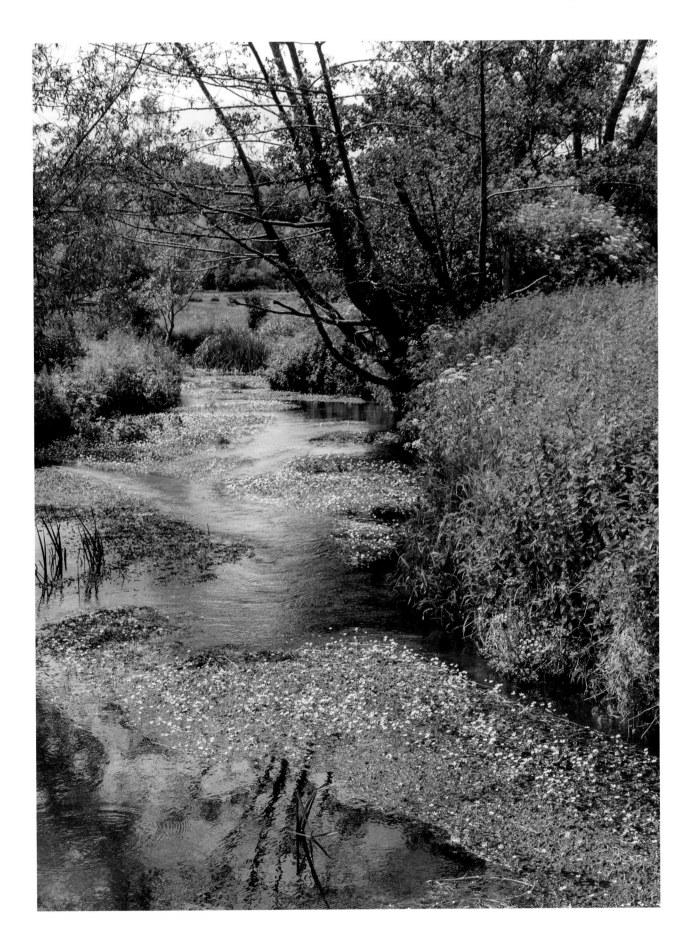

WATER SHREW – LIFE IN THE FAST LANE

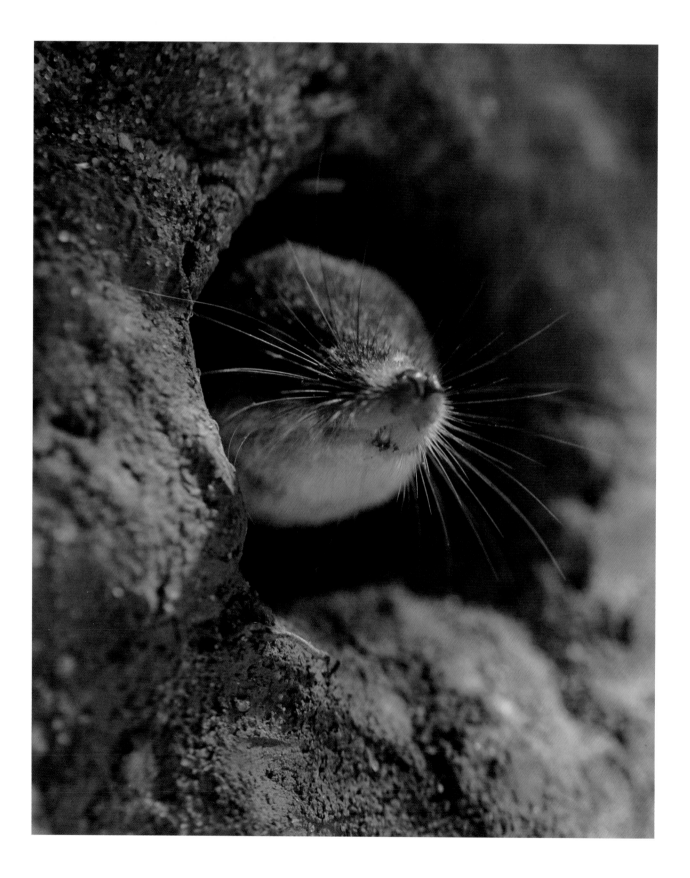

As the mayfly eggs sink to the riverbed, something small, furry and very, very fast dashes past. The water shrew (*Neomys fodiens*) is Britain's largest shrew, but it is still small and extremely elusive. It also has one of the most remarkable lifestyles of any small mammal. Can a warm-blooded mammal scurry underwater? The water shrew can. In fact, it travels so fast through the water that it looks like it is sprinting. It is no slouch on land either. It moves incredibly quickly, and so it must because, like other shrews, it is condemned to this pace by its extremely fast metabolism. This small beast must fuel up almost constantly to survive and thrive.

Most mammals have a special aptitude for either land or water. A seal isn't very effective at moving fast on land. A human can't really catch its own food by its own propulsion in the water. But the water shrew is equally adept on the earth as it is in water, and a ruthless predator in both elements.

At first glance, the water shrew looks similar to the common shrew. Like its brethren, it has a long pointed snout, small ears and tiny eyes, and short, velvety, mole-like fur. But it is slightly larger and, when dry, has a distinctly two-tone coat – charcoal or black on top with pale cream fur beneath.

Its beautiful adaptations for its dual life are subtle. For a start, it is unusually buoyant and so must leap up to gather enough momentum to take it swimming down below the surface of the water. Then it has a fringe of stiff white hairs on each hind foot to help propel it along underwater. Two rows of similar hairs turn its tail into a keel. Its fur is thicker than a normal shrew, enabling it to dive for prey even in midwinter – there is no hibernation for this little creature – down to the depth of two metres.

Perhaps its most unusual superpower is the shrew's ability to blow a scented diving bubble under the surface – 'tasting' their prey underwater. In rivers, ponds and streams, it feasts upon aquatic crustaceans, insect larvae, snails, worms, frogs, newts and small fish. On land, it will take worms, beetles and millipedes, sometimes travelling up to three kilometres in its incessant fast-paced forage for food.

If its darting speed wasn't terrifying enough, this awesome predator also possesses venomous saliva. A toxin in the saliva helps stun its prey and can enable it to take on prey larger than itself, such as fish. Even people can feel the effect of the toxin, with a mild red rash appearing where a shrew has attempted to bite.

For all its special qualities, the water shrew tends to race along well out of sight of all of us. It is not an easy animal to find or spot. They are mostly nocturnal, with a burst of activity at dawn, live at low population densities for small mammals, reside in burrows with entrance holes just two centimetres across, and rarely leave paw prints in the dirt outside. They like to live on banks beside fast-flowing streams but will also choose slow-flowing rivers and still ponds, canals and marshes. Some particularly enjoy a life where watercress is grown and farmed. The only clue to the presence of a water shrew is usually their carelessness with food: they are in such a hurry much of the time that they may discard half-eaten fish, piles of snail shells and caddisfly cases on rocks beside a stream.

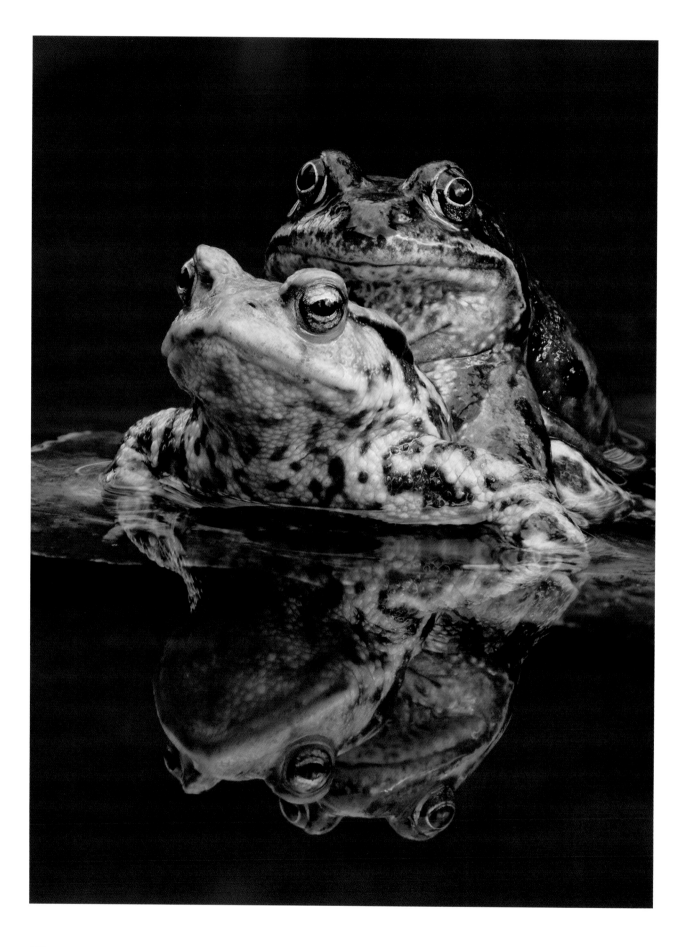

TOADS AND LEECHES – LOVE IN THE POND, HORROR JUST BEYOND

Baby toads can fall prey to a fast-moving water shrew but there is another, rather more slow-moving predator that may take its pick of the tumult of life that emerges from a pond in midsummer.

Months before, the moon rises on the most romantic night of the year. It is Valentine's eve and something is stirring in the undergrowth. One of our biggest mass movements of animals in Britain is the annual pilgrimage of the common toad (*Bufo bufo*) to ponds where it will mate and lay its spawn. In a land dominated by people, this is hazardous, but volunteers on toad patrol help the amphibians safely navigate our traffic-filled roads.

Toads are strongly migratory, and return to their ancestral waterways. When they reach these ponds in spring, often a few weeks before frogs gather, competition for a mate is fierce. Males pursue and cling to females in their eagerness to fertilise her eggs. A mating ball, a knot of toads, can be dangerous for the female, who is sometimes drowned by the desperation of rival males. Once mated, the female lays her eggs encased in jelly in long strings attached to the vegetation. A seven-metre long string can contain more than 4,000 eggs. After several weeks, the tadpoles emerge.

For around 80 days, they grow in the pond, and are eaten by everything. Newts, dragonfly larvae, diving beetles, grass snakes, all kinds of birds – the tadpoles are a delicious buffet for other hungry animals with young mouths to feed. Finally, in July, the plucky survivors have become toadlets, and these beautiful, miniature toads are ready to leave their birthing grounds.

They've done so well, and off they go, marching through the undergrowth, to begin their adult lives. Unfortunately there is one final, gruesome obstacle lying in wait. The horse leech (*Haemopis sanguisuga*) is a slow-moving, eyeless animal, which doesn't sound particularly threatening. But this amphibious leech is a lethal predator.

The horse leech can swim in water and creep on land. It uses chemo-receptors to detect the scent of its prey, and will devour earthworms, snails, slugs, insects, small or wounded fish and frogs, as well as leeches of its own and other species. Like a shark swimming through a shoal of sardines, it will snatch a tadpole by snaking its way into a big gathering of tadpoles basking in the shallows of a pond. The tadpoles appear to sense danger but with a lunge the leech grabs one with its suction pad. It also enjoys feasting upon almost any kind of carrion – including human corpses.

When the toadlets emerge from the pond, they are plentiful and naïve. As they crawl away from the pond, the leech is lurking in the damp grass. Some toadlets

miss certain death by a centimetre, wandering past a waiting leech, oblivious to the danger. But a few unlucky toads stumble straight into the leech. The leech detects the animal and grabs it.

The toad is held fast, but there is still hope. The leech has to gain a fairly specific grip on the toadlet, either grabbing a limb or part of the young toad's back. If the leech gets its grab wrong, the toadlet can wriggle free. But plenty of young toads are not quick or alert enough to avoid a gruesome fate. Held tight, the toadlet is swallowed, alive and whole. Bit by bit the helpless creature disappears. An arm struggles, waving in the air, a little face looks forlorn, and then the toadlet is gone.

The horse leech's name is a puzzle because it does not cling to horses, nor suck the blood of large mammals. Its teeth are too blunt to pierce a mammal's skin. Its common name may be derived from its fondness for hanging out in places where horses and cattle drink, because of the dampness and the invertebrates exposed by their hooves. Or it could be derived from the Anglo-Saxon word for 'false', like 'horse mussel' and 'horse chestnut' (with its seed that is bitter rather than sweet). Leeches were widely used in traditional medicine but leech gatherers would have known that the horse leech was not suitable for medicinal treatments, unlike the European medicinal leech, *Hirudo medicinalis*.

The horse leech may be deadly but it is just another important component of the cycle of life in Britain's freshwater ecosystems. They lay up to 16 eggs in a cocoon close to water, and the centimetre-long baby leeches are food for everything bigger. At any age, this sinister predator can be predated itself by fish, other leeches, grass snakes, blackbirds and even moles.

Previous: One of Britain's biggest mass movements of animals is the annual pilgrimage of the common toad to ponds where it will mate and lay its spawn, often, as here, alongside frogspawn too.

Above: A toadlet is devoured whole by a horse leech.

CONSERVATION HERO:
LUCY HODSON, TOAD PATROLLER

Naturalist Lucy Hodson was driving home from work one night when she saw a small toad in the middle of the road. She pulled over and helped it cross to the other side. When she climbed back into her car, she saw another one making a similarly perilous crossing.

Lucy had stumbled across a common sight in early spring: toads migrating from their winter hibernation places to their ancestral ponds to breed and lay spawn. She discovered that the Amphibian and Reptile Conservation Trust and Froglife jointly run the Toads on Roads project, organising teams of volunteers to help toads navigate our increasingly busy roads. There is an online map which shows the location of all the seasonal patrols and known toad crossing sites.

So Lucy signed up to join her local patrol near her home in Tamworth, in the West Midlands. Early in March, when temperatures rise about 8°C, the toads go on the march. They don't like a bright moon or the wind, and so wait to move on still, cloudy nights. Only fully mature adults migrate, which means toads of about four years old.

When conditions are right, an enormous number of toads can be crossing roads to reach certain ponds or lakes. Unfortunately, their peak movement tends to occur soon after darkness falls, which clashes with rush-hour traffic.

At Lucy's crossing, she waits, with a special high-powered 'toading' torch and a bucket. Her ears become attuned to the rustle of a toad moving through last year's leaves, up the hill towards the road, and the pond further up the hill beyond. She moves quickly to intercept the toad before it crosses the road, putting it in her bucket and collecting any others on the move before transferring them safely to the other side of the road.

'I like to describe it as my Christmas. It's the best time of year', she says. 'You can stay inside and watch telly or you can go out and collect a bucket of toads. It's a no-brainer. You're active, you're outside and you see all sorts of other wildlife as well – tawny owls, bats, badgers.'

Some nights, she and her fellow volunteers will help 200 toads cross safely. 'It's chaotic and you have to stop traffic', she says. Most drivers are supportive, many have no idea about toad-safety, and a small minority are hostile, furious at being held up for 20 seconds while an amphibian's life is saved.

She loves 'toading' because of the character of this much-maligned yet also incredibly lovable small animal. The males make a chirping squeak, 'the most adorable noise', and there's a whole language to toading: 'doubles' are where a male is so keen to mate that he is already riding piggy-back on a larger female as she staggers up towards the pond.

Of course, on some patrols, a toad will be squashed by a car before the patrollers can reach it but, as Lucy points out, it is quite rare in conservation work to feel like you are making a difference, and on toad patrol you know you are saving the lives of a long-lived and declining creature. The toad population is falling across Britain but at Lucy's crossing, where 800 usually cross each season, records show that the numbers there are steady. Each year, they save scores, if not hundreds of toads from dying on the roads.

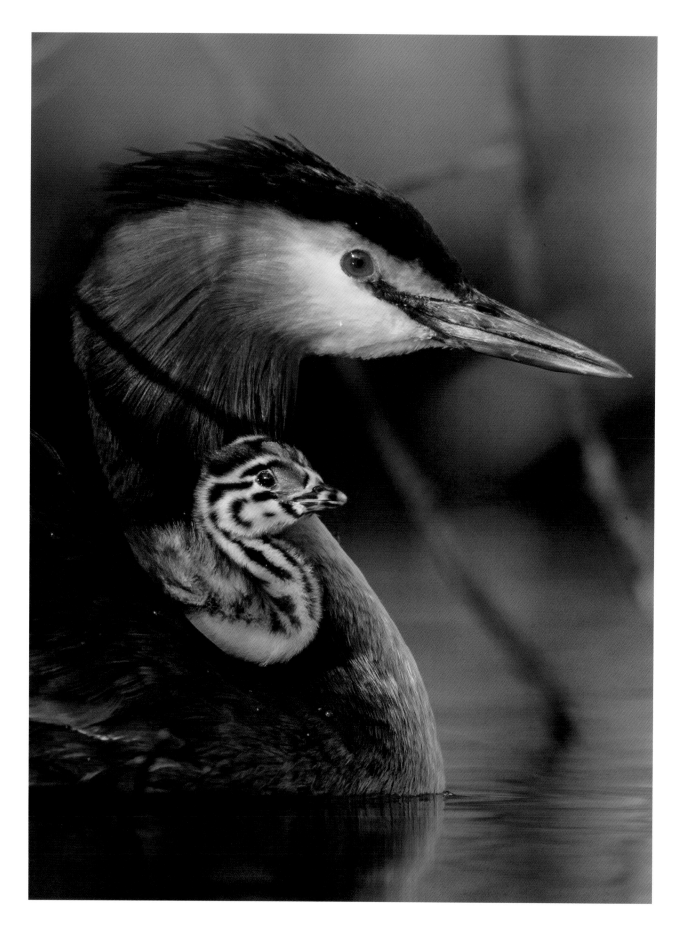

GREAT CRESTED GREBE – ELEGANCE AMONG THE REEDS

Opposite: By hitching a ride, a great crested grebe chick is protected from underwater predators such as pike. Great crested grebes are committed co-parents – chickcare is shared by mum and dad.

From a distance, the great expanse of a tawny-coloured reedbed does not give much away. But inside the reeds is a hidden world of freshwater life, thriving all the more because of this marshy, uncertain habitat's inaccessibility to humans.

Red deer can penetrate the maze of a reedbed, and their trampling creates pathways and space for other animals as they push through. The thick beds provide security for elusive ground-nesting wetland birds, from the bittern to the water rail. And they serve up food for others, most notably the marsh harrier, a reedbed specialist which flies low and slow over the waving heads of the reeds, eyes down in search of any vulnerable young chicks or water voles.

Reedbeds provide shelter and sustenance for wildfowl in the winter, and in the spring the reedbeds and their waterways are an arena for many a courtship ritual. Every fancy male duck is trying to impress the more understated females, and each has its own signature dance move, from mallard to pintail, teal to goldeneye.

But the most beautiful and intriguing of all is the dance of the great crested grebe (*Podiceps cristatus*). This is a striking and justly celebrated waterbird, particularly in its mating plumage. Its ruby-red eye is set in a white face surrounded by a ruff of feathers in bright golden brown and black, and it sports a black mohican which can be worn in a dizzying array of styles, as if the grebe is constantly reimagining its look at the barber's each morning. There's the slicked-back style, the stylish flat-top, and the full-crested punk. Both male and female look gorgeous, and almost identical, which is interesting because in the natural world appearances always tell a story.

To anthropomorphise an animal is to sometimes risk obscuring the wonder of difference or invite misunderstanding of another creature's unique biology. But the grebe's way of life certainly resonates with our own desire for equality between the sexes. It is a pin-up for our times.

Most ducks conform to the following pattern: the males are ornate, multi-coloured creatures who invest all their energy in looking fantastic and displaying themselves to females who are sensibly camouflaged in subtle hues because they do all the child-rearing. The males preen, perform, mate and then disappear, leaving the female to single-handedly raise their offspring.

Despite being the more taxonomically 'primitive' bird, the grebe does things differently. Not only do males and females look the same, but it appears that they are equal partners in their elaborate courtship. Both offer an extraordinary array of moves, poses, dances and gifts, before sealing a partnership in which both birds are devoted parents and share the load of bringing up a family in the hazardous world of a reedbed.

The courtship of the grebe is a prolonged dance in which the pair develop a bond and learn to trust each other. And although each stage of the performance has been admired and studied by bird lovers over generations, and each one named like a yoga move, there are all kinds of hidden subtleties to their performance, and cues and stimuli that make them move as they do.

The starting point is often a mutual spell of head waggling and shaking. The birds hold their necks level, fluff up the feathers on their heads and make a ticking noise. Flashing colours of white, brown and black merge together.

Another move is when one grebe abruptly takes off from the water – they are not great flyers – and skitters for 20 metres or so before dropping down onto the water again. Here it pauses, and lifts its wings into a 'w' shape. This is known as the Cat's Face, because it is said to look like one.

Grebes are famed for taking long dives in pursuit of their food and one bird will disappear underwater to pop up close to its mate, whereupon it performs a paddle dance.

The weed dance is often the climax of courtship, and the holy grail for many a wildlife photographer. The birds extract weed from underwater and hold it low before them, rushing in, breast to breast, before rising up high in the water and waggling their prize in each other's faces. Some believe the weed move is led by a male seeking to impress his nest-making credentials upon the female, but expert watchers believe the different roles in the grebe's displays are not predictably gendered and can be performed by either sex.

The naturalist and wildlife filmmaker Simon King has been fascinated by grebes for decades. He believes the reasons for their complex displays are still not fully understood, and honest observers are often not sure which bird is male and which is female in the heat of the moment. They often seem to swap roles in the courtship. 'They both play a very proactive role in display', says King.

A lot of the grebes' rituals are actually to defuse aggression, he believes. Moving the head low in the animal kingdom is often seen as threatening, for instance. 'If one of those body signals is wrong, it could break down into confrontation.'

What starts as head-shaking doesn't always end in romance – King has seen plenty of courtships turn into fights in the early stages of pair bonding. Tussles can be quite brutal. One bird will dive underwater and peck into the belly of another. The fiercest clashes tend to be between neighbouring pairs, or sometimes two females.

The great crested grebe was once a species in jeopardy, and the bird's healthy population today is a legacy of one of the first conservation triumphs in Britain. Until the mid-nineteenth century, grebes were found across most of the southern part of the country but by the end of the Victorian period just 32 breeding pairs remained. The skins of four grebes in full breeding plumage were displayed at the Great Exhibition in 1851, which sparked a trend for their pelts replacing mammal furs in muffs and boas and for grebe feathers to be used in hats. Fishermen also persecuted the grebes, believing them to be competition for the fish they caught, and shotgun technology improved, making it easier to hunt and kill the grebes as soon as they surfaced from the water.

Overleaf: The courtship of the great crested grebe is a prolonged dance in which the pair develop a bond and learn to trust each other.

Pressure grew to stop these fashions and save the birds. In 1870, the first of a series of bird protection laws were passed in Parliament. The final act, the Wild Birds Protection Act of 1880, gave the grebe protection during its breeding season, from March until July, and its population started to recover. But the bid to protect grebes and other birds from the vagaries of feather-related fashions continued, leading to Emily Williamson in 1889 founding in her living room in Didsbury, Manchester, the campaigning organisation that would become the Royal Society for the Protection of Birds.

Since their protection, the widespread extraction of gravel for construction across Britain has led to the creation of hundreds of new freshwater lakes which provide ideal habitat for the grebe.

Once the grebes have bonded, they are really committed to co-parenting. They will build their own floating nest platform on water close to the reeds or occasionally they will borrow the nest platform that belongs to an angry coot. Grebes are true water birds, poised elegantly in their aquatic manoeuvres but clumsy on land, owing to their legs being situated at the back of their body – for ease of swimming rather than walking.

After eggs are laid, their incubation is shared between mum and dad. Unlike many birds, the grebes begin incubating an egg as soon as it is laid, and so the first chick may hatch five days before the rest. The chick is quickly off the nest and onto the water and so, just like in many human families, it is dad who looks after the toddler while mum prepares for the next baby – incubating the remaining eggs.

The father grebe may take charge of two chicks while the mother continues to incubate more eggs. Often there is no sign of a youngster as dad glides across the lake. But then there's a ruffling of feathers on his back and they part to reveal a chick with black-and-white strips along its face and down its neck that give it the appearance of a mint humbug. By hitching a ride, the chicks are protected from underwater predators such as pike. One parent will care for the chicks while the other finds them fish. Later, the parents will often take a chick each and look after them.

While a mallard typically produces ten chicks, nine of which may well get eaten, the grebe usually only produces around four. But both parents are in attendance, night and day, to offer food, shelter and protection from predators. Of course, the chicks are still extremely vulnerable to attack from larger denizens of the reedbed but the grebes' truly collaborative parenting produces a higher fledging success rate than the average duck. Then again, as just one glance at a grebe confirms, this is far from an average bird.

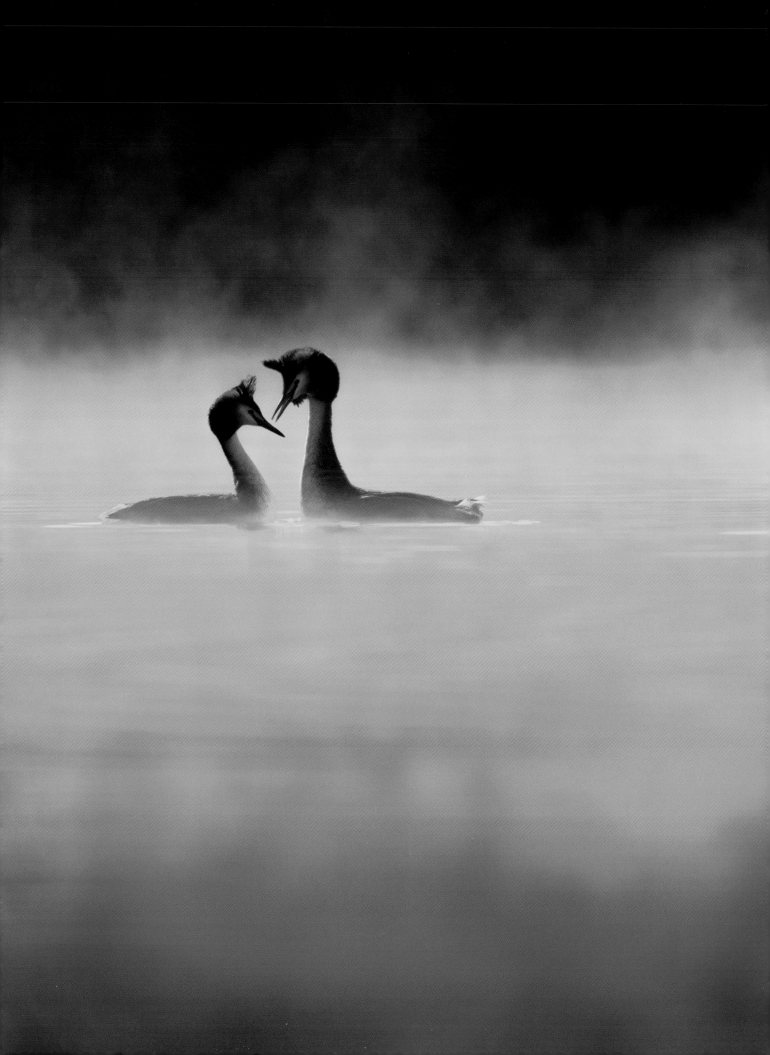

FLOCKING KNOT – ABUNDANCE IN WINTER, AND AN UNEXPECTED THREAT

The meeting point of freshwater and the sea is a place of vast skies and ribbons of water. Estuaries are the last wilderness, in southern Britain at least, liminal arenas ruled by the movement of the tide, and not easily farmed, fished, inhabited or made use of by humans.

The Wash is one of our mightiest estuaries (although Morecambe Bay has a bigger intertidal area). Four rivers feed the Wash – the Witham, Welland, Nene and Great Ouse – and its tidal mudflats, salt marsh, sands and shallow seas stretch over 620 square kilometres, three times the size of Birmingham. It is a wetland of international importance and is guarded by virtually every conservation designation going: it is a Site of Special Scientific Interest, a Ramsar site (a wetland of international importance under the Ramsar Convention), a Special Protection Area, National Nature Reserve and part of an Area of Outstanding Natural Beauty.

On an icy day in late autumn, the bitter north wind sweeps from the Arctic Circle straight down into the Wash, pushing a high tide even higher. Mud flats shine dark purple as the sun drops down from a vast sky. Where the sun catches the incoming tide, the water shines silver and turquoise, even though there is little blue to be seen between scudding clouds.

Against the last rays of the sun, a low pulse of birds rises up, black against the sky, moving sinuously against the horizon.

The birds settle again on the mudflats but the tide, moving over the flats at walking pace, soon forces them up again. Thousands of birds pulse like a shoal of fish. These are knot (*Calidris canutus*), a stocky wading bird with an attractive rusty-orange patch on its underside and olive-green legs. In summer, knot breed all around the Arctic Circle. In winter, they retreat from frozen ground and subzero temperatures to enjoy the balmy climes of estuarine Britain, where the winter temperature may only hover around zero and the nutrient-rich mudflats are always unfrozen – and open for the business of finding food.

There are around five populations of knot in the Arctic, and some groups fly as far south as Patagonia and Australia to overwinter. The knot who arrive at the Wash are from northeastern Canada and northwestern Greenland, and fly over Greenland's ice cap to reach Britain. Non-breeding birds may return here as early as July, with most arriving in September.

They are here for shelter, but they are also here for food. They prospect in the mudflats of the Wash revealed by each day's tide for cockles and Baltic tellin, pink and white shells which they eat whole and crush inside their stomachs. There is still shellfishing on the Wash but it is closely monitored and there is plenty of food for the knot.

Opposite: Each winter, thousands of knot gather on the Wash, one of Britain's largest estuaries. When the tide comes in, numbers become even more concentrated on the low banks.

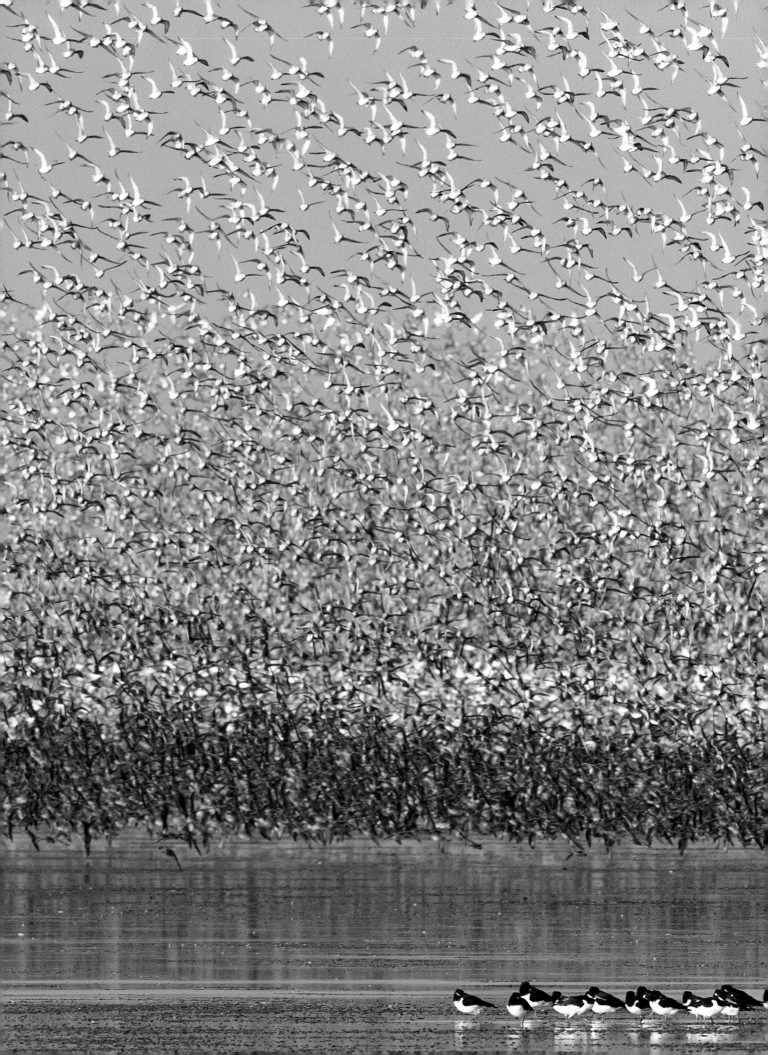

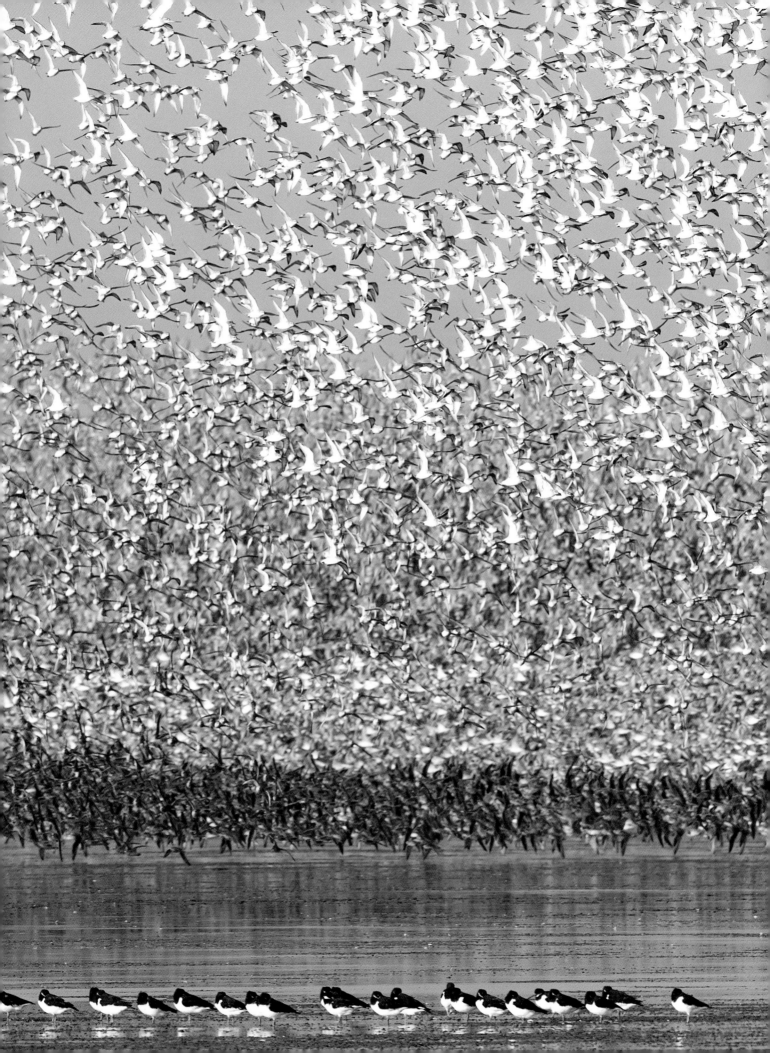

As autumn turns into winter, huge numbers of knot flock on the Wash, more than anywhere else in Britain. In the winter of 2020/21, there were 220,000 birds gathered on the mighty estuary. And on a high tide, as the mudflats are covered, the birds are squeezed together, packed tighter and tighter. It is here that the birds rise up, in great shimmering flocks, like a murmuration of starlings only mightier, with much bigger birds.

Britain has clung on to precious fragments of its special wildlife but rarely do we encounter abundance in our nature-depleted land. But an uplifting mass of life is here on the Wash in winter.

RSPB Snettisham is a large nature reserve on the southeastern corner of the Wash. It can appear a bleak, barren place but it provides a safe haven for overwintering birds. From late November to January, alongside more than 100,000 knot that gather on this one portion of the Wash, there may be up to 50,000 pink-footed geese roosting here at night, flitting between this reserve and similarly protected places on the North Norfolk coast at Holkham and Scolt Head Island. Alongside the geese and the knot there can be up to 4,000 bar-tailed godwits, 7,000 oystercatchers and 5,000 dunlin.

We know this because Jim Scott, the RSPB warden here for more than 20 years, conducts an arduous monthly count during winter. Even a rare and declining bird such as the curlew may gather in its hundreds here. Of a grand total of nearly half-a-million wading birds in the Wash, a third of them are usually mucking about at Snettisham, picking through the mud in their search for precious winter food.

It is uplifting to experience so many birds. Their calls echo through this grand arena, and when the incoming tide causes a group to lift up, the air is filled with the swish of thousands of wingbeats, sounding like a mighty engine. But other animals are attracted to such a bounty of life too: predators.

When the high tide crowds the knot onto a small area of mudflat, they are vulnerable. And a peregrine knows it.

A peregrine will launch a surprise attack on a flock of knot. It approaches by flying low, fast and hard, more like a female sparrowhawk than a peregrine, using the ground to conceal its approach. By the time the first group of knot take to the skies in alarm, the peregrine is almost upon them. There are so many birds it can usually grab one in midair.

The knot scatter, a mass of silver-grey shapes rising in panic, each one twisting and turning to evade their mortal enemy. There is safety in numbers but when a knot knows it is being targeted it will do almost anything to escape. They roost near a body of water very deliberately, because they see security here.

The peregrine loops higher and turns, an anchor-shape in the sky, and hones in on a single knot. The desperate prey spirals away from the peregrine and throws itself into the water, ducking under and then pulling out and setting off in the other direction. This knot has escaped: the peregrine is wrong-footed and will not follow it into the ice-cold salty spray.

But the peregrine continues its assault, and whirls around to target another knot. This one panics, seeking out the security of the water so desperately it misjudges where the tide is and crashes headlong into the mud. The mudbank is soft but not soft enough and the knot picks itself up, injured, and unable to fly. The peregrine loops in again and picks up its tea.

Previous: The Wash is full of bird species in winter because the daily tides expose vast mud and sand flats rich with intertidal life – a precious and reliable food source.

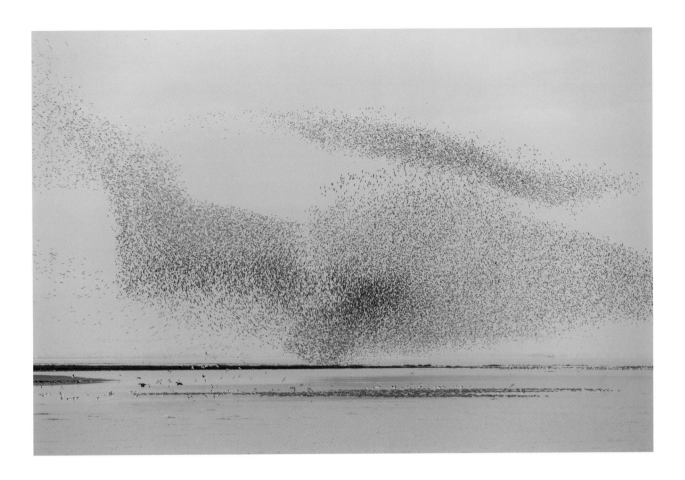

Above: For the knot, like many other birds, there is safety in numbers: large flocks offer some security against the probing eye of predators such as peregrine falcons.

These winter gatherings are valuable sources of food for predators such as peregrines but the buffet does not last long. By the middle of winter, the knot sense that the supplies of cockles are diminishing and start to leave the Wash, travelling to other estuaries across western Europe. They may move into France and beyond in their search for food.

The knot will continue to visit estuaries like the Wash as long as they supply a larder of winter food, and so, as everywhere, people need to carefully manage their own use of these natural resources. Climate change will also lead to changes in the Wash and elsewhere. Salt marshes absorb water and wave energy and make excellent natural sea defences but as sea levels rise, salt marshes in front of sea banks and walls – as there are around the reclaimed land at the edge of the Wash – will reduce in size. We will need to make space to extend or restore salt marshes further inland to ensure this natural abundance, and uplifting spectacle, continues to prosper, and reward us with awe and delight.

4. Our Woodlands

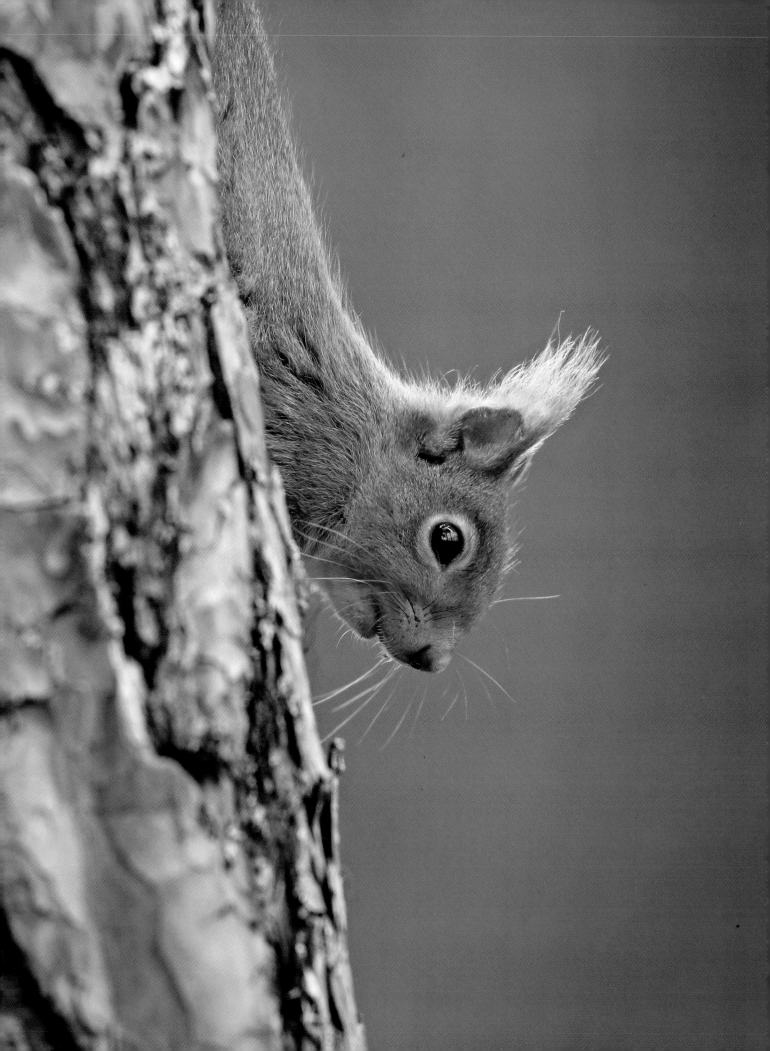

RED SQUIRRELS – AND AN INTRODUCTION TO THE BRITISH 'FOREST'

In the warmth of a wood in midsummer, a red squirrel is having a snooze. Her kittens have just left her drey and she is free for the first time in the season. She lives in the ancient Caledonian forest in the Cairngorms National Park in Scotland, and as a mature animal she has mastered the art of being a squirrel.

She is a graceful, balletic creature, alertly pretty, possessing extravagant tufts of hair above her ears and a big fluffy tail that looks like a decorative adornment but is a highly practical balancing aid and means of communication. She is not really red but bright orange, and her vivid coloration blends with her environment unexpectedly well. The deeply textured bark of the Scots pine is pinky-orange too, and the stems of blaeberry turn red-orange with age.

She lives in the oldest part of the forest, among the imposing Scots pines, above a healthy understorey of birch, holly, heather and blaeberry. It is a fabulous place but tricky habitat to manage. The big trees are a long way apart and if she wants to stay in the canopy – where she is safest – she must undertake death-defying leaps. A leap from one tree to another requires a fully committed run-and-jump. Her back legs almost reach her front as she sails through the air. She lands on what looks like a rotten branch but she is so light and nimble that there is no cracking of twigs and she is safely onto the trunk of the next tree.

It has been said that a native red squirrel, *Sciurus vulgaris*, a species which arrived after the last Ice Age, could have once acrobatically danced its way from John O'Groats to Land's End without its paws ever touching the ground, such was the dense canopy of wildwood that swathed the British Isles before people began chopping down the woods. But this is a myth, and the true history of our vanished treescape is a lot more complicated.

This chapter tells the story of some of the most remarkable residents of our forests and woodlands, which have in fact been shaped and changed by another woodland resident – the human being – over many centuries. Thanks to a rapidly growing population well before our early industrialisation, Britain has long been one of the least wooded countries in Europe. It might be said that the conservation movement in Britain began in the woods, with the battle to save Epping Forest in 1878. Today, woodland cover stands at 13 per cent of our land and rising, although this is far less than most European countries.

The red squirrels of the Cairngorms still prosper in large and expanding tracts of forest, where Cairngorms Connect, a partnership of landowners and charities, has a 200-year vision to restore the ancient forested landscape of the Cairngorms across 60,000 hectares, an area equivalent to half of Bedfordshire. But if the

squirrels scamper further into Scotland, they will find a wild Highland landscape almost bereft of trees.

The history of woods in Scotland is one of arrival and rapid retreat. Pines were among the first trees to move north after the end of the last Ice Age 11,000 years ago, alongside juniper and fast-growing silver birch. For a brief pulse of geological time, Scotland was probably wrapped in forest. When the first farmers, the Neolithic people, established civilisations in the far north some 6,000 years ago, the forest began to be exploited, managed and cut down. The original Caledonian wild wood, 'the Great Wood of Caledon' as it was called by Frank Fraser Darling, the twentieth-century ornithologist and Highland writer, contracted to a fragment of its former glory.

Pollen analysis reveals that Scotland had lost most of its wildwood before the Romans reached Britain. Most disappeared before there was any written record of it. How far the trees naturally extended across the Highlands is debatable. Oliver Rackham, one of the leading woodland ecologists of recent times, has argued that pinewoods were forced into retreat quite naturally – by the wet climate of western Scotland. Minerals leached out of the soil and blanket peat came to dominate both hill and glen, consigning the early pines to fall and lie prone within newly formed bogs.

If a red squirrel ventures further south, it would discover that our archipelago's forests endure mostly in fragments today. The story of the retreat of the Caledonian woodland is repeated across Britain and Ireland. The first modern-looking trees, early conifers, appeared on Earth some 310 million years ago. Trees have grown tall in Britain for millions of years but for long periods during the last two million years our northerly landmass has been treeless, and dominated by the glaciers of successive Ice Ages. In the warmer intervals, trees quickly colonised, and the pillars of our current forests first grew as the last Ice Age melted away.

Entire forests disappeared under rising seas. When the final land bridge across the North Sea around Dogger Bank was flooded, only a few dozen tree species had made it onto our newly formed islands alongside hunter-gatherers, and other animals that browsed trees and shaped woodland, including elk, aurochs and deer.

As pine, birch and juniper marched northwards, rowan and hawthorn followed. Alder and black poplar rose up in wet valleys. Small-leaved lime dominated the south, alongside emerging woods of oak, ash, hazel and elm. Beech and hornbeam prospered in the west. At some point during the early centuries of human habitation of our islands, we reached peak tree. Holocene Britain, according to archaeologist Sir Cyril Fox, in 1943, was 'an illimitable forest of damp oakwood, ash and thorn and bramble, largely untrodden'.

For a long time, the prevailing view in ecology was that land left to itself reached a self-sustaining 'climax' of dense woodland. And so, it was thought, Britain and Ireland were once smothered in lush, wild wood. But it is doubtful that this was ever the case. Trees found they could not grow everywhere, and open peat bogs soon developed naturally in Ireland as well as in the Scottish Highlands.

In recent times, the traditional view of how wild forest develops has been challenged, particularly by Dutch ecologist Frans Vera who has argued that the presence of wild herbivores such as aurochs (a kind of wild cow), tarpan (wild horses), deer and other grazing animals would have created a wilderness not of pure

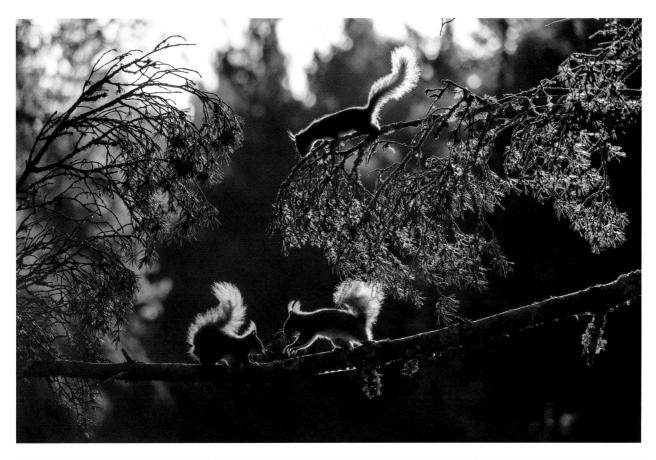

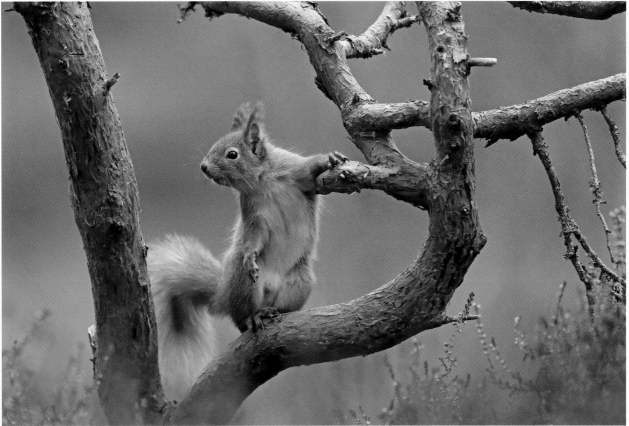

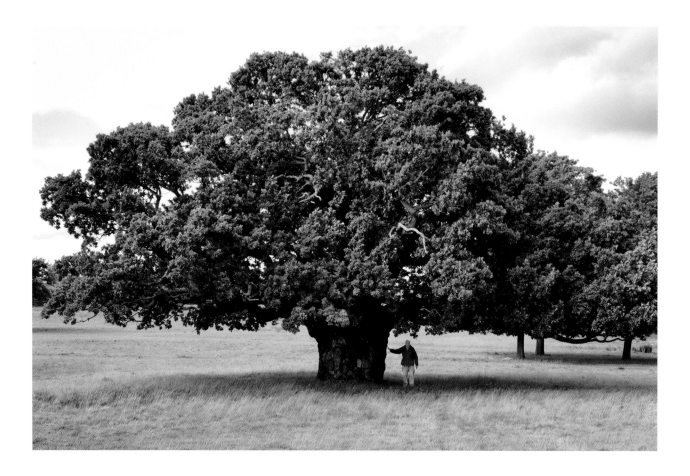

trees but interspersed with glades and open grassland. This would have resembled wood pasture, a historic type of human-shaped forest where livestock is grazed in meadowland between groves of trees.

Oliver Rackham has argued that dense wildwood, if it ever existed in Britain, was gone by the age of the first Neolithic people. 'It is debatable whether "virgin forest" or "primaeval forest", unaffected by mankind, exists anywhere in the world', wrote Rackham, 'or whether it is one of those phantoms, like "primitive man", that haunt the scholarly imagination.'

More recently, paleo-ecological studies of the fragmentary remains of beetles, for instance, have revealed a constantly changing patchwork of woodland and open areas throughout the early Holocene with later periods of deforestation as Neolithic farmers vigorously cleared woodland to grow wheat. They also managed forests for the first time. The Sweet Track, an early Neolithic pathway across the boggy Somerset Levels, was constructed around 3,900 BCE from timber and large poles of ash, oak and hazel that came from woods that were coppiced – deliberately cutting back trees for wood on a rotation, so that they regrow. This may be the earliest evidence of primitive woodland management.

It is not known exactly how much forest covered Britain during its early human history but the landscape cannot have been impenetrable wildwood by the time Neolithic people rolled bluestones on huge timbers from Wales to Stonehenge. Some historians guess that forests still covered as much as 40 per cent of the land before the Roman invasion but Rackham believes there was less. The

Iron Age forged the iron plough which grubbed up roots more rapidly. It was really a 'Wood Age': there were wooden pathways, fencing, buildings, boats, wagons, tools, beds, barrels, and wood was burned to keep people warm and cook their food. About one-fifth of Britain was still forested during Anglo-Saxon times but by the Normans and the Domesday Book woodland was reduced to about 15 per cent with large areas of east Yorkshire, the Fens and the east Midlands having almost no woodland at all.

The Normans established and vastly expanded special areas reserved for hunting which they called 'forests'. These were not dense plantations of trees but contained farmland, heathland and open countryside. A medieval forest was a place for deer more than trees. When the Black Death almost halved Britain's human population to 2.6 million, some farmland was abandoned and woodland returned. But it was not long before timber was being used more than ever. Cities were built of timber-framed houses and wood burned to smelt iron. Forests gave rise to the navy that ruled the waves: the demand for the finest English oak for ships of trade and war led to new oak plantations. Many early nineteenth-century woods contain trees still referred to as 'Napoleonic oaks'.

By the early decades of the twentieth century, Britain's forest cover had shrunk to barely 6 per cent. Britain arrived in the First World War without quite realising that it now imported most of its wood. When German U-boats began sinking ships bringing in crucial timber supplies, a coal-fired country abruptly realised it would have to find its own source of timber props to keep the coal mines open. In 1919, the government established the Forestry Commission which planted more than a million acres of new forests by the 1950s. By 1985, almost five million acres of British land were plantation forests. These were overwhelmingly non-native conifers – not particularly hospitable for most native wildlife, and sometimes disastrous for it. Since the 1980s, however, there has been renewed emphasis on planting broadleaved woodlands. There is also much greater awareness of the need to protect the last fragments of ancient woodland. These are woods which have been forested since at least 1600 in England and Wales, or 1750 in Scotland. Ancient woodlands are treasured not just for their ancient and veteran trees but for their pristine soils – untouched by farm fertilisers or pesticides – and unique plants and flowers. Species that indicate an ancient woodland include wood anemone (*Anemone nemorosa*), the wild service tree (*Sorbus torminalis*) and hairy woodrush (*Luzula pilosa*).

Britain retains an astonishing richness of ancient trees and there are at least 3,400 ancient oak trees in England. It is estimated that this is more than the rest of Europe put together. Similarly, 978 ancient or veteran yews (more than 500 years old) have been recorded still standing in England with another 407 in Wales. France has only 77 and Germany and Spain have just four each.

In the *Wild Isles* series, Sir David Attenborough is filmed beneath an ancient oak he has known for more than 70 years – just a tenth of the tree's life. 'There are hundreds of oaks that old here in Richmond Park, and in the British Isles we have more ancient oak trees than the whole of the rest of Europe put together', he says. 'But it is a sad fact that since I was born, we have lost almost half of our ancient woodland and today we are one of the least forested nations in Europe.'

The oak is almost an ecosystem in its own right and ancient oaks, and other veteran trees, are particularly rich havens for other creatures. Their dead and decaying limbs and cavities are just as useful for other species as the foliage and living parts. Hole-nesting birds, bats, beetles and other insects that specialise in dwelling in rotten wood make their homes in old trees. So do specialist spiders, insects that nest beneath old dry bark, bryophytes and specialist lichens.

It is a little celebrated fact that the British Isles is home to three types of global forest: temperate woodland, temperate rainforest and the Caledonian pines that make up boreal forest, or taiga – the largest land biome in the world. Britain's position at the Atlantic edge of the European continent has also bequeathed it fragments of what was once a temperate Atlantic 'rainforest', while in Ireland, the famed wet oak woodlands of Killarney are home to a wealth of moss and lichen species. Britain is also home to almost half the world's *Hyacinthoides non-scripta*, the native bluebell, which thrives particularly in these mild, wet westerly woodlands. They are another forest floor species that usually indicates that a wood is ancient.

The British have always appreciated woodlands and ancient trees. Today we realise that there are multiplying threats to British woodlands, from a rapidly changing climate to pollution, the spread of tree diseases, invasive species (from grey squirrels to rhododendron), excessive deer populations and new roads, railways and housing. But our grand diversity of woods and forests are a much-loved feature of our land. There are many inspiring projects to connect the fragments of forest that remain and enable more life-giving trees and plants to flourish in our land once again.

The red squirrel is perhaps our best-loved woodland resident. But while it is a common native animal across much of Eurasia, over the last century its British population has drastically reduced from millions to around 140,000. Today the red squirrel is most commonly found in northern Scotland, with other populations clinging on in northern Northumberland and Cumbria, in parts of Wales and on islands such as Anglesey and the Isle of Wight.

The cause of its decline is partly the loss of good woodland habitat but primarily the rise of the grey squirrel (*Sciurus carolinensis*), a larger North American species which was first shipped to Britain in 1876 by Victorian landowners keen to add this exotic animal to their ornamental parklands. Unfortunately, the grey squirrel carries a disease, squirrelpox, to which it is immune but the red squirrel is not. As the larger, ground-feeding greys spread, reds rapidly succumb to the disease and populations disappear. There are around 2.5 million grey squirrels in Britain.

The reds of the Cairngorms are untroubled by the greys which have not reached this terrain. The immediate challenge for the offspring of the mother squirrel is how to navigate and find food in their woodland home. The glade where they are learning their acrobatics is full of younger, spindlier trees, and the food is not so good. Still, the youngsters appear to have fun while they learn, chasing each other round and round the trunks and trying unappetising-looking scraps of pine-cone. They are cute but still have to master the big leap into adulthood.

For animal lovers and conservationists, the fate of red and grey squirrels is a troubling issue. In southern England, where there is no memory of reds as a natural

part of the landscape (apart from where populations endure on islands such as the Isle of Wight), for many people, grey squirrels are a much-loved part of particularly urban landscapes. Further north, where the red squirrels are clinging on, the greys are often viewed with hostility, because their arrival in a landscape or woodland usually presages the end of the red squirrels. Grey squirrels are also disliked by many foresters for what they do to trees, stripping bark and imperilling the quality of the timber produced.

Britain, Ireland and Italy are the only countries in the world inhabited by both red and grey squirrels, and it appears that squirrelpox means that the two species, which have not evolved together, cannot both happily inhabit the same environments. The grey squirrel is classified by the International Union for the Conservation of Nature as one of the most damaging invasive non-native species in the world. Culls of grey squirrels, where the greys are shot or trapped and killed with a blow to the head, are controversial but undertaken to protect reds particularly in Cumbria, Northumberland, Merseyside and North Wales, currently the most southerly boundary of the red's population on mainland Britain.

Red squirrel conservationists hope that widespread culling of the greys won't be necessary in the long-term if contraceptives can be safely deployed to reduce grey squirrel populations. It is also hoped that the return of a natural predator, the pine marten, will help control the greys. Although pine martens also predate reds, studies have found that the naïve, ground-feeding greys are more susceptible to being taken by the martens. Neither martens nor contraceptive controls will wipe out the greys, however, and many people don't want that either. There is no one simple solution to the challenge of maintaining healthy populations of red squirrels while accepting that greys are almost certainly here to stay.

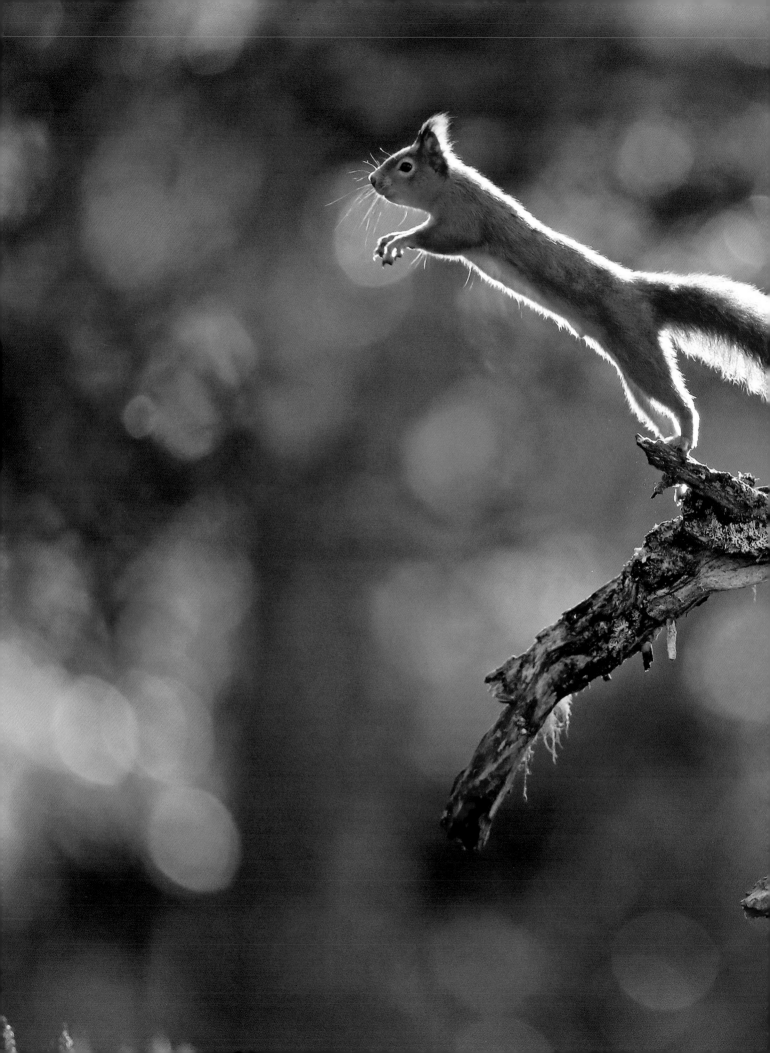

CONSERVATION HERO:
LEE SCHOFIELD, RSPB SITE MANAGER, HAWESWATER

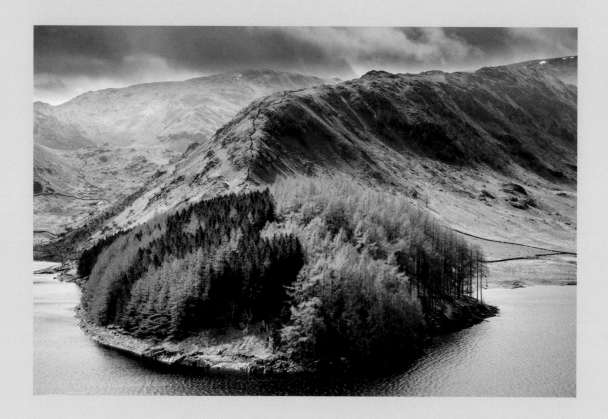

In the heart of the Lake District, the 250 hectares of woodland along the shores of the reservoir of Haweswater are an important stronghold for the red squirrel. These are native broadleaved woods, unlike many of the other refuges for reds in northern England. Relatively little natural broadleaved woodland remains in this region and so in many places the reds survive in conifer plantations, such as the vast Kielder Forest.

At Haweswater, the reds feed on hazelnuts and other native species rather than pine cones, and local people keep a careful eye on 'their' squirrels. There are feeding stations for reds in the area and in the nearby village, and people quickly report if any reds show any signs of squirrelpox, or if any grey squirrels arrive in the area. Camera traps also help monitor the reds and the greys. A grassroots collective, the Penrith and District Red Squirrel Group, send out professional or volunteer controllers to cull any grey squirrels spotted in the area.

Haweswater has the second most important block of ancient oak woodland in the North Lakes after Borrowdale. 'But they are still fragments', says Lee Schofield. 'We want to create a much more red squirrel-friendly landscape.'

In partnership with the landowner, the water company United Utilities, the RSPB

Opposite: The Rigg at
Haweswater in the Lake District
on a stormy spring day.

manages 3,000 hectares of moorland, farmland, heath and bog at Haweswater. Like much of the Lake District, this landscape has been dominated by sheep farming for centuries, and most of the mountainsides are treeless. As site manager, Lee is leading efforts to expand Haweswater's woodland and increase the good habitat and connectivity for red squirrels as well as many other woodland species.

Part of that is to reduce the grazing pressure from sheep and deer and try to stimulate natural regeneration. But upland landscapes a long way from natural sources of seeds will take decades and possibly centuries to reforest. So the RSPB is speeding up the process.

It has a nursery at Haweswater where staff and volunteers grow native trees and wildflowers from local seed collected on the site. Haweswater has been growing its own trees for 30 years but the nursery is now being expanded from producing 5,000 trees from seed each year to up to 30,000 every year.

The nursery nurtures juniper, a small native evergreen which has been lost from many wild places, and other upland trees including montane willows, alder, rowan and holly.

Tree planting is a big part of the winter work at Haweswater. The trees are not in regimented rows, nor densely planted, but arranged to create a modern mosaic of wood pasture, with clumps of trees and glades so flowers and other plants can thrive too. 'It's not a dense plantation', says Lee.

The Lakes will always have spectacular open mountains and peaks but Lee is heartened by the growing pace of woodland restoration. 'The Lake District gets typecast as a barren place but there is a hell of a lot of good stuff going on and much of it is being led by farmers', he says, citing the conservation work and tree planting of a near neighbour, the writer and hill-farmer James Rebanks. 'There's loads more woodland going in and lots more hedges and a big push for wood pasture.' For some, the pace of wildlife restoration in England's largest and most celebrated national park is not quick enough but, with many farmers and conservation charities working together, a more biodiverse landscape is inexorably taking shape.

THE WILD BOAR AND THE ROBIN –
ANCIENT WOODS, ANCIENT PARTNERSHIPS

Forests are eerily quiet in winter. Slanted sunlight reaches far into broadleaved woodlands, and birds and animals can find shelter here. Many, like the dormouse (*Muscardinus avellanarius*), shut down their bodies and huddle in the warmth of a tiny nest. Others must continue feeding. For small birds such as long-tailed tits (*Aegithalos caudatus*), the challenge is to get through the chill of each night.

At dusk, long-tailed tits flit together through the trees in large family groups. Each night they will choose one of a network of favoured roosting sites, usually secure in an evergreen holly, ivy or rhododendron. Some of their roosts – in a leafless hawthorn or blackthorn – look less secure. For these little birds, which weigh only around nine grams, predation is always a risk, but the biggest killer is the cold. The dominant birds in the flock get to pick the prime spot, and muscle into the warmest, most sheltered position in the middle of the group. After some jostling for position, last summer's subordinate young males and females find themselves positioned on each end. These sociable birds – bound together in groups of up to 18 – are so tightly wedged that they look like a bundle of pompoms with the occasional tail sticking out.

Below: A robin in the Forest of Dean is waiting for a wild boar to root up earthworms.

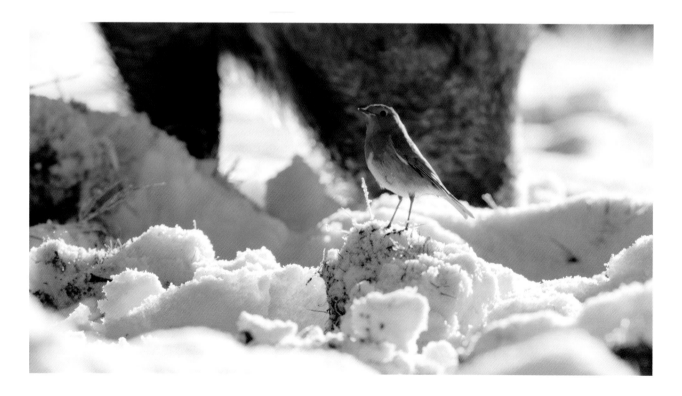

A long-tailed tit loses on average about 9 per cent of its body mass overnight; those at the edge lose significantly more than those on the inside.

In winter, there may be few obvious signs of insects or other sources of food. For birds that feed primarily on earthworms or other invertebrates picked from the soil, there is a particular problem: how can they break into the forest floor when it is frozen hard? Fortunately for the robins of the Forest of Dean, help is at hand. It comes from a formidable source, an animal as heavy as a rugby prop forward and as fast-moving as an Olympic sprinter: wild boar (*Sus scofar*).

The wild boar, the wild ancestor of the domestic pig, was already becoming rare in the British countryside by the eleventh century. and this popular source of wild meat was hunted to extinction by the seventeenth century.

If you want to reintroduce an animal to Britain, writes the naturalist Peter Marren, farm it in fenced enclosures and wait for a storm. It may be that the Great Storm of 1987 caused fencing to fail and first allowed farmed wild boar to escape into English woods once again. Today, through a combination of accidents and secretive unofficial reintroductions, this former native animal has re-established itself in the wild in small populations in parts of Devon, Dorset and Scotland, with strongholds in East Sussex and Kent, and in the Forest of Dean.

The Forest of Dean is a distinctive landscape of wood, pasture and steep valleys between the River Severn and the River Wye, near both rivers' confluence in the Bristol Channel. Since Norman times, the Forest of Dean has been a royal hunting ground, the second-largest after the New Forest. We think of 'forest' as being dense woodland but the Norman concept of the word simply meant land reserved for aristocratic hunting that was governed by forest law. The monarch owned and was entitled to take the wild beasts of the hunt – deer and wild boar – from the forest, as well as timber. The monarch also obtained a useful income from fines for breaches of forest law. The forest itself was not continuous woodland but a mix of woodland, pasture, meadow and moor. People lived in these forests and farmed in them. Each hunting forest was different but places such as the Forest of Dean, where limestone was struck through with seams of coal, saw extensive mining, iron working and charcoal production, alongside the royal hunt. Coal was mined from the Forest's seams as early as Roman times.

Boar were numerous in the woods in the early Middle Ages: a Christmas feast in 1254 ordered 100 boars and sows from the Forest of Dean. But pressure from poachers as well as royal huntsmen saw them disappear by the 1300s. As the fashion for hunting diminished, the Forest of Dean became famed for the size of its oak timber trees, which built houses and naval ships. For centuries, it was a source of 'super oaks', which were transported all over England and Wales and used in the construction of massive buildings, and even the Tower of London.

Charcoal to fuel the iron industry saw much of the forest cut down but new oak plantations were created in the nineteenth century. With the decline of both traditional forest management and the charcoal industry, by the turn of this century the Forest of Dean was more wooded than it had been for centuries. It is believed that wild boar accidentally escaped from several farms in the 1990s. The area's population was topped up by a secretive release in 2004 which saw dozens more boar released into the woods.

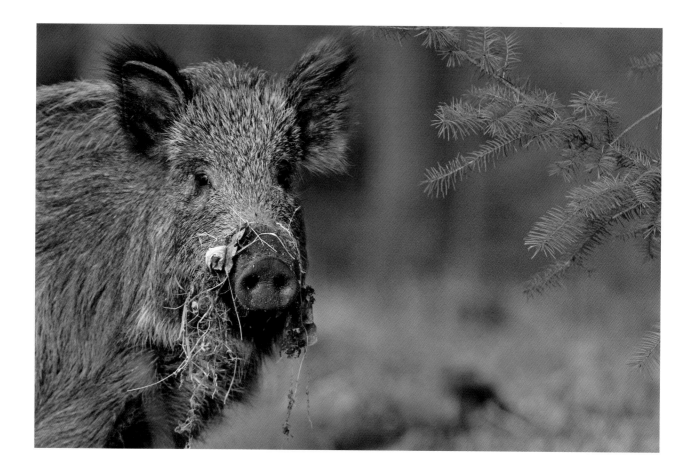

Today, the wild boar are an unmistakable part of the modern Forest of Dean. The sows and their attractively striped piglets draw in tourists and photographers. The boar are shy and mostly nocturnal, but if a sow fears that her piglets are threatened, she will stand her ground and defend her young. They would have once been predated by wolves, but have no natural predators in the British landscape, apart from the motor car. The Forest of Dean's thriving population, which rose to more than 1,500 but has fallen again due to a government-led cull, divides opinion.

The boar are omnivorous and will take carrion but spend most of their time eating roots, shoots and invertebrates, rooting through the forest floor with their powerful snouts. This 'ploughing' has caused conflict with people when it extends to road verges, pasture and even the occasional cricket pitch or playground. But for the robin and other ground-feeding birds, it is a great boon in winter. The boar break open frozen ground and reveal tasty invertebrates within the soil.

Perhaps when a robin hangs around us in the garden, or poises picturesquely on the handle of a spade, it is regarding us as a rather strange, two-legged boar. Waiting for our excavations to reveal food. In the same way, these 'garden' birds attend boar in the forest. A gathering of blackbirds in the scrub will often reveal the boar at work below. Small birds such as dunnocks and wrens will dart to the ground to prospect over the boar's fresh earthworks. So will corvids, such as jays. And in winter, the hefty boar thud through ice-covered puddles, smashing the ice and exposing valuable drinking water for the birds as well.

Above: A female wild boar in the Forest of Dean, where a buoyant population lives wild. Numbers are controlled by culling, which is controversial.

Like the beaver in the water, these forest-dwellers are ecosystem engineers. The boar are creatures of habit and when they begin rolling in one place they will return again and again, creating a wallow. In summer these become mud baths in dry areas and in winter they fill with rainwater and become seasonal ponds. Scott Passmore, a naturalist who lives in the heart of the Forest of Dean and campaigns for the conservation of wild boar, has found boar wallows 20 metres long. 'It's almost like a plasterer has been in there with his plastering trowel', he says. 'The ground and mud is completely flat where they've made it smooth. At other times, you see the imprint of the boar in the mud.' As well as frog and toad spawn, newts have been found using the ponds, with up to 50 young newts in one boar wallow. 'It shows how much the wild boar, given the chance, can benefit other species', says Passmore.

The rooting of wild boar is a boon to many flowers and plants, as well as invertebrates that thrive on disturbed ground. There was some concern that the boar would eat the bluebells in the Forest of Dean but the bluebell's roots are actually slightly toxic for the boar – one Gaelic name for the bluebell, *fuath-mhuc*, can be translated as 'hated by pigs'.

'Ten individuals could churn acres into a battlefield of the Somme in a matter of hours', reported Isabella Tree, who introduced Tamworth pigs as proxies for wild boar on the rewilded Knepp estate in West Sussex. 'But the land's ability to regenerate was equally astonishing.' Solitary bees colonised the exposed ground, pioneer plants moved in and anthills appeared to get a head-start using the pigs' upturned clods of earth. As the exposed soil warms up over the summer, it provides welcome microclimates for basking small copper butterflies and common lizards. It is believed that one reason that the turtle dove – the UK's fastest declining breeding bird species – is thriving at Knepp is because the birds can find seeds more easily on the bare ground created by the rooting pigs.

Wild boar are still classified as 'feral' animals in the Forest of Dean and across Britain. This means that they are not yet recognised as a native species again and have only limited legal protection. Nevertheless, it is widely accepted in the Forest of Dean that the boar are here to stay. The culling programme, led by Forestry England which owns and manages much of the forest today, aims to return the population to 400 individuals. The boar are thriving and, at the end of a long winter, their earth-moving helps bring the spring and summer flora of the Forest of Dean into bloom once again.

The Flowering Forest –
And the Power of Pollen

In the world of plants, trees are rather like the top predator. They are the dominant force in a forest, the winners of the race to reach the light. But every woodland offers thousands of niches for other species. Many identify alternative strategies to thrive beneath the tall trees' shade. Modest trees and shrubs, such as holly, make their living in the shadier understorey. Epiphytes such as mosses and lichens grow on many trees. Woody climbers, from honeysuckle to ivy and old man's beard, run rampant, using each tree as a climbing frame.

As the slowly rising winter light slants into the forest, one group of plants come into their own. These shade-evaders make the most of the months before leaves arrive on deciduous trees, and grow and flower in winter or early spring. A succession of flowers turn the woodland floor into a glorious carpet in spring. Snowdrops at first are followed by a steady succession of primroses, violets, celandines and wood anemones. Most celebrated, of course, are the dazzling purple-blue carpets of bluebells.

By growing before leaves arrive, these woodland plants receive approximately ten times more light than plants that come into leaf in the shade of summer. Many of these flowers are a sign that the woodland is ancient, its soils undisturbed for centuries. But the snowdrop is a relatively recent, if welcome, addition to the winter flowering of many woods. It is a native of southern Europe and only escaped into our countryside after being introduced into the gardens of the wealthy from the sixteenth century.

A floral display that is just as unmissable as the one on the forest floor occurs in the canopy. But the profuse flowering of trees is often missed. Early flowering trees bloom before many pollinating insects emerge, and so rely on the wind to do the work for them. Hazel is often the first. The dangling male catkins that release pollen are one of the most recognisable signs of early spring but minuscule pink female flowers are also found on the same branch. Both emerge long before the leaves to maximise the wind-borne pollen's chance of finding other hazels to fertilise.

The most dramatic of the wind pollinators is the yew (*Taxus baccata*), one of only three native coniferous trees in Britain alongside the Scots pine and juniper. Many yews are found in churchyards and may have been planted by pagan people because they pre-date the ancient Christian church buildings. The age of the oldest yews in Britain and Ireland is hotly debated because an ancient yew's heartwood disappears and its growth is erratic so rings and girth do not produce a reliable estimate. While some believe that the largest and most ancient yews could be

5,000 years old, international dendrologists estimate the oldest are around 2,000 years old.

Even ancient yews can produce prodigious amounts of pollen. On the first warm day after a cold winter, male yew trees can release a mass of yellow, smoke-like pollen so spectacular that the fire brigade is sometimes called out to attend a 'forest fire'.

Willows or sallows also rely on the wind to broadcast their pollen. They also have other helpers. Goat willow (*Salix caprea*) and grey willow (*Salix cinerea*) have male and female catkins on separate trees, so, to set seed, pollen must be transferred from male to female plant. It was once thought that only bumblebee species assisted this pollination but further observational studies unexpectedly discovered that an important pollinator in March and April is the blue tit (*Cyanistes caeruleus*). After a tough winter, these birds will repeatedly jab at male and particularly female catkins of goat and grey willow. Male catkins are broad and yellow; female are narrower and greener. Each catkin contains between 100 and 300 flowers. Nectar is secreted from the base of each flower as a visible droplet. Female catkins are favoured because they contain more nectar. By foraging in the morning and evening, a blue tit can obtain a major part of its daily energy needs from these droplets. They also find small insects during their tours of the flowers. The blue tits' nectar-seeking trips to willow plants of both sexes ensure that they also inadvertently transfer pollen from male to female willows. In tropical forests, birds and mammals such as bats are important pollinators of woodland flowers.

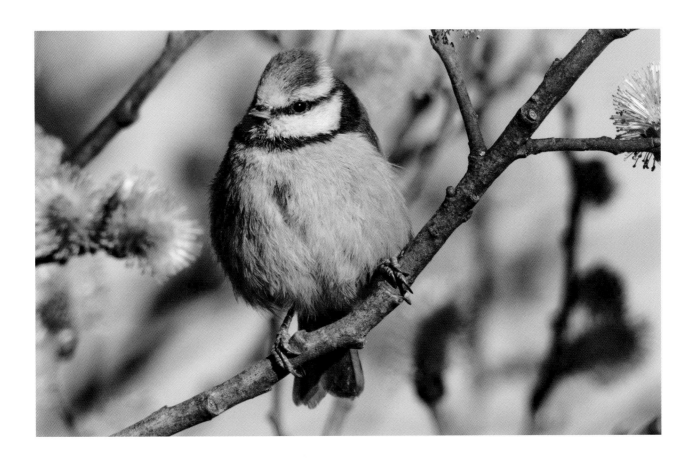

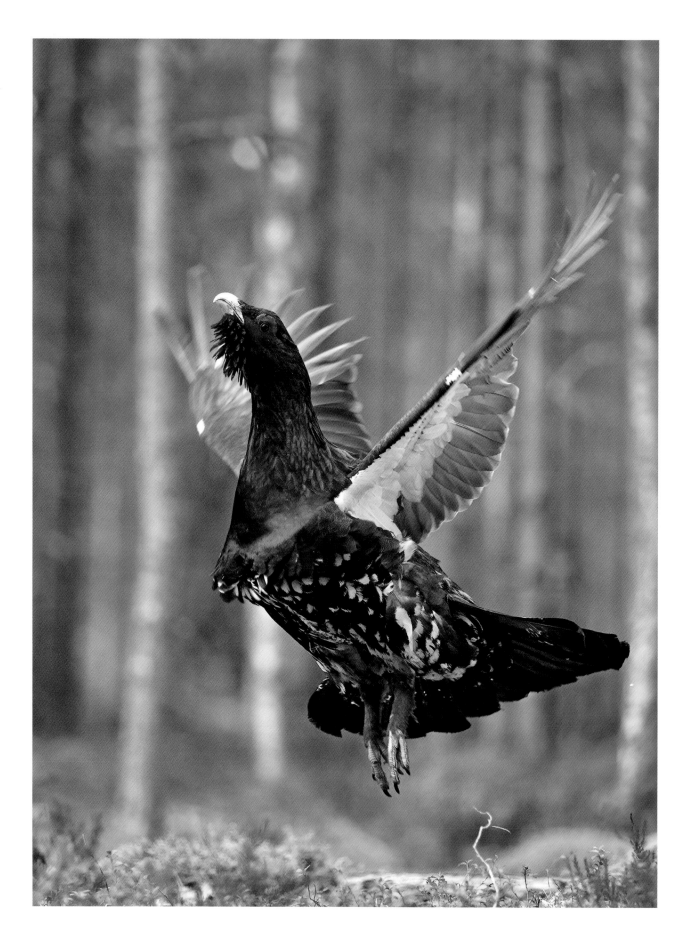

THE CAPERCAILLIE – AN EARLY SPRING PASSION

As the forest warms and the sap rises in the Highlands of Scotland, the biggest species of grouse in the world is preparing for the climactic moment of its year. In wet glades and marshy wood edges, bog cotton springs to life. Feeding on the first fresh shoots of the season is an unobtrusive woodland bird with cryptic patterning. The female capercaillie (*Tetrao urogallus*) is the size of a pheasant and has endured winter on a diet of pine needles. It is now intent on feeding on the lush new shoots. Until, ringing through the awakening forest, comes a rather more obtrusive sight and sound.

As a strange pop-popping noise fills the spring forest, the female flies up into the branches of a tree and surveys the forest floor. There below her, straining its neck high, with the fierce red eyebrow of a warrior and displaying a glorious fan tail like 'a black sunrise' in the words of the Scottish writer Jim Crumley, struts the male capercaillie. In one of the most dramatic examples of sexual dimorphism in the animal kingdom, the cock is a turkey-sized bird, twice as large as the hen, with vivid black feathers and a chest that flashes iridescent pine-green. While the hens gather to quietly look on, the cocks puts all their new-season energy into a vigorous contest to win themselves a mate – or five.

The capercaillie lek, where males gather to display and attract the attention of the watchful females, can be a dramatic contest. The parading cocks make extraordinary noises with their beaks that sound like a conker bouncing down a flight of stone steps before landing in a still pool of water. When two males compete for the prime arena in the Caledonian pine forest, there is a rumble in the jungle. These huge, herbivorous birds launch themselves at one another through the hummocks of heather and blaeberry, each attempting to rip tail feathers from the other to reduce their rivals' magnificence. Mostly this is all flap and bluster. But, occasionally, the fights become serious, and cocks can be badly injured and even die. The battles are fierce because the rewards are so great. The females show little interest in the males who finish second. Most will drop in on the most powerful male, hunker down and wait to be mounted. If they can distract him from his display for a moment or two, they will be mated. The dominant cock bird can be rewarded with several hens in one session, and as many as 20 if the hens are plentiful.

Unfortunately, healthy numbers of capercaillie are becoming harder to find in the relatively small part of Scotland where they still live. This quintessential bird of the Caledonian pine forest is under very real threat of extinction – for a second time.

The capercaillie takes its name from a corruption of *capall-coille*, which in Gaelic means 'wood horse'. It thrives at northerly latitudes across Europe but was driven to extinction in Scotland by 1785, due to deforestation and hunting. In 1775, a Scottish clergyman, Lachlan Shaw, described capercaillie flesh as 'tender and delicious' with a note of 'resinous fir'.

As large landowners in the Highlands moved from sheep farming to newly fashionable estates providing deer stalking and grouse shooting in the nineteenth century, so it became desirable to restore the most magnificent of the grouse species. The capercaillie was reintroduced in 1837 using birds brought from Sweden.

The returned population did well and by the 1970s there were thought to be 20,000 birds, mostly in the network of forests across the Cairngorms. Unfortunately its population has never risen above a paltry 2,000 since scientific counting began in 1992. In 2022, the population had fallen to just 542 individuals, a 50 per cent fall on the previous survey. This magnificent bird is on the brink of extinction.

A challenging conjunction of six different factors is causing the capercaillie to struggle. The loss and fragmentation of forest habitat is the first, long-term cause of the bird's decline. Its key food source, blaeberry (*Vaccinium myrtillus*), not only provides the birds with leaves and berries but is an excellent host for invertebrates, and capercaillie chicks are insectivorous in the first weeks of their lives. Blaeberry reaches its greatest size in old Caledonian pine forests but where it is grazed it becomes a low-ground plant with fewer flowers and fruits. The arrival of large-scale sheep grazing in the Scottish Highlands followed by today's almost unprecedented deer population – far higher than any comparable north European countries – has reduced the varied forest understorey that the capercaillie requires to prosper. Capercaillie can survive in new plantation woodlands but particularly thrive in a mosaic of habitat that includes boggy areas. These are often drained and removed from commercial plantations.

Scientific monitoring reveals that adult capercaillie are surviving reasonably well – a cock can live to the grand old age of ten. The key problem is the bird's low breeding productivity. Rapid climatic changes are the second major pressure on population, contributing to the adults' failure to rear enough youngsters. The hen birds nest on the ground and their chicks usually hatch in June. In recent years, the Highlands have endured extremely wet Junes. During this weather, the chicks become hypothermic and die. While overgrazing has been a historic cause of capercaillie decline, it may be that in areas where the deer population is now excluded or controlled, vegetation that grows faster than ever during today's warm, wet summers is becoming too rank and damp for the chicks to move through. This also contributes to infant mortality.

The third, rather bitterly ironic factor in the species' decline is the fencing that keeps deer out of plantations and old-growth forest. While this should allow blaeberry to flourish and thereby help the capercaillie, the birds have a habit of not seeing the wire fences, crashing into them during their brisk, heavy flight, and dying.

Disturbance by people is the fourth challenge to the capercaillie in the modern age. The bird is furtive and vulnerable to disturbance, faring better in untrodden corners of the forest. Studies have shown it avoids areas close to footpaths in the

Highlands. Unfortunately, the growth of 'off-track' activities such as mountain-biking, orienteering and the latest winter trend, snowshoeing, has further shrunk and fragmented the areas of forest where the capercaillie will thrive.

Although people no longer hunt capercaillie in Scotland, the resurgence of other native predators is the fifth major problem for the bird. This big juicy herbivore, and its vulnerable, ground-dwelling chicks, are a tantalising treat for some. Golden eagles will take the birds as, occasionally, will white-tailed eagles. Goshawks are another threat. Lacking larger predators such as wolves and lynx, Scotland has a preponderance of medium-sized mesopredators – particularly foxes but also badgers and crows. All will take chicks. And yet there is evidence that if foxes are controlled, this benefits another, more widely welcomed native predator: the pine marten. While conservationists are keen to see this endangered, tree-dwelling native mustelid recover its population, the pine marten will raid capercaillie nests. Although both creatures evolved together over thousands of years, the capercaillie becomes far more vulnerable to predation when its forest habitat is degraded, overgrazed (or under-grazed) or fragmented.

As if that wasn't enough to contend with, conservation scientists believe there may be a sixth cause of the capercaillie's decline. Because the birds were reintroduced before a modern knowledge of genetics, they are descended from a relatively narrow genetic stock. Studies earlier this century revealed that the genetic health of the Scottish birds was low but not low enough to be suppressing the population. However, the population has fallen since then. There are fears that important connections between metapopulations of the birds have been lost, and so their genetic health is falling further, as is their reproductive success. Genetic studies are currently underway to establish if this theory is correct.

Fortunately, help is at hand. The capercaillie would probably have already fallen extinct were it not for conservation efforts over the last three decades. The species is benefitting from Cairngorms Connect, an ambitious mission involving multiple landowners, conservation charities, the Scottish government and the Cairngorms National Park, to recreate and reconnect a much larger area of native Caledonian pine forest. The project has a 200-year vision to restore a mosaic of native wild forest over 600 square kilometres within the vast Cairngorms National Park. There is also a specific Cairngorms Capercaillie Project to tackle each cause of the bird's decline, funded by partners including the National Lottery Heritage Fund, the RSPB and the Scottish government's forestry agencies, Forestry and Land Scotland and Scottish Forestry. Education programmes are raising awareness of the birds and seeking to ensure that people who stray off tracks are not disturbing them. There is funding for forest management so foresters are incentivised to protect the boggy cotton-grass glades that the species so enjoys. There are grants available so the canopy density can be managed to ensure that understorey species such as heather flourish but don't grow too quickly. Deer fencing is adorned with bright orange or green-coloured netting, or wooden poles, so that the birds see it and do not hurtle into it. And there is more scientific monitoring of leks. By monitoring population numbers, including of young birds, more closely, conservation scientists hope to better get a handle on what is happening and how we can ensure this magnificent species remains part of our native forests.

CONSERVATION HERO:
MOLLY DOUBLEDAY,
CAPERCAILLIE PROJECT OFFICER

The capercaillie, says ecologist Molly Doubleday, who became the Cairngorms Capercaillie Project's conservationist in 2018, is one of the most charismatic creatures of the Caledonian forest. 'There is a sense of capercaillie being here forever', she says. 'They just fit with the landscape really well. There's a prehistoric feel about them – this massive bird erupts from a tree. You can't ignore that. You can't miss that.'

Employed by the RSPB and also funded by the Cairngorms Capercaillie Project and NatureScot, Molly is working on every aspect of the bird's conservation, from devising new informative signs, to adding colourful netting to fences, to encouraging land managers to tweak their forest management to help the bird. 'A lot of land managers are very proud to have capercaillie in their forest', she says. 'There's lots to be done to improve habitat but one of the things is just to create more of it – more, bigger, connected forests.'

As well as leading all the population monitoring, with labour-intensive 'lek counts' during April, Molly is also raising awareness of the bird among the local community. Despite their size and noise, capercaillie are elusive birds and cannot be easily seen in the wild, particularly when they are so easily disturbed. 'It's very challenging to engage people with a species they cannot see, because they are elusive and because we have to be protective of them and their habitat', she says. 'We can do all the good we want with habitat but if we haven't got people onside it's going to fall a bit flat.' One key challenge is to work with groups such as mountain bikers to ensure that people can enjoy the Highlands without the birds being unnecessarily disturbed.

For all the glamour of the cock birds, Molly's favourites are the low-key hens. 'They are really under-appreciated. When you see them in the lek, that's really special', she says. 'As soon as a hen is about, the male birds all put on their best show.'

Molly admits that saving a declining species from extinction can feel daunting at times. 'People say capercaillie conservation has been going on for 30 years and yet the species is still struggling. But if that hadn't been done I don't think we'd have them anymore.'

Opposite: The male capercaillie displays his magnificent plumage at a sunrise lek – where male birds compete to attract females.

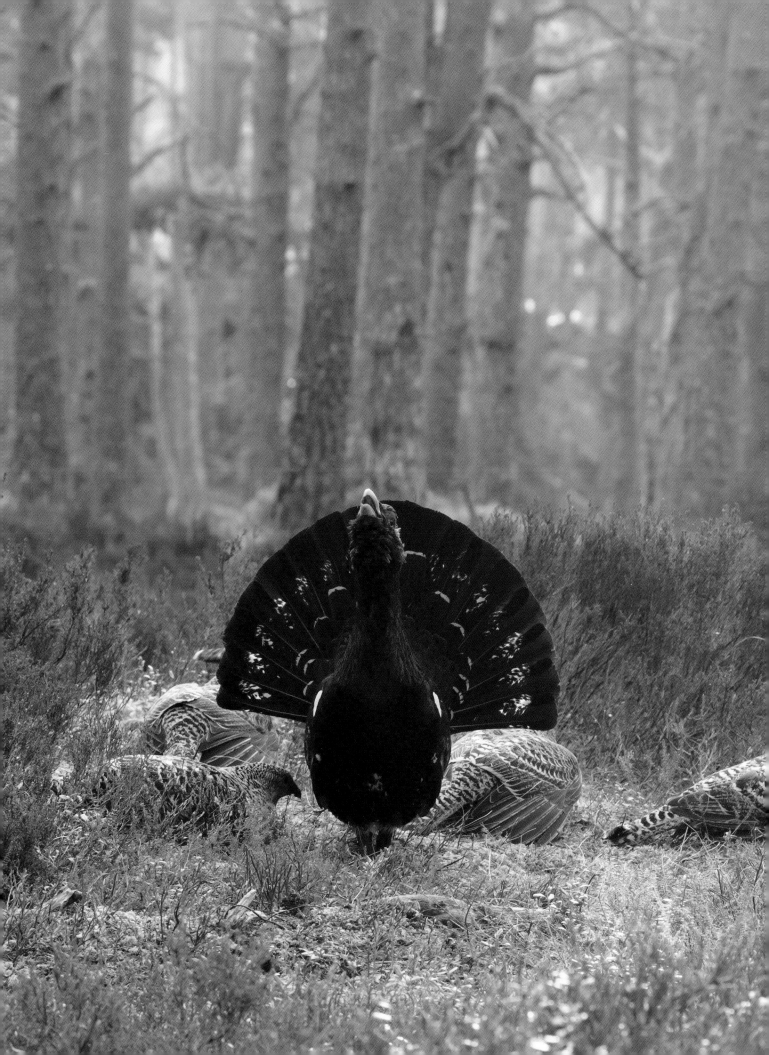

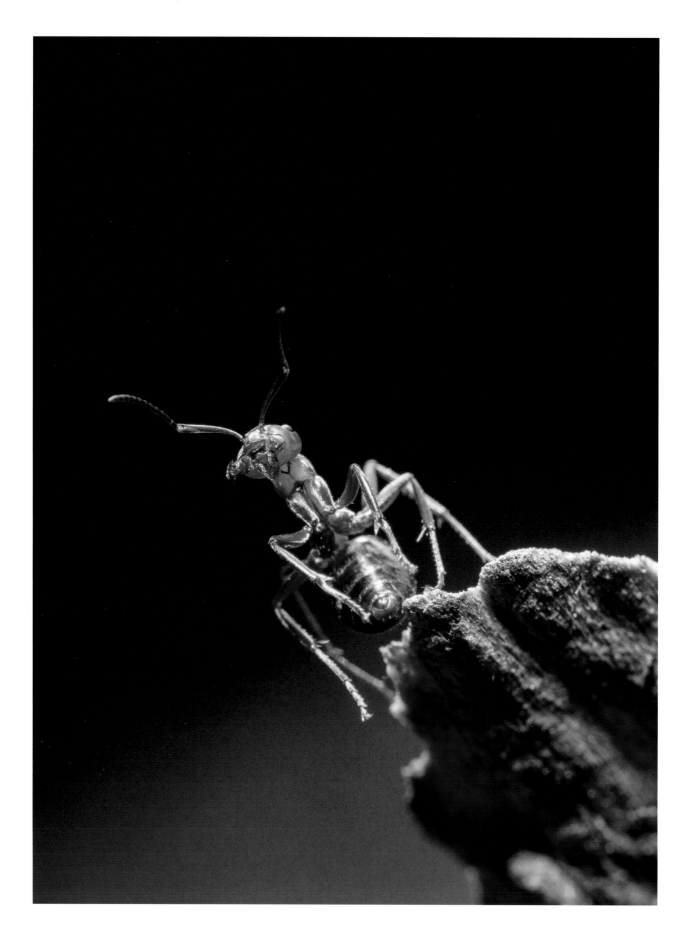

Wood Ants – Friend or Foe?

Opposite: Here, a wood ant is adopting a defensive posture in the ancient wood of Burnham Beeches in Buckinghamshire.

There is the cackle of a green woodpecker and the screech of a jay as the sun rises over the ancient forest of Burnham Beeches in Buckinghamshire. The day is still, soft and quiet, shafts of low sunlight arrowing through magnificent ancient trees – mostly stout beeches that have been pollarded for many centuries and live on, even though their central trunks are almost completely hollow. The wood resounds to the scratch of squirrel claws, as grey squirrels chase each other, helter-skelter, up, down and around the veteran trees.

It takes longer to spot the forest resident who is far more numerous and significant than the squirrels. If we stop, and look carefully at the soft woodland floor of last year's leaves, every single square metre has an ant striding purposely across it. Scattered between the ancient trees are huge mounds, each almost the size of an armchair, constructed from tiny twigs and chewed up leaf litter. These are seething ant cities, and they are home to one of the most important predators and engineers in our most biodiverse woodlands. An individual wood ant may be minuscule but collectively these communal creatures play a surprisingly large part in forest life. The wood ant is a forester, a farmer, a carer, a soldier, a brilliant engineer – and a ruthless killer.

Wood ants are the largest native ant in the British Isles, with workers measuring between 8 and 10 millimetres in length. Put beneath a microscope, the northern hairy wood ant (*Formica lugubris*) can be told apart from its cousin, the southern wood ant (*Formica rufa*), by its bushy eyebrows. Even in the sheltered forests of southern England, the southern wood ant is at the northerly edge of its natural range. The key challenge for its colonies – there can be 65,000 inhabitants within one nest – is to stay warm.

To do so, these indefatigable insects build large mounded nests featuring a heating system as ingenious as a high-tech 'passive house'. Every ant colony is headed up by a queen, who is the sole producer of subsequent generations. She may live up to 15 years but she cannot survive without her workers, female ants who perform an astonishing variety of complex roles for their community during their year-long lives. On a sunny day, the workers will head to a patch of sunlight on the forest floor and form a dense black cluster like treacle. Each ant soaks up the sun's rays until warm, and then races back into the nest, taking the heat with them. These mobile radiators will move back and forth, from sun spot to nest, until their queen and her larvae have the warmth they require.

The nest's thick thatch also acts as insulation for the structure, which reaches as far below ground as it sticks above it. The site is carefully chosen, and may be against or around a rock, which can also absorb heat from the sun and conduct

it into the nest. The queen and her grubs will be moved around within the nest. They are taken to higher levels when warmth is required, and shifted further underground if it gets too hot, or too cold. The queen's home is vented as well. If warmth is needed, worker ants will open shafts when the sun spills upon them. If the sun moves away from that part of the nest, the shafts will be closed again to keep the warmth inside. If it gets too hot, ventilation holes in the shaded side of the nest will be opened to allow cool air in. During winter, if light snow falls on the forest, the first place it melts may well be upon on a wood ant's nest. Even in the depths of winter, when the ants cannot feed and must hibernate, they generate considerable warmth.

Unsurprisingly, such a well-heated home is attractive to other forest residents. Unique species of beetles, woodlice, spiders and even a pseudoscorpion make their homes inside southern wood ant nests. Another contented resident is the shining guest ant (*Formicoxenus nitidulus*). This tiny, two-millimetre-long glinting stowaway is like a mouse in a human house. It scurries quickly around, eats scraps and disappears inside hollow twigs within the nest to conceal itself. The shining guest ant's eggs and larvae would be devoured by the wood ants if they got a chance but the little ant sensibly nests in crevices so small that the fearsome workers cannot reach it.

Ants have remarkable powers. If we humans could run like an ant we would run as fast as a racehorse; if we could lift the weights that an ant can haul around, we could carry a bus. Worker wood ants usually begin life performing roles inside the nest, tending to larvae or clearing away waste products and keeping their home clean, tidy and free of disease. Later, they leave the nest and become foragers, seeking food for their colony. They can be predatory carnivores but they can also be farmers.

'We tend to think that we don't have any big predators in our woodlands', says Dr Elva Robinson of the University of York, who studies the behaviour and ecology of wood ants, 'but collectively they are the dominant predator in most woodland ecosystems. You might think it's a badger or a fox but in terms of biomass consumed, it will be wood ants in most places. It's fascinating what dramatic effects they have on invertebrates around them. They really shape the whole ecosystem that they are in.'

Wood ants are aggressive hunters. They have good eyesight (some ant species don't) and a keen sense of smell but often locate prey by vibration. They will feed on a wide range of insects they encounter – caterpillars, beetles, other ant species and even adult butterflies. But 90 per cent of their diet comes from farming. The ants collect honeydew, a sweet, sugary substance excreted by the thousands of aphids that feed on trees and shrubs. Ants will 'milk' the aphids for the honeydew, stroking the aphid's abdomen with their antennae to stimulate the secretion of honeydew. Like shepherds with a flock of sheep, the ants protect the aphids from predators. They will chase away ladybirds. They will even move their aphids to better feeding grounds. The workers' abdomens swell with the honey which they take back to the nest and regurgitate for the queen and other workers. Aphids may be 'dairy' livestock for the ants but they are also 'meat': after farming some species for a while, the worker ants will kill them for eating.

Opposite top: Wood ants often build their nests around dead and decaying wood, such as this one in Burnham Beeches, Buckinghamshire.

Opposite below: Wood ants are voracious predators, capturing prey many times their size, such as this lesser stag beetle.

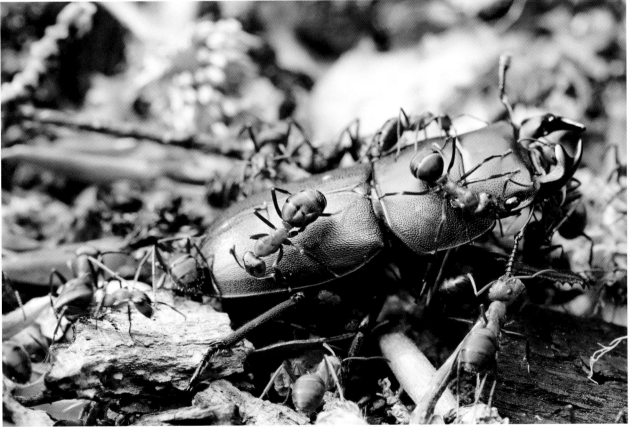

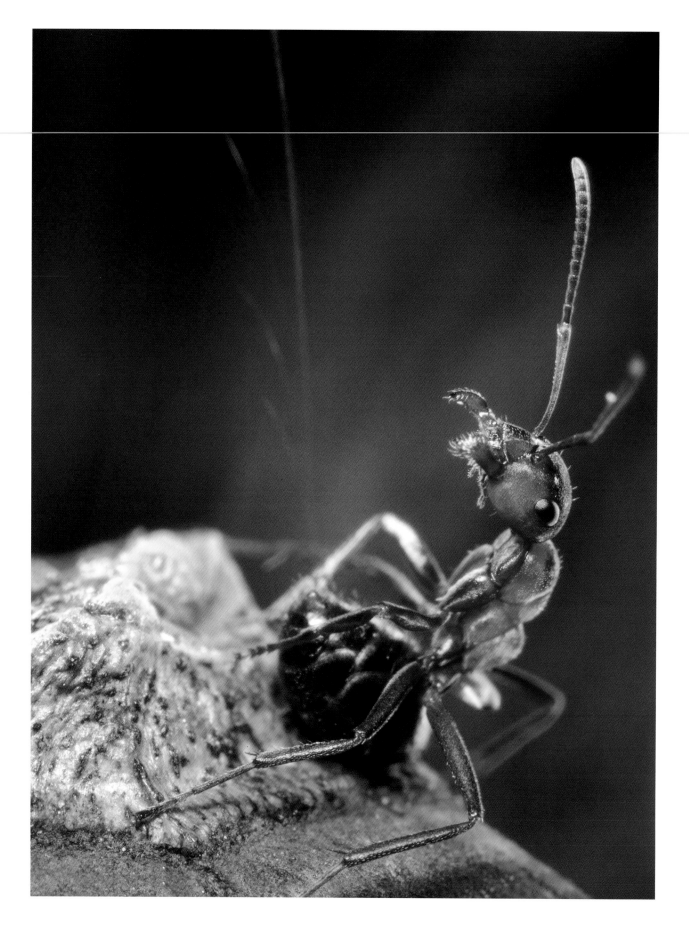

Opposite: Wood ants will
defend their nest against much
mightier prey. Here, a worker
is in defence mode, spraying
formic acid from its tail.

Back at the nest, there is another job to be done: defence. The juicy larvae being raised inside the nest are tempting for larger predators. While the workers cannot do much about a badger, who will dig into the nest for grubs, they will use all their weapons to repel birds that arrive for a feast. The ants swiftly mobilise to spray formic acid from their abdomens. Like water from a firefighters' hose, jets of vinegar-like acid can be fired to distances up to 12 times the ant's length. This will repel many attackers but birds such as jays and green woodpeckers have turned it to their advantage. While green woodpeckers are one of the few birds to enjoy eating lean, unappetising worker ants – 'It's mostly crunch and acid. There's not much nutrition in a worker ant', says Robinson – sometimes they will visit a nest deliberately for a disinfecting bath. The formic acid gets rid of parasites that live on a bird, such as lice and mites.

The miraculous communities of wood ants invite many comparisons with our human world. Relative to their size, ants have the largest brain of any insect, typically containing 25,000 cells. A human brain has 10,000 million cells so a colony of 40,000 ants is equal to one human brain. Is an ant colony actually one super organism? Or is it in fact a community of individuals, like a human city? It is actually a bit of both.

'All the individual workers doing their own jobs have individual memories and existences', says Robinson. 'They remember routes and will go back to the same branch of a tree for instance, but they are not independent individuals because they are so tightly integrated into the colony that they are part of.' In the super organism analogy, each group of ants is an indispensable part of the whole. The queen cannot survive without the workers, nor the workers without the queen. In effect, the queen represents the reproductive organs, while the workers are the body parts that process the food and tend to the young. And yet this idea doesn't precisely fit the character of an ant colony either. Collectively the ants may solve some impressive cognitive challenges, such as finding food in a constantly changing forest world, but an individual worker ant possesses more agency than a group of cells within a brain.

Comparisons with people are difficult to avoid once again when taking a closer look at how wood ants shape the forest ecosystem around them. Wood ants' nests create a habitat niche where a range of invertebrates can prosper. They provide a source of food for a variety of forest animals. Wood ants also influence the growth of trees. Protecting and 'farming' so many aphids can be compared to livestock overgrazing a meadow: on occasion, the ants may farm so many aphids that these insects, which feed on tree sap, can slow the growth of trees. But in German plantations, foresters will move wood ant nests into their woods to help protect the trees. If a pest descends, and there is an outbreak of caterpillars devouring leaves for instance, predatory wood ants will quickly move in and destroy the invaders. Aerial photographs have revealed an area of defoliated trees – stripped bare by caterpillars – but one tree in their midst, mysteriously, still in leaf. Further investigations found a wood ant nest at the base of that tree – proof of the protective power of wood ants, the guardians of the forest.

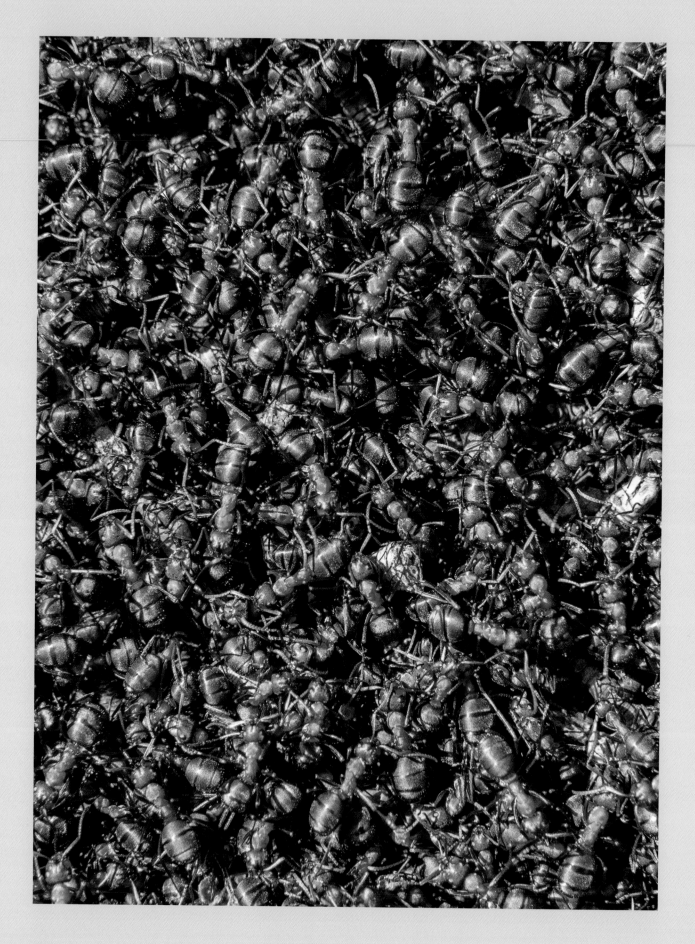

CONSERVATION HERO:
DR ELVA ROBINSON, SENIOR LECTURER IN BEHAVIOURAL ECOLOGY, UNIVERSITY OF YORK

When Elva Robinson was a child, she conducted her first scientific experiments on ants in her garden. She decided to investigate whether they preferred cabbage or biscuit crumbs. 'Unsurprisingly they preferred biscuits', she laughs. 'Hold the scientific press!'

When Elva began a five-year academic study of the northern hairy wood ant, she imagined that she had time to answer all her questions. Now, after more than a decade of studying ants, sometimes fitting workers with miniature radio tags so individual ants can have their movements tracked and recorded with scanners, she realises that this complex group of species poses so many questions it would take more than a lifetime of research to answer them.

One of her key findings is that northern hairy wood ants practise polydomy. This means that one super-colony lives across multiple, co-operative nests. Southern wood ant colonies usually live in one nest, and different colonies compete with each other. But northern hairy wood ants spread through the forest by 'budding', with queens leading groups of ants out to establish other colonies. Eventually, there is a network of nests which despite their different locations continue to co-operate, or display altruism. The workers from one nest will even supply another with food.

'That's a striking form of co-operation', says Elva. 'Co-operating outside of your immediate group is very unusual in the animal kingdom. It's really only humans, bonobos and polydomous ants that do this.'

Why do they share resources? It was thought that a network of nests enables the ants to take advantage of different tree species that house different aphids at different times of year. But 'that doesn't seem to be happening', says Elva. She believes the most likely explanation is that it is very risky and difficult to establish new nests. Wood ants do not disperse widely, and new nests will often fail. Sharing food enables nests to persist in shadier, less favourable sites; a network of nests is more resilient than individual units.

Ants are very different from humans but they may have valuable lessons for us. With these polydomous nests, the wood ants are radically decentralised. A colony can spread its risk, hedge bets, switch roles. Its decision-making is distributed. In contrast, human societies often lean towards centralised control which is 'actually a really risky strategy', says Elva. 'People talk a lot about resilience now and it's something that we really need in our systems.'

Opposite: A wood ant nest in Burnham Beeches.

ROE DEER FAWNS –
HIDDEN FROM SIGHT

Concealed beneath the fast-growing young bracken is a dainty orange-brown animal, a young roe deer. It is a newborn, spindly and staccato of movement like a spring lamb. Its mother licks it tenderly.

The roe deer (*Capreolus capreolus*) is one of only two native deer species, alongside the larger red, and has made its home in British woods since the last Ice Age. By the eighteenth century, however, these small deer were almost extinct because of hunting. Since then, their numbers have recovered as many landowners reintroduced the animals, keen to have this attractive deer to hunt, and to adorn our landscapes once again.

Roe deer are a wood-edge animal, and today they are thriving, often living discreetly in suburban and even urban woodlands. Here, in southern England, an old cemetery is an ideal and tranquil safe haven, its sunny glades and secluded undergrowth mimicking the ancient wood pasture where the deer once roamed.

The doe is feeding on the lush vegetation of early summer. She mated last August but her fertilised egg did not implant and start growing until January. After five months of foetal development, her fawn was born in May, timed to coincide with the months when nutritious young grass is at its most luxuriant.

The doe eats hungrily but she is wary. Her fawn is hidden close by. It cannot keep up with its mother yet, so she leaves it on the forest floor where its spotted back is perfectly camouflaged in the chiaroscuro of dappled light falling upon last year's leaves. This fawn wants to get going, however. So it struggles to its feet, and wanders off.

The life of a young roe deer inspired Felix Salten's 1928 book, *Bambi*, and the first steps of a young roe would once have been fraught with danger. In modern times, the roe's natural predators, the lynx and the wolf, have long been exterminated in Britain, and the major hazard this youngster must negotiate are the vehicles rushing along the roads beyond the woods.

When the young roe deer becomes lost, it makes a high-pitched whistle to attract its mother. She is not far away, and soon they are walking side-by-side, quietly and carefully through the woodland in search of food. After two weeks, the youngster loses its spots, and the bright red-brown animals move together, feeding, growing and gaining in strength for the winter to come.

If we chance upon a roe family in a summer wood, they will almost certainly have seen or heard us first and so we usually only catch a glimpse of a white rump disappearing into the bushes. The tail-less roe is a much-loved part of native woodlands but there is growing concern about the impact of deer on trees, plants and other animals. The fashion for keeping deer as parkland ornaments, or beasts

to be hunted in deer parks began with the Romans, who brought the fallow deer
to Britain. The Victorians and subsequent eras of landowner added more species
which soon escaped into the wider landscape. Today, there are fallow deer too, and
three non-native species from Asia: the small, dumpy muntjac deer, the graceful
Chinese water deer and the larger sika deer.

All are attractive animals but there are almost certainly more deer in Britain
today than at any time since the Ice Age. As we saw in the Grasslands chapter, in
Scotland native red deer live at far higher densities than in any other European
country to sustain the lucrative tradition of deer stalking in the Highlands. High
densities of red deer prevent the natural regeneration of ancient Caledonian pine
forests, nibbling away what would be a naturally expanding native forest growing
along unnaturally barren Scottish glens. Unless deer numbers are radically reduced,
new trees must be protected by tall, expensive deer fences.

Further south, non-native animals such as muntjac find every plant palatable.
Grazing by deer is impoverishing the botanical diversity of many woodlands.
Other species, such as woodland butterflies, suffer because of the loss of foodplants.
Deer browsing also dismantles the dense understorey in many woods which has
been home to nesting birds such as nightingales, which are increasingly rare.
Conservationists don't like to kill animals but many now believe there needs to be
more culling of both native and non-native deer to reduce their populations and
allow wildflowers and other woodland species to flourish once again.

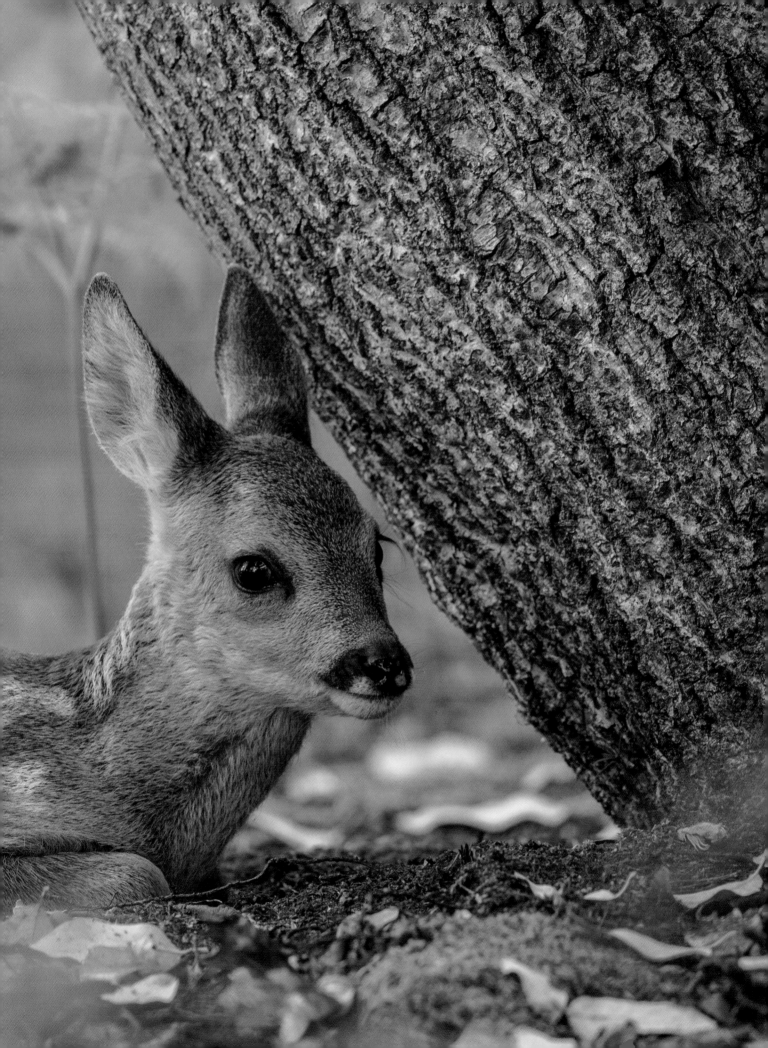

PURPLE EMPEROR BUTTERFLIES – BATTLES IN THE TREETOPS

Opposite: The caterpillar of the purple emperor butterfly is supremely camouflaged as it devours sallow, or goat willow, changing colour to match the season.

As summer arrives, one of Britain's most charismatic insects, the purple emperor (*Apatura iris*) lives out its short adult life among the trees of the Midlands and the South of England. The emperor has long bewitched its many admirers, for it is the second-largest butterfly in Britain and the males flash iridescent purple when caught in the sunlight. But it has other special qualities too: it is notoriously elusive, remarkably aggressive and does not descend from its treetop realm to refuel on flowers like other butterflies. Instead, it prefers to imbibe minerals from tree sap, muddy puddles or more execrable treats – fox scat, horse manure, and even stinking fish pastes laid down by enthusiasts as 'bait' so these majestic creatures can be photographed.

Seeking out the emperor is a challenge rather like bird-watching. The males of this big, bat-like butterfly are vigorous and fast-flying. They are most frequently glimpsed as a dark silhouette against the sky, dashing around the canopy of prominent trees in a wood, commonly oak trees. The males usually emerge around midsummer and can be seen through the first half of July. Butterflies follow a cycle, from egg to caterpillar to chrysalis and adult, and every adult butterfly is fully grown and possessed of one sole purpose: to reproduce. Male emperors pursue this purpose with particular vim and vigour.

In the mornings, the male emperor will cruise around clumps of goat or grey willow, the fast-growing trees once regarded by foresters as 'weeds' but which are havens of biodiversity and this caterpillar's foodplant. It is searching for freshly emerged females, which hatch from superbly camouflaged pupae that dangle from the sallows. Each pupa resembles a curled green sallow leaf. Later in the day, the emperor retreats to the high ground, usually in a sheltered part of the canopy of a woodland and among the highest trees. Sometimes one tree is favoured, known as a 'master tree'. Here, the male establishes a vantage point and a territory which he will defend from all-comers. Oaks are favoured because their dense foliage offers plenty of shelter, but emperors may also choose to perch high on beech, sycamore, poplars or even pines.

When emperors zoom in to land on a spray of leaves, they perform a last-ditch backwards flip so they settle facing outwards, ready to race off again. If an emperor encounters another male invading its territory, it launches itself at the invader. Both butterflies circle each other several times and then ascend upwards in intense combat, chasing each other until they are far out of sight. The winner then descends to take up possession of the most desirable arboreal real estate.

The fearless male emperors will intercept and chase off other intruders too: horseflies, hornets, dragonflies and even birds. Matthew Oates, a naturalist, author

and emperor obsessive who has studied the butterfly all his life, has compiled a list of birds chased by male purple emperors. It includes siskins, great spotted woodpeckers and even buzzards, hobbies and, at the Knepp Estate in Sussex, a reintroduced white stork. Attacking a carnivorous dragonfly is risky enough but the emperor which launched itself at the hobby was one of many whose life was cut short because of its foolhardy bravery.

The male's taste for aerial combat makes them a short-lived insect. Oates estimates that most don't survive more than ten days. The more cautious, and much more elusive female lives longer and later through the summer. Unlike us, insects see within the ultraviolet range. The vivid flashing purple of the males makes them ultra-visible to other males and, possibly, to females too. Interestingly, the males are not so visible to other animals to whom they show up as a dull brown, with white wing markings seemingly designed to scatter light within a forest.

The female has no need for flashing look-at-me purple because her role is different: once mated, she has no need for any male attention but must survive as long as she can, gestate her eggs and lay up to 200 of them on sallow. Once males have found a female, mating occurs out of sight in a tree canopy. Oates has recorded an average of three hours and 32 minutes for each pairing, despite frequent interruptions from other males. Once mated, the female avoids amorous males as much as possible, often lurking within dense thickets of sallow. Plenty of emperor fans have never even seen a female purple emperor.

The purple emperor spends by far the greater part of its life as a caterpillar. The female's eggs hatch onto sallow leaves in late summer. Caterpillars move through stages of growth, or instars, where they shed their skin. By its second instar, the emperor caterpillar sports a pair of forward-facing V-shaped horns. By the third instar, they are ready for hibernation. They may be a large butterfly but they are still a tiny caterpillar, less than 10 millimetres long – about the size of a slender woodlouse. They are masters of camouflage, changing colour from green to grey-brown as the leaves fall off the autumnal sallows. During winter, each caterpillar lies dormant, as if asleep, usually between the fork of a sallow twig, or beneath a bud, which it strongly resembles.

The caterpillars may be virtually invisible to human eyes but they suffer great mortality particularly in early spring, when bands of long-tailed tits, great tits and blue tits bounce through the sallows, each with a beady eye for a small caterpillar. The emperor caterpillars that survive this carnage turn green again with the spring growth and feed up rapidly on sallow leaves, developing into a fleshy, handsome lime-green horned caterpillar. By June, they are the size of a child's little finger, still well-camouflaged, and ready to pupate.

It was once thought that the emperor was only a creature of closed-canopy woodland. But the ubiquity of the butterfly at Knepp Castle, in the West Sussex Weald, reveals a different picture. Knepp is a 3,500-acre dairy farm which was rewilded by its owners, Charlie Burrell and Isabella Tree, at the turn of the century. With the abandonment of pasture and arable fields, among the first trees to recolonise the land were fast-growing sallows. Within a decade, these sallow thickets had lured in emperors from the surrounding landscape. At Knepp, the males today do battle around old hedgerow oaks. The key for this butterfly is not mature woodland but simply an ample supply of sallow.

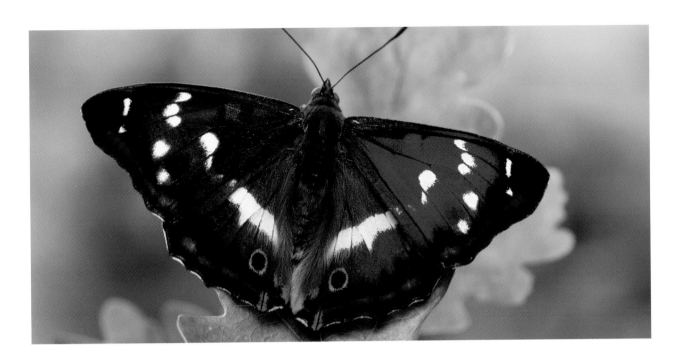

Above: The male purple emperor flashes iridescent purple in the sunlight. It dwells in treetops and will defend its 'territory' from allcomers, even birds of prey.

This revelation, together with an innovative surveying method pioneered by naturalists Liz Goodyear and Andrew Middleton, has revealed the emperor in many new haunts. We've got much better at tracking down this butterfly. Today it is found in cities, industrial estates and roadsides. In recent years, emperors have been discovered on Hampstead Heath in London, in the woodlands of Milton Keynes, and on roadside sallows in Northamptonshire.

While three-quarters of Britain's 59 native species of butterfly are in decline, the emperor appears to be expanding in numbers and in its geographical range. Although this tree-top dwelling species is vulnerable to summer storms, and the hibernating caterpillars also die off if winters are too mild, it may be benefitting from climate change. In the latter decades of the twentieth century, the emperor was confined to southern England, with strongholds in Surrey, Sussex, Hampshire, Wiltshire and Oxfordshire. This century, it has been discovered, or rediscovered, across eastern England. It appears to be moving northwards, with vigorous and relatively new colonies in Warwickshire, Nottinghamshire and Lincolnshire.

In the past, this butterfly probably suffered because its caterpillar's sallow foodplant was treated like a weed by foresters and removed from woodlands. Today, increased tolerance for species-rich sallow is helping it to flourish. The emperor's expansion has also been assisted by the clandestine work of a handful of butterfly breeders who have bred this insect in captivity and released large numbers into suitable woodlands, of which there are many.

The flourishing of this dynamic butterfly is a welcome sign that not all British wildlife is in retreat. Global heating may not be good news for many species but at northerly latitudes it should benefit warmth-loving butterflies, if – and it is a big if – there is suitable habitat for them. And the emperor's northwards expansion is a pattern repeated on the continent, with the butterfly moving north through the Netherlands and Denmark and flying into Sweden where it has now spread as far as Stockholm.

SLUG SEX – THE FOREST AT NIGHT

When night falls, there is perhaps no place more mysterious than Wistman's Wood, a tiny pocket of relict woodland in a small valley within the mostly treeless landscape of Dartmoor. While an oak normally reaches up 40 metres, the ancient trees of Wistman's rarely grow more than five metres. 'Their dark branches grow to an extraordinary extent laterally; they are endlessly angled, twisted, raked, interlocked, and reach quite as much downward as upward', wrote the author John Fowles, who was transfixed by the wood when he visited in the 1970s. 'These trees are inconceivably different from the normal habit of their species, far more like specimens from a natural bonsai nursery. They seem, even though the day is windless, to be writhing, convulsed, each its own Laocoon, caught and frozen in some fantastically private struggle for existence.'

Below: Two ash-black slugs dangle from an overhanging branch as they mate, their pale blue penises coiled together.

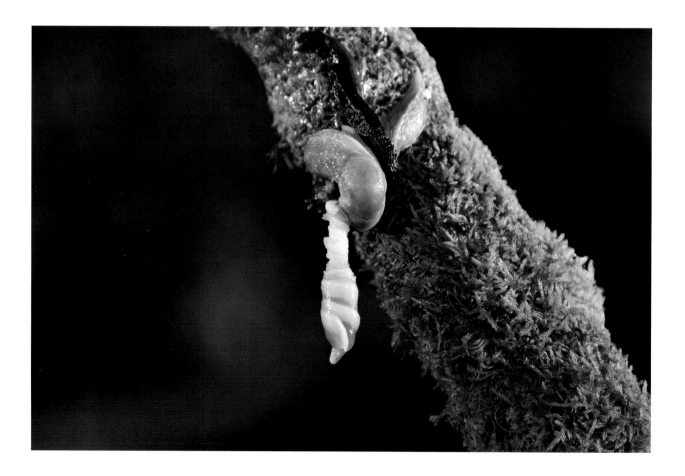

Ancient oaks provide niches for so many forms of life. The generous crevices created within the heartwood of these slow-living, slow-dying trees are particularly cherished by tree-roosting specialists. Barbastelle bats (*Barbastella barbastellus*) are one of only two of Britain's 17 resident breeding bat species to be listed as 'Near Threatened' globally on the International Union for the Conservation of Nature's (IUCN) Red List. As darkness falls, it is time for the bats to feed. Leaving their roost, they flit into the gloom, their rapid echolocation helping them arrow in on moths. Their nocturnal treats are mostly airborne. Sometimes, however, a beetle is too large to ignore.

On this occasion, the beetle's low profile helps it evade the predator's swoop. This creature, a blue ground beetle (*Carabus intricatus*), has its mind on prey of its own. This impressive beetle has an iridescent purple-blue wing-case and is Britain's largest ground beetle at three centimetres long. It is also a swift and ruthless predator. Its name is a misnomer because while it does live on the ground it is an adept tree-climber, and moves rapidly on its long legs, hunting up and down the brilliant-green mossy trunks of these Dartmoor woodlands.

It is so rare that it was once considered extinct before it was rediscovered at a handful of sites on Dartmoor and along the southern edge of Bodmin Moor in the 1990s. More recently, it was found in one wood in South Wales. It requires warm, damp forests, and does not like the cold. It is also an ancient woodland specialist, requiring plenty of moss and deadwood, and it will hibernate under the bark of trees.

The beetle's target is another creature only found in ancient woodlands: one of the largest land slugs in the world. The ash-black slug (*Limax cinereoniger*) can grow up to 30 centimetres in length (although most are between 10 and 20 centimetres). It is nocturnal, lives in trees, feeds on fungi and glides through the woodland at night rather elegantly. A damp summer's evening is a perfect time to mate. When these hermaphrodites (each individual is male and female at the same time) find a partner, the pair hang from a branch and strange blue corkscrew-like appendages unfurl from the side of each slug's head. Each corkscrew is actually genetalia, and this strange twirling dance is a battle to determine who will perform which role.

The ash-black slug is fast-moving, for a gastropod. But it cannot outstrip the blue ground beetle. When a beetle confronts one of these monster slugs, it looks like it is biting off more than it can chew. While the slug emits slime to clog up the beetle and make its escape, the beetle clamps on to the slug tightly. It injects digestive juices into the slug to kill it. Then it dissolves the slug into a jelly-like gloop, perfect for sucking up. As it feeds on its enormous meal, the beetle expands its abdomen and swells up, like a snake gorging on oversized prey.

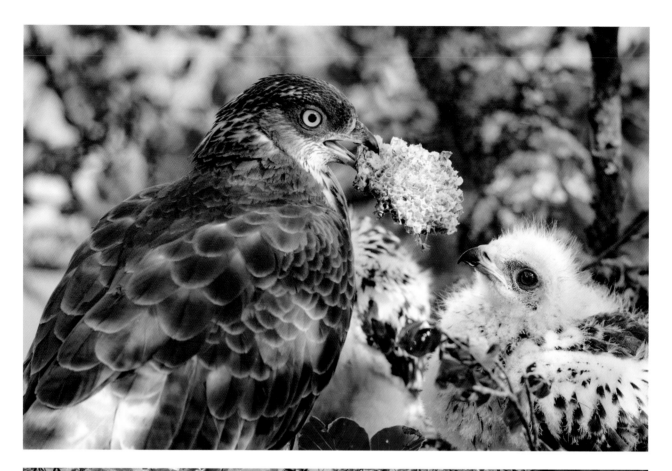

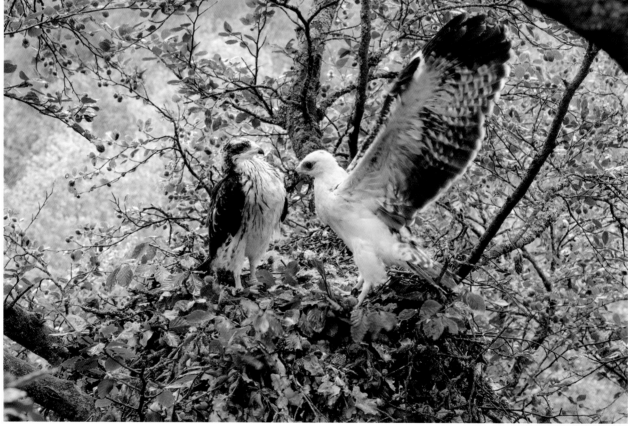

HONEY BUZZARD – A HIGH-RISE HOME

Opposite top: A female honey buzzard brings wasp comb back to her nest.

Opposite below: The female's two chicks will feed on the larvae inside the comb.

By the middle of the summer, in the middle of our woods, one of our most mysterious and elusive foreign visitors is making the most of the warmth of the season. In a nest high in a tree at a secret location within the New Forest, two chicks are feeding up well. An adult arrives. In flight, this bird can be mistaken for a buzzard. Up close, its unusually small head and slender neck look more like a cuckoo. It is a honey buzzard (*Pernis apivorus*).

Like the cuckoo, this bird is a long-range migrant, flying from sub-Saharan Africa to arrive in northern Europe by the middle of May. The honey buzzard's common name is misleading. So is 'bee-hawk', its old British name. This buzzard-sized bird of prey is more closely related to kites than to true buzzards. And the Germans have got it right: they call it Wespenbussard – 'wasp buzzard'. For this bird does not have a taste for honey – it much prefers the grubs of a wasp.

The honey buzzard is one of Britain's rarest breeding birds, with fewer than 50 pairs nesting across the country from southern England to northern Scotland. 'The honey buzzard is a bird of such elusiveness and strangeness that it teeters on the brink of myth', writes the naturalist James Macdonald Lockhart, 'a bird whose presence here is so short-lived and secretive it is barely here at all.'

Distinguishing the honey buzzard from the common buzzard is a challenge. The ubiquitous common buzzard is stockier, possesses a distinctive necklace of brown that separates its paler throat from its stomach, and flies with shallow, rather stiff-looking wing-beats. When it soars, it holds its wings aloft, in a low 'v'. In contrast, the honey buzzard soars with its wings held very flat, and flies with deeper wing-beats, as if using the whole extent of its wings. The underside of its longer tail features several distinctive bands of dark brown feathers, unlike the buzzard which has only one clear dark brown band across the outer edge of its tail.

The honey buzzard requires woods with plenty of sunny clearings and rides where its favourite food can thrive. It also requires suitable soil conditions: heavy clay is too difficult to dig into, and although the hot Mediterranean is full of wasps, its soils are too hard and dry to easily excavate. The sandy-soiled New Forest is ideal, not least because it is home to a rich invertebrate life, including more than 30 species of bee and wasp. Along its sunny rides fly the common wasp, the tree wasp, the red wasp, the German wasp and the Norwegian wasp.

The honey buzzard's late arrival in the British summer is still too early for most wasps, who are less active at this time. So it must get by on young birds, especially from the nests of pigeons, as well as frogs, lizards and insects. No creature seems too small for this unusual raptor: it will excavate beetles and worms from heaps of dung and will devour everything from ants to earwigs if the opportunity arises.

As well as feeding, the early days of summer are devoted to surveillance. While chicks are being incubated, the male honey buzzard will sit in a tree beside open forest glades, silently scanning the warm wood for potential prey. If it spies a worker wasp, it will set off in pursuit through the trees, following it back to its nest. But the honey buzzard does not always strike immediately. Instead, it logs where the nest is, and bides its time, stealthily building up a mental map of wasp nests throughout the forest that can provide a buffet later in the summer, when wasp larvae are ready – and the honey buzzard's chicks are too.

When it is time to strike, this unique bird of prey is ideally equipped for the job. It is more badger than bird of prey, with blunt claws that are not curved but almost straight, and so ideal for digging. Unlike other raptors, it is also a good walker, and is comfortable striding about on the ground in search of its prey. Its bill is more delicate than many other birds of prey and its tongue is tubular, perfectly adapted for delicately removing ant larvae from their chambers.

A honey buzzard can take hours to dig out a subterranean wasps' nest, and may feed from it for days, steadily retrieving chunks of grub-containing combs for its chicks. It is astonishing how calm the bird is when raiding the homes of furious stinging wasps. Unlike other raptors, it has thick, scale-like feathers on its face which offer it protection from stings. Occasionally it is beaten back by the angry wasps, but returns to indefatigably finish its excavation work. During its plundering, it will snap at attacking wasps, decapitate and eat them. It is also thought to release chemicals that calm the wasps.

When it returns to the nest with pieces of comb, the eager chicks will sometimes become sticky with honey. The chicks soon understand their unique lifestyle, and their impulse to dig is so strong that they will sometimes practise it in the nest, threatening to undermine their aerial home.

Although the honey buzzard is rare, and historically has been persecuted even though it does not predate gamebirds or any other creatures coveted by humans, it is surprisingly resilient when the summer is not as hot as expected. The male's careful mapping of wasp nests throughout the forest stands it in good stead if the season is wet and cool, and wasps are not as plentiful as they usually are. At summer's end, fuelled up on the grubs of the forest, the honey buzzard migrates south to warmer climes, disappearing before most of us notice that it ever arrived.

Opposite: A female honey buzzard filmed by the *Wild Isles* team in the New Forest.

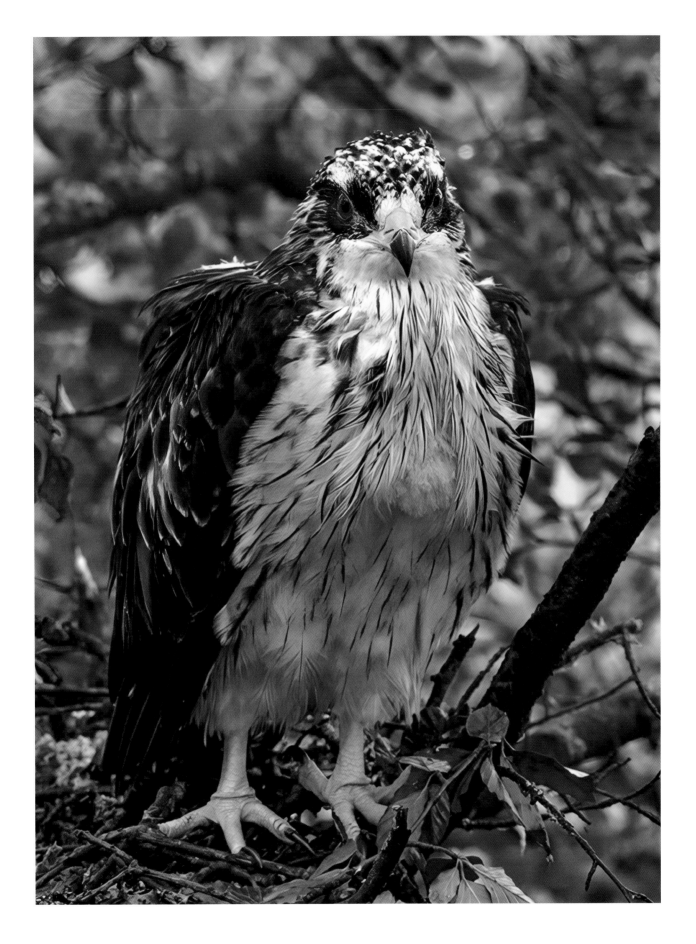

Autumn Forest and Fungi – The Wood Wide Web

As the days grow shorter, the forests prepare for winter. The most obvious sign is the glorious colours of the leaves of deciduous trees, which turn our woodlands into shifting kaleidoscopes of yellow, orange and red.

Leaves are green because they are filled with chlorophyll, which processes sunlight to generate sugars. Because sunlight dramatically diminishes in winter, the leaves can no longer make food for the tree. Before the leaves are cast off – a process known as abscission – the tree extracts all the valuable material it possibly can from them. The green chlorophyll is broken down into colourless compounds, revealing other compounds: the carotenoids reveal themselves in brilliant yellows and oranges; the anthocyanins show up in the deep reds and purples.

The season of growth is over, and decay becomes the motif of the forest. As the leaves swirl downwards, fungi begin to break down and reuse rotting matter. Autumn is the season when chanterelles, boletuses and spectacular fly agaric fungi sprout up, and reveal their crucial, and usually hidden role in the life of the forest. The fungi that are such attractive 'flowers' in an autumnal forest are the visible fruiting bodies of a much larger organism. Each fungus is built to disperse spores through the wood but has a vast, often overlooked subterranean life.

Fungi, like 'animals' and 'plants', are an entire taxonomic kingdom of life. There are actually many more species of fungi than plant. It is estimated that there are up to 3.8 million fungi species in the world, from microscopic yeasts to a honey fungus in Oregon that covers more than 10 square kilometres and is one of the largest organisms in the world. Just 8 per cent of all fungal species have names and are known to science. Fungi can break down rocks, they can grow in radioactive environments and, in a forest, they are the hidden engineers of its ecosystem.

Most fungi produce networks of hyphae, which are thin filaments of root-like threads, or mycelium. These mycorrhizal hyphae form an incredibly dense and complicated subterranean network beneath the ground. If joined together, the mycorrhizal hyphae in the top 10 centimetres of the soil around the globe would stretch halfway across our galaxy. If ironed into a flat sheet, their surface area would cover every bit of dry land on Earth two and a half times over.

The scale of this 'wood wide web' is remarkable and so is what it does. It is only in recent decades that scientists have begun to grasp that this underground network connects individual trees and allows them to share, trade and exchange crucial resources, and even communicate with each other.

Fungi have often been regarded as agents of decay, hastening the end of dying trees or feasting on rotting wood. These roles – as decomposers, or undertakers – are vital within each forest system but many species of fungi play a more life-giving

Above: A common puffball emitting spores into the air. Spores are ejected when the fungus is disturbed, such as by falling raindrops.

role. Mycorrhizal fungi are crucial for soil health: they increase the volume of water that the soil can absorb, and can halve the quantity of nutrients leached out of the soil by rainfall. Mycorrhizal fungi also produce tough organic compounds which are a store of carbon (and soils store far more carbon than plants).

The wood wide web consists of tiny threads of mycorrhizal fungi woven into the tips of the roots of trees and plants, connecting individual plants of the same and different species. A fungus attached to a tree can obtain carbon produced by the tree's photosynthesis, which deploys chlorophyll that fungi do not possess. But the benefit is mutual: in return, a tree can acquire nutrients it lacks, such as nitrogen or phosphorous which the fungus acquires from the soil via enzymes.

We usually see trees as ruthless competitors for light and resources within a forest but the wood wide web subverts this understanding. The mycorrhizal network enables supposedly competitive trees to help each other. This was first scientifically documented by a Canadian forest ecologist, Suzanne Simard, who noticed that when paper birch saplings were removed from young Douglas fir plantations to protect the young firs from competition, these firs actually began to struggle and die. Through a series of ingenious experiments, she tracked the flow of carbon isotopes as they moved down one tree, into its root tips, and then along the intricate fungal network to the roots of other trees. She discovered that the young Douglas firs were receiving extra supplies of photosynthetic carbon from the paper birches – so weeding out the birches was not removing unwelcome competition

but actually starving the firs of crucial resources. And when firs were shaded, they received more carbon from their birch 'donors' than when they were unshaded.

Since Simard first published her findings in the scientific journal *Nature* in 1997, numerous experiments have revealed the complexity of the wood wide web. It enables plants to distribute resources such as sugars or nitrogen. A struggling young tree may be supported by a 'well-networked' older tree. A dying tree may put its resources back into the network, rather like passing on an inheritance. A plant being attacked by aphids can even communicate chemical warnings to other plants so they can muster their defences (although whether this is a deliberate message or rather like a scream that is overheard by nearby individuals is still debated). Some mycorrhizal fungi provide up to 80 per cent of a plant's nitrogen and almost all of its phosphorus. Fungi can also supply other nutrients, including zinc and copper. By providing water, they can help plants survive drought.

Clearly, the forest is a more co-operative, well-networked place than we might imagine. But, just as the human internet has a darker side, so competition and crime still occurs within the wood wide web. Not all forest plants will help each other via fungi: the birches and firs in Simard's study shared a mycorrhizal network and so could benefit each other but birch and cedar are not connected via fungi, and so do not assist each other. Some organisms are parasitic and don't appear to give anything much back. And some plants, including trees such as acacias and American sycamores, release biochemicals to sabotage their rivals, a practice known as allelopathy. These toxins can be transmitted via the fungal network.

In British woodlands, certain conspicuous fungi are associated with particular trees because their mycelium partner with the roots of those trees. The fly agaric is the archetypal 'toadstool', the lurid red-capped, white-spotted poisonous fungi of many a fairy story. It links with birch or pine.

Trees may use fungi but so do animals. Fungi provide a feast for many invertebrates. The Caledonian forests of Abernethy in the Highlands are home to more than 700 species of fungi, and red squirrels have been observed here collecting and apparently storing fungal foods for a rainy day. For thousands of years, humans and their predecessors have not simply eaten edible mushrooms but have benefitted from their medicinal qualities as well. Archaeologists recently found that one Neanderthal with an abscess in their mouth had been eating a type of fungal mould that produced penicillin, implying that supposedly primitive species were wise to its antibiotic properties.

The mycologist Merlin Sheldrake calls fungi 'metabolic wizards' who 'explore, scavenge and salvage ingeniously' in forest environments. And according to Sheldrake: 'We are only just beginning to understand the intricacies and sophistications of fungal lives.'

Conservation hero:
Chantelle Lindsay, Great North Wood project officer

One of the most surprising and mysterious woodlands in the country is the Great North Wood. Its name is deceptive – it's actually in South London – and most people have forgotten it is there. Chantelle Lindsay is on a mission to remind everyone about it – and the importance of urban woodlands.

Chantelle works with volunteer groups in 21 wooded sites across the Great North Wood, managing woodland habitat for biodiversity, looking after wildflower meadows and enhancing access for wildlife and people. She also runs guided walks, forest school sessions for children and outreach work with urban and Black, Asian and ethnic minority communities that don't commonly access the woods.

The Great North Wood is a relic woodland, fragments of a mighty forest that once swathed the land north of Croydon to the Thames, from Streatham Common in the west to Sydenham in the east. Gradually, over the centuries, the capital expanded, and much of the forest was built over. In many areas, the ancient woodland is honoured by street names and the names of the suburbs: Forest Hill, Norwood ('north wood') and Penge, which means 'edge of wood'.

'The history of it runs through the veins of South London. I've lived here most of my life but before I came into this project I had no idea about it', says Chantelle, one of two London Wildlife Trust project officers working on the Great North Wood project, which has been supported by the Heritage Lottery Fund and the government's Green Recovery Challenge Fund. 'We get a lot of people saying "I've never heard of it but I'm so glad you've brought it to my attention."'

Wild species are astoundingly adaptable, and the wood did not completely disappear and nor did its inhabitants. 'Now it lives on in fragments,' says Chantelle, 'in parks, cemeteries, gardens, sports grounds, railway embankments – these little pockets of rich oases for wildlife and people.' Treetop-dwelling butterflies including the purple hairstreak and the white-letter hairstreak are found in the wood alongside a wealth of fungi and birdlife, from green woodpeckers to hobbies.

Two of the 21 sites are London Wildlife Trust Nature Reserves, others are owned by councils or other organisations. Not all are always open to the public, such as the railway embankments. 'Sometimes it is nice to know that wildlife has its own secret place', says Chantelle. 'It's also nice to have the key as well – you feel like you're a little keeper of a beautiful green secret. And I'm constantly switching between which one is my favourite. Each site is so beautifully unique. They all tell a different story and you can feel the history of the place. We've got ancient trees still in places, boundary oaks, and an amazing veteran ash tree with a huge hollow in it on one site.'

One of Chantelle's favourite woodland refuges is New Cross Gate Cutting, which is only opened on occasion or for her volunteer groups when they need to cut back vegetation or remove invasive, non-native plants (the spread of rhododendron and cherry laurel is a challenge across the wood). 'You open the gate and you don't expect there to be much, but it's so much bigger than you think – the trees loom over you like a hug. I like the woodlands where you can't always see through the canopy. It's

this little patch of unexpected wilderness with a lovely mosaic of habitats.'

Another favourite is Beaulieu Heights, 16 acres of woodland between South Norwood and Upper Norwood, with some remnants of ancient woodland. 'You leave the busy Croydon Road and you're in this gorgeous woodland', she says. 'It's a big woodland on a slope, it's full of fungi and hobbies visit. I love that it's completely different to what people think of as Croydon.'

An awareness of the value of the fragments of the Great North Wood in South London has blossomed during and after the Covid pandemic as people discovered nature on their doorstep. 'During the school sessions we're telling the next generation of local children, "Do you know that you live in this incredible, magical place full of history?" The wood adds a bit of magic and depth to perceptions of where they live. I do love being that mouthpiece to tell people about it.'

Chantelle's work makes her aware of the constant pressure that urban green space is under from developers. While politicians and their policies still sometimes fail to protect such treasures, she sees all the unheralded local community groups that work with such passion to save and enhance green spaces in their neighbourhoods. 'I do think people are appreciating their urban green spaces a lot more', she says. 'Urban conservation is so underrated. With it, you have to be more innovative, you have to find fragments you can connect with potential green corridors and link it all together. It's amazing to be part of that.'

Chantelle's work also includes a passion for helping more people of colour into the world of conservation. Despite being a 'nature nerd' all her life, and studying animal behaviour and wildlife conservation at university, she struggled to find paid work in the sector until she got a London Wildlife Trust 'Keeping it Wild' traineeship for under-represented young people which offered her a paid post for three months. This led to her current job.

'Working in conservation, you notice that you are the only Black person or woman of colour in the room a lot of times. Volunteer groups are often made up of mostly older white men. When I realised that London Wildlife Trust were really trying to come up with a solution to the lack of Black people in the sector, I felt really seen. It empowered me. Being on social media has helped too. This narrative that there aren't people of colour interested in wildlife just isn't true. It's not that there aren't people like me who want to get into the sector, they just haven't been given the opportunities. Thankfully other wildlife charities are starting to take steps to address this too.'

Chantelle's championing of urban wildlife has opened up new opportunities for her, including presenting *Teeny Tiny Creatures*, a children's nature show on CBeebies. 'My volunteers come in and say, "I saw you on telly yesterday" but I still find myself being a bit shy to say "I'm a presenter"', she says. 'It's been this amazing mesh of my two loves – being out in nature and finding out about the wonders of nature and telling people about it. Telling little tiddly people about it is one of my favourite things.'

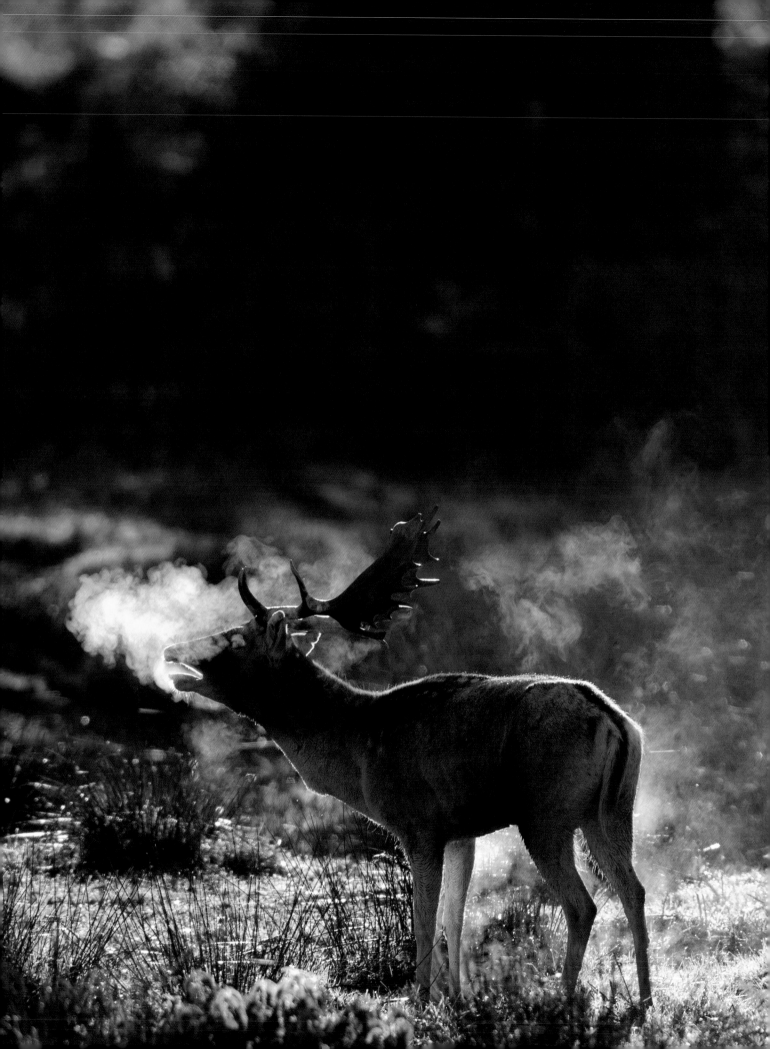

FALLOW DEER RUT –
THE ROAR OF THE FOREST

As the year ages, the sunlight softens and slants through the trees. In the stillness of autumn, the forest can be almost miraculously quiet. Then a cacophony of primal groans echoes through the misty landscape. The guttural roaring, like pigs snorting but with more volume, persistence and resonance, is made by a mammal with a strong claim to be one of Britain's prettiest beasts.

A graceful, rather delicate deer that evolved in the warmer climes of the eastern Mediterranean, the fallow deer (*Dama dama*) is an unlikely source of such a primal sound. These dappled deer with unusually long tails are not as large as red deer – most stand barely 95 centimetres tall – but they are the noisiest of the six species of deer that roam our land.

The bucks have prepared all year for this moment. Their sculptural, palm-like antlers have grown all spring and summer, they have browsed as much as they can find from the forest, and their testosterone has steadily risen. By the third week of October, the males are at the peak of their powers. Testosterone levels are many times higher than normal. The rut begins.

Where fallow deer live at a high density, each buck creates and defends a little woodland stage to entice does to mate. This territorial competition is known as lekking, and is more common in the world of birds. With fallow deer, the fittest males hold the best positions in the forest. These are often slightly hollow depressions in the woodland floor. Each male urinates around them, rolls in them and thrashes their antlers around this spot. From this stage, each male begins to call out – groaning with as much resonance and majesty as they can muster to attract themselves a mate. A buck may need to hold a harem of a dozen or so does because each doe comes into oestrus at a different time, and only for a few days. The buck needs to have them close at hand and be ready to mate.

The fallow deer is the most numerous of the four non-native species of deer that have joined the native red and roe deer in British woodlands. In areas where it lives at a low density, bucks may simply seek out willing females. But the bigger the fallow population, the more intense the rut. Fallow are a common sight in parkland across the countryside, and were first brought to Britain as a parkland animal by the Romans. Genetic analysis of bones at the site of a former Roman palace at Fishbourne, West Sussex, has revealed that fallow deer from the Western Mediterranean were kept in enclosures known as 'vivaria'. They were symbols of prestige, and of man's dominion over nature. These animals did not survive the collapse of Roman rule in Britain, but they were brought back, this time from the Eastern Mediterranean, by the Normans who created deer parks for sporting hunts in the eleventh century. By the Tudor period, fallow deer were the favoured

quarry for women hunters, offering a suitably genteel and unthreatening version of hunting. As deer parks fell out of fashion, so animals escaped into the wild, and there is now a free-living population of more than 100,000 fallow deer in Britain, with more in Ireland. Alongside other non-native deer and the two native species, such high populations present a challenge for the biodiversity, grazing and browsing wild plants and trees and damaging the invertebrate and bird life associated with plants and woodlands. Many larger fallow herds have retained their association with the parkland landscape around stately homes and in the nineteenth century, they were such a familiar feature that J. M. W. Turner painted fallow deer on several occasions at Petworth Park, West Sussex. Petworth still boasts the largest fallow herd in Britain.

A few miles from Petworth, Knepp Castle first established a deer park in early medieval days. Only now, Knepp's fallow deer lead a wilder life. Since the 3,500-acre estate was rewilded by its owners, Charlie Burrell and Isabella Tree, herds of fallow deer have roamed freely in this new forest, which resembles ancient wood pasture with its mix of ancient trees, emerging groves and new thickets. The deer live completely wild, except for the absence of natural predators such as lynx, and so their population density is regulated by the owners harvesting venison each year, mostly to prevent overgrazing as the landscape bounces back from decades of intensive farming.

David Plummer, a naturalist and photographer, follows the fallow rut at Knepp each autumn. 'It is an amazing spectacle', he says. 'There is an incredible, roaring grunting and bucks appear out of the mist. In essence, the call, the grunting, is just like birds singing. It's "Hello ladies and clear off guys". It's that dual purpose.'

The threat of violence may hang in the air but, like most animals, observes Plummer, they avoid brute combat if at all possible. As well as blustering noisily from their stages, males will walk parallel to potential rivals or challengers, seeking to make themselves look formidable, but also sizing each other up. 'Some males will have does around them and they will protect them if there is another challenger close by – that's potentially when you get clashes', says Plummer. 'If one animal is not strong enough, violence is avoided because why pick on the biggest guy when he will beat the hell out of you? But you can tell when they are going to clash, if they are closely matched. And if it's two fairly mature bucks it is brutal. I've had these clashings of antlers happen three to four metres from me and both animals were oblivious. They were fighting like crazy.'

After all that bluster, when a buck does finally win a doe and she comes into oestrus, mating is brief and perfunctory. There may be lulls during the day but the rut continues around the clock and through the night. Towards the end of this two-week frenzy, the groaning becomes more plaintive and weaker. The bucks are exhausted after hardly feeding during this intense competition. Plummer has approached bucks lying on the ground in their little stages and thought they were dead. 'As I've approached, the fallow has lifted its head, grunted at me, and then put its head down again', he says. 'This is not only the climax of the year for them but potentially the climax of their lives, and they are not strong enough to keep this going for too many years.'

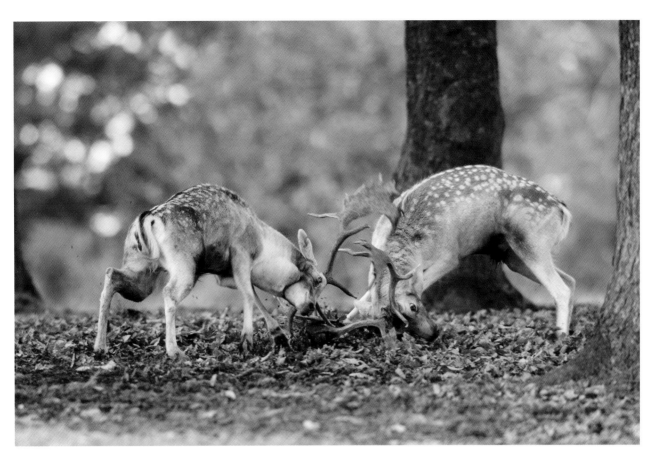

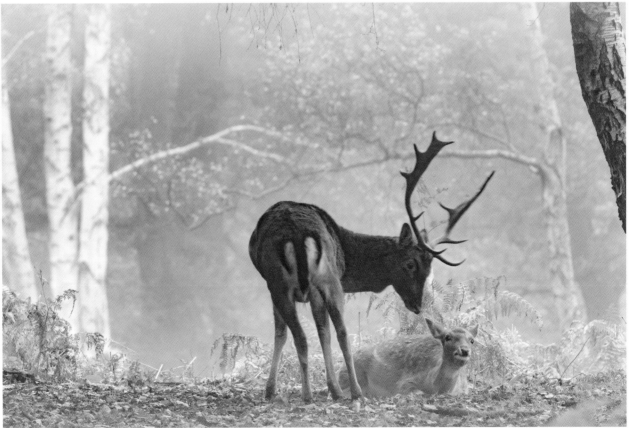

STARLING MURMURATION – A WOODLAND REFUGE

The cycle of the seasons turns, and late afternoon skies at the end of the autumn are enlivened by one of the simple wonders of our natural world. From miles around, starlings fly in to roost together on the heights of Bodmin Moor in Cornwall. This is a largely treeless landscape, but a narrow belt of conifers provides shelter, safety and a communal bed for the night.

The starling (*Sturnus vulgaris)* was once a rather derided bird because it was such a noisy and ubiquitous sight across these lands. After declining by more than 60 per cent since the 1990s, it is now on the 'Red List' of Britain's most endangered breeding birds. Thankfully, there are still enough starlings to gather in spectacular winter roosts, in cities and towns as well as meadow, moor, reedbed and wood. The roosts build up dramatically in autumn when migrant starlings arrive: most of the birds in the Bodmin roost are probably from Eastern Europe.

The swirling movements of the starlings coming in to roost for the night trace miraculous, pulsating Etch-a-Sketch patterns in the sky – funnels, twisters, and fantastical drawings that coalesce for a split second and then disappear: seals, mountains, tadpoles, even hedgehogs. It may look like graceful cloud ballet but on occasions it may be an intelligent, communal response to a deadly threat. Somewhere in nearby airspace, usually unseen by human eyes, a bird of prey could be lurking: a merlin, a sparrowhawk or, on Bodmin Moor, a small fleet of hungry peregrine falcons.

Scientists have long puzzled over how starlings do not scatter but are able to move in unison. It was once thought the birds had telepathic powers. There is no leader in the group. Individual birds do not follow one bird; the moving whole somehow organises itself. Physicists have discovered that the starlings move in what is called 'scale-free correlation'. No matter how large or small the flock, the murmuration behaves as any system on the cusp of change, even phenomena such as the movement of snow in an avalanche. A huge flock of starlings responds just as quickly to a threat as a small group, and remains united. Further research measuring each bird's changes of direction within the murmuration found that an individual's movement was only affected by its seven closest neighbours. Paying attention to this number of neighbours appears to strike the optimal balance between individual effort and group cohesion. And the group stays remarkably cohesive because birds take in and process information much more quickly than humans do, and so respond almost instantaneously to the movement of their peers.

The shimmering, shifting and noisy murmuration may be a deterrent that baffles and discourages birds of prey. Despite the evasion of the murmuration,

Right: A group of common starlings come in to roost after dark – shown using thermal imaging cameras, Bodmin Moor, Cornwall.

Overleaf: A murmuration of starlings on the edge of Bodmin Moor.

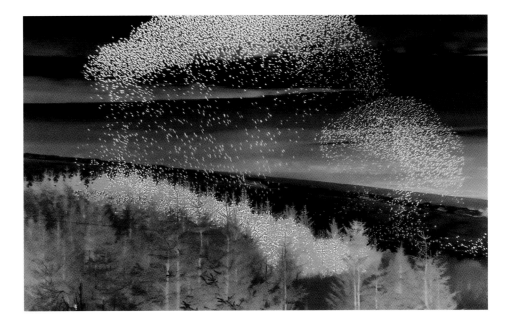

however, a peregrine can swiftly pick off a straggler, or launch itself upon the unwary before they enter the safety of the wood.

Inside the small block of forest, the stench of guano hangs heavy on the still evening air. A low cacophony of calls is emitted by the birds settling down in the trees above. Several million starlings may congregate together and sometimes pack themselves into a roosting site at a density of more than 500 birds per cubic metre. In winter, this helps them keep warm, just as much smaller groups of long-tailed tits huddle on a branch together to keep warm. But given the energy expended in reaching these far-flung roosting sites, naturalists believe that there must be other benefits.

The 'information centre' hypothesis is one shared by Devon-based naturalist John Walters, who has regularly admired the Bodmin murmuration. He believes that there must be additional benefits to these massive nightly gatherings, which may feature up to 800,000 birds. With birds coming in from all directions, the hungry can pick up useful information about good winter feeding grounds from their peers. Roosts are larger during winter, when food is scarcer. The birds' information sharing may not be the verbal chattering that we imagine in our anthropomorphic view of the world. It may be that one bird can deduce from the condition of another whether it is well-fed, and decide whether or not its daytime feeding grounds are worth exploring. Scientists have yet to prove this theory, however. There is still so much to learn about these smart birds and their sophisticated communal lifestyles.

The lowering and rising of the sunlight each season gives motion and purpose to the life in all our forests. Plenty of threats to the woodlands of Britain and Ireland remain, from dramatic climatic changes to novel tree diseases and non-native fauna often spread by humans. But as long as we continue to cherish what is left, and restore and recreate a fraction of what has been lost, then the woods can continue to provide food, shelter and protection for the varied wildlife of our wild islands.

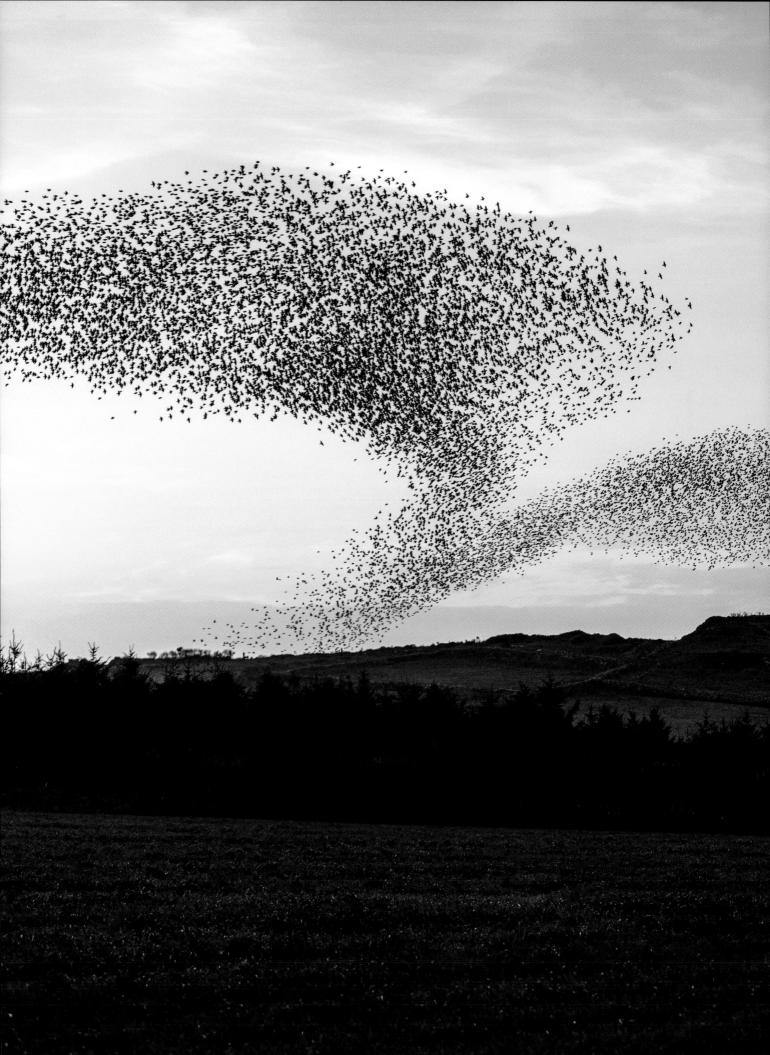

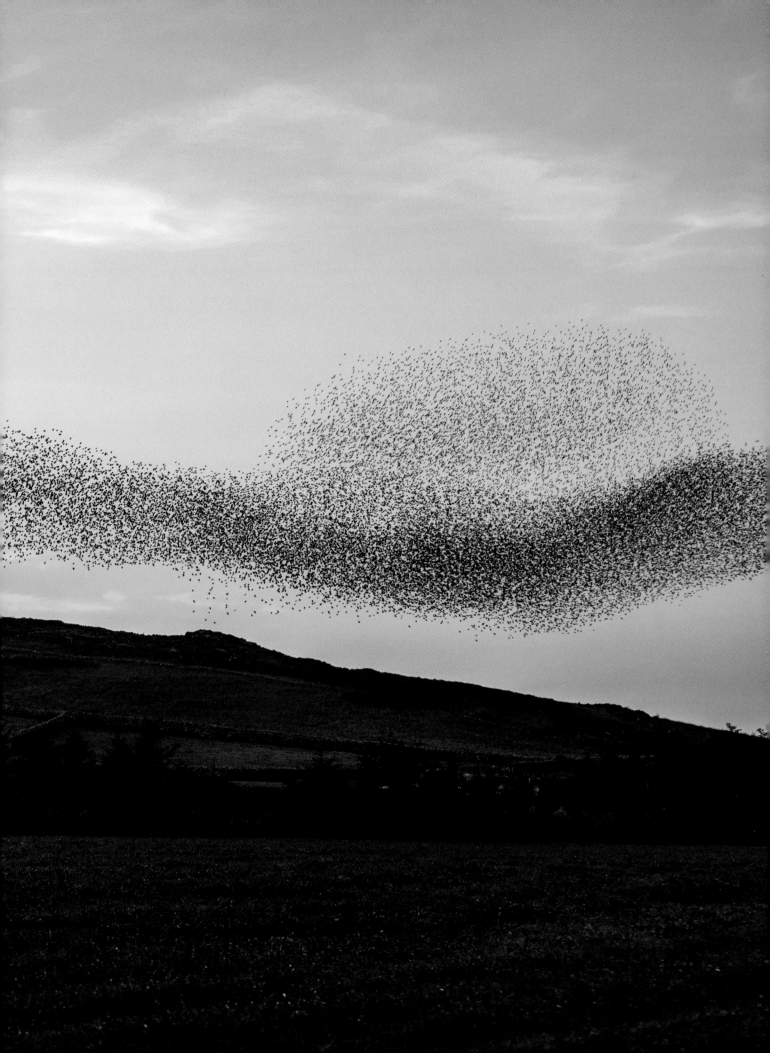

5. Our Ocean

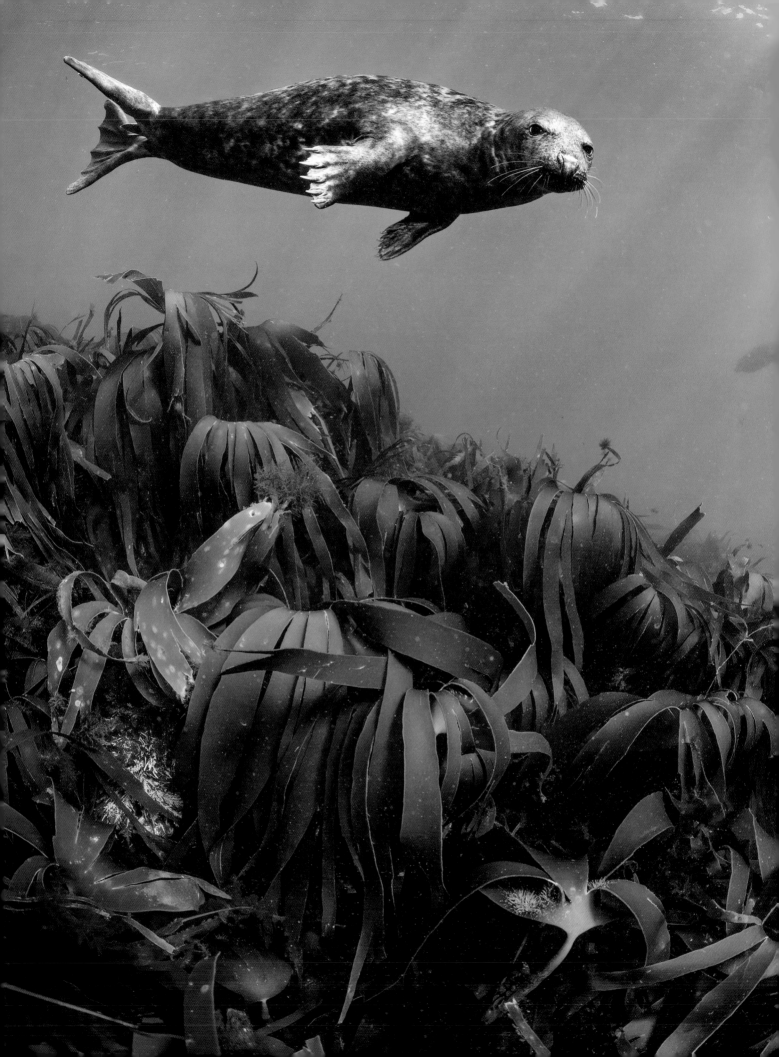

A SPECTACLE OF SEALS

On the wildest stretch of our coastline, at the bleakest time of year, there is born what many of us regard as the cutest of all mammal babies. With its huge, round, dark, liquid eyes and creamy, fluffy fur, a young grey seal rolls into the world on a beach in November.

She is closely protected by her mother, and she needs to be. Because this is not a peaceful place. Even in southern England in dazzling sunshine, the windchill takes temperatures below zero. Storms fly in from the north, the wind rushing unimpeded from the Arctic to batter the North Norfolk coast.

On the remote shingle spit of Blakeney Point, undisturbed by people, grey seals gather in their thousands to give birth. Numbers have dramatically increased around the Norfolk coast this century. In 2001, there were 25 pups born on the National Trust reserve at Blakeney. By 2020, there were almost too many pups to count: some 4,000 in total. The long coastline of Britain is an important place for grey seals. Some 40 per cent of the global population is found around our isles.

Our waters are graced by two species of seal: common seals (*Phoca vitulina*) and grey seals (*Halichoerus grypus*). Grey seals are larger than common or harbour seals and coloured dark grey above with a pale underside. Greys have a long, flat muzzle that gives them a distinctive profile, their nostrils are almost parallel. They are big animals, the males typically reaching 230 kilograms, more than three times the weight of a typical human, and the females can live for more than 30 years.

The onset of winter might seem an odd time to give birth but the female seals are usually in fine shape after a summer of good foraging, diving for sand eels, cod and whatever other sealife can be seized in the shallow waters off the coast. For three weeks, the newborn pup stays close to her mother, drinking two-and-a-half litres of her super-charged, super-rich milk every day. It is so nutritious, containing 60 per cent fat, that a 14-kilogram newborn can treble in size in its first few weeks of life. When an animal rescue centre takes in an abandoned seal pup it takes four months to feed up the pup to the same weight as a three-week-old wild cousin.

But even when a seal pup is well-fed and undisturbed by people or predators, its early life is fraught with conflict. Grey seals may be gregarious but they are not particularly sociable, and keep their distance from each other. There is a cacophony of calling, moaning and grumbling, and constant comings and goings in the pupping season. A mother may leave her pup, sometimes for hours, if she needs to head out to sea to forage for more food. Left alone, a pup starts mewling. When the mother returns, she must search the beach for her pup. If one approaches her that isn't her own, she may attack and even bite it until it scampers away.

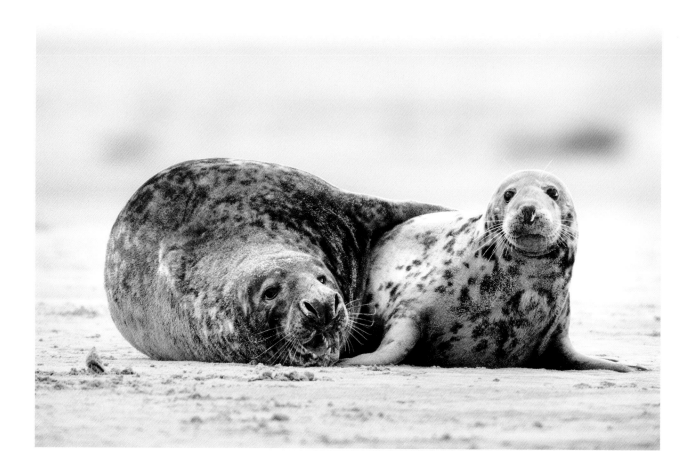

There is another impediment to the maternal bliss on the beach at Blakeney: the menfolk. The beach is covered in seals not simply because mothers are tending to their babies. There are males here too, and they've arrived to mate.

The females wean their pups promptly, after around three weeks. Their mothering duties are over and they are almost immediately ready to mate again. As soon as they are fertile, the males are prepared. Stretches of beach where the females haul out to give birth are territories of individual 'beachmasters', each a large male who can gather a harem of up to 20 females. He will not allow other males near. When a new male pulls onto the beach, the beachmaster moves across the sand and shingle surprisingly quickly, heaving his body up and down, pounding along the beach. Sometimes a confrontation is nothing more than an exchange of hissing.

A big bull will also belly-slap the beach, rising up and slamming his hefty bulk onto the sand to make an emphatic thud. If that's not enough, a fight begins. These are usually short-lived battles but they can be violent, rival males tearing skin off of each other. The victorious male may even chase the vanquished down the beach, the dispute only ending when the retreating male slips into the sanctuary of the water.

For a retreating male, winning the role of beachmaster is not the only route to a successful pairing. Other males will assert their right to stay in the surf zone, or close to it. When a female has weaned her pup, she will return to the water to feed and encounter males ready to mate. Younger and more subordinate males will head

Above: A male grey seal with a female – the males are larger and will battle with each other to win over females.

further inland in their search for a mate. As the colony expands, females seek quiet spots to give birth in the sand dunes, which are also sheltered from the wind and storm surges. Smaller males will seek out any isolated females and, with patience, find a mate or two.

If a female is not receptive to mating she will howl at an approaching male and fend him off with claws and mock bites. If the male is inexperienced and continues his approach, the female will resort to real bites.

Females will also fight other females if they stray too close to their pup. They usually keep a careful few metres apart but if another animal comes too close the mother will first start howling. Then she will lie on her side with her mouth open. Sometimes she waves a flipper, which looks innocuous to us but is trying to scratch a seal. A seal will also dramatically shoot out her head, and then retract her neck once again, to keep unwelcome intruders at bay.

In 1914, after centuries of persecution had decimated their populations, grey seals became the first mammals to be protected by law in Britain. But annual culls continued, with seals blamed for declines in fish. Another law in 1970 protected them throughout their breeding season but many seals were still killed due to various loopholes. As these were closed, and demand for seal skins disappeared, numbers started to recover. Following the mass loss of seals caused by an outbreak of phocine distemper disease in 1988, grey seals were fully protected in England and Wales. Seals continued to be shot under licence in Scotland for interfering with salmon farms but in 2021 this shooting was outlawed too. Today grey seals are thriving, with an estimated population of more than 120,000, with numbers rebounding particularly in southern Britain.

After around 18 to 21 days, the pup is weaned and the mother disappears back into the sea, to feed and to mate again. The young pup must shed its creamy fur – a relic of the days when it would have been born on ice and snow – and make its way into the water on its own, relying on innate instinct to learn to feed in the cold and turbid waters.

When it swims into the surf on its maiden swim, the underwater world it will encounter is unexpectedly bountiful. We don't always realise the incredible wealth of life and colour that lie beneath the often unpromising-looking waves of silver, grey and bronze that roll into our isles.

CONSERVATION HERO:
DAVID VYSE AND THE FRIENDS OF HORSEY SEALS

Opposite: A grey seal sleeping vertically in the water, its nose poking out to breathe. This is known as bottling.

Twenty years ago, there were few grey seals giving birth on the seven-mile stretch of quiet, sandy beach on the northeast Norfolk coast. When a handful of females began to do so, wardens for Natural England, the government's conservation watchdog, roped off sections of the relatively modest beach, to give the seals some room.

The seals soon took that room. Today, there are an estimated 3,000 pups born on the beaches and sand dunes around Horsey Gap. The draw of the beach for the seals is matched by the draw of seals for us, and more than 100,000 people now visit from across the country, guaranteed a fine view of seals and newborn pups from the tops of the dunes.

This influx of nature-lovers requires skilled management and when financial cutbacks meant Natural England could no longer watch over the seals, a group of local people stepped in. Friends of Horsey Seals was formed and now the registered charity has more than 400 volunteers.

The volunteers ensure that there is no conflict between visitors and seals, and watch over the safety of both. Unfortunately, over-eager photographers or parents wanting their children to have an intimate nature experience have occasionally crept right up to baby seals, risking separating mothers from babies, causing panic in a seal colony, and putting themselves in danger of receiving a painful bite from a protective mother seal. Out-of-control dogs have also caused problems. The volunteers set up cordons and manage viewing platforms so visitors can enjoy the seals safely, and they also count and monitor the visiting seals.

Volunteer David Vyse, now vice-chair of the charity, is one of the Friends' six-strong seal rescue team. When a seal is spotted in difficulty, for example with its head tangled in discarded fishing net, or a plastic frisbee stuck tight around its neck, Vyse and his colleagues move in with a special net, catching the seal and placing it on a stretcher. Plastic pollution is a big problem for seals. If the Horsey volunteers can't safely remove the plastic or netting, they'll take the seal to the RSPCA animal rescue centre at East Winch, which specialises in rehabilitating injured seals.

The Horsey seals are so well-watched that the volunteers are discovering new insights into the complexity of seals' lives. Vyse and others missed a mother giving birth to twins by minutes and nobody believed the seal had really produced two pups. When the mother was thought to have run out of milk for the pair after 12 days and abandoned the pups, they were rescued. DNA samples sent to Norway proved that they were indeed twins, although fathered by different males. This was the first recorded incidence of grey seal twins in the world. The twins, named R2D2 and C3PO, were successfully returned to the wild.

'There is a lot still to learn', says David. 'For me, this is doing good for nature, and protecting the seals. Ninety-nine per cent of people are very good but if we weren't there, some would be going up to the seals and trying to touch them. We make sure the seals lead a natural life without being inundated by the public.'

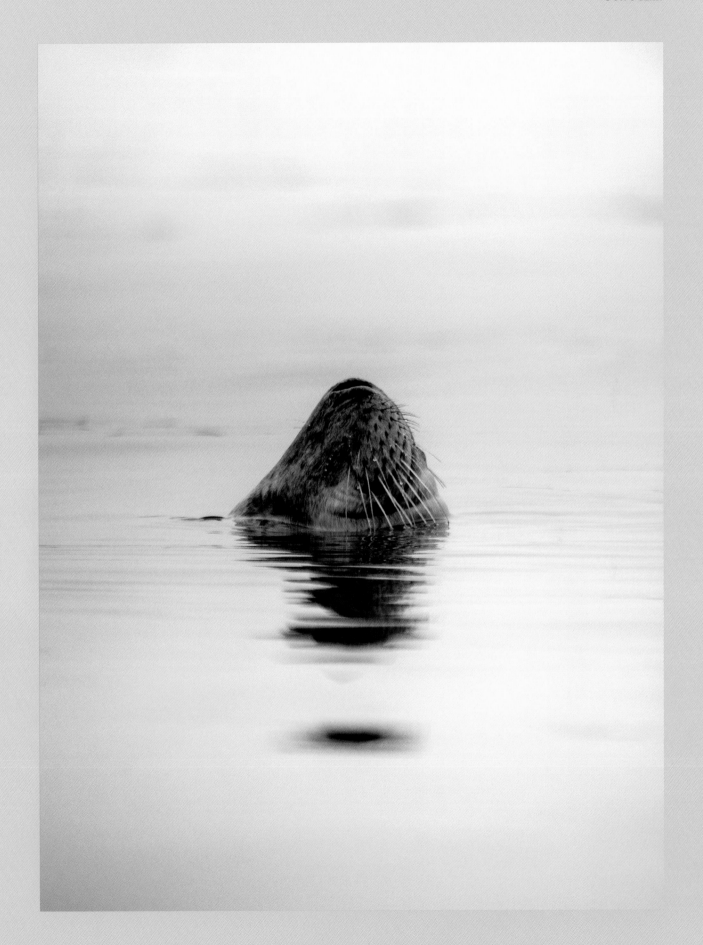

Our Unique and Surprising Coastal Waters

The Earth is unique within the solar system for its liquid seas. Oceans cover 71 per cent of its surface. These seas are a vast, fluid interconnected habitat and, as island nations, Britain and Ireland have more water than most. Even close to our shores, our seas are home to apex predators and some of the planet's biggest animals.

We think of our seas as often grey, brown or monochromatic. We assume vibrant multicoloured marine life is better found in aquamarine tropical waters and on kaleidoscopic coral reefs. But we are mistaken. Beneath our waves are vivid technicolour worlds, rich in spectacular marine life. There is a kaleidoscope of intense colours swirling through this world. Neon, fluorescent, iridescent; you can have any hue or colour you desire around the British coast, and there's plenty of subtly beautiful shades of brown and grey too.

This underwater world contains anemones shaped like exploding fireworks, flatworms striped like sweeties, and a plethora of creatures as vivid and tantalising as anything from Woolworth's pick'n'mix. There are shimmering meadows of bright-green seagrass where seahorses dance. There are golden-brown forests of kelp where otters, seals and orcas hunt. Our coastal waters contain a significant proportion of the kelp beds found outside Norway in Northern Europe. The North Sea is easily dismissed as brown but it can be a vivid royal blue on a fine, clear day, and set within it is our own miniature version of the Great Barrier Reef: a 20-mile reef of chalk off the coast of northeast Norfolk that is still being discovered even now and is home to more than 350 marine species within a vivid palette of white rocks and blood-red seaweeds.

Another common assumption is that the seas are one type of habitat. In reality, the marine environment is another world, containing a multitude of different places where special and spectacular creatures find their niche. The ocean exists in three dimensions. There are a multitude of what are called benthic, or bottom-dwelling habitats: sandy seabeds, muddy seabeds and rocky seabeds. These sites and their species vary hugely depending on whether they are low-energy or high-energy sites – whether the seabed is exposed to wave energy or not. Above them, different communities exist in different levels and layers of the ocean. Fish that live in the water column of the open ocean are known as pelagic creatures, and they include familiar fish in our diets such as mackerel and herring. Salinity and light levels – which depend not only on depth but the turbidity of the water and the plant or algal life found there – also defines what sealife lives where. And many ocean creatures make a living from tidal currents. This creates plenty of diverse life in shallow, sunny, tidal waters close to the coast.

Britain and Ireland have a lot of coast. Britain's is longer than India's and the coast is complex, wiggling and geologically diverse – creating a home for a diverse array of plants and animals. But perhaps most crucial to the wealth of our seas is the fact that we are situated on one of the largest areas of continental shelf in the world. There are sizeable continental shelves off Patagonia and Indonesia but the northwest European continental shelf is a huge expanse of shallow seas, up to 160 kilometres wide in places. This means that there is a short vertical distance between the vast store of nutrients in the seabed and the surface of the sea.

In many oceans, there are distinct layers of warm and cold water, and the nutrients that accumulate far down at the bottom of the seabed are never animated by sunlight and nor do currents or tides cause these nutrients to rise up and give life to the upper layers of the sea. Around Britain, however, those seabed nutrients can be closer to hand and, each winter, they are stirred up by the weather systems and winter storms that sweep in from the west, thanks to the Gulf Stream, which transports warm water – and warm air – from the Gulf of Mexico, making the seas around the islands pleasantly mild. Stirring by winter turbulence means there are plenty of nutrients in the light-filled upper waters by springtime, when increased light levels and gentle warming causes a great bloom of phytoplankton – the basic microscopic plants that float in the upper part of the ocean and are a great engine of productivity – feeding a wealth of creatures higher up the food chain. Each spring, in a well-balanced system, these phytoplankton bloom and are devoured by zooplankton, tiny sea creatures, which in turn feed many more layers of marine life from shrimp and snails to jellyfish and basking sharks. There is an explosion of seasonal life in our seas.

A wide variety of types of seabed also give rise to varied marine life. Sandy and gravelly seabeds are home to worms, bivalve molluscs, crustaceans and other species, which provide food for fish that live on the bottom – such as plaice – or close to it, including cod, haddock and sole. Sand eels living in the sediment provide important food for fish such as turbot, seals and seabirds. Shellfish found here include many familiar, harvested species: cockles, scallops, oysters and, in areas of deep mud, scampi, otherwise known as Norway lobster.

We also benefit from colder water rich in nutrients welling up the edge of the continental shelf, endowing the small islands on its edge with rich marine habitats. The reefs surrounding the islet of Rockall are exposed to wave action like no others and are rich in kelp which extends unusually deep in such clear waters. Living among the kelp are anemones, sea squirts, sponges and plentiful fish. Elsewhere, sea lochs and bays provide habitats where very different creatures can flourish, such as horse mussels (*Modiolus modiolus*), maerl and gaping file shells, sheltered from wave action and tidal currents.

The Gulf Stream brings those nutrient-stirring storms but is also famous for bequeathing a relatively mild climate for our northerly latitudes. This fast-flowing surface current carries a hint of the heat of the Caribbean into northern climes, arriving at our shores after crossing the Atlantic from the east coast of North America. It is part of the global ocean conveyor, a system of currents that sweeps around the planet, and loops down from the surface to the deep sea and then up again. The Gulf Stream ensures that the seas around Britain are much warmer than

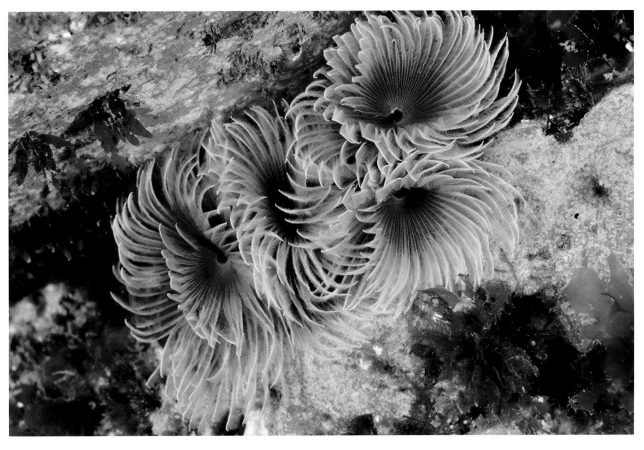

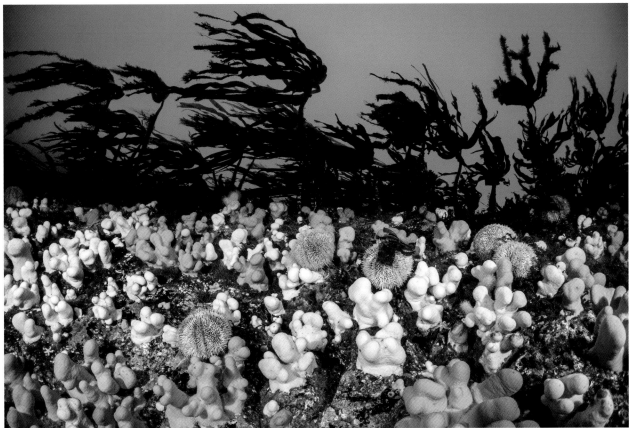

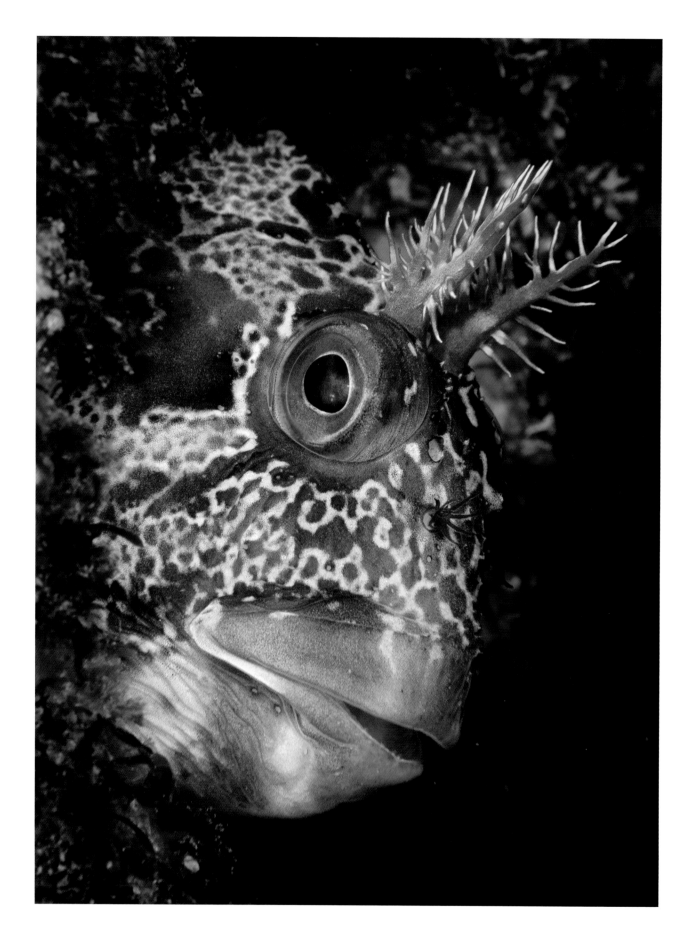

other countries on the same latitude as our islands. This allows species that would normally live much further south to survive here.

Britain's diverse marine life also benefits from some of the largest tidal ranges in the world. The tides can rise and fall by up to 15 metres in the Severn Estuary. Tidal currents can be ferocious in places, and if moving between pinch-points in the land can cause spectacular whirlpools like the famous Corryvreckan, the third largest whirlpool in the world which whips up in the narrow strait between the islands of Jura and Scarba off the west coast of Scotland.

Tidal currents mix the waters, bringing nutrients up from the depths, but also create useful habitat, keeping rocks and organisms free of silt. The sea floor in areas of significant tidal currents are some of the richest anywhere around our isles. Every square inch of the bottom can be covered with life. This is because the tidal currents bring in food. Anemones, corals and sea cucumbers might look like plants, but they are in fact animals. As the current picks up, they open up, extending their tentacles into the water to filter out edible parcels carried by the current. Sea cucumbers stuff their whole arms into their mouths, one at a time, to lick off pieces of food. Big tides also create large intertidal zones, and estuaries, where rich muds contain shellfish and plentiful other intertidal proteins that feed millions of waders and other seabirds.

Adding to this diversity of different niches are habitats provided by other marine species. Mussel reefs reach a significant size on the northwest coast, and around Orkney and Shetland. There are up to 100 mussels in every square metre of the mussel beds at North Cava in Orkney, and they provide habitat for up to 300 other species including queen scallops, brittlestars, sea urchins, sea squirts, welks and barnacles. Maerl beds are made of calcified seaweed that forms detached nodules. Maerl develops extremely slowly, growing only one millimetre each year, and the beds take centuries to become established. Some have been found to be more than 6,000 years old. These beds are easily destroyed by dredging for scallops or dredging to create channels for shipping. Once obliterated, they are unlikely to come back.

It is sometimes said that our underwater worlds are less well-known than parts of space, and there is something extraterrestrial about the miniature – and not so small – universes found beneath the waves. Sponge gardens containing some of the 400 species of sponge found in British seas look like alien planets. Snakelocks anemone *(Anemonia viridis)* wave purple-tipped tentacles of vivid greens in the shallows where they thrive. Sea cucumbers are commonly rendered as dull brown or black slug-like creatures in photographs, but caught at the right moment the sea cucumber (*Psolus phantapus*) looks like a miniature oak tree illuminated from within by orange-red neon.

There is an array of colourful and charismatic species living secret lives within a few metres of our coastline. Funny red head tentacles like a pair of crazy deely-boppers, soulful eyes with bright red-orange irises and thick lips – it is impossible not to fall in love with the tompot blenny (*Parablennius gattorugine*). We relate to creatures that remind us of ourselves, and it is possible to recognise individual fish.

These little fish are occasionally found in rockpools but more often seen by snorkellers peering into rocky crevices. This crevice will be one male's territory, and

the blenny busily evicts any trespassers, from other males to passing crabs. A male may occupy the same territory for several breeding seasons. Paul Naylor studied blennies off the coast of Devon, finding one, Bradley, who kept the same crevice for seven years. Females visit, lay eggs on rocks meticulously cleaned by the male, and leave.

We tend to associate octopi with warm waters, but in the past, fishermen would complain about a plague of octopus on our coasts. Today we still find these complex, intelligent animals, the common octopus (*Octopus vulgaris*) and the lesser octopus (*Eledone cirrhosa*) hiding in their watery lairs in the rocks.

Wrasse are the most conspicuous fish found on our rocky reefs, and more abundant in the south than the north. The cuckoo wrasse (*Labrus mixtus*) is a vivid mix of fluorescent blue stripes, turquoise wiggles and oranges, with a base layer of olive greens and yellows. There are few 'normal rules' of biology, ecology and animal behaviour on the land but in the sea our version of 'normal' definitely does not always apply. Sealife does things differently. All cuckoo wrasse begin as coral pink females. Some turn into males later in life if required to maintain a balance of the sexes in their neighbourhood.

As well as fluidity between the sexes there are also intriguing marine behaviours. Relationships between species may involve scavenging or predating but can also be co-operative or exploitative. In some cases, one species cannot survive without the other. The ballan, our largest wrasse, has been observed taking large pieces of kelp from the seabed and releasing it higher into the water column where a smaller species of wrasse, the rock cook, dart in to eat the tiny crustaceans found on the kelp. Is this altruism? Perhaps the ballan benefits from having a little shoal of rock cooks in close proximity. They warn it about predators and provide free personal hygiene services, nibbling parasites from the bigger fish's scales.

Parasitic anemones will cling to a hermit crab, sometimes almost smothering it with their size and weight. The cloak anemone's relationship with the small hermit crab is more mutual. This garish pink-spotted anemone can stay with the same crab for life, forming a hard extension which obviates the crab's need to find a bigger home as it grows. In return for shelter and protection, the anemone's tentacles dangle between its host's legs, picking up scraps as the crab feeds. If touched, the anemone defends both creatures by emitting long sticky white threads from its 'cloak'.

For most of us, our scant knowledge of the sea is derived from what we eat – scampi and shrimps, perhaps a mussel or a scallop and sea fish – but this is a tiny fillet of marine biodiversity. For every haddock or plaice, there are hundreds more species of sea fish, from five-bearded rockling to red bandfish. For every edible crab there are dozens more: shore crabs, velvet swimming crabs, masked crabs, Montagu's crab, hairy crabs and broad-clawed porcelain crabs.

This is not a dull and boring place. And one modest resident is perhaps the most interesting of them all.

Opposite: The colourful cuckoo wrasse swims through a kelp forest close to the Lizard Peninsula, Cornwall.

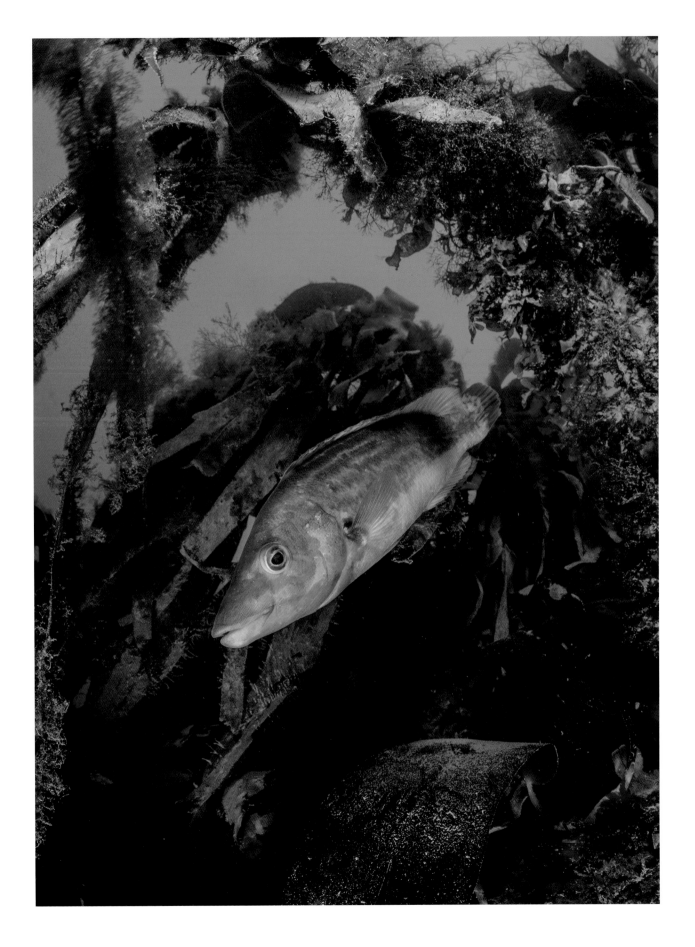

The Cunning of the Cuttlefish: Fighting, Sneaking and Hunting

Is there an animal in our oceans as magical, mysterious and multi-talented as the cuttlefish? The common cuttlefish (*Sepia officinalis*) is certainly an extraordinary-looking creature. A broad, flat body is bordered by a waving fin running from behind its oversized, rather horse-like head. Its head is actually mostly arms, eight of them, held around its mouth. It also possesses two much longer tentacles which fire out to catch prey, bringing them back to within the clutch of its arms, which pass them into its mouth – and its razor-sharp beak.

Perhaps surprisingly, the cuttlefish is a mollusc. We usually think of molluscs as 'shells' with a hard, chalky exterior. These simple, single-part limpets and hinged mussels aren't renowned for their intelligence. The cuttlefish is most commonly seen by us as a 'shell' – the white cuttlebone which is found washed up on beaches, and given as a calcium-rich supplement to pet budgerigars. This is its internal skeleton and buoyancy aid. It contains miniature chambers filled with liquid or gas that give a cuttlefish the required amount of lift in the water.

What really distinguishes the cuttlefish, however, is its intelligence. Cuttlefish are demon hunters, and sophisticated communicators, and we are only belatedly learning about their remarkable capabilities. Most molluscs have separate nerve centres distributed around their body but cephalopods such as cuttlefish have fused these into a sophisticated brain, which is super-sized by the standards of their fellow invertebrates. We may sense its intelligence if we have the good fortune to encounter a cuttlefish in the wild: its amazing green eye and squiggle of a pupil seems knowing as it meets the watcher's gaze. Even so, there is more to the cuttlefish than meets our eye.

Self-control is a trait usually linked to higher intelligence. It is found in corvids, parrots, chimpanzees and humans – at least, sometimes! A recent scientific study has found that cuttlefish also possess an ability to defer gratification for a greater reward.

The Stanford marshmallow test is an old classic, in which children were given the chance to eat an immediate reward (one marshmallow) or could wait to earn a delayed but better reward (two marshmallows). Researchers devised a version for cuttlefish involving live grass shrimp – their favourite food – and less favoured king prawns and Asian shore crabs. The cuttlefish were presented with sealed chambers marked with different visual cues. One cue signalled that the moment food was put in the chamber, the door would open. Another meant that there would be a delay before the door opened. Another cue was a trick: even though food was placed in the chamber and the door was opened, an extra layer of plastic prevented the cuttlefish from reaching their reward.

Opposite: A pair of common cuttlefish, the female in front of the male, during spring spawning season, at Babbacombe Bay, Devon.

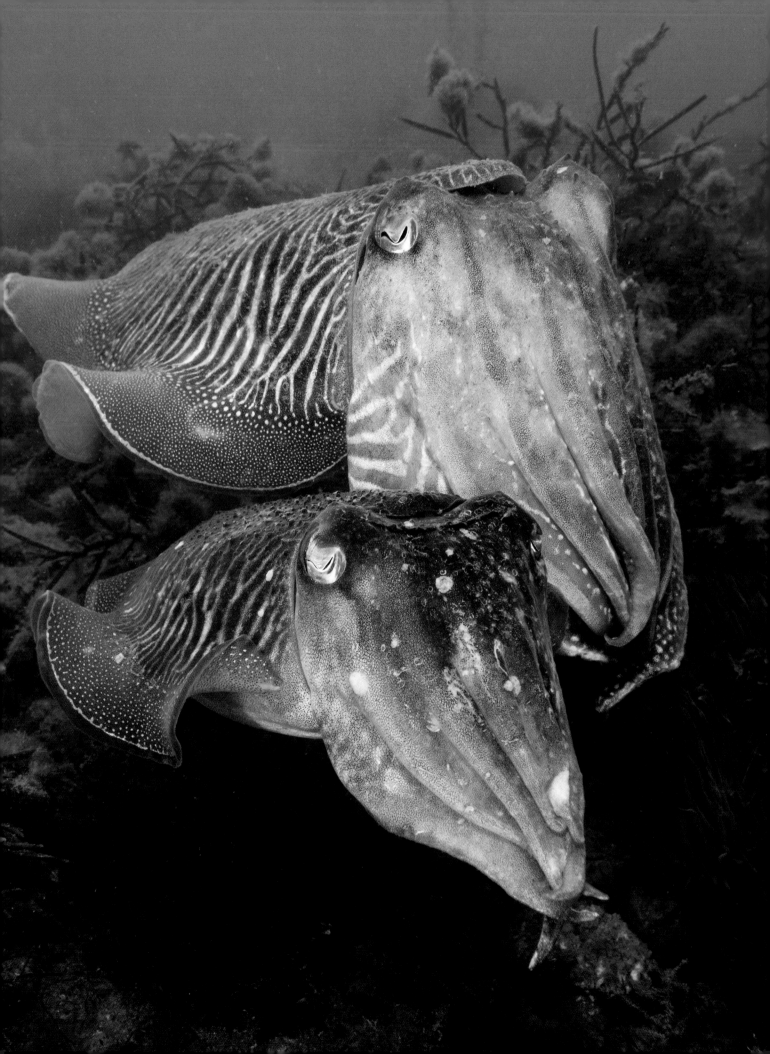

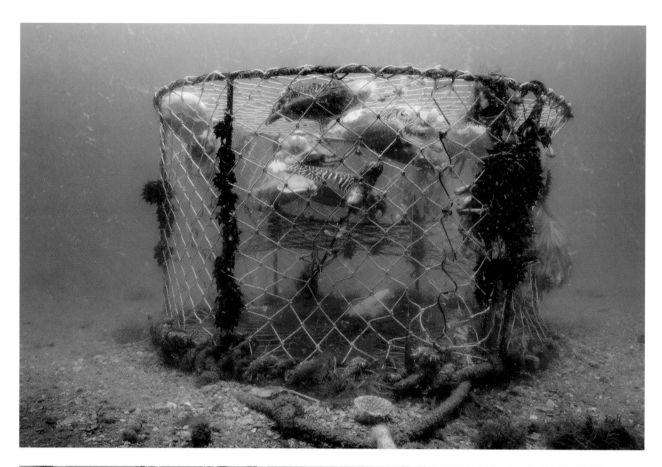

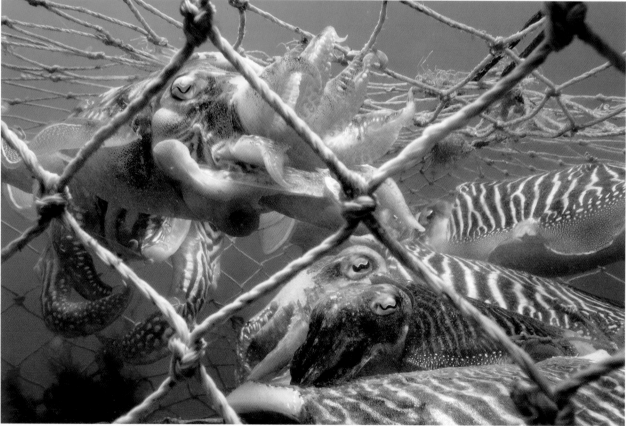

When the cuttlefish were first shown the chambers, they immediately attacked them when they saw food. Over time, however, they deduced that each chamber had its own rules. Eventually they didn't even bother trying the trick chamber because they learned they would never obtain the food.

Once they had been trained, the cuttlefish's capacity for delayed gratification was tested. In the chamber that opened immediately was placed an Asian shore crab or a king prawn. In the chamber where there was a delay before the door opened, they were given their favourite treat – a live grass shrimp. There was also a control setting, in which their favourite shrimps were placed in the unobtainable chamber.

Every cuttlefish was able to wait for at least 50 seconds and up to 130 seconds to earn a better food reward, the kind of forbearance seen in chimpanzees and corvids. Sometimes they would even turn away from the immediate, less preferred reward as if to distract themselves from temptation, a trait previously observed in jays, parrots, dogs and, of course, humans. Interestingly, the cuttlefish that could wait the longest also did better in cognitive tests, the first tentative signs of a link between self-control and intelligence that is more usually identified in humans and chimpanzees.

Delayed gratification in humans is believed to strengthen social bonds between individuals, and may also assist the building of tools, giving an animal the patience to wait to hunt until a weapon or tool is constructed. But cuttlefish do not build tools and they are not a social animal. Scientists believe that their patience may be derived from the cuttlefish's need to camouflage to survive, and sit and wait before they begin foraging. As soon as they hunt for food, they expose themselves to every bigger predator, and so the ability to wait to optimise their foraging could be a useful aptitude.

Another recent scientific study has found that cuttlefish have a remarkable memory, and can remember specific events no matter how old they are. Humans have two kinds of recall: semantic memory, where we remember facts, which don't tend to fade with time, and episodic memory, which include unique events in our own lives – where and when something happened, and how we felt about it. Jays, rats and monkeys have these kinds of memories too, and so do cuttlefish. While human memory tends to fade with age, tests found that older cuttlefish could retrieve episodic memories more quickly than younger ones, suggesting their ability to recall may improve with time.

We find it difficult to assess the brains and other capabilities of animals, such as their communication skills, without relating everything back to our own measures of 'intelligence' and the ways we communicate. But we know this much: cuttlefish communicate in very different ways to us.

Their camouflage skills are derived from their ability to rapidly change the patterns and colours of their skin, which is also the most obvious way they communicate. Their bodies are almost like digital screens in their capacity for broadcasting changing scenes, to disguise, hide, communicate or express emotions. Chameleons have nothing on cuttlefish. On a gravelly bottom, the cuttlefish can rapidly change to a mottled, gravelly skin tone that is perfect camouflage. It completely disappears from view. If a cuttlefish is suddenly startled, it may flash other messages: dark spots like eyes on its rear or rings around its eyes. This speaking with their skin is derived from cells called chromatophores, tiny bags of

pigment which turn dark or light when they are extended or contracted by muscles. These are operated by the cuttlefish's sophisticated brain.

Its colour-changing communication skills come to the fore during courtship. A male cuttlefish woos a female by displaying bright zebra stripes of white and purple. He is dressed to impress, and the fearsome stripes demonstrate his fitness and warn other males to keep away. If rival males deem themselves to be evenly matched, and neither retreats, they will fight each other, by grabbing with their formidable arms and grasping their opponent.

But a male cuttlefish does not need to be huge to be a mating success. A smaller male knows he can't scare off the big guys but he has a cunning plan: he cross-dresses. He switches his skin pattern and colouration to resemble a female and sidles up to a female being wooed by a big male. The big male thinks he has two females but while he fends off other males, the little male sneaks beneath and fertilises the eggs. The reason both strategies exist is that both work, and this way both males will father some eggs while the female obtains more genetic diversity for her offspring.

Cuttlefish mating seems rather quaint to us. The male holds the female and passes her a packet of his sperm using one of his arms that is especially configured for the task. Afterwards, a male may guard the female while she lays her eggs, tying each one individually to seaweed or seagrass. They are known as 'sea grapes' for their resemblance to black grapes, dyed that colour by their ink.

The cuttlefish is an extremely sentient ocean animal but the urge to mate can override caution. Where these cuttlefish swim, there is a fish trap, and it is full of cuttlefish. The trapped individuals have all been attracted into the trap by a female already inside, and now they are all injured after trying to escape through the mesh. Fishing in spawning grounds is good for fishers, as the animals have gathered here from far away so good catches are almost guaranteed – at least for a while. This practice can, however, wipe out populations of some species in a few years, and is therefore unsustainable. When pots are left in the water for too long without being checked, the animals inside die and start rotting. 'Ghost fishing gear' – lost or abandoned nets and pots – are a similar hazard for many marine creatures. Their entrapment is a stark image – and a sign that all is not well with our seas.

The cuttlefish has a formidable array of skills to prevent it being eaten by larger sea creatures. As well as its skin camouflage, if threatened, it can raise two arms which then perfectly resemble seaweed, helping it melt into its surroundings. Alongside disguise, another anti-predator tool at its disposal is a reverse thrust, a kind of jet propulsion, which sends it rapidly out of harm's way – backwards. Finally, it can also emit clouds of ink, which was once used by artists and gives the species its scientific name: *Sepia*.

But the cuttlefish is also an awesome predator itself. A young cuttlefish that has hatched in the summer is a proficient hunter by autumn. Its large, highly developed eyes are capable of adapting to the very different light levels found in the waters down to about 200 metres where cuttlefish are found, and the cuttlefish will hunt for prey in daylight, moonlight and starlight.

Even when darkness falls, there are other lights that the cuttlefish can utilise. Bioluminescence is a wonder of the ocean at night. Tiny single-celled algae floating

Above: A juvenile common cuttlefish catching its prey at night in water filled with bioluminescent algae.

in the water column glow when they are touched. When a shrimp swims away from the seabed, the bioluminescence flashes around it. A juvenile cuttlefish spots the light flash, and darts towards the blinking lights, attacking by shooting out its two extra-long tentacles. But it is not easy to catch a creature in the darkness and the shrimp uses its tail to 'jump' to safety.

Another shrimp has eaten some of the bioluminescent algae. This is a mistake. The algae continues to glow in the shrimp's belly, making it visible through the transparent shell. As the shrimp emerges from a patch of seagrass, the cuttlefish spots it, races over and enjoys an evening meal – not exactly by candlelight, but by bioluminescence.

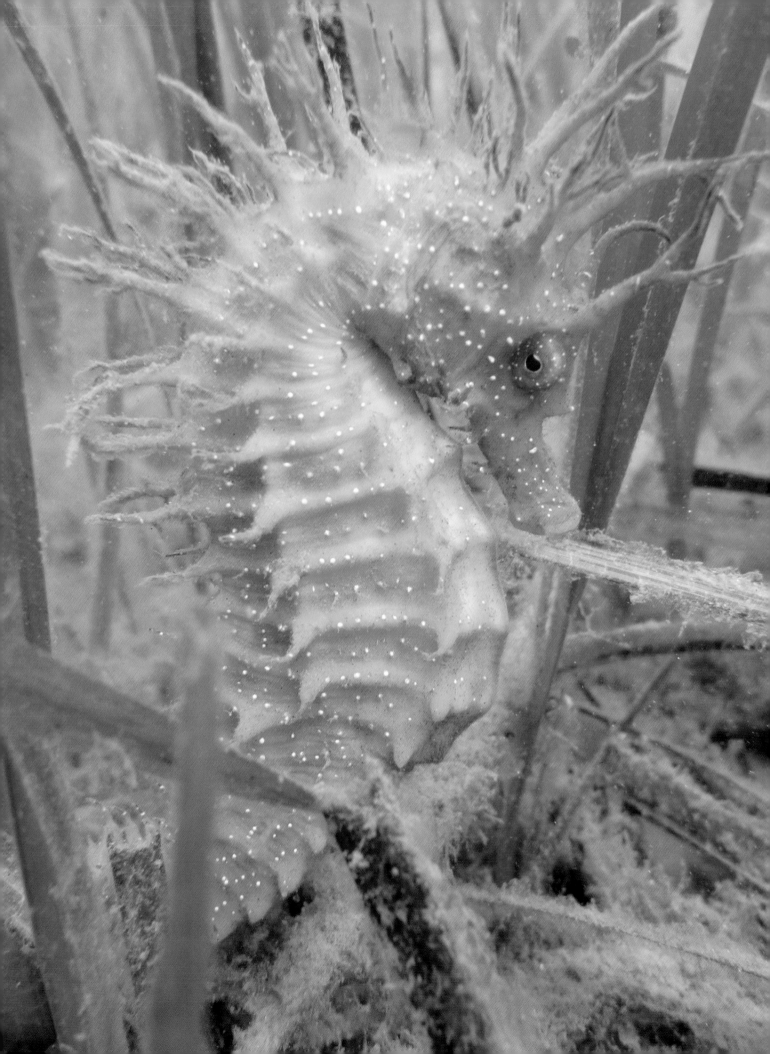

GRASSY MEADOWS AND SEAHORSES

Opposite: The long-snouted
or spiny seahorse is one
of Britain's two seahorse
species. It is distinguished
from the short-snouted
seahorse by the longer length
of its snout.

In the shallow waters around Britain are dazzling green meadows full of life. Seagrasses are not seaweeds but the only flowering plants to have successfully recolonised the marine environment. They have roots, or rhizomes, they flower and shed seeds, all while completely submerged in seawater.

Zostera marina, or eelgrass, is the common species of seagrass in temperate regions. Its roots stabilise sediment and provide shelter for fish. The blade of a seagrass can grow as much as a centimetre in a day but few marine animals graze directly upon it because it is so tough, although ducks and swans will take a nibble. But plenty of marine creatures live on or among these grasses.

Seagrass supports a world of colour and life, from cuttlefish to hermit crabs, two-spotted gobies, the nettled dog whelk and the spectacular snakelocks anemone. Burrowing around the seagrass roots are razor shells, common otter shells, the fan mussel and the sea potato. On the seabed there are king scallops, brown shrimps and the sea hare (*Aplysia punctata*). This unusual grazing animal is a species of sea slug, and it lives on algae. Juveniles that feed on red algae are red, whereas the adults turn brown or green according to the kind of algae they've eaten.

The most renowned residents of the seagrass meadows are the seahorses. These fairytale-like creatures are one of the most instantly recognisable marine animals with their horse-shaped silhouettes, created by their bent-over heads and stiff bodies protected by bony plates of armour. Britain's two species are distinguished by nose length: the snout of a short-snouted seahorse (*Hippocampus hippocampus*) is slightly concave and less than one third of the length of its head. The long-snouted or spiny seahorse (*Hippocampus guttulatus*) has a straight snout more than a third of its head length.

It is not surprising that seahorses were once routinely collected by naturalists and nature-lovers. Today, both species are protected under the Wildlife and Countryside Act, so it is illegal to disturb or collect them.

During the breeding season, a male and female seahorse form an apparently monogamous bond – by dancing together. These sessions, holding each other's tails, appear to cement their connection. We are even more intrigued by the fact that the male seahorse 'gives birth'.

The female seahorse lays her eggs in a belly pouch on the male. He broods, hatches and rears them, releasing them as fully formed miniature seahorses. The seahorse is not unique in this. Pipefish do the same, and the males of other marine animals also take a leading role in egg or childcare. Because the males invest so much time in rearing children, they tend to be the choosy ones during mating, with the females on display, in a reverse of many species' mating games.

We are only lately coming to an appreciation of seagrass meadows as storers of 'blue carbon', capturing and sequestering carbon dioxide emitted by humans in a crucial contribution to reducing global warming. Britain has important seagrass beds, with Scotland holding a fifth of all seagrass beds in northwest Europe.

Globally, however, seagrass meadows are under threat and in decline, like many special habitats close to our busy and frequently fished coastlines. Nearly a third of the globe's known seagrass meadows disappeared between 1879 and 2009. The rate of loss before 1940 was 1 per cent per year but since then it has accelerated to 7 per cent per year. Britain has experienced similar declines: it is estimated that at least 44 per cent of our seagrass meadows have disappeared since 1936, with more than a third of this loss happening in the last 30 years. More than 300 hectares of seagrass has been lost from the Greater Thames Estuary.

Seagrass is disappearing because of sewage discharge, coastal development and seabed dredging, which release nutrients and sediments into coastal waters, reducing the clarity of the water and smothering the seagrass. Seagrass meadows are also under pressure from commercial and leisure boat traffic. It is easily torn up by boat propellers and every time an anchor is dropped, the grass is damaged. It may also become stressed by pollution and rising water temperatures.

There is some hope that the message from marine biologists about the importance of seagrass is reaching the ears of politicians, especially now that policymakers urgently need to find ways of sequestering carbon emissions to reduce planetary heating. Many seagrass beds have been placed in recently created Marine Protected Areas. A handbook giving advice on how to restore seagrass has also been produced by the Environment Agency. But much more action needs to be taken to protect this precious marine habitat.

Opposite top: Wildlife-rich seagrass meadows occur in shallow waters around Britain. Seagrasses are not seaweeds but flowering plants, with roots or rhizomes, flowers and seeds.

Opposite below: A spotted seahare, a type of sea slug, searches for food in a seagrass meadow on the Helford River in Cornwall. Seagrass meadows are increasingly valued for their biodiversity but also as vital stores of 'blue carbon'.

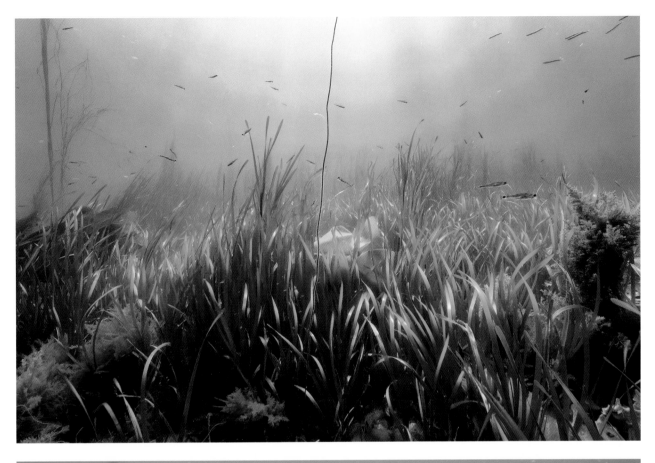

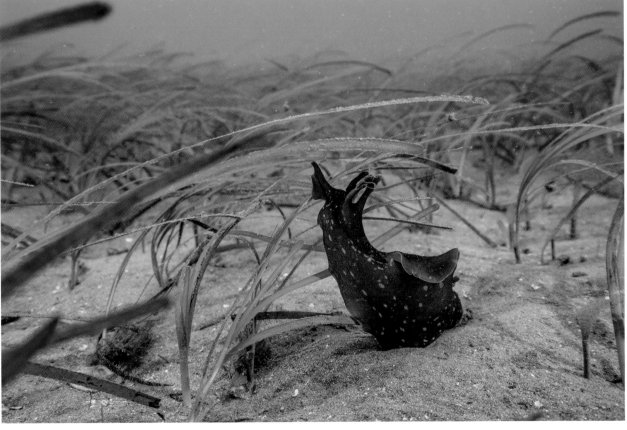

CONSERVATION HERO:
AMELIA HURSHAM, GREENER THAMES TRAINEE, RSPB

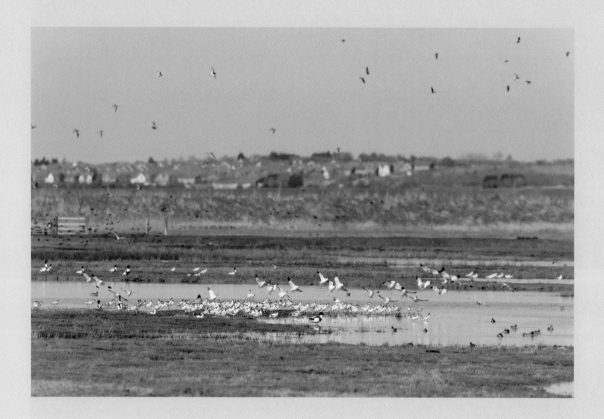

When Amelia Hursham, who uses the pronouns she/they interchangeably, was at Portsmouth University, they volunteered to help a PhD student studying oyster bed restoration. 'That's where I fell in love with the ocean', she says. 'We spent the day building oyster cages and my mind was blown by the facts that they were telling me – that these bivalves are so important, and important to the history of the Solent and Essex too.'

Greener Thames is a £1.8 million landscape-scale conservation project run by the RSPB in partnership with Essex Wildlife Trust, Kent Wildlife Trust and other local organisations, which aims to revitalise more than 1,800 hectares of wetlands in the Greater Thames estuary. It is part of a wider push in the region to protect marine life around the coasts close to the capital and reinvigorate lost habitats including oyster beds and seagrass meadows.

Amelia's work includes monitoring fish life with the Thames Estuary Partnership. After 'putting on a nice comfy pair of waders and using multi-method fish sampling strategies' in the Thames, Amelia once found a zander, a non-native species which had never before been recorded on that stretch of the river. They regularly find sea bass and flounders. 'This narrative that the Thames was ecologically dead in the 1950s has stuck, and of course the colour of the Thames doesn't look inviting, but

Opposite: A flock of avocet in flight over Elmley Marshes, an RSPB reserve in North Kent.

it amazes people when you tell them there's so much life on their doorstep', they say.

She also undertakes hands-on conservation at RSPB reserves such as Rainham Marshes, brush-cutting for lapwing habitat or assisting reed-bed creation for bearded reedlings. When meeting visitors to the reserves, they enjoy telling young people about the wonders of overlooked marine life such as oysters – and the incredible fact that one tiny oyster can filter 16 pints of water in under an hour. Oyster reefs can be highly effective sea defences and carbon stores too.

Another marine habitat Amelia is passionate about helping restore is the seagrass meadow, and they recently undertook a research trip to Italy to collect samples and measure these precious features. They are a scuba diver and swimming through the seagrass 'really opened my eyes to how beautiful seagrass meadows can be. You can see them on these amazing Sir David Attenborough TV shows but experiencing them first-hand, swimming through these towering meadows, is like being on another planet. I felt as if I was in *Finding Nemo*. The colours, the life and the silence of being underwater is like nothing you can describe.'

Amelia grew up in Witham, Essex, and was always interested in wildlife. They didn't realise that marine biology was a career option for them until they were studying A Levels. Today, another task she views as part of her job is showing other young people of colour that the overwhelmingly white world of conservation is open to them – while also urging conservationists to ensure their organisations are embracing people of all backgrounds.

'Growing up and watching Sylvia Earle and Steve Backshall, all these amazing people on wildlife programmes, there weren't many who looked like me – that can play into your psyche about the accessibility of conservation. When I got to university, I was the minority in the room but conservation is changing. Young people are so interested in the world around them and there's definitely a shift towards the sciences', they say. 'If I can inspire one person who looks like me to realise marine conservation is open to them that's just as important work as restoring our oyster beds and seagrass meadows.'

STARFISH ON THE HUNT – BUT SCALLOPS HAVE A TRICK UP THEIR SLEEVE

On the shallow seabed, a carpet of arms reach up in the water, in many hues of brown and grey that may also shine pink, red, yellow and blue. These are brittlestars, which look rather like emaciated starfish. As its name suggests, a brittlestar's arms are easily broken. But the brittlestar is more resilient than it looks. An arm can be cast off to escape from a predator and then can be grown back again.

There is also strength in numbers. Brittlestars may gather, clustered together in their thousands in just a single square metre of seafloor. If the current becomes too strong, the brittlestars hunker down and work together: they can form a community, linking arms to create a vast mat of brittlestars that is unlikely to be swept away when seas rage.

The brittlestar is a passive suspension feeder: it relies on moving water to bring in food. When tidal currents are slow, the brittlestar's arms lie mainly flat on the seabed. As the current picks up, their flexible arms are raised into the water to catch food suspended in the water column as it drifts past. Long slender spines like translucent stalagmites on their limbs catch the food and pass it along the arms to their central mouth.

The brittlestar is an echinoderm, an animal with tough plates embedded in the wall of its body, alongside starfish, sea urchins and sea cucumbers. Ingeniously, echinoderms have no front or back. A starfish does not need to turn its body to change direction. It does not need to move forward or reverse because it is based on radial symmetry, and can easily move in any direction.

The brittlestar can move too, and strokes its long arms in a snaking motion to swim over the seabed more rapidly than starfish. This is just as well because starfish are one of heir predators.

From the spiny starfish (*Marthasterias glacialis*) with its purple-tipped arms to the vivid pink and red-blotched bloody henry starfish (*Henricia oculata*), there are a multitude of spectacular-looking starfish in our seas. We mostly see the common starfish (*Asteria rubens*), the familiar, five-armed pale orange creature washed up on beaches. Its upper surface consists of small blunt spines.

They may look benign but starfish are lethal predators. If a starfish appears, a group of brittlestars will flee, crawling and 'swimming' over each other in desperation. The starfish usually has more time to attack a bivalve mollusc – a shell with two halves. When a starfish finds one, it arches itself over the shell, pressing as many of its tube feet as possible on to both sides of the shell to prise it open. Its mouth hovers above the crack between the halves and pulls with such force that the mollusc eventually weakens. When a tiny crack opens up, the starfish forces its stomach through its mouth and into the mollusc. Digestive juices do the rest.

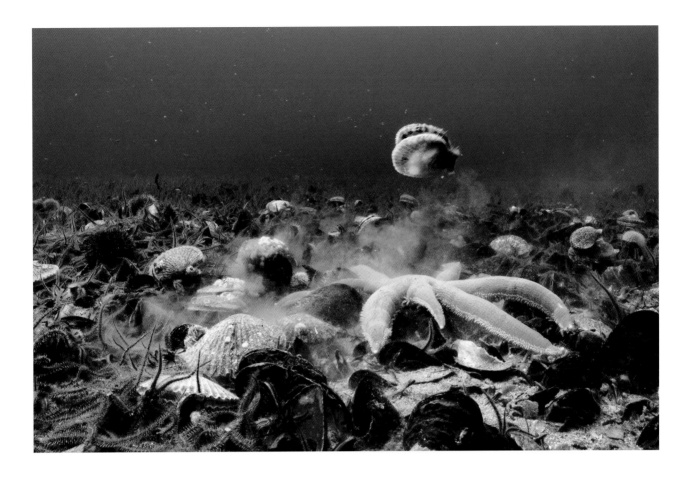

Above: A stealthy starfish will pull apart and devour a scallop. But the scallop can defend itself by rapidly snapping its shell, creating a jet of water that propels it away from the sluggish predator.

Scallops are a particularly beautiful mollusc, and known to people of course as a much-prized source of food. The great or king scallop (*Pecten maximus*) can grow to up to 15 centimetres across while queen scallops, known as queenies, are slightly smaller. Unlike many other bivalve molluscs, the scallop's two shell halves are quite different. The lower half has the curve of a bowl; the upper half is flat, like a lid.

As a scallop filter-feeds in the water, it uses its eyes to keep a lookout for fast predators such as fish. But the stealthy starfish is slow enough to avoid detection. There seems to be no escape, since the starfish can pull any shell apart. But the scallop has a special power. As soon as the starfish touches the scallop, it opens up completely. By rapidly snapping its shell, it creates a forceful jet of water, enabling it to swim rapidly away from its slow-moving predator. A scallop swimming can look balletic and comic in the same movement. It may be tiring to swim like this but it gives them enough propulsion to escape the starfish.

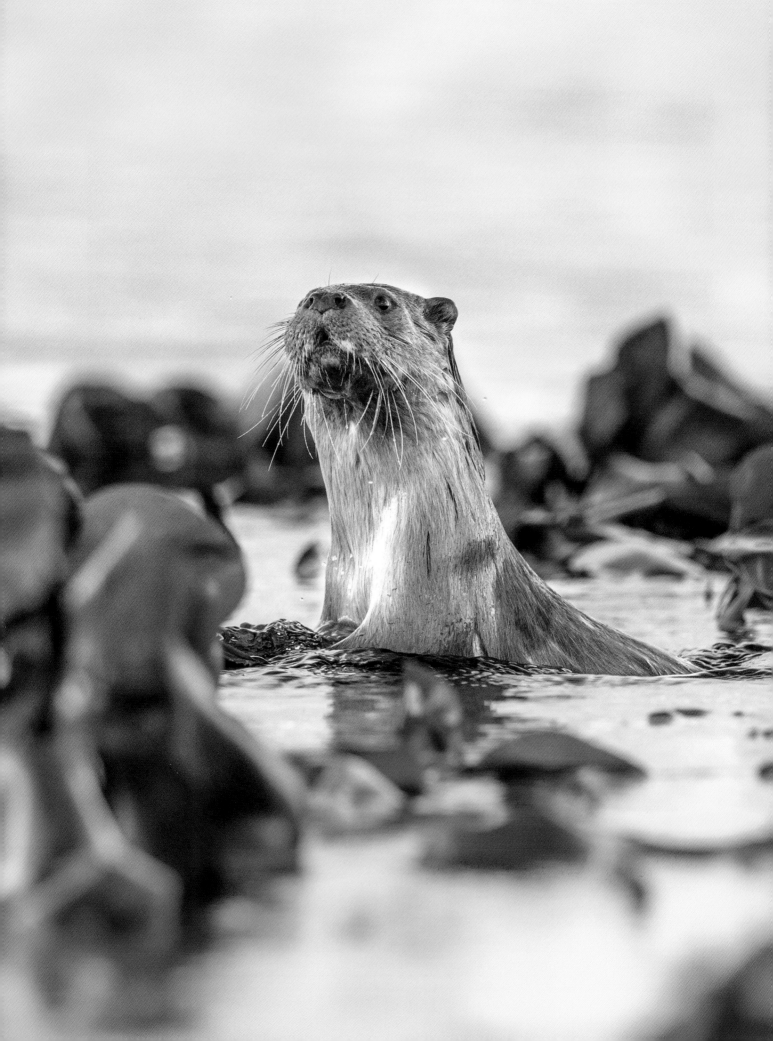

The Trials of an Otter Mum

Moving through the swirling bronze of a shallow forest of kelp seaweed is a sinuous brown shape. The rocky coast of the archipelago of Shetland is the European capital of a much-loved mammal: the otter (*Lutra lutra*). Today, thanks to the widespread recovery of this once perilously endangered member of the mustelid family, we see otters in rivers across England and Wales, as well as throughout Scotland and Ireland. But this energetic, strategic fish-seeking predator is equally at home in seas and saltwater.

In his celebrated book, *Ring of Bright Water*, Gavin Maxwell discovered that his pet otter, Mij, was superbly adapted to swimming and hunting in 'the gaudy sea forests' off the northwest coast of Scotland. When Maxwell was writing, in the 1960s, *Lutra lutra* had all but disappeared from England, a victim of habitat loss and hunting but most significantly the build-up of organochlorine pesticides and 'heavy metals'. These toxic chemicals increased in concentration as they moved up the food chain, peaking in otters and other top predators, suppressing their immune systems and causing infertility and a sudden population crash across most of Europe.

Otters clung on in north and western Scotland. Happily, since the chemicals were withdrawn in the 1960s and totally banned in Britain and the EU in the early 1980s, the toxins have diminished and Britain's otter population has bounced back, assisted by reintroductions onto southern rivers. Even so, postmortems of otter carcasses in recent years still find traces of organochlorines in their bodies. As the fate of tragically poisoned orcas shows, the toxic legacy of organochlorines and heavy metals is still with us today.

Scotland remains a stronghold for otters, supporting a population of around 8,000 animals who mostly live in coastal areas, enjoying a seafood diet. These animals are sometimes called 'sea otters' because their lifestyle seems so different from our riverine creatures but they are the same species; the sea otter (*Enhydra lutris*) is a separate, larger species not found in Europe but living around the north and east Pacific coasts. Food and good habitat are so plentiful on Shetland that there is likely to be a higher density of Eurasian otters here than in any other place in Britain. The islands' population is around 900 animals. The Yell Sound in Shetland is believed to support more than two per cent of the entire British population.

The reason for their success on Shetland is its long, low rocky coastline with plenty of intertidal riches. Easy access to freshwater is also important. Otters can thrive on a salty diet but must have access to freshwater pools or streams as well, for freshwater is vital for otters to maintain a healthy fur and manage their body

temperature. Otters' movements on Shetland are also influenced by the tide, and they tend to forage less at high tide. At low tide, when shallow inlets and rockpools are exposed, it is easier to find something to eat. Scientific studies have found otters tend to stick within 100 metres of the coast and undertake short, rapid thrusts underwater to grab prey, sometimes as deep as 10 metres but mostly within two metres of the surface and lasting less than 20 seconds.

On the shoreline and in the shallows of the kelp beds are rich pickings for an otter but this species always seems to be in a hurry. Otters' rapid lifestyle and exposure to cold waters means that they must catch and eat around a quarter of their body weight each day, and this hunting burden rises if you're a hard-pressed parent. Otters live in a den known as a holt, which is typically in a rocky cave or beneath the roots of a tree. In truth, however, there is no typical holt: the Shetland naturalist Brydon Thomason has found otters nesting in ruined sheds, old hen houses, wrecked cars and boats. Once he found a mother using a one-tonne bag for building material which was dumped behind the drystone wall and had been partly grown over with grass. It was rather like a tent, and flapped in the wind but it was still a shelter for a mum and her pups for several months.

After at least a month in the secure, dry otter holt, a pup emerges; after two months, it is swimming in the water. It will stay with its family for up to a year, and in the early days it is fed. But before it hunts, it must learn to feed.

A spider crab doesn't make for much of a meal but when an otter mum returns to her pup with a larger offering, a live octopus, the naïve youngster struggles to handle it as the octopus fights back. It's a similar problem when the mum seizes a large crab in the shallows. The pup has not encountered such a feisty meal before, and is hesitant in its approach. The crab will not give up easily, and uses its best weapon – its strong claws – to fight back. The pup inches forward, and jumps back when it is pinched. Finally, the pup works out how to subdue and devour this prey without getting nipped. The young otter's hunger is finally sated when its mum returns with another treasure from the kelp forest – a lumpsucker. These are often easy prey for otters. And there is a good reason for that...

Opposite top: A crab doesn't make for much of a meal for a hungry otter, especially when it uses its best weapon – its strong claws – to fight back.

Opposite below: There is plenty of other nourishing food which an otter mum will bring back from the kelp forests for her pups, from octopus to the ball-like lumpsucker fish.

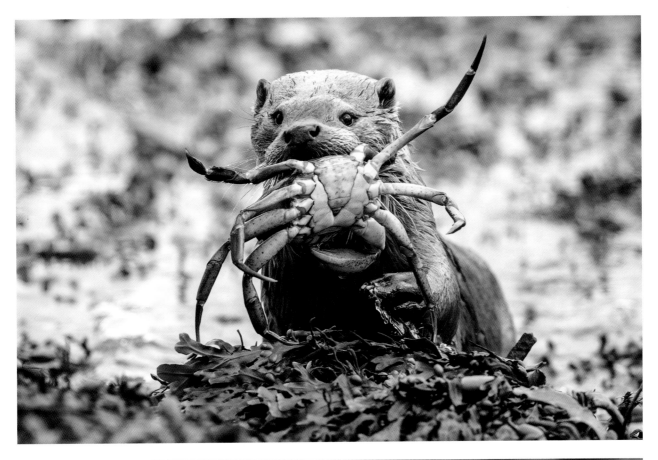

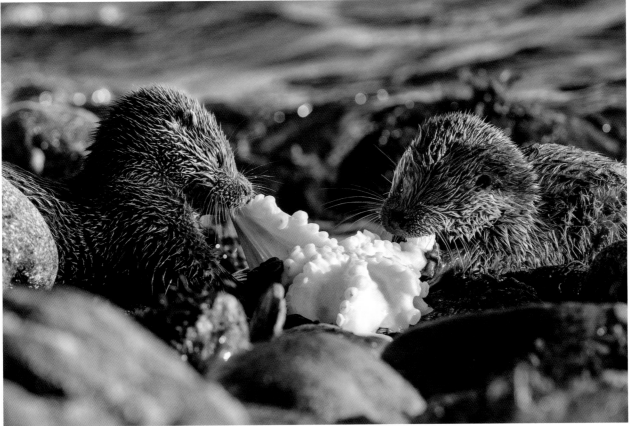

TO HAVE AND TO HOLD – LUMPSUCKER AND CLINGFISH

There is a wealth of colour and life in the restless zone between high and low tide. On rocky shores, this is a world of secret pools, waving weed, anemones, limpets and the flash of a tiny fish. While otters find food here, larger mammals find joy: children love to explore these miniature worlds and adults remember their treasure-seeking rock-pooling days for the rest of their lives.

The creatures that make their living in intertidal waters must have special qualities to cope with their habitats being scoured by the waves and tides each day. Most of all, they must be able to hold tight. A good suction pad always helps. The lumpsucker (*Cyclopterus lumpus*) lives up to its name. It is one of the largest fish a rock-pooler is likely to encounter, up to 50 centimetres long, with an oversized head, grey-blue skin and a humped body all bumpy and lumpy, protected by a series of bony plates. Beneath its chin, its pelvic fins have merged to become a powerful suction pad. This allows it to cling to the surface of rocks, even when they are pounded by wave power.

Lumpsuckers spend much of the year in deeper water but move to the shallows in February to find a mate. After breeding, the female lays a cluster of eggs on the rocks and returns to the deep. She leaves behind the male, who shows himself to be one of the most devoted dads in the ocean.

For up to seven weeks, the male, who displays an orange-red belly, tends to his patch of eggs. Occasionally he will guard more than one. He bustles about, cleaning the eggs and keeping them oxygenated by fanning them with his fins. Sometimes he presses his head into the eggs, blowing on them. Rotten eggs are removed. Eggs would be a protein-rich treat for many a passing fish and so the lumpsucker's devotion keeps away scavengers.

Guarding eggs laid in often extremely shallow water while the waves sluice to and fro is quite a challenge. The lumpsucker's suction prowess comes in handy so he can hold tight to the rock and protect his precious offspring against all-comers. Occasionally his devotion means death. If the female has laid her eggs in too shallow water, the eggs, and dad, are left high and dry by a big spring tide. The lumpsucker still won't leave and is an easy feast for a passing gull.

The shallow waters around Britain contain some of Europe's finest forests of kelp, a large seaweed whose thick, leathery fronds can shine bronze, or be coloured like coffee with milk, or turn a deeper chocolate brown. For snorkellers or scuba divers, a glimpse into a kelp bed is to witness an underwater forest, its 'trees' swaying with the rhythms of the waves and tides.

Opposite: The female lumpsucker, distinguished by her grey colouration, uses her sucker – modified pelvic fins – to attach herself to a kelp frond. The females are rarely seen in shallow water.

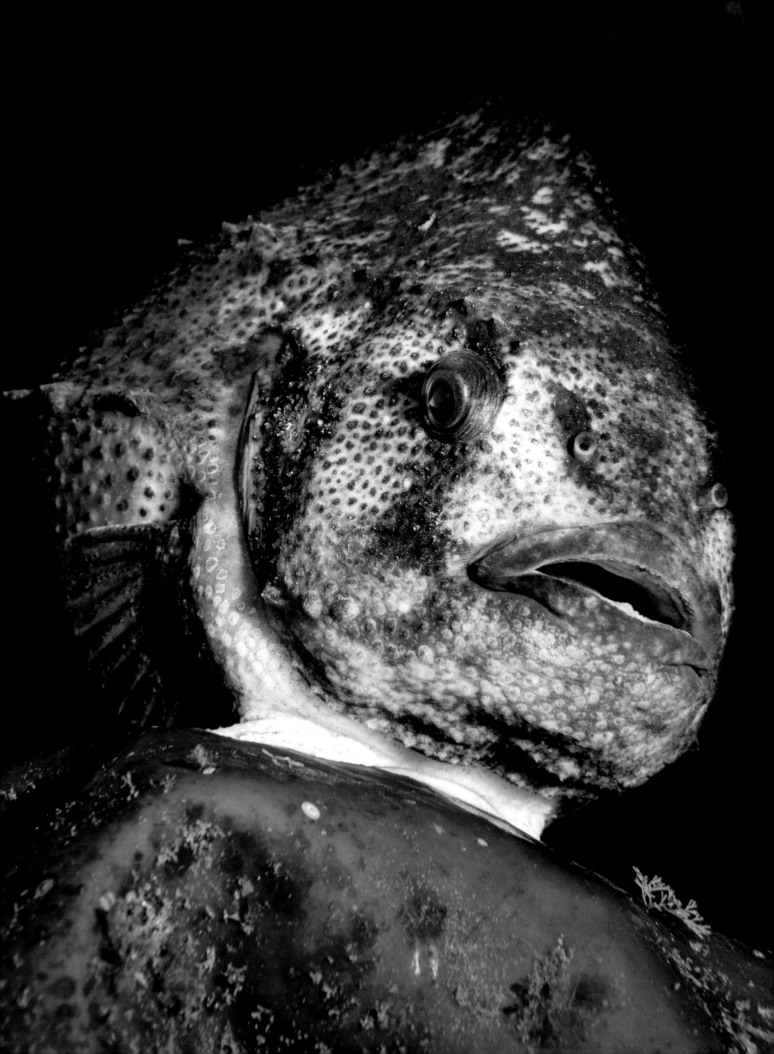

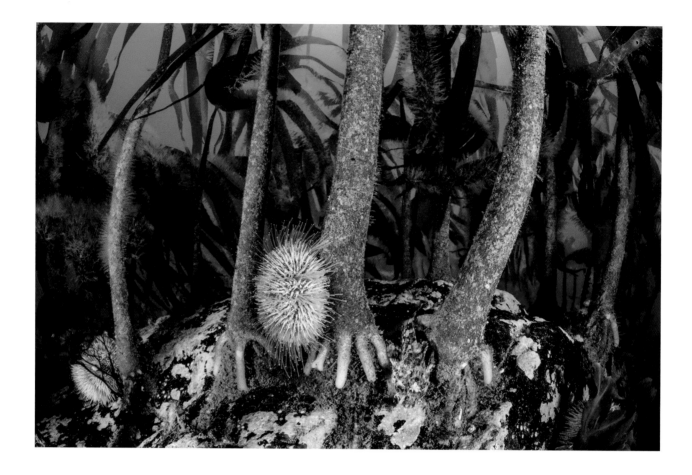

These aquatic forests are one of the richest and most diverse ecosystems in the world. More than 1,800 species of flora and fauna have been recorded in kelp-dominated areas. They provide food and shelter for sea anemones, sea firs, sea squirts and sponges. And they are nurseries for fish and shellfish. The array of life here attracts larger predators from birds to seals, otters and orcas.

Kelp forests thrive in cool coastal waters where temperatures rarely exceed 20°C, and in areas where nutrient-rich cool waters well up from the deep. This upwelling occurs at the edge of the continental shelf to the west of Britain and Ireland. Kelp requires sunlight to survive so it usually only grows in shallow water. But by the remote Atlantic islet of Rockall – on the edge of that continental shelf – kelp has been found growing down to 33 metres below the surface because the waters are clear.

Britain's kelp forests contain seven of Europe's 14 species of kelp. Winged kelp or dabberlocks (*Alaria esculenta*) is most abundant on the wave-wracked coasts such as those of the Isles of Scilly. Oarweed (*Laminaria digitata*) is the most conspicuous species of kelp, while cuvie kelp, or tangle (*Laminaria hyperborea*) is the main forest-forming kelp in Scotland. Around the Scottish coast, there are kelp forests covering 2,155 square kilometres of the seabed, an area larger than Nottinghamshire.

Kelp originally referred to the ashes of the seaweed which was used as a source of potash and iodine in the early decades of the industrial revolution. Kelp beds remain extremely useful to people today, being harvested in some countries but also

Above: A common sea urchin between the holdfasts of a cuvie kelp forest around the Farne Islands. The holdfasts look like a root but do not take up nutrients, simply anchoring the kelp to the rock.

stabilising sediments on the seabed, oxygenating the water and, as more extreme storms buffet Britain in an era of climate change, helping to buffer wave energy and protect beaches and coasts from erosion. Another 'service' they provide which benefits us is to absorb huge amounts of carbon dioxide. Globally, kelp forests absorb an estimated 600 million tonnes of carbon each year, about twice Britain's annual carbon emissions.

Kelp has a tough, thin stalk, called a stipe, which holds it upright in the water while flat fronds fan out like long leaves. These contain bladders of air that help the kelp float upright. Its fronds are smooth and slippery to touch, covered in a mucus that makes it harder for animals to attach themselves. Even so, sea firs and sea mats can gain a grip.

But where small creatures really thrive is in the caverns and hollows created by the kelp's 'holdfasts'. These look like a root but do not take up nutrients. Instead, they anchor the kelp securely to the rock when it is pushed and pulled by wave power. One marine biologist has recorded 389 species of marine animals living in holdfasts off the northeast coast of England, including worms, brittlestars, amphipods, molluscs, anemones and sea squirts.

One of the most characterful residents of the kelp holdfast is the shore clingfish (*Lepadogaster purpurea*), also known as the Cornish sucker, who hides inside the golden cave-like hollow. There are more than 160 members of the clingfish family *Gobiesocidae* around the world, showing the many niches that can be found in these intertidal waters.

The shore clingfish is a small fish, no more than seven centimetres in length, with a pair of vivid turquoise or blue 'eye' spots on the top of its head and a fringed tentacle in front of each nostril. Its flat head and bill-like snout make it look like a tiny duck-billed platypus and this unlikely-looking creature has an unlikely superpower: it can survive long periods out of the water, breathing with its gills and absorbing oxygen through its skin. Hiding under rocks or exposed by the retreating tide, its reddish-brown body shines like a wet pebble.

The clingfish shares the lumpsucker's adaptation to intertidal life: a fusion of its pelvic fins to form a powerful suction pad. The male clingfish also shares the lumpsucker's devotion to parental duty, and will use his suction pad to cling to a rock beside his eggs. These yellow eggs look easier to defend, because they are securely placed in the cave formed by the kelp's holdfast. But first dad must chase off mum, who has a tendency to eat the eggs that have been laid by other females but which also belong to the male clingfish.

Compared to the lumpsucker, the clingfish father has an easier time of parenthood. As the eggs develop, they change colour from yellow to orange and then to dark grey. Now the eyes of the developing young become visible, looking out through their translucent case. First the clingfish dad chases off a crab. But then a shadow falls on the holdfast. Waving tentacles appear. Sea urchins are on the march, and they want eggs for tea.

One urchin has already been attacked and repelled by the lumpsucker, which grabbed it in its mouth and carried it away from its young. But the urchin's strong teeth can easily chew through the walls of the holdfast, exposing the clingfish and his young. Now the invader crawls into the clingfish's safe space.

The clingfish will bravely defend his eggs but the urchins are bigger. The clingfish doesn't stand a chance. But suddenly, the urchin is ripped off the holdfast. The shadow disappears. There is a crunch. The wolf eel may look scary but on this occasion one of the key predators in the kelp forest has saved the day, crunching the urchin and maintaining the delicate balance in the sophisticated bowl of life on the rocky edges of the sea.

The rapid loss of some kelp beds around the world has occurred in recent decades, with one trigger being overgrazing by sea urchins. When their predators – such as larger fish – are removed by us, the urchins can increase to such an extent that they are a threat to the kelp beds. As we saw earlier, otters, and particularly the sea otter (a separate species, which was once widespread around the northern rim of the Pacific Ocean), predate urchins and help keep their numbers in check.

As recently as the 1980s, a majestic kelp forest stretched 25 miles along the coast of West Sussex from Selsey to Brighton, reaching four kilometres into the English Channel. But the forest disappeared because it was smothered by sediments from dredging which were dumped at sea, and by the repeated action of bottom trawlers, bumping, scraping and ripping the seabed in their search for fish. Only fragments of this forest remain.

Now there is hope that this kelp forest can be restored following a 'Help Our Kelp' campaign. Conservationists including Sir David Attenborough and the Sussex Wildlife Trust have called for the kelp forest to be revived but, crucially, so have local fishing interests led by the Sussex Inshore Fisheries and Conservation Authority.

In 2021, a new bylaw was passed to ban trawling over 304 square kilometres of coastal seabed. This 'rewilding' of the sea will allow the kelp forests to recover and regenerate and restore marine life. As well as biodiversity returning, it is hoped that fishers will benefit too because if the kelp regenerates it will boost populations of cuttlefish, lobster and black sea bream. Sir David described the bylaw as a 'landmark decision'. It is likely to pave the way for more 'no trawling' or more comprehensive 'no take' zones around Britain to help restore degraded marine environments for the benefit of everyone.

Opposite top: One marine biologist has recorded 389 species of marine animal utilising the caverns and hollows created by the kelp's holdfasts. They include the male clingfish, which guards its eggs in these caves.

Opposite below: Unfortunately for the clingfish, hiding in a kelp holdfast is no guarantee of protection from predation – especially when a sea urchin comes calling.

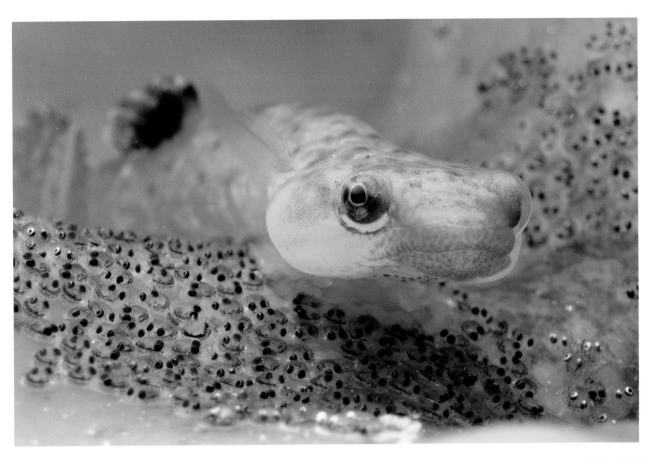

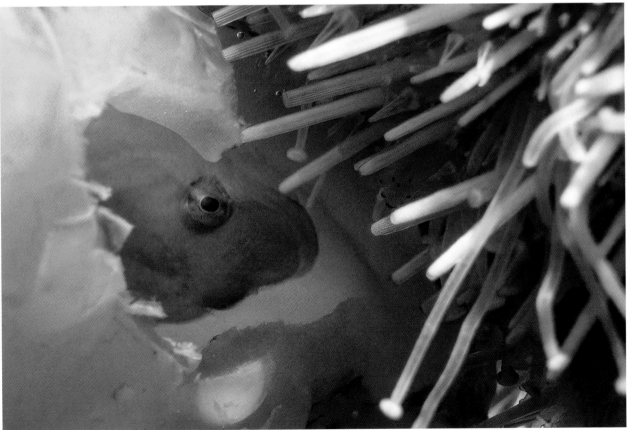

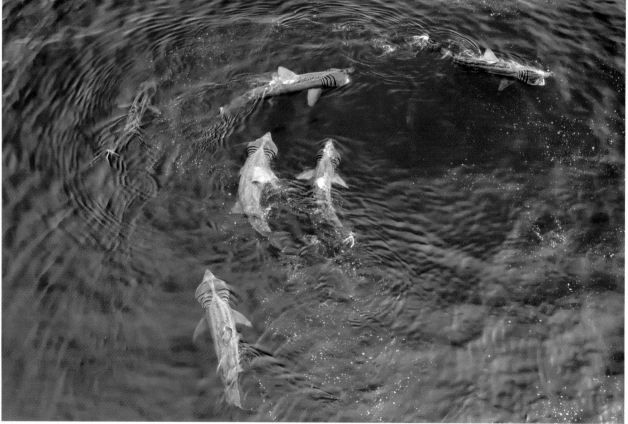

Spawning, Bloom and the Gentle Giants of the Ocean

Opposite top: Zooplankton are tiny animals, adrift in the water column, who feed on billions of microscopic plants – phytoplankton – to grow and mature. These were photographed in the waters near Cunningsburgh, Shetland.

Opposite below: Zooplankton may be tiny, but they are vast in number and support much greater marine life, including these basking sharks.

In spring and early summer, the waters around Britain experience an explosion of life. Winter storms and strong tides have stirred up nutrients from the shallow seabed. Under the warmth of the sun, the light-filled upper waters bloom with billions of phytoplankton, microscopic plants that float in the water column and feed a wealth of creatures higher up the food chain. There may be tens of millions of phytoplankton in a litre of seawater.

When this great green bloom emerges, billions more tiny creatures are waiting to feed upon it: zooplankton. These are tiny animals, adrift in the water column, who must feed on the phytoplankton to grow and mature. Many zooplankton are microscopic and known as protozoa, which are single-celled animals. Some zooplankton species are particularly numerous and spend their whole lives suspended in the water, such as krill and copepods. Others are the newly hatched larvae of seabed-dwelling animals, such as starfish, lobsters and crabs. There are fish eggs, shrimp and barnacles. The larger zooplankton, such as young jellyfish, are visible to the naked eye.

As these tiny animals feed upon the phytoplankton, they form dense clouds of life, drifting in waters that warm with the season. These plant and animal planktons form the base layers of a food chain that powers an extraordinary abundance of sealife, and terrestrial life too – from seabirds to humans.

This food chain is quite different from our familiar terrestrial food pyramid. On land, approximately 450 billion tonnes of carbon from the biomass of plants supports a total of about 20 billion tonnes of consumers at higher levels. In other words, a great mass of plants supports a smaller mass of animals. In the oceans, the situation is reversed: about one billion tonnes of primary producers support a total of around five billion tonnes of consumers. This is because marine phytoplankton, the microbial producers in the ocean, have a very rapid reproduction rate. They have extremely high metabolic rates and are highly efficient engines of photosynthesis, and so grow and divide very quickly, reproducing sexually or asexually and creating their entire biomass almost every week on average.

Zooplankton feeds all kinds of small fry, but their blooms also draw in the gentle giants of the ocean. The basking shark (*Cetorhinus maximus*) may be the length of a bus and the second-largest fish in the ocean but it feeds upon the smallest organisms.

The basking shark acquires its name from its habit of appearing to bask in the sunshine, its large, dark, triangular dorsal fin moving languidly through the water on a sunny summer's day, when the zooplankton are gathered near the surface of the water. Its tail swishes from side to side as it constantly twists and turns its body into

the mass of tiny animals, sometimes performing a full 360-degree roll to maximise its catch. This 12-metre long, six tonne behemoth is one of only three shark species to be a passive filter feeder – gliding through the water with its one-metre-wide mouth open through the densest clouds of zooplankton. Although its mouth has very small teeth, its key feature is its gill rakers, which act like a sieve: these are finger-like appendages covered in mucus that trap microscopic zooplankton, preventing the tiny animals escaping as the seawater flows through the gills. A single basking shark can sieve up to 2,000 tonnes of water each hour.

Basking sharks are great nomads, always wandering, because zooplankton is not evenly distributed throughout the ocean. Although essentially solitary, they may gather and work together if they find a particularly rich spot. At times, up to 20 have been spotted together in the zooplankton-rich waters off the west coast of Ireland. They swim in formation to maximise their catch, as escapees from one mouth are hoovered up by another. These rich feeding zones are also good places to meet a mate.

Between May and October, basking sharks are most frequently seen off the west coasts of Britain and Ireland, particularly around headlands, islands and bays where a strong tidal flow causes different masses of water to meet and there is plentiful zooplankton to eat. For many years, their disappearance in winter was a mystery. It was once thought that they hibernated but many basking sharks migrate south to North Africa or swim across the Atlantic. Satellite tagging has revealed how they change their behaviour in winter, when there is no longer the sunshine to trigger great blooms of plankton. Basking sharks move into deep water, diving to great depths to feed on the deep-ocean plankton found there.

Basking sharks are considered endangered in the northeast Atlantic but populations here are stable, with the fishing of this species banned in British waters since 1998 and across EU waters since 2007. In 2020, waters around the Hebrides became the world's first Marine Protected Area specifically designated for basking sharks. But they are still hunted elsewhere in the world and are at risk of being unintentionally caught as bycatch or colliding with fishing or commercial boats. A more intangible threat to the basking shark is the change in global temperatures that is making the timing of the spring plankton blooms more unpredictable. The offspring of so much sealife require these blooms during the critical first weeks of life to survive. If the unpredictability of the spring bloom worsens, it could have a devastating effect on all marine life.

Opposite: A basking shark is one of just three filter feeding sharks in the world. Here one is opening wide its mouth to feed near the Hebridean island of Coll.

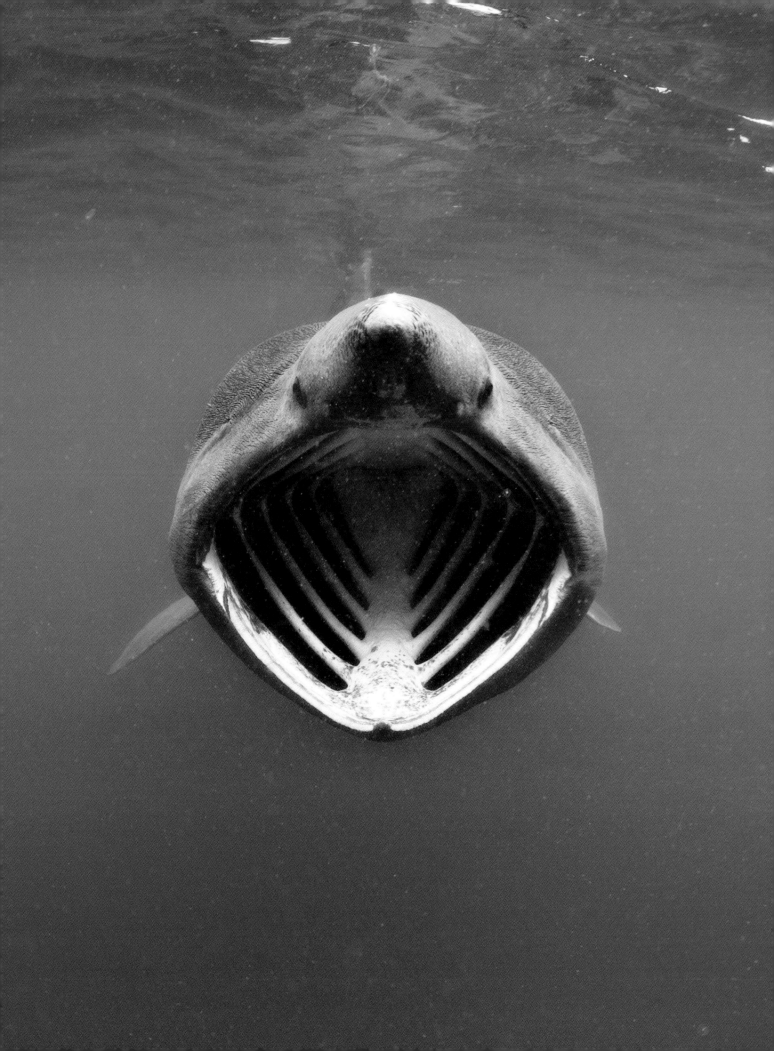

An Abundance of Seabirds

Like the basking sharks, mackerel have special sieves in their mouths that allow them to filter the water for microscopic zooplankton. Like the sharks too, the mackerel will gather and work together to find their food. But these gatherings are conspicuous, and easily visible to aerial predators. The mackerel are powerful swimmers, and there is some safety in numbers – until a great flock of daggered predators coalesces above them.

Scanning the ocean surface from altitude, gannets and Manx shearwaters spot the potential feast and congregate in great numbers to size up the food swirling in the blue ocean below. The gannet (*Morus bassanus*) is the largest seabird in the North Atlantic, with slender wings spanning almost two metres. It plunge-dives, plummeting towards the water at speeds of up to 24 metres per second, tucking its wings back to make a perfect arrow-shape. The bird's long, slender neck looks like it might buckle on impact with the water but it straightens and contracts, locking vertebrae in place before entry. The gannet also has air sacs beneath its skin to cushion its breast, and no external nostrils to ensure that water won't be forced into its head as it would in a human diver.

Bang! Detonations of spray erupt over the surface of the water as the gannets make an emphatic but precise entry into the ocean. The plunge from height gives the bird momentum to reach the mackerel. If required, the gannet uses its webbed feet and wings to power itself further underwater in pursuit of the fish.

The spectacle of a gannet feeding frenzy is one of the great wonders of nature, a demonstration of hunting prowess, speed and abundance. Our archipelago is of global significance for seabirds. Britain is home to eight million breeding seabirds belonging to 25 species, more than other island hotspots such as the Falklands (four million breeding seabirds) and the Caribbean (1.3 million breeding seabirds). These species have bred here for centuries. Francis Willughby, the father of modern ornithology, commented on the 'remarkable Isles, Cliffs, and Rocks about England, where Sea-fowl do yearly build and breed in great numbers' in the seventeenth century. Willughby first described the Manx shearwater (*Puffinus puffinus*) after a memorable visit in the summer of 1660 to the Calf of Man, at the southern tip of the Isle of Man.

Today, there are more than 600,000 gannets in Britain, and some 65 per cent of the world's population living in 21 gannetries around the islands, stacks and cliffs of Britain and Ireland. Almost all of the world's population of around 400,000 pairs of Manx shearwaters breed in Britain and Ireland. The Welsh islands off the coast of Pembrokeshire are home to more than half the world's population, and another sizeable proportion of Britain's shearwaters breed on Rum. The great skua

Opposite: Northern gannets 'fence' with their bills during courtship to cement their pair bond.

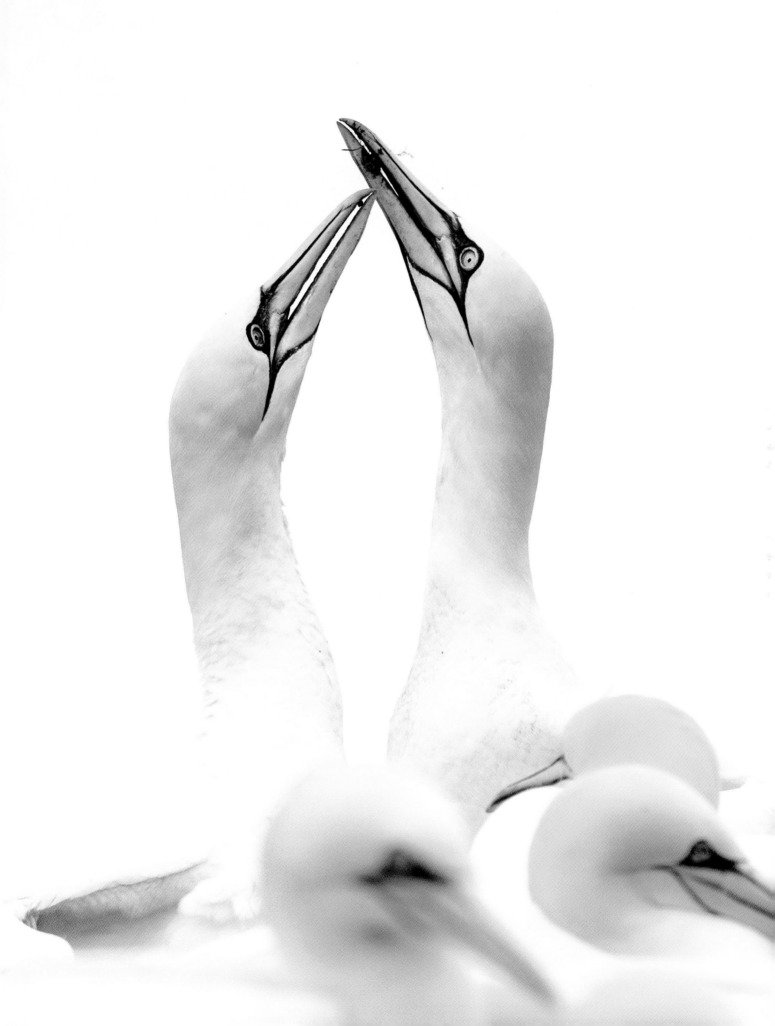

(*Stercorarius skua*), popularly known as the bonxie, is a fairly recent arrival on our northern-most islands but Scotland now holds 60 per cent of the global population.

Britain is also home to 1.4 million guillemots (one of the more globally common seabirds), a third of all European shags, a fifth of all razorbills, and a tenth of the world's population of Atlantic puffins, which also has strongholds in Iceland and Norway.

Seabirds breed here in such number because our coastline still supplies a diversity of remote, relatively predator-free cliffs, rocks, shingle spits and sand dunes where different species can raise their chicks in relative safety. And, equally crucially, our diversity of seas, and the mixing of nutrient-rich waters to create epic seasonal blooms of zooplankton and fish, ensures that seabirds and their chicks are well-fed.

The success of seabirds has not been constant over the centuries, however, and a plethora of new threats are emerging today.

Historically, seabird numbers fell because they were hunted for food and feathers over the centuries. When Francis Willughby visited the Calf of Man in 1660, he recorded local people killing 9,000 shearwater chicks each year for food. Until the twentieth century, cliff-nesting seabirds were a crucial part of a healthy diet for the residents of many small islands, with islanders climbing the cliffs to harvest puffins, gannets and razorbills.

As predation from people lessened and then was finally ended with new laws protecting breeding birds, another foe emerged: rats, and other predatory species including stoats and cats which were brought by people onto small islands. Manx shearwaters vanished from their eponymous colony on the Calf of Man after rats from a shipwreck reached the uninhabited islet in the late eighteenth century. Burrow-nesting birds such as puffins and Manx shearwaters proved particularly vulnerable to predation by rats. The breeding populations on islands from Lundy to Ramsey drastically shrank in the twentieth century because of the rapacious rodents.

Brown rats jumped from the numerous ships that were wrecked in the notoriously dangerous waters around the island. By the 1800s, rats were established on the island for the first time, and were eating their way through the populations of ground-nesting seabirds and other small birds.

Seabirds have evolved in rat-free places, and when rats arrive on small islands they have found it all too easy to raid their nests on the ground, and eat their eggs or chicks. The puffins that nested in burrows on Ramsey, an RSPB reserve, were driven to extinction, and so were the storm petrels. The Manx shearwaters clung on but, by the turn of this century, there were fewer than 500 pairs on the island, many hundreds fewer than in the past and a fraction of those on neighbouring islands: there are 350,000 pairs of shearwaters on rat-free Skomer, and 100,000 on Skokholm.

But the shearwaters have made a comeback on Ramsey off the coast of South Wales since the uninhabited island benefitted from one of the first successful invasive species eradication programmes in the British Isles. In the winter of 1999/2000, a specialist team from New Zealand set specially constructed poison-bait traps for the rats. These had raised entrances so the harmless bank vole would not be caught. Winter is the best time for any island eradication programme

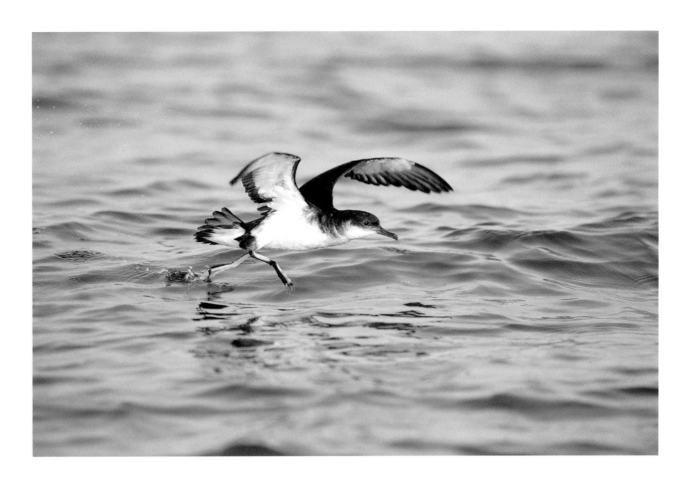

Above: Britain's coast provides the breeding ground for some 90 per cent of the world's population of Manx shearwaters.

because the rodents are at their hungriest and the breeding seabird populations are mostly elsewhere, minimising any risk to them. The rats disappeared after the first trapping season, but then began the long task of monitoring to ensure the trappers had not missed some rats, or other animals recolonised the island.

Fortunately, there has been no sign of a rat on Ramsey ever since, and the lethal currents of Ramsey Sound make it unlikely that a rat – a good swimmer – could make it across by itself. But even today, the island continues to be monitored for rats, with ink traps recording rodent footprints and camera traps also set. There must also be strict biosecurity measures to minimise the risk of rats being inadvertently brought onto the island by boat. Anything brought by boat is carefully sealed up and made rat-proof. Food is always locked in plastic boxes. No-one can bring open carrier bags onto the island. Bales of hay for the island's sheep are also never brought onto the island in case they contain a stowaway.

With the rats gone, the abundance of seabirds on Ramsey has bounced back. By 2016, the Manx shearwater population on Ramsey had surged ten-fold from just 500 pairs to 5,000 pairs; by 2022 it had increased again to 6,225 pairs. In 2008, storm petrels returned to breed on the island, with a small population of 12 pairs sustained since then. Only the puffins have failed to return, despite there being 30,000 individuals on nearby Skomer, the largest population in southern Britain. Removing the rats has benefitted the wider small island ecology, with many more small birds too: wheatears had been reduced to barely 30 pairs but their breeding population reached 120 pairs in 2020.

The removal of rats in recent decades has also benefitted seabirds on Lundy in the Bristol Channel and the Shiants, a trio of uninhabited Hebridean islands.

Our unparalleled colonies of breeding seabirds have survived centuries of predation by humans and by rats but their next challenge may be their biggest yet. An apparent loss of food in the sea, and reduced or more unpredictable blooms of phytoplankton and zooplankton is challenging some populations of seabirds, alongside multiple other threats including entanglement in fishing gear and, most recently, avian influenza. Seabird colonies off the coast of Wales have generally continued to do well. But there are worrying signs among many northern populations of seabirds. On pristine islands such as St Kilda, undisturbed by people and rodents, both puffins and Leach's storm petrels are struggling. Kittiwakes are another seabird suffering big declines. As rapid climatic changes imperil our sealife in new ways, all seabirds face an uncertain future.

Above: In the summer of 2022, Sir David Attenborough travelled to the island of Skomer to witness chicks fledging from the 350,000 pairs of Manx shearwaters that breed on the Welsh island nature reserve.

Overleaf: The spectacle of a gannet feeding frenzy is one of the great wonders of nature.

CONSERVATION HERO:
GREG MORGAN, SITE MANAGER FOR THE ISLANDS OF RAMSEY AND GRASSHOLM

From March to November, Greg Morgan lives on Ramsey alongside a warden and volunteers who stay for shorter periods. Small islanders must be a jack-of-all-trades, and the job is varied. Greg must protect the seabirds, monitor them, and ensure the visitors who arrive on day-boats from April to October are safe and don't disturb the island's wildlife. He must also count seals and farm the sheep on the island whose grazing is important to create the short turf required by rare choughs. On a small island, the weather is often against you.

While many wardens of small islands stay for a couple of seasons, Greg has done the job for 16 years. 'The years have ticked by – it's unbelievable where they've gone. When you're enjoying something, time does fly', he says. 'It's just so varied and it's a fantastic location to live.'

The Manx shearwater should be better known, he says, but it is often overlooked, perhaps because it is mostly nocturnal and only found living in burrows on remote small islands before making its remarkable migrations at the end of summer to the southern hemisphere.

People living close to the coast of West and South Wales have rallied to help the shearwater, however. When the chicks fledge, they emerge at night. Using the horizon to navigate, they want to head west, ultimately to Argentina, where they will spend the winter. So they are drawn to the lighter sky in the west. Unfortunately, particularly on murky nights, they can be confused by light pollution inland, and set out eastwards – in completely the wrong direction.

Like swifts, shearwaters are masters of the air (and water too) but are helpless on land. Lured to the lights of a village, town, oil refinery or even the illuminated toilet blocks of a campsite, they crash-land and cannot take off again. So Greg and the RSPB have teamed up with the Wildlife Trust of South Wales and assembled a team of volunteers who rescue stranded shearwaters and wait for good conditions to release them again. Residents who find shearwaters in their gardens or on the road – roads with a shiny surface can be mistaken for water by some of the birds – phone the volunteers and get them to help the birds. Each year, between 200 and 300 juvenile shearwaters are saved in this way.

'It has helped raise the profile of Manx shearwaters locally and it's got the community involved', says Greg. 'People have been really supportive. The Manx shearwater should be Wales's national bird. There's no other species where the Welsh population is more globally important than the shearwater.'

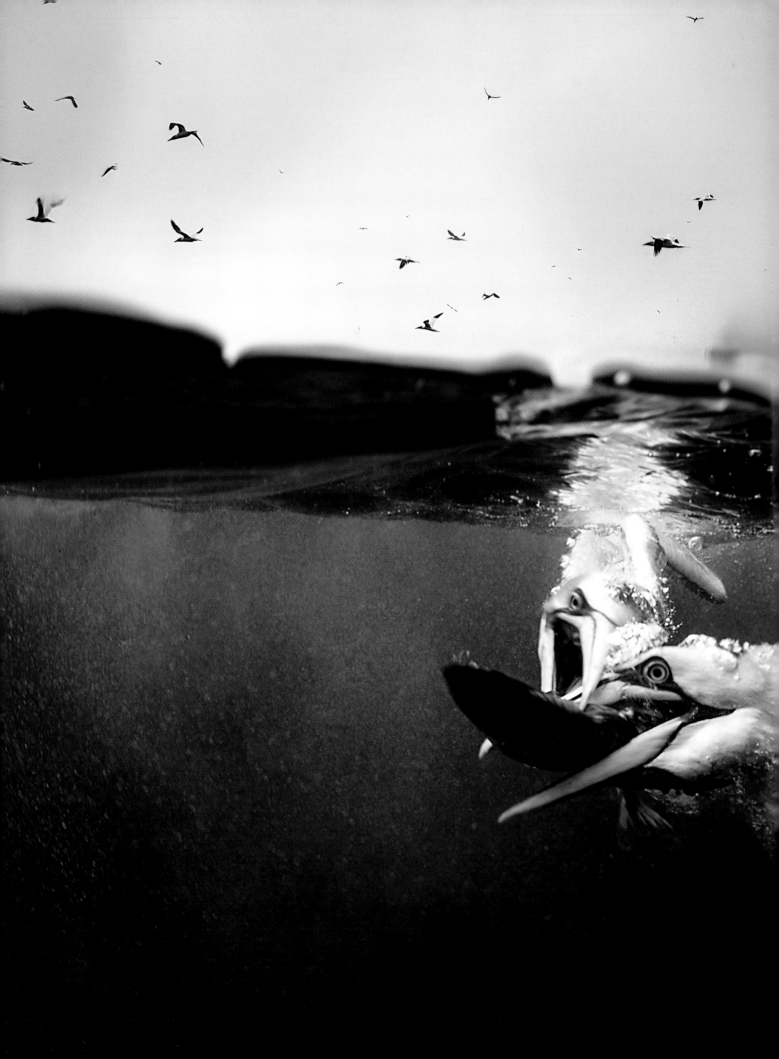

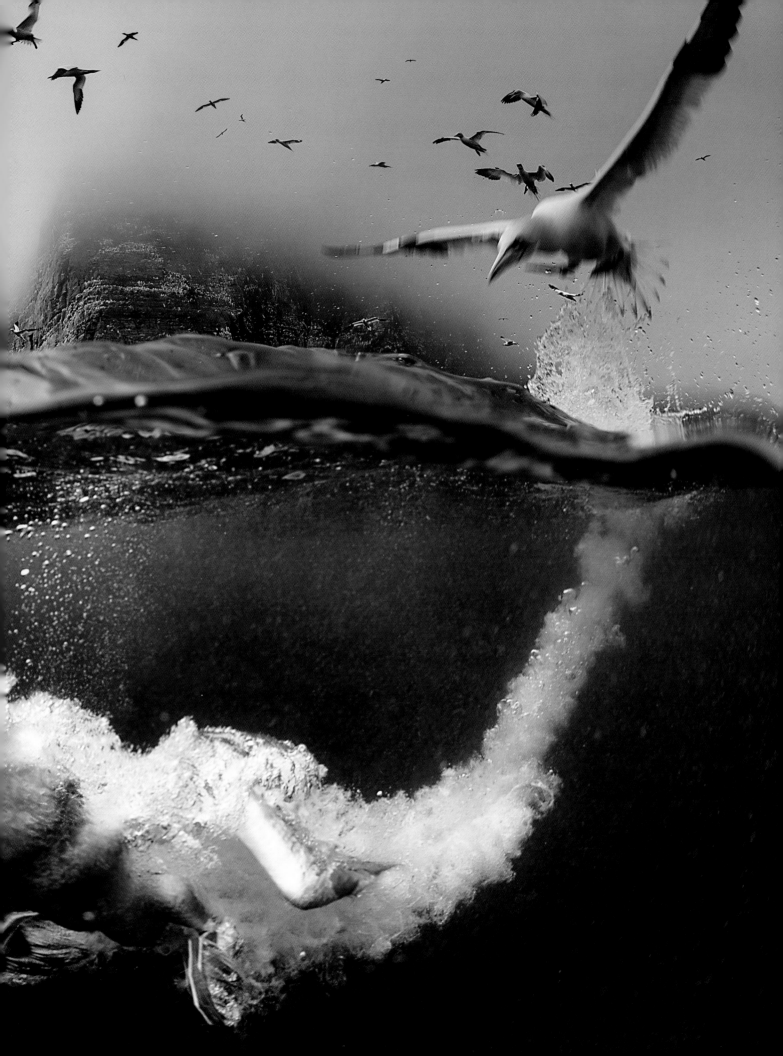

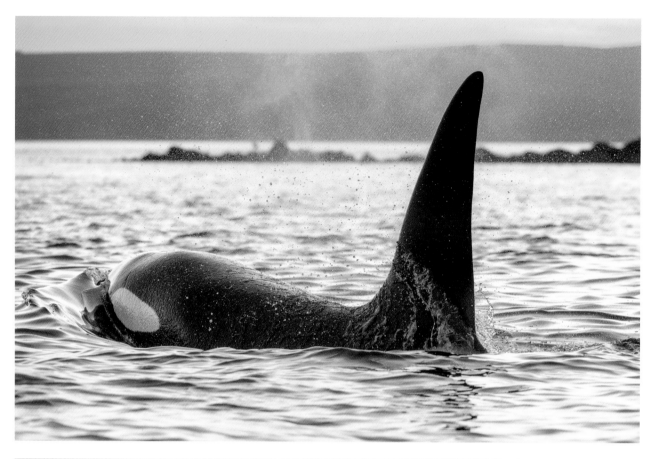

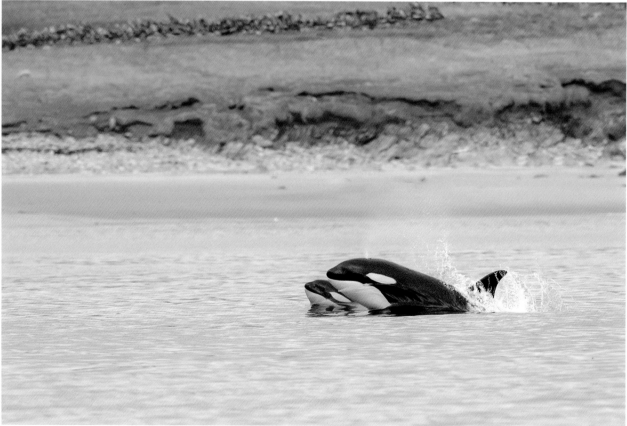

OUR IMPERILLED OCEANS

The orcas that opened our grand tour around the unexpectedly wild isles of Britain and Ireland are one of the smartest, strongest and most formidable animals on our planet. But they are powerless in the face of human activities that threaten their very existence.

The group of orcas found in the seas to the west of Scotland, known as the West Coast pod, appear to be doomed because of a build-up of polychlorinated biphenyls (PCBs) and 'heavy metals', toxic chemicals which increase in concentration as they move up the food chain. Comparable chemicals caused the crash in Britain's otter population as well. But although PCBs were phased out in the 1980s, these toxins have continued to accumulate in harmful concentrations within long-lived orcas, suppressing their immune systems and causing infertility.

There were thought to be eight members of the West Coast pod left but there have only been two large males identified in recent years. In 2016, a female member of the pod, Lulu, was washed ashore on the Scottish island of Tiree. She had become entangled in fishing rope and had suffocated and drowned. When a necropsy was undertaken, Lulu was found to have the highest levels of contaminants in her body ever recorded in any marine mammal anywhere in the world.

'It was off the scale', says Rob Lott, orca programme lead for the charity, Whale and Dolphin Conservation. 'It was twenty times higher than the threshold where we know that damage for an individual would occur.'

Lulu was a mature female, and only in her twenties, but had never had a calf. In one way, she was an exception because female orcas tend to live longer (sometimes beyond 50) in the wild than males. The reason for this is a tragic one, according to whale conservation scientists. When a female gives birth and feeds milk to her calf, she inadvertently offloads some of her toxic burden via the milk. The young calf innocently devours a toxic cocktail of chemicals in the mother's milk. An orca is usually 15 years old when she first gives birth: a first-born receives 15 years' worth of toxins. Second-born calves tend to fare better because they only receive four or five years' of toxins absorbed from ocean prey by the orca mother. First-borns among orcas studied in the Pacific were found to have a mortality rate as high as 50 per cent whereas subsequent calves have a higher survival rate. Of course, first-time mums tend to be less adept at motherhood but conservation scientists increasingly subscribe to the theory that Polychlorinated biphenyls (PCBs), highly carcinogenic chemical compounds, are contributing to this disastrous infant mortality.

The Shetland and Orkney Northern Isles pod appears to be in a healthier state than the Western Isles pod, and several of the group are relatively young orcas.

Unfortunately, in September 2021, a member of the 27s pod was found dead: a five-year-old male. There was evidence of rope marks on his tail stock, where a rope had been twined around the orca, and so it is likely that this young animal became fatally tangled in fishing ropes – either active ropes or 'ghost gear' lost or deliberately dumped over the side of a boat while at sea.

Fishing communities don't want to catch orcas, but too much fishing gear still gets lost or damaged and deliberately abandoned in remote seas. New technology has been slowly developed – but not yet introduced – to enable fishers to use ropeless pots to catch crab and lobster, removing the trailing ropes that pose an entanglement risk for orcas, dolphins and sharks. Timed or acoustic triggers release a buoy attached to the submerged pot which allows them to float to the surface for retrieval. 'The future is to make sure there's harmony between the need to maintain a livelihood in UK waters and protect these iconic creatures at the same time', says Lott. 'Nobody wants to see an orca tangled in fishing gear. It's harrowing.'

The increase in human-generated noise in the sea – from fishing boats, other vessels, oil and gas rigs and offshore wind turbines – is another challenge for orcas. Research in the Pacific Northwest shows that orcas connect with whistles and clicks and have to call much louder because of noise pollution, and spend more time searching for food. Orcas need to spend more time hunting and travelling in a noisy ocean, which saps their strength. The orcas 'seem to be socialising less and resting less because they are on a mission to find food for the pod', says Lott. 'They are primarily acoustic creatures. They rely on a quiet, clean ocean to survive. They don't rely on us for anything apart from to keep their habitat as pristine as possible.'

How do we keep our waters as healthy as possible? Our oceans are crucial for all life on Earth – including our own – but sadly, much of the life within them is imperilled. They produce half of the oxygen we breathe, they stabilise our climate, they provide food and natural products for medicines. Attempts to put a monetary value on oceans are fraught with difficulties but a conservative estimate suggests they are an asset worth US$24 trillion annually: if the oceans were a country, they would be one of the biggest economies in the world.

Today the seas are changing faster than at any other time in the history of Earth. We are the agents of that change. Until relatively recently, the ocean was regarded as a source of inexhaustible riches available for our exploitation and enjoyment. Now we have achieved dominion over it. As Callum Roberts, one of Britain's leading marine biologists, warns in his book, *Ocean of Life*: 'It is hard to grasp the prospect of seas so compromised that they no longer sustain the ecological processes which we take for granted, and upon which our comfort, pleasure and perhaps even our very existence depends.'

Unfortunately, this is the danger that our oceans face. How have we reached this point? For centuries, the story of people's relationship with the sea is told in a history of fishing. As islands, Britain and Ireland are blessed by the extent of their waters, and the fish – and food – found therein. The Romans fished extensively for seafood but after their era, sea fishing dwindled in much of Europe, except for northern Scandinavia. Domestic waste dumps in England and elsewhere in northern Europe in the ninth century are dominated by the traces of fish that live in freshwaters, at least part of the time: sturgeon and salmon plucked from the

Above: Spider crabs camouflage themselves by allowing algae and other marine plants to grow on their backs.

rivers. Sea fishing got underway in Britain by the eleventh century when extensive agriculture washed sediment into rivers and human settlements alongside rivers contributed to pollution that turned clear waters sluggish, brown and warm. New dams for water mills also cut off spawning routes for migratory salmon. As the abundance of fish in rivers disappeared, so people turned to the sea.

Through the Middle Ages, salting technologies gradually improved, so cod taken from their Arctic spawning grounds could be shipped as far as the Mediterranean. In the fifteenth century, Amsterdam developed an improved preservation method: herring in brine. Around this time, beam trawling was developed. Nets held open by a beam of wood could now be dragged across the seabed. Peasants appealed to their king to ban the trawl that 'runs so heavily and hardly over the ground when fishing that it destroys the flowers of the land below water'. Ever since, technological improvements have enabled the massive expansion of bottom trawling. Today almost no parts of the seabed around Britain are undisturbed by fishing gear that bounces against the seabed, pulverising fragile organisms. In effect, industrial-scale trawling ploughs up vast tracts of seabed, turning three-dimensional habitats, places of corals, sponges and seaweeds into rubble, mud and sand, destroying the complexity of sealife that lives there.

It is estimated that trawlers sweep an area of seabed equivalent to half of the world's continental shelves every year. Today's commercial trawlers can reach depths of 2,000 metres – well over a mile beneath the waves. Closer to home, in the northern North Sea, trawling intensity tripled between 1960 and the mid-1990s.

Most of the North Sea is ravaged by trawlers two or three times a year; favoured areas are hit by trawlers tens of times each year.

Above: Sprat schooling in the English Channel near Swanage, Dorset.

Technological advances in fishing have increased in pace and so has the scale of the fishing effort. Steam power in the 1880s created one fishing revolution. Echo-sounders in the 1950s enabled another, revealing the presence of shoals of fish where even the wisest captains of old couldn't locate them. Lines have become long-lines, some tens of miles long that carry thousands of hooks.

With technology, ingenuity and bravery, we have fished a large chunk of life out of the sea. It is difficult for us to appreciate the denuded state of our seas because each generation accepts what we have and doesn't realise what we've lost. This is known by conservation scientists as 'shifting baseline syndrome'. But historical evidence and fishing catch records give us a sense of the abundance stripped from our seas.

In 1785, Henry Beaufoy, an MP, described the catches of fishermen in the Firth of Clyde, an expanse of productive sea west of Glasgow. One fisherman baited 400 hooks and would commonly take 350 fish: turbot, sole, flounders. There were whales, porpoises and visiting shoals of herring. When these 'silver darlings' arrived, the sea appeared as two parts fish to one part water. A fisherman could fill his boat with skate but he didn't bother because there was so much else. Then, within a few decades of the introduction of trawlers at the end of the nineteenth century, the herring fishery in the Clyde collapsed. A ban on bottom trawling helped preserve fish but it was repealed in 1984 by a generation who had forgotten what it was for.

They would soon regret that decision. Cod, haddock, plaice and whiting – all the Firth's productive fisheries – quickly disappeared. 'Today the seabed is barren and the only fisheries left are for prawns and scallops, and even these are overfished', wrote Callum Roberts in 2009. 'It is a marine wasteland.'

Objective data also reveals the loss of fish from British waters. Reliable records of catches from bottom trawlers began in 1889. These catches rose steeply until the middle of the twentieth century, levelled off, and then dramatically collapsed. In 1889, when most of the fishing fleet was powered by sail, more than twice as many bottom fish – the fish-and-chip staples such as cod, haddock and plaice – were caught in British waters than are caught today. This is incredible when we consider the superior fish-finding technology, boat-power and net sizes that fishers have at their disposal. Callum Roberts, who is now Professor of Marine Conservation in the Centre for Ecology and Conservation at the University of Exeter, and a team of scientists have examined the amount of time spent fishing and power expended to better calculate the decline in caught fish. For every hour of fishing today, fishers land just 6 per cent of what they did 120 years ago. Put another way, fishers have to work 17 times harder to get the same catch as their Victorian forebears.

Over the decades, the fish we have caught have got far smaller. Fishing methods invariably select the larger fish and even shellfish. Mussels fell in size by more than 40 per cent over a period of almost 10,000 years in California, according to studies of shell middens. The loss of larger fish and shellfish is a problem because size matters in the marine world, where these animals carry on growing as they age and remain fertile for most of their lives. So bigger, older fish and shellfish produce far more offspring than smaller, younger fish. Animals adapt to being heavily fished – by becoming smaller. Sole in the North Sea mature at half the body weight they did in the 1950s. This sounds like good news but small fish produce many fewer eggs than larger creatures, and a spiral of decline sets in.

The Victorian scientist James Bertram observed a classic pattern of fishing as early as 1873. 'We are continually, day-by-day despoiling the waters of their food treasures', he wrote. 'When we exhaust the inshore fisheries we proceed straightaway to the deep waters.' As one species of fish becomes scarce, we move on to another species. Large predatory fish, such as tuna or cod, are bold and easily lured, so they get taken first. In this way, we have 'fished down the food web', targeting and virtually obliterating species from large to small, first predator, then prey.

Today, globally, there are more than 4.6 million fishing vessels working on the oceans, catching wild seafood of a landed value of more than US$130 billion. But globally, despite an intensification of fishing effort, seafood catches peaked in the 1990s and are now falling. A third of all fish stocks are overfished and face collapse. Here in Britain we are still advised to eat fish for our good health but we've been shielded from the loss of fish by the global trade in fish, the industry moving from one type of fish to the next, and also by the growth in farmed fish. Unfortunately, intensive aquaculture brings further problems for our wild marine environment.

Overfishing is an environmental problem with an extremely straightforward solution: fish less, using less destructive methods, waste less and protect more. Animal populations bounce back if we stop killing them. Seal populations have

rebounded following the 1970 ban on hunting grey seals. And this may sound paradoxical but if we fished less, there would be more fish for everyone. Major fish stocks of the world would produce 40 per cent more if we fished them less, according to a World Bank study.

Unfortunately, reducing our fishing seems to be incredibly difficult. The biologist Edward O. Wilson famously declared: 'We have Palaeolithic emotions, medieval institutions, and godlike technology.' It is hard to restrain ourselves.

The marine environment suffers from what ecologists call 'the tragedy of the commons'. When a natural resource is held in common ownership – or is owned by no-one – it is too tempting for individuals to compete with each other and increase what they take while they can, eventually causing the commonly held resource to wither away. Politicians also struggle to take tough, long-term decisions. Fishing communities tell powerful personal stories, and it is difficult to deny anyone a livelihood, or tell them their job must pay less, change or even stop.

Fishing is controlled in the seas around Britain, with annual catches set by politicians making complicated agreements with neighbours such as Norway and the EU. Unfortunately these continue to be set right at the limit of what fisheries scientists calculate is the maximum sustainable yield – and often beyond it.

In 2009, Callum Roberts declared: 'In the European Union, the relationship between politicians and the fishing industry has become like that of a doctor assisting the suicide of a patient.' Politicians, he argued, continued to give fishers catch quotas that were, on average, a third larger than the 'safe' – sustainable – levels recommended by scientists.

In 2022, catch limits agreed by Britain, the EU and Norway for North Sea fisheries saw an increase in catch allowances for whiting of 25 per cent, herring of 20 per cent and haddock of 5 per cent, with reductions for plaice and saithe. The allowable catch for cod was maintained at 2021 levels, against the advice of the International Council for the Exploration of the Sea which provides politicians with scientific information on the population of fisheries.

'As a result of the continued exploitation of fish stocks and failure to effectively management our seas, the condition of the marine environment has continued to decline', says Kirsten Carter, principal marine policy officer for the RSPB. 'Neither our fish stocks or seabed are in the healthy state required to sustainably feed growing human populations, support wildlife or help address climate change.'

Fisheries management, explains Carter, often relies on short-term decision making and measures to save fish stocks in poor health balanced against the need to maintain the economic viability of the fishery. Fishing effort is restricted as stocks reach critically low levels but these restrictions are often lifted before the fish reach fully healthy levels. Sand eel fishing in UK waters was largely closed throughout 2022 but could re-open before reaching healthy levels, due to pressure from fishers in other countries.

Carter argues that sustainable fisheries will only come when decisions are made on the basis of best scientific advice and when robust monitoring and compliance is in place. There is also the matter of making sure that there are not too many vessels chasing too few fish as this will always undermine sustainability. She believes that we need to fully understand how and where fishers are fishing and what impact it has on the marine environment – from what is caught accidentally

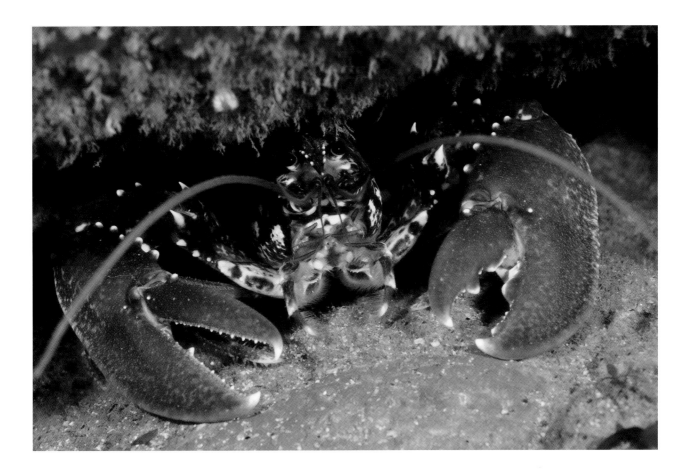

Above: This common lobster is another species to benefit from the 'no take' Marine Conservation Zone around the island of Lundy. Marine conservationists hope that some of Britain's wealth of Marine Protection Areas will be toughened to prevent damaging activities such as trawling.

and what impacts on seabird integrity and marine wildlife might be. This needs to be underpinned by effective investment, much in the way that farmers are paid to undertake sustainable practices. Taken as a whole these measures would help bring an end to unsustainable fishing. Fisheries could be more closely seasonally managed for instance, with an emphasis on long-term management of healthy fish stocks and ecosystems. 'There seems to be positive support for more research and information gathering to assist change,' says Carter. 'You see some fishers willing to make a change but this can be totally undermined when super-trawlers are able to sweep up all the fish. It's very difficult to incentivise people to change while these practices continue.'

There is hope, and positive change. Many small fishers want to support a thriving marine environment, and help themselves enjoy a more predictable, sustainable livelihood. Technological advances such as Remote Electronic Monitoring (REM) cameras on boats can help us better manage fisheries, understanding what we catch and the implications for bycatch (the capture of non-target sensitive species).. There are also ingenious 'scarecrows for the sea' being fitted to gill nets in Cornwall to stop birds such as cormorants becoming entangled.

Sealife can recover in a remarkable way if fishing pressure is eased. In the denuded Firth of Clyde, a small group of islanders on Arran began a campaign to protect a short stretch of coastline in Lamlash Bay in the 1990s. The campaign grew and, in 2008, Lamlash Bay became Scotland's first marine protected area to be closed to all fishing. Within two years of protection, habitats inside the

reserve started to recover, with juvenile scallops found to be more numerous in the protected zone than in nearby fishing grounds. Lobsters in a small no-take zone east of the island of Lundy in the Bristol Channel were 7.7 times more abundant than in the fished area just a few years after its designation. Scallops in a no-take zone off the Isle of Man increased in the protected area but also produced larvae to seed adjacent areas.

With political will and a sprinkling of long-term vision, the blight of overfishing can be stopped and fish stocks can start to recover. As humanity's dominion over the planet increases however, so our seas are under pressure as never before from development and industrialisation. Our seabeds are dredged for sand and shingle. Coastal developments, port expansion and sea defences in an era of sea-level rise threaten coastal waters and estuaries. Nutrients washed into the sea from farm fertilisers and sewage disposal continue to pollute the marine environment, fuelling plankton blooms that starve the waters of oxygen and smother much life. Nitrogen pollution and disease from aquaculture, the increasingly intensive farming of fish, damages biodiversity. At the turn of this century, Scotland's salmon farms released as much nitrogen (potentially fuelling plankton blooms) as contained in the untreated sewage of 3.2 million people, more than half Scotland's population. Chemical spills and other pollution including microplastics continue to despoil our seas.

Nuclear power stations are sited by the sea, and release warm water into it, alongside the risk of radioactive leaks, and the last half-century has seen the development of huge offshore oil and gas industries in the North Sea. Despite the need to scale back fossil fuel production because of climate change, this industry is still having an impact.

The most visible industrialisation of the sea today is one that most people agree is much-needed: in the shallow seas around Britain there is a massive increase in the construction of offshore wind farms to meet the government's target to cut carbon emissions to net zero by 2050. Creating more renewable energy is crucial to stop runaway climate change but the scale and siting of offshore wind farms poses a challenge for seabirds and marine mammals in particular. There is little research yet on mega-windfarms' impact on marine life but, during construction, the noise from pile-driving can damage the hearing of dolphins if they are within a few hundred metres. Once operational, wind farms produce a low-frequency rumble underwater. Their construction disrupts the seabed, and life there may be adversely affected by the laying and operation of cables from the wind farms to bring power to shore. Electromagnetic fields may disrupt fish movements, especially of electro-sensitive species such as elasmobranchs – sharks, rays and skate. Research also shows that turbines can pose a danger to migrating birds and bats.

The RSPB is urging the government to think carefully about where new wind farms are built so they work in harmony with nature and don't take up crucial feeding areas for seabirds or interfere with migratory pathways. But if new wind farms come with new regulations to help nature, they could be an opportunity to dramatically benefit underwater wildlife. The Netherlands have passed laws to stop fishing in areas of wind farms. In Britain, there is no such law but trawler fishers find it difficult to obtain insurance for their operations inside wind farms because

of the hazard posed by the sea-floor electricity cables. Less fishing in areas of wind farms will mean more wildlife. 'They are acting as de facto refuges to a degree', says Callum Roberts, 'and attracting different kinds of wildlife. The footings made of rock are going to permit reef-dwelling animals to get a foothold.' Big fish that have been extirpated could come back – or be reintroduced. According to Roberts, these inadvertent artificial reefs could see the return to the North Sea of skate, halibut, big turbot and angel sharks.

However, there remains a big challenge with the development of wind farms and other industrial uses of the sea: each scheme is assessed in its own right, and there is limited consideration of the whole. Conservationists believe effective holistic planning to better manage our seas is the key to success. 'The absence of holistic planning in itself is a significant threat to the marine environment', says Kirsten Carter. She argues that we need to consider the cumulative impact of all this activity on marine life, and better plan what can happen where. The sea needs effective cross sectoral planning for the long-term. Unfortunately, electoral cycles are short and there is little to encourage politicians to take decisions that might be difficult in the short-term but will reap rewards long after their careers are over.

The biggest challenge to marine life around Britain is probably the phenomenon we feel most powerless to prevent: climate change. Our seas are facing unprecedented events as great warmth potentially disrupts ocean currents or causes acidification. Like our rainforests, they are threatened by global heating but are also one of our best weapons against it. The global ocean has absorbed about 40 per cent of anthropogenic carbon emissions. Each year, it continues to absorb at least 25 per cent of the 41 billion tonnes of carbon dioxide emitted by humans – about the same amount as all the world's forests.

Our seas are heating up. In the last 25 years, the North Sea has warmed by 1.25°C. New species are arriving in British waters and familiar species are moving north. Over the last 35 years, 15 of 36 fish species surveyed in the North Sea have moved by, on average, 300 kilometres north. The effect of newly arrived species is difficult to predict but there will be unintended consequences. 'Warming seas will trigger a global diaspora that will lead to a massive reorganisation of life as long-separated species invade each others' ranges', warns Callum Roberts. Fish grow larger in cooler waters so heat-stressed fish will become smaller. Lower dissolved oxygen, due to warmer water, will also slow fish growth.

With the warming of our oceans, a warm layer of water that sits like a lid over much of the ocean will thicken, and stop the transfer of nutrients upwelling from the lower ocean. This is likely to make some seas less full of life on the surface. In a warmer world, low-oxygen zones within the oceans will expand and so the volume of water capable of supporting life will shrink. The upper limit of low-oxygen waters has already risen 100 metres closer to the surface off the west coast of North America.

There is also the likelihood of more low-oxygen events in the ocean when nutrients are sent upwards and phytoplankton flourish, turning the sea green. Zooplankton would normally eat them, and in turn be eaten by larger fish but can't keep pace. When phytoplankton decays, it sinks and starves the sea of oxygen at

lower levels. An anoxic sludge forms, which emits methane and hydrogen sulphide, the waste products of microbial metabolisms.

The climate crisis is also causing the acidification of the ocean. Gases dissolved in seawater are in equilibrium with those in the air. As carbon dioxide concentrations rise in the air, so they increase in the oceans. Carbon dioxide dissolved into the sea produces carbonic acid, which reduces carbonate ions and increases hydrogen ions. These hydrogen ions make the sea more acidic. The average pH of surface seawater in 1870 was about 8.18. Now it is around 8, and predicted to fall to 7.7 to 7.8 by the end of this century. This sounds modest but it is actually a huge decrease in alkalinity, and it is happening about ten times faster than anything that has happened over the last 65 million years. Acidification threatens far-distant coral reefs but also plenty of marine life closer to home. The loss of carbonate ions makes it harder for all marine animals that build chalky shells and skeletons.

Scientists do not yet know if marine life can adapt quickly enough to survive in our warming oceans. But climate scientists warn that a certain level of atmospheric heating will eventually turn the seas from being a carbon sink to an emitter of carbon. This creates a climatic tipping point that will cause runaway global heating more dramatic than current models predict. Seas and sealife are most likely to be resilient to climate change if diverse habitats and marine life are protected and kept healthy.

Opposite: A flock of knot beside a wind turbine in Liverpool Bay.

WHAT CAN WE DO?

The picture of what has happened to our oceans in recent decades can seem depressing but in every crisis there is opportunity, and the climate crisis may give humanity the nudge it needs to save the sea. For instance, if trawling becomes more tightly regulated to reduce its emissions, then marine life will be a huge beneficiary.

'We are in a period of change', says Kirsten Carter of the RSPB. 'It's now or never. There are a lot of drivers now that can push us to be positive. Most of these are coming from a climate angle rather than biodiversity alone, representing the need to consider the nature and climate emergency and their solutions collectively.'

More than a third of the waters around Britain – 38 per cent – are now designated Marine Protected Areas with 374 such zones in UK waters. If these were managed for wildlife, they could make a huge positive impact on marine life and begin an era of restoration. Unfortunately, most of these zones are currently what conservation scientists call 'paper parks'. Less than a tenth of these areas have management plans. In 2022, 62 of 64 MPAs surveyed were still open to destructive activities such as trawling or dredging; that year Britain issued 1,000 fishing licences for EU and UK vessels to bottom trawl in our Marine Protected Areas.

'It's just a travesty', says Callum Roberts. 'We need to have protected areas for nature just as we do on land. You can't have an MPA that is effectively ploughed up constantly. Nobody says an ancient woodland is good for growing sweetcorn. You just wouldn't do it on land. Underwater, the authorities are getting away with it.' He sees MPAs as empty picture frames in a gallery. 'All we have to do is give them the right protection and these incredible pictures will become visible in these frames. It's nature recovery, and the potential is there.'

The government is currently planning to introduce a small number of 'highly protected' areas with 'no-take zones' of 5km/sq in size. Conservation scientists say these areas are not big enough. Callum Roberts has calculated that, to be effective, Marine Protected Areas should be 10 to 20 kilometres across and no more than 40 to 80 kilometres apart. If there were 10-km reserves 80 km apart they would cover one-ninth of the sea. If 20-km reserves 40 km apart then they would cover a third of the sea. The current plans are 'wildly under-ambitious', argues Roberts. 'The government has accepted that these highly protected marine areas are necessary yet it's taking such baby steps in consulting where to put them and making them really small. It is pathetic.'

There are plenty of scientific studies that demonstrate the wildlife benefits of 'no-take zones' but, understandably, fishers tend to conclude that fully protected Marine Protected Areas take away their livelihood. Encouragingly, the science suggests that the opposite is true. Paradoxically, if we create genuine protected

Above: Our changing climate, bringing global heating and increasingly intense storms, presents a big challenge to marine life.

areas, the fishing catch goes up. A study in the journal *Nature* in 2021 found that setting aside 28 per cent of the ocean for conservation would maximise fish catches because no-fishing zones serve as nurseries, replenishing fish and shellfish populations which then disperse into the wider seas. The scientists discovered that closing areas to fishing caused a sixfold increase in fish biomass within a decade. Protecting the right areas could actually boost the global catch of fish by 8 million tonnes, or 10 per cent of the global catch in 2018. There is good global evidence of the transformation of fisheries by no-take zones: one recent study found that a 35 per cent reduction in the fishing grounds for the California spiny lobster resulted in a 225 per cent increase in catches after six years.

The 'game changer' for Marine Protected Areas and controlling destructive trawling is the belated discovery that the seabed is a vital store of carbon, says Callum Roberts. One of Roberts' new research areas is examining seabed carbon deposits around the world. Currently, seabed carbon, or 'blue carbon', is not accounted for in any countries' 'nationally determined contributions', which are the national targets for carbon emission reductions at the heart of the Paris Agreement on climate change. Seabed carbon must become part of these calculations because if nations continue to allow the release of seabed carbon via trawlers and dredgers then they won't cut back emissions as they must.

'We've been banging on for years about trawling being amazingly destructive. Finally there is a consensus that this is true', says Roberts. 'Carbon deposits are the game-changer here. If the government is to control emissions it has to protect its seabed carbon. In the next five years we're going to see much more restrictions on trawling and dredging because of its twofold impact on wildlife and carbon. Taken together, they can't be ignored anymore.

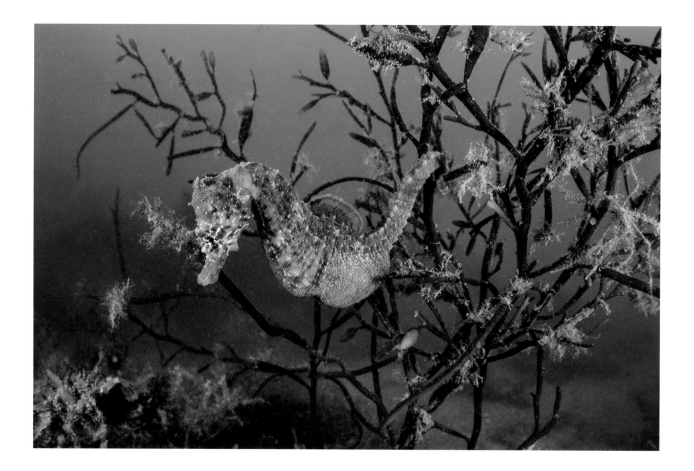

'There is a compelling need to improve management of the sea because climate change is breathing down our necks. To promote the adaptive capacity of nature we need to manage it with a lighter touch. I do think we're gradually steering in the right direction.'

Properly protecting the 38 per cent of our seas now designated Marine Protected Areas could transform marine life and protect stores of carbon. But Callum Roberts believes we must go further. Most of the Marine Protected Areas do not include many of the coastal habitats that are particularly important for storing carbon – particularly areas of muddy seabeds. 'We have to protect much more if we want to protect these seabed carbon stocks', he says. He estimates that we need to protect two-thirds of the sea under MPAs or as carbon-rich seabed protection zones to tackle the biodiversity and climate crises.

It is easy to feel overwhelmed when faced with such big challenges but we can play a part in getting necessary protection for our most valuable marine habitats. No-one in Britain or Ireland lives further than a day-trip away from the coast. Everyone has a 'local' beach – and patch of sea, too. There are 374 Marine Protected Areas around Britain so we all have a local marine nature reserve as well. 'How many people know about any of their local ones?' asks Callum Roberts. 'There isn't that kind of public attachment to their protected areas yet. Unless we build a constituency of interest there won't be champions of these places to speak up for them against the interest of industry.' Obviously it is more difficult to champion an area we can't easily visit or don't pass on our way home from work, and which

Above: Short-snouted seahorses are one of many species that could benefit from a greater appreciation of 'blue carbon'. We must ensure that our seabeds sequester as much carbon as possible in the fight against global heating.

isn't signed 'nature reserve'. But we can find out about our local protected areas, and visit them, and experience some of their special qualities, whether we scuba-dive or swim, sail or simply admire their landscapes and seabirds from the land. We can make a difference, if we speak up for these places and if we fill our MPs' inboxes with messages about why politicians must take action to protect them.

We can lobby politicians to introduce appropriately protected areas which will sequester carbon as well as saving wildlife. But we also have the power to change our seas for the better through specific campaigns against pollution and, of course, in choosing what we eat. The 'Switch the Stick' campaign launched in 2016 by the City to Sea charity proved extremely effective in persuading consumers and shops to stop using and selling cotton buds with plastic sticks to reduce marine pollution. The acclaimed BBC series *Blue Planet II* caused an upsurge in action against plastics pollution after it was broadcast in 2017. The following year, twice as many volunteers took part in the Great British Beach Clean than in the previous year, and reported a 16 per cent decrease in the number of items collected per 100 metres of shoreline.

We can choose what fish we eat more carefully. Did you know that eating salmon or bluefin tuna is rather like eating a fellow apex predator such as a lion? A simplified food chain consists of plants, then herbivores and detritus feeders, then meat-eaters and finally carnivores that eat other meat-eaters. Approximately 90 per cent of the energy passed upwards is lost at each step: an explosively energetic fish such as a bluefin tuna only uses about 10 per cent of the energy it acquires from its meals to build its body. The trophic level for Atlantic salmon and bluefin tuna is 4.4 – their position on the food web is actually higher than African lions which, like us, are less than 4. Extraordinarily, some bluefin tuna are farmed, which as their position in the food chain demonstrates, is a wasteful, energy-intensive operation.

So it is kinder to the planet if we can avoid eating top-of-the-food-chain fish, as well as other large or long-lived species that mature later in life because these are easily overfished. So no skate, sharks, swordfish, bluefin tuna, halibut or sturgeon (caviar). We should eschew all deep-sea species such as Chilean seabass, also known as Patagonian toothfish, blue grenadiers (hoki), deep-water prawns and orange roughys because of damaging trawls affecting their populations. The Marine Stewardship Council's certification scheme has its critics but it is better to eat MSC-certified fish than those without the label. If we eat farmed fish it is better to choose vegetarian fish such as tilapia and carp rather than predators such as salmon or seabass, which must be fed other fish. Organic is better too: fewer chemicals for us and the sea.

Eating local is a good principle but not if that local fishery is on the brink of collapse, such as the scampi fishery in the North Sea. We also have to eat less fish: we are advised to eat 280 grams of fish each week for good health; around the world, the recommended average is 260 grams per person per week, nearly double the availability from the catch of wild fish. And of course consumer pressure must be applied to supermarkets to encourage the sourcing and sale of fish that are truly sustainable, with no space on the shelves for those that are not.

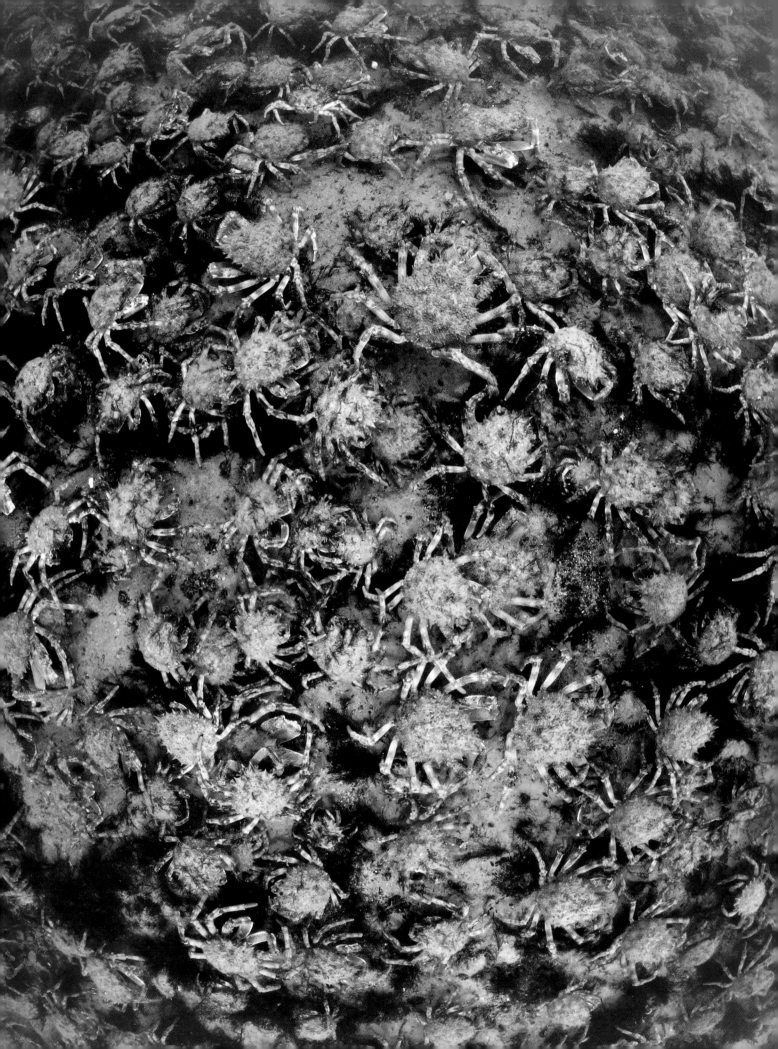

OUR CHANGING OCEANS

One of the many wisdoms shared by the great naturalist John Muir was this: 'When one tugs at a single thing in nature, he finds it attached to the rest of the world.' And just as one creature's fate is entwined with many others, so our fate is entwined with the rest of life on Earth too. Hearteningly, while the great extinction event that humanity is now triggering represents an unravelling of the tapestry of life, we are learning to stitch pieces back together from the humblest of beginnings. Even saving just one species can put in motion a whole series of natural events that lead to the restoration of many more species, and the revival of a whole habitat, ecosystem or biosphere.

Our seas are a dynamic place, and they are always changing. We must acknowledge the grave threat of rapid climate change, and the ever-greater incursion of human life into the ocean. And yet we can also enjoy the excitement of some of the positive changes occurring in our seas.

Despite all our mistreatment of marine life over the centuries, there is still sometimes a startling and joyous abundance in our seas. The mighty skeins of geese that fly onto estuaries and marshes in winter; the feeding frenzies of gannets as they dive into schools of mackerel; even the more intimate abundance of anemones and starfish still found in rockpools when the tide draws down – we can still find spectacles around our oceans.

One less well-known abundance is the gathering of spider crabs (*Maja brachydactyla*) in a shallow bay in Devon. When a spider crab splits open its old shell, the new crab that ventures out is soft and vulnerable. Its new shell needs to harden. In the meantime, to reduce its chance of being picked off, it seeks out company – safety in numbers.

This gathering has another function, because it is the only time they can mate. For most of the year, the female is inaccessible. The tough shell that protects it from predators also shields it from amorous males. Now, when she moults, a male will approach and flip the female upside down to mate. After that, he will protect her until her shell has hardened.

Another swarm is found in the open ocean when warm late-summer water temperatures encourage a great mass of maturing jellyfish. Eerily beautiful moon jellyfish catch zooplankton using their thin tentacles, sieving the sea for prey drifting in the water column. They amass in their thousands, and other creatures are drawn in too. The lion's mane jellyfish (*Cyanea capillata*) is one of the largest jellies in the world; up to two metres in diameter and trailing 30-metre long tentacles, it can weigh up to a tonne. It feasts on the smaller, weaker moon jellies.

This wealth of jellyfish life brings a magnificent ocean wanderer closer to our shores at the end of summer. The leatherback turtle (*Dermochelys coriacea*) is the largest of all turtles, and can reach lengths of up to two metres and 600 kilograms in weight – as much as a 1960s Mini. With its front flippers growing up to 2.7 metres in length and its elegant, streamlined teardrop shape, this turtle is built for travel. In the Atlantic they roam from the North Sea to the Cape of Good Hope, searching for their favourite food: jellyfish.

Leatherbacks tend to follow the jellyfish into deep water during the day, and will dive into frigid dark waters below 1,000 metres – beyond the physiological capabilities of all other diving tetrapods except for beaked whales and sperm whales.

There is another exciting visitor to our seas in late summer and autumn whose life is a high-speed chase. The Atlantic bluefin tuna (*Thunnus thynnus*) is a skittering, flashing, flying speed-machine, one of the fastest fish in the sea. It is made for predatory sprints: warm-blooded, blessed with a high metabolism, the body of a torpedo, retractable fins and eyes set flush to its body. These eyes are keen, because bluefin hunt by sight, seeking schools of herring and mackerel. In the waters beyond southwest England, bluefin dart after a pod of common dolphins. They know that the dolphins can lead them to food.

Dolphins use a kind of echo-location to find prey in the open ocean. When they identify a school of fish, and round them up, the tuna roar in to strike. They attack with such speed and ferocity that the surface of the sea churns and boils. Both predators power in from below, keeping their prey pinned against the surface of the water, where they have fewer options to escape.

The drama of a bluefin bait-ball is a new experience in modern times. Bluefin tuna vanished from our coast in the 1960s. Hearteningly, seven years ago, the fish began to be sighted regularly around southwest England once again. Is this a welcome revival?

This spectacular fish has always attracted attention. In the 1930s, bluefin tuna drew big-game fishers to the Yorkshire coast. Their record catch weighed 387 kilograms. Sixty years ago there were 30 times more Atlantic bluefin swimming wild than there are now. Over a century, its population decline is estimated to be 95 per cent. Bluefin disappeared from the North Sea in the 1970s. In the 1980s, the Black Sea population vanished. This mighty, once abundant fish was pushed to the edge of extinction.

Bluefin are the largest species of tuna, living up to 40 years and growing some 2.5 metres in length. The reason they disappeared was simply because each individual was so valuable the species was fished far too much. Across the eight 'true tuna' species, commercial tuna fishing generates more than US$42 billion each year.

Countries continued to take quotas of bluefin even when it had rapidly declined. Finally, some controls on illegal fishing and more sustainable fishing quotas have enabled its population to begin to recover. Eastern Atlantic bluefin tuna spawns in the Mediterranean and has increased by at least 22 per cent over the last four decades. Many other tuna populations are still severely under pressure. The species' smaller native western Atlantic population, which spawns in the Gulf of Mexico, has declined by more than half in the same period. Yellowfin tuna is still overfished in the Indian Ocean.

Opposite: Swarms of moon jellyfish may become more common in our waters as the seas warm.

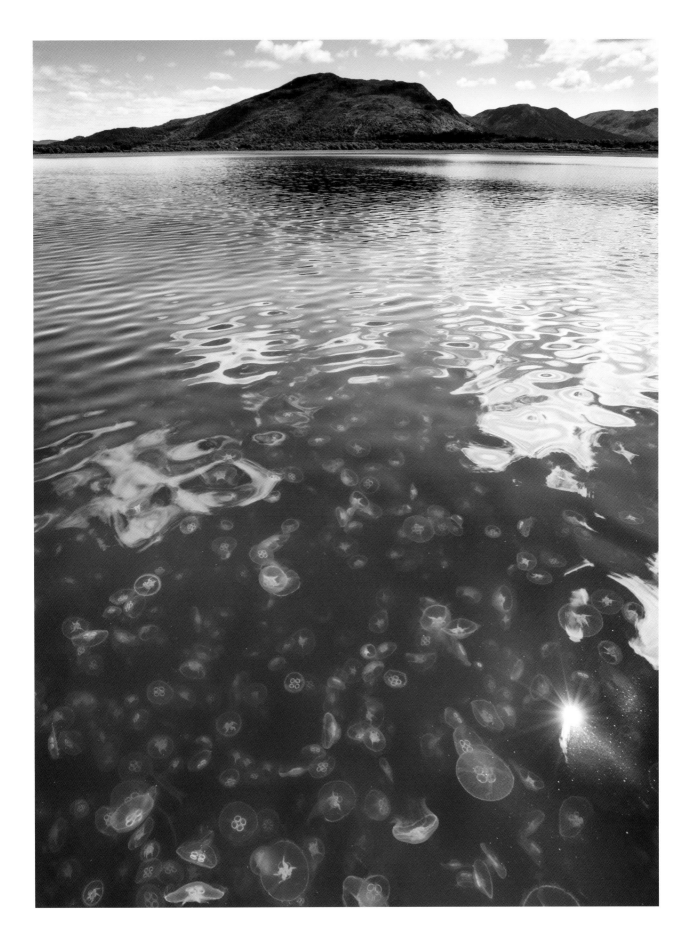

Above: 'Never has there
been a more important time
to invest in our own wildlife,
to try and set an example
for the rest of the world, and
restore our once Wild Isles for
future generations.' Sir David
Attenborough, filming for the
Wild Isles series on Skomer
Island, June 2022.

In Britain, it is illegal to purposely catch bluefin, either commercially or for recreation, but tuna have washed up on Scottish beaches and even in a sea loch. In 2018, a 350-kilogram bluefin tuna was accidentally caught by Devon sprat fishers but the strict rules meant that no-one was allowed to eat it. Fishers complained that it would have fed their whole town. With growing numbers in the Atlantic, more individuals are likely to be spotted in British waters, but it may be that warmer temperatures caused by climate change are also encouraging their comeback. There could also be bigger populations of bait fish for them to pursue.

In 2021, the International Union for Conservation of Nature (IUCN) changed their entry for Eastern Atlantic bluefin tuna from 'endangered' to 'least concern'. In an attempt to learn more about the bluefin's revival, in 2021 Britain was given a quota of bluefin to allow for accidental mortality arising from bycatch and from a new satellite-tagging programme.

The Catch and Release Tagging Programme (CHART) is funded by the government. Recreational anglers are permitted to seek out tuna under the guidance of scientists who fit the fish with satellite pop-up archival tags and acoustic tags and release them unharmed. The 20-centimetre-long archival tags record light, temperature and depth every 15 seconds for up to a year. On a certain date, the tag detaches from the tuna and floats to the surface of the sea, where it transmits a summary of the data to a satellite.

Satellite tags are another window beneath the waves, where too many of us have failed to look for too long. As we learn more about the creatures that shape this beautiful, complex other-world, we can only hope that our delight and wonder leads us to take strong action to better protect our living seas.

Sir David Attenborough concludes the *Wild Isles* TV series by spending time with puffins on the island of Skomer, off the coast of Pembrokeshire. Puffin numbers have been increasing on the island but Skomer is an exception. 'Most of our puffin colonies are in decline. Overfishing and climate change mean the sand eels they depend on are increasingly hard to find', says David. 'It is a clear example of just how fragile and fragmented our nature is. Though rich in places, Britain as a whole is one of the most nature-depleted countries in the world.

'Never has there been a more important time to invest in our own wildlife, to try and set an example for the rest of the world, and restore our once Wild Isles for future generations.'

EPILOGUE:
TAKING ACTION FOR NATURE

THE STATE OF OUR NATURAL WORLD

We are known as a nation of wildlife lovers and explorers in awe of our great outdoors. For centuries we've celebrated the beauty of the natural world right here at home.

And yet, as it has gradually disappeared, we have barely noticed the changes.

Today one-fifth of all our mammals are at risk of extinction. And the same is true for one-third of our birds. In just 20 years, our flying insects have declined by as much as 60 per cent.

The UK is one of the most nature-depleted countries on the planet, and changing that is a responsibility that rests on all of us. It has never been more important to get involved than it is right now.

OUR ROLE

As we've seen in this book, from the heart of London to the remotest peaks of the Cairngorms, there are passionate people right across our isles, dedicating their lives to restoring our lost wildlife.

But this shouldn't just be the preserve of those on the front line. Every one of us, no matter our background or where we live, can and must play a part in restoring nature to our isles if we're to turn the crisis around. It will take the whole of society to shift its thinking and its attitude to nature to bring back its richness, diversity and abundance.

The millions of us who live here in the UK have the power to make a real difference, creating a better world for generations to come.

WHAT DOES THAT LOOK LIKE?

There are so many ways to save nature – in how we build, travel, farm, govern, manage space and feed our families. Here are a few ideas to get you started and details of where to find out more.

MAKE SPACE FOR NATURE

Whatever your outdoor space, be it a balcony or courtyard, garden or window box, you can make it a happier place for you, and for the nature on your doorstep. Find expert tips and stories of people making space for nature here:

https://www.rspb.org.uk/get-involved/activities/nature-on-your-doorstep/

SHOP SMART

The things we buy, the way we run our homes, the way we travel, all have an impact on nature. You can calculate your personal footprint and find ways to reduce it here:

https://www.wwf.org.uk/myfootprint

EAT FOR NATURE

The food we eat can come at a huge environmental cost. In the UK, agriculture accounts for 10 per cent of our greenhouse gas emissions, with meat and dairy farming accounting for two-thirds of this. Eating seasonal foods, reducing meat and dairy in your diet, and reducing food waste can all make a big difference in reducing the pressures on wildlife.

MOVE YOUR MONEY

The finance sector plays a vital role in deciding the types of projects that take place around the world, by providing the investment needed for them to happen. This could include anything from financing infrastructure projects to providing the money needed to develop renewable energy systems.

We all have a role to play in driving change. A large proportion of the money lent or invested by financial institutions in harmful practices and companies, comes from all of us. For example, there

is around £3 trillion in UK pensions. This is a huge amount of money that could all be invested in a greener future instead. In fact, making sure you have a sustainable pension is one of the most powerful things you can do to reduce your personal footprint – by one estimate, it could have 27 times the impact of giving up flying and going vegan combined.

Give time

Across the UK there are a wealth of organisations working to protect and restore nature – from friends of local parks groups to huge charities – and they all rely heavily on volunteers. There are many ways in which you can play a role, from joining a one-off event or regular volunteering days to residential placements. *Do-it.org* is a database of UK volunteering opportunities. You can search more than a million by interest, activity or location and then apply online.

People power

You have a powerful voice in persuading politicians, policy-makers and business leaders to do more for nature and the environment. Join the movement and use your voice by signing up as a campaigner. There are lots of opportunities to take action online and in your community.

Fundraise

Fundraising is a great opportunity to turn your skills, hobbies and interests into funds for nature, as well as a way of challenging yourself and learning new skills. From running your first ever 5k to holding a bake sale, or donating to appeals or through regular giving, your contribution can make a huge difference for nature.

Tell stories

Storytelling, sharing experiences and connecting with other people can be a really powerful way to motivate others to act too. So if you are doing your bit for nature, share your story. It has the power to inspire.

How to get started

The Wild Isles website has a raft of information about how you can help make our isles wilder. Go to *www.SaveOurWildIsles.org* to find out more. Or visit any of the following:

> *https://www.SaveOurWildIsles.org*
> *https://www.rspb.org.uk/get-involved/activities/ so-many-ways/*
> *https://www.wwf.org.uk/how-to-help-nature*
> *https://www.nationaltrust.org.uk/discover/nature*

As Sir David Attenborough says at the end of the final episode of the *Wild Isles* television series:

'Because this is our home, it can only be our responsibility to restore and protect our wildlife. Perhaps you can be the first to pass these wild isles onto the next generation in better shape than you inherited it?'

FURTHER READING

CHAPTER 1: OUR PRECIOUS ISLES

Trevor D. Blackall et al, 'Ammonia emissions from seabird colonies'. *Geophysical Research Letters*, 34, L10801, 2007 DOI: *https://doi.org/10.1029/2006GL028928*

Mark Cocker, *Our Place – Can We Save Britain's Wildlife Before it is Too Late?*, Jonathan Cape, 2018

Dominic Couzens, Andy Swash, Robert Still and Jon Dunn, *Britain's Mammals – A Field Guide to the Mammals of Britain and Ireland*, Princeton University Press, 2017

Annette L. Fayet et al, 'Local prey shortages drive foraging costs and breeding success in a declining seabird, the Atlantic puffin', *Journal of Animal Ecology*, 2021 DOI: *https://doi.org/10.1111/1365-2656.13442*

Peter Fiennes, *Oak and Ash and Thorn – The Ancient Woods and New Forests of Britain*, One World, 2017

Sophie Lake, Durwyn Liley, Robert Still and Andy Swash, *Britain's Habitats – A Guide to the Wildlife Habitats of Britain and Ireland*, Princeton University Press, 2015

Robert Macfarlane, *Underland*, Hamish Hamilton, 2019

P. Ian Mitchell, Stephen F. Newton, Norman Ratcliffe and Timothy E. Dunn (Eds.) *Seabird Populations of Britain and Ireland: results of the Seabird 2000 census (1998-2002)*, T. and A.D. Poyser, 2004

Oliver Rackham, *Woodlands*, William Collins, 2015

Timothy J. Roper, *Badger*, Collins New Naturalist Library, 2010

Katia Sanchez-Ortiz et al, 'Land-use and related pressures have reduced biotic integrity more on islands than on mainlands', *BioRxiv*, 2019 DOI: *https://doi.org/10.1101/576546*

Susan Wright, Peter Cairns and Nick Underdown, *Scotland: A Rewilding Journey*, Wild Media Foundation, 2018

Marketa Zimova et al, 'Lack of phenological shift leads to increased camouflage mismatch in mountain hares', *Proceedings of the Royal Society B*, December 2020 DOI: *https://doi.org/10.1098/rspb.2020.1786*

CHAPTER 2: OUR GRASSLANDS

Nick Acheson, *The Meaning of Geese – A Thousand Miles in Search of Home*, Chelsea Green, 2023

Patrick Barkham, *The Butterfly Isles – A Summer in Search of Our Emperors and Admirals*, Granta, 2010

Roy Dennis, *Restoring the Wild – Sixty Years of Rewilding Our Skies, Woods and Waterways*, William Collins, 2021

George Ewart Evans and David Thomson, *The Leaping Hare* (reissue), Faber and Faber, 2002

Dave Goulson, *Silent Earth – Averting the Insect Apocalypse*, Jonathan Cape, 2021

James Macdonald Lockhart, *Raptor – A Journey Through Birds*, Fourth Estate, 2016

Jeremy Thomas and Richard Lewington, *The Butterflies of Britain and Ireland*, British Wildlife Publishing, 2010

CHAPTER 3: OUR FRESHWATER

Laurence Bee, Geoff Oxford and Helen Smith, *Britain's Spiders – A Field Guide* (2nd edition), Princeton University Press, 2020

Amy-Jane Beer, *The Flow – Rivers, Water and Wildness*, Bloomsbury, 2022

Derek Gow, *Bringing Back the Beaver – The Story of One Man's Quest to Rewild Britain's Waterways*, Chelsea Green, 2020

Mark Kurlansky, *Salmon – A Fish, the Earth, and the History of a Common Fate*, One World, 2020

Mike McCarthy, *The Moth Snowstorm – Nature and Joy*, John Murray, 2015

Martin Salter & Stuart Singleton-White, *Chalk Streams in Crisis*, The Rivers Trust, 2019

CHAPTER 4: OUR WOODLANDS

John Fowles, *The Tree*, Little Toller, republished 2016

Matthew Oates, *His Imperial Majesty – A Natural History of the Purple Emperor*, Bloomsbury, 2020

Oliver Rackham, *Woodlands*, William Collins, 2015

Lee Schofield, *Wild Fell – Fighting for Nature on a Lake District Hill Farm*, Transworld, 2022

Merlin Sheldrake, *Entangled Life – How Fungi Make Our Worlds, Change Our Minds and Shape Our Futures*, The Bodley Head, 2020

Suzanne Simard, *Finding the Mother Tree – Uncovering the Wisdom and Intelligence of the Forest*, Allen Lane, 2021

Peter A. Thomas, *Trees*, Collins New Naturalist Library, 2022

Isabella Tree, *Wilding – The Return of Nature to an English Farm*, Picador, 2018

CHAPTER 5: OUR OCEAN

Charles Clover, *Rewilding the Sea – How to Save Our Oceans*, Witness Books, 2022

Keith Hiscock, *Exploring Britain's Hidden World – A Natural History of Seabed Habitats*, Wild Nature Press, 2018

Richard Kerridge, *Cold Blood – Adventures with Reptiles and Amphibians*, Chatto & Windus, 2014

Gavin Maxwell, *Ring of Bright Water*, Little Toller, republished 2009

Philip V. Mladenov, *Marine Biology – A Very Short Introduction*, Oxford University Press, 2020

Paul Naylor, *Great British Marine Animals* (4th edition), Sound Diving Publications, 2021

Annabel A. Plumeridge and Callum M. Roberts, 'Conservation targets in marine protected area management suffer from shifting baseline syndrome: A case study on the Dogger Bank', *Marine Pollution Bulletin*, 116, 2017 DOI: *https://doi.org/10.1016/j.marpolbul.2017.01.012*

Callum Roberts, *The Unnatural History of the Sea*, Gaia, 2007

Callum Roberts, *Ocean of Life – How Our Seas Are Changing*, Allen Lane, 2012

Bryce D. Stewart et al, *Marine Conservation Begins at Home: How a Local Community and Protection of a Small Bay Sent Waves of Change Around the UK and Beyond*, Frontiers in Marine Science, 2020 DOI: *https://doi.org/10.3389/fmars.2020.00076*

ACKNOWLEDGEMENTS

A huge thank you to the following scientists, naturalists, rangers and other professional conservationists who spared their time, shared their expertise and in many cases helped fact-check what was written about their areas of expertise:

Prof John Altringham, Prof Diana Bell, Jamie Boyle, Kirsten Carter, Richard Davies, Molly Doubleday, Nigel Hand, Lucy Hodson, James How, Amelia Hursham, Carol Laidlaw, Chantelle Lindsay, Rob Lott, Greg Morgan, Stephen Murphy, Padraig O'Sullivan, Scott Passmore, David Plummer, Prof Callum Roberts, Prof Elva Robinson, David Simcox, Lee Schofield, Jim Scott, Helen Smith, Prof Jeremy Thomas and David Vyse. Particular thanks to Simon King and John Walters for their expertise on a wide range of different wildlife subjects and for their thorough checking of facts. Thanks also to Prof Richard Brazier, Carl Jones and Matthew Oates.

Thank you to my co-author, Alastair Fothergill, co-founder of Silverback, for creating and leading the whole *Wild Isles* mission with such expertise and wisdom. Thanks to Laura Barwick for her superb picture research and selections and thank you to *Wild Isles* episode producers for their help, expertise and contacts: Chris Howard, Hilary Jeffkins, Nick Gates and Gisle Sverdrup. Thanks also to many other members of the Silverback team including Samantha Davis, Joff Fenton, Laura Howard, Harry Yates and Lily Moffat. Thanks to the teams at RSPB and WWF who have contributed to this project and particular thanks to Martin Fowlie and Gareth Brede in the RSPB press office.

At HarperCollins, thanks to Myles Archibald, publishing director, for his enthusiasm, wisdom and guidance; thanks to Hazel Eriksson, senior editor, for her attention to detail and for bringing such a complicated book together so smoothly and efficiently; and thanks to Sally Partington for her excellent copy edit. Many thanks to the wider team at HarperCollins from designers to publicists for their dedicated work on this book.

Finally, thank you Sir David Attenborough for continuing to give so much to inspire and urge us to better protect and restore wildlife and living landscapes, here in Britain and across the planet.

INDEX

William Collins
An imprint of HarperCollins*Publishers*
1 London Bridge Street
London SE1 9GF

WilliamCollinsBooks.com

HarperCollins*Publishers*
Macken House
39/40 Mayor Street Upper
Dublin 1
D01 C9W8
Ireland

First published in Great Britain by William Collins in 2023

1

Designed by Eleanor Ridsdale Colussi
Printed and bound by GPS Group in Bosnia-Herzegovina

Picture Credits

NPL – Nature Picture Library; SF – Silverback Films

2–3 Scotland:The Big Picture/NPL; 5 Alex Board; 6–7 Sam Stewart/
SF; 10 Scotland: The Big Picture/NPL; 13 *t* Jesse Wilkinson/SF; 13
b 14 Nick McCaffrey/SF; 16 Fergus Gill/NPL; 17 Guy Edwardes/
NPL; 19 Peter Cairns; 20 David Chapman/Alamy; 22–3 Ian
West/Alamy; 25 Terry Whittaker/2020VISION/NPL; 26 Robin
Cox/SF; 29–31 Rachel Bigsby; 33–5 Jesse Wilkinson; 36 David
Tipling/2020VISION/NPL; 38 Alex Board; 41 Anete Terentjeva/
Alamy; 43 Charlie Hamilton-James/NPL; 44 Jussi Murtosaari/
NPL; 46 *t* John Spencer Cook; 46 *b* David Kjaer/NPL; 49–51
Sam Hobson/NPL; 52 Fan Zhongyoung; 53 Alex Board; 54 Guy
Edwardes/NPL; 57 *t* Jesse Wilkinson/SF; 57 *b* Mark Hamblin/
scotlandbigpicture.com; 58 Nick Gates; 60 Mark Hamblin/
scotlandbigpicture.com; 63 David Woodfall/NPL; 65 Jo Hansford;
68–9 Hamza Yassin/SF; 72 Arterra Picture Library/Alamy; 74–5
Andrew Parkinson/NPL; 77 John Walters; 78 Andrew Parkinson/
NPL; 81 Simon King/SF; 82 KristianBell/Getty; 85 Gary K.
Smith/NPL; 86 *t* Ellie de Cent; 86 *b* Alastair MacEwen; 92–3
David Woodfall/NPL; 96–7 Mark Hamblin/scotlandbigpicture.
com; 98 Harry Yates; 101 Our Wild Life Photography/Alamy;
102 John Cancalosi/NPL; 104 Jerome Murray CC/Alamy; 108–9
Mark Hamblin/scotlandbigpicture.com; 110–5 Paul Madigan; 116
Ben Hall/NPL; 119 *t* Kevin Flay/SF; 119 *b* Gavin Thurston/SF;
120–3 Jack Barnes; 124 *t* Charlie Phillips Images; 124 *b* Richard
Davies; 127 Chris Howard; 129 Linda Pitkin/2020VISION/NPL;
130 Mark Caunt/Alamy; 133 Richard Davies; 134–5 Tursiops
Photography/Alamy; 137 Nick Upton/NPL; 138 Chris Howard;
140 Nick Upton/NPL; 142 Stephen Dalton/NPL; 145 Alex Hyde;
146 Stephen Dalton/NPL; 148 Guy Edwardes/NPL; 151 Wayne
Hutchinson/Alamy; 153 Nick Moore/Alamy; 154 Simon Lewis;
156 Andy Sands/NPL; 158–9 Linda Pitkin/2020VISION/NPL;
160 Peter Cayless/SF; 162 Andy Rouse/NPL; 166–7 Ben Hall/
NPL; 169 Nick Gates; 170–1 Craig Denford; 173 Chris Gomersall/
Alamy; 174 Wolstenholme Images/Alamy; 176 Neil McIntyre; 179
t Mark Hamblin/scotlandbigpicture.com; 179 *b* Neil McIntyre; 180
Chris Howard; 184–5 Neil McIntyre; 186 MSE Stock/Alamy; 188
Robin Smith/SF; 190 Andy Rouse/2020VISION/NPL; 193 Mark
Yates/SF; 194–5 Alex Hyde; 196 Markus Varesvuo/NPL; 201 Mark
Hamblin/scotlandbigpicture.com; 202 Sam Duckerin; 205 *t* Alastair
MacEwen/SF; 205 *b* Matt Chippendale-Jones/SF; 206 Kim Taylor/
NPL; 208 Sam Duckerin; 211–3 Jules Cox; 214–7 Alex Hyde; 218
Alastair MacEwen/SF; 220 *t* Nigel Bean/SF; 220 *b* Harry Yates/
SF; 223 Harry Yates; 225–6 *t* Alex Hyde; 226 *b* James Stevens/SF;
230 Paul Hobson/NPL; 233 *t* Whittaker Wildlife UK/Alamy; 233
Simon King/SF; 235 Mark Yates/SF; 236–7 David Chapman/Alamy;
238–40 Alex Mustard/NPL; 242 Tom Walker/SF; 245 Nick Gates;
246–7 Gisle Sverdrup; 248 Oxford Scientific/Getty; 251 *t* Linda
Pitkin/2020VISION/NPL; 251 *b* Alex Mustard/NPL; 252 Alex
Mustard/2020VISION/NPL; 255 Alex Mustard/NPL; 257 Alex
Mustard/2020VISION/NPL; 258 *t* Doug Anderson/SF; 258 *b* 261
Doug Anderson/SF; 262 Dan Burton/NPL; 265 *t* Doug Anderson/
SF; 265 *b* Lewis Jefferies/NPL; 266 Terry Whittaker/2020VISION/
NPL; 269 Doug Anderson/SF; 270 Brydon Thomason; 273 Richard
Shucksmith; 275–6 Alex Mustard/NPL; 279 Doug Anderson/SF;
280 *t* Scotland: The Big Picture/NPL; 280 *b* Bertie Gregory; 283
Alex Mustard/2020VISION/NPL; 285 Brydon Thomason; 287
Mike Potts/NPL; 288 Alex Board; 290–1 Richard Shucksmith;
292 Brydon Thomason; 295–6 Alex Mustard/NPL; 299 Linda
Pitkin/2020VISION/NPL; 303 Andy Rouse/2020VISION/
NPL; 305 Howard Oates/Getty; 306 Alex Mustard/NPL; 308 Alex
Mustard/2020VISION/NPL; 311 Alex Hyde; 312 Alex Board